HISTORY OF BEAUTY

HISTORY OF BEAUTY

EDITED BY

UMBERTO ECO

Translated by
Alastair McEwen

RIZZOLI NEW YORK

New York · Paris · London · Milan

Original hardcover edition first published in the United States of America in 2004 by
Rizzoli International Publications, Inc.
300 Park Avenue South
New York, NY 10010
www.rizzoliusa.com

This paperback edition first published in the United States of America in 2010

Second printing, 2014
2014 2015 2016 2017 / 10 9 8 7 6 5 4 3 2

Printed in China

ISBN: 978-0-8478-3530-0

Library of Congress Control Number: 2010923599

This volume, with supplements and adaptations, derives from the CD-rom *Bellezza. Storia di un'idea dell'occidente* edited by Umberto Eco, produced by Motta On Line in 2002.

The texts were written by Umberto Eco (Introduction and chapters III, IV, V, VI, XI, XIII, XV, XVI and XVII) and Girolamo de Michele (I, II, VII, VIII, IX, X, XII and XIV), who also edited the research on the passages of the anthology.

The following people collaborated on the CD-rom:
Danco Singer, general coordination of the project
Margherita Marcheselli, publishing coordination
Rossana Di Fazio, iconographic conception
Horizons Unlimited, editing

The following people collaborated on the present volume:
Polystudio, graphic design
Anna Maria Lorusso, editorial coordination
Marina Rotondo, editing
Sergio Daniotti, production

Mario Andreose, Publishing Director RCS
Elisabetta Sgarbi, Editorial Director Bompiani

CONTENTS

Introduction

"Beautiful"—together with "graceful" and "pretty," or "sublime," "marvelous,"
"superb," and similar expressions—is an adjective that we often employ to
indicate something that we like. In this sense, it seems that what is beautiful
is the same as what is good, and in fact in various historical periods there
was a close link between the Beautiful and the Good.

But if we judge on the basis of our everyday experience, we tend to
define as good not only what we like, but also what we should like to have
for ourselves. There is an infinite number of things that we consider good, a
love requited, wealth honestly acquired, a refined delicacy, and in all these
cases we should like to possess that good. A good is that which stimulates
our desire. Even when we consider a virtuous deed to be good, we should
like to have done it ourselves, or we determine to do something just as
meritorious, spurred on by the example of what we consider to be good.
Other times we describe as good something that conforms to some ideal
principle, but that costs suffering, like the glorious death of a hero, the
devotion of those who treat lepers, or those parents who sacrifice their own
lives to save their children. In such cases we recognize that the thing is good
but, out of egoism or fear, we would not like to find ourselves in a similar
situation. We recognize this as a good, but another person's good, which we
look on with a certain detachment, albeit with a certain emotion, and
without being prompted by desire. Often, to describe virtuous deeds that
we prefer to admire rather than perform, we talk of doing a "beautiful" thing.

If we reflect upon the detached attitude that allows us to define as
beautiful some good that does not arouse our desire, we realize that we talk
of Beauty when we enjoy something for what it is, irrespective of whether
we possess it or not. If we admire a well-made wedding cake in a baker's
window, it may strike us as beautiful, even though for health reasons or lack

of appetite we do not desire it as a good to be acquired. A beautiful thing is something that would make us happy if it were ours, but remains beautiful even if it belongs to someone else. Naturally, here we are not dealing with the attitude of those who, when they come across a beautiful thing like a painting made by a great artist, desire to possess it out of a certain pride of possession, or to be able to contemplate it every day, or because it has enormous economic value. These forms of passion, jealousy, lust for possession, envy, or greed have nothing to do with the sentiment of Beauty.

The thirsty person who, having found a spring, rushes to drink, does not contemplate its Beauty. He or she may do so afterwards, once thirst has been slaked. This explains where the sense of Beauty differs from desire. We can consider human beings to be most beautiful, even though we may not desire them sexually, or if we know that they can never be ours. But if we desire a human being (who might also be ugly) and yet cannot have the kind of relationship we desire with him or her, then we suffer.

In this review of ideas of Beauty over the centuries, we shall be trying first and foremost to identify those cases in which a certain culture or a certain historical epoch has recognized that there are things pleasing to contemplate independently of the desire we may feel for them. In this sense we shall not start off from any preconceived notion of Beauty: we shall review those things that, over thousands of years, human beings have considered beautiful.

Agnolo Bronzino
An Allegory with Venus and Cupid, detail, probably 1540-1550.
London,
National Gallery

Another criterion that will guide us is the fact that the close relationship forged by the modern age between Beauty and Art is not as obvious as we think. While certain modern aesthetic theories have recognized only the Beauty of art, thus underestimating the Beauty of nature, in other historical periods the reverse was the case: Beauty was a quality that could be possessed by natural things (such as moonlight, a fine fruit, a beautiful color), while the task of art was solely to do the things it did *well,* in such a way that they might serve the purpose for which they were intended—to such an extent that art was a term applied even-handedly to the work of painters, sculptors, boat builders, carpenters, and barbers alike. Only much later, in order to distinguish painting, sculpture, and architecture from what we would now call crafts, did we conceive of the notion of Fine Arts.

Nevertheless, we shall see that the relationship between Beauty and Art was often expressed ambiguously because, although the Beauty of nature was preferred, it was acknowledged that art could portray nature beautifully, even when the nature portrayed was in itself hazardous or repugnant.

In any case, this is a history of Beauty and not a history of art (or of literature or music), and therefore we shall mention the ideas that were from time to time expressed about art only when these ideas deal with the link between Art and Beauty.

The predictable question is: so why is this history of Beauty documented solely through works of art? Because over the centuries it was artists, poets,

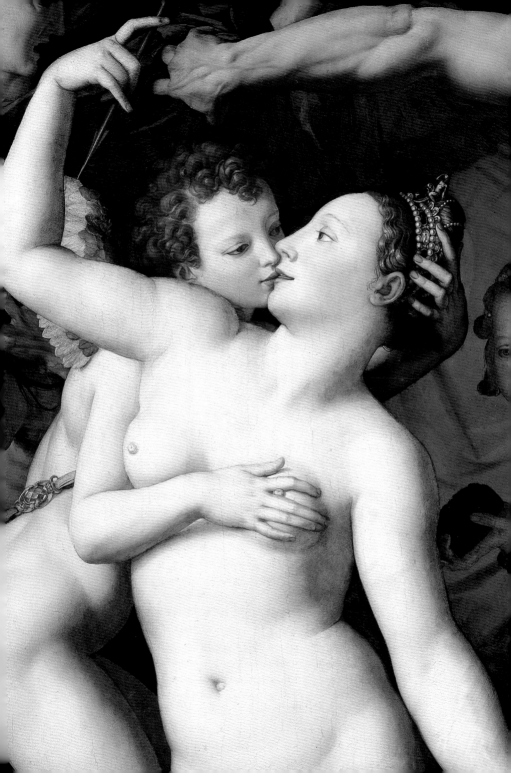

and novelists who told us about the things that they considered beautiful, and they were the ones who left us examples. Peasants, masons, bakers, or tailors also made things that they probably saw as beautiful, but only a very few of these artifacts remain (like vases, constructions erected to provide shelter for livestock, some clothing). Above all, they wrote nothing to tell us why they might have considered such things beautiful, or to explain to us what natural Beauty meant to them. It is only when artists portrayed barns, tools, or people wearing clothing that we can surmise that they may be telling us something about the ideals of Beauty held by the craftsmen of their time, but we cannot be entirely sure. Sometimes, in portraying people of their own time, artists were inspired by the ideas they had about fashions in Biblical times or in Homer's day; contrariwise, in portraying Biblical or Homeric characters, they drew inspiration from the fashions of their own day. We can never be sure about the documents on which we base our opinions, but we can nevertheless hazard certain inferences, albeit with due care and prudence. Often, when considering the products of ancient artists or craftsmen, we are helped by the literary or philosophical texts from the period. For example, we cannot say whether those who sculpted monsters on the columns or capitals of Romanesque churches considered them to be beautiful, yet we do have a text by St. Bernard (who did not consider such portrayals to be either good or useful) in which we learn that the faithful took pleasure in contemplating them (and in any case, in his condemnation of them, St. Bernard reveals that their appeal was not lost on him). And at this point, while thanking the heavens for this testimony that comes to us from a source beyond suspicion, we can say that—in the view of a twelfth-century mystic—the portrayal of monsters was beautiful (even though morally censurable).

Paul Gauguin
Aha oe feii?,
detail, 1892.
Moscow,
Pushkin State Museum
of Fine Arts

It is for these reasons that this book deals solely with the idea of Beauty in Western culture. As far as regards so-called primitive peoples, we have artistic items such as masks, graffiti and sculptures, but we do not have any theoretical texts that tell us if these were intended for contemplation, ritual purposes, or simply for everyday use. In the case of other cultures, which possess a wealth of poetic and philosophical texts (such as Indian and Chinese culture, for example), it is almost always difficult to establish up to what point certain concepts can be identified with our own, even though tradition has led us to translate them into Western terms such as "beautiful" or "right." In any event any discussion of this would fall outside the scope of this book.

We have said that for the most part we shall use documents from the world of art. But, especially as we work toward modern times, we shall be able to make use of documents that have no artistic purpose other than pure entertainment, advertising, or the satisfaction of erotic drives, such as images that come to us from the commercial cinema, television, and advertising. In principle, great works of art and documents of scant aesthetic value will have the same value for us, provided that they help us to understand what the ideal of Beauty was at a certain given time.

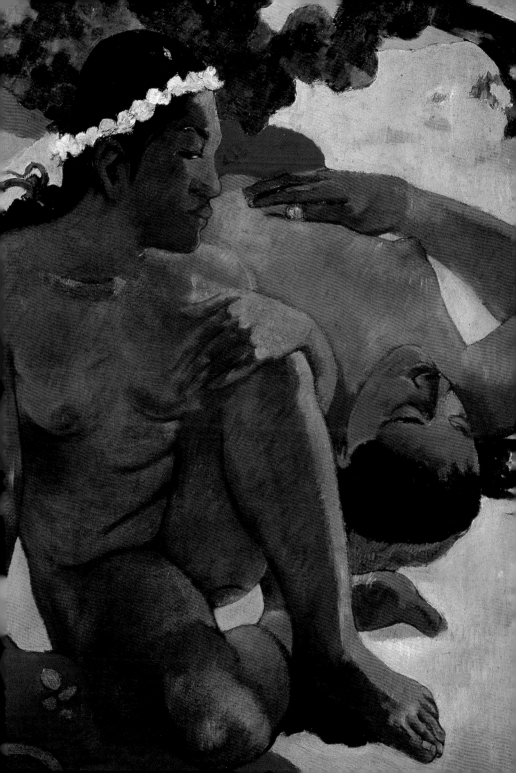

This having been said, our book could be accused of relativism, as if we wanted to say that what is considered beautiful depends on the various historical periods and cultures. And this is precisely what we do mean to say. There is a famous passage in Xenophanes of Colophon, one of the pre-Socratic philosophers, which reads, "But had the oxen or the lions hands, or could with hands depict a work like men, were beasts to draw the semblance of the gods, the horses would them like to horses sketch, to oxen, oxen, and their bodies make of such a shape as to themselves belongs" (Clement, *Stromata*, V, 110).

It is possible—over and above the diverse concepts of Beauty—that there may be some single rules valid for all peoples in all centuries. In this book we shall not attempt to seek them out at all costs. Rather, we shall highlight the differences. It is up to the reader to seek any unity underlying these differences.

This book starts from the principle that Beauty has never been absolute and immutable but has taken on different aspects depending on the historical period and the country: and this does not hold only for physical Beauty (of men, of women, of the landscape) but also for the Beauty of God, or the saints, or ideas …

Allen Jones
with Philip Castle
Pirelli Calendar, detail,
1973.

In this sense we shall be most respectful to the reader. We shall show that, while the images made by painters and sculptors from the same period seemed to celebrate a certain model of Beauty (of human beings, of nature, or of ideas), literature was celebrating another. It is possible that certain Greek lyric poets sang of a type of feminine grace that was only to be realized by the painting and sculpture of a later epoch. On the other hand we need only think of the amazement that would be felt by a Martian of the next millennium who suddenly came across a Picasso and a description of a beautiful woman in a love story from the same period. He would not understand what the relationship between the two concepts of Beauty was meant to be. This is why we shall have to make an occasional effort, and try to see how different models of Beauty could coexist in the same period and how other models refer to one another through different periods.

The layout and the inspiration for this book are made clear right from the beginning, so that the curious reader may have an idea of the *taste* of the work, which begins with eleven comparative tables designed to visualize immediately how the diverse ideas of Beauty were revisited and developed (and perhaps varied) in different epochs, in the works of philosophers, writers, and artists that were sometimes very distant from one another. Subsequently, for every epoch or fundamental aesthetic model, the text is accompanied by images and quotations connected to the problem in question, in certain cases with a highlighted reference in the body of the text.

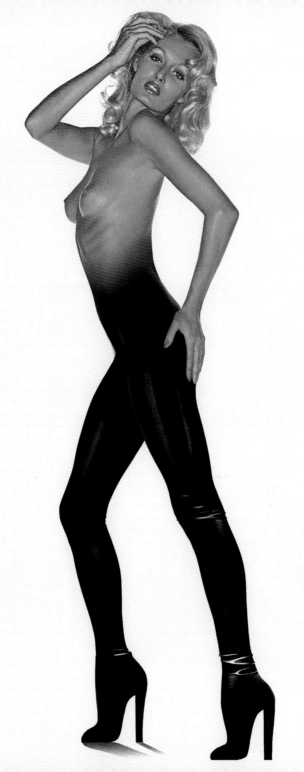

Comparative Tables

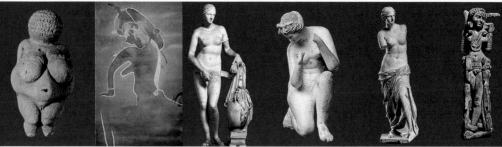

Thirtieth millennium BC	Fourth millennium BC	Fourth century BC	Third century BC	Second century BC	Second–first century BC
"Venus" of Willendorf. Vienna, Naturhistorisches Museum	*Antinea.* Jabbaren, Tassili, Algeria	Praxiteles, *Aphrodite Cnidia,* Roman copy of a Greek original. Rome, Museo Nazionale Romano	*Crouching Aphrodite,* Roman copy of a Greek original. Paris, Musée du Louvre	*Venus de Milo.* Paris, Musée du Louvre	*The Goddess Lakshmi,* ivory statuette, South Asian, found in Pompeii. Naples, Museo Archeologico Nazionale

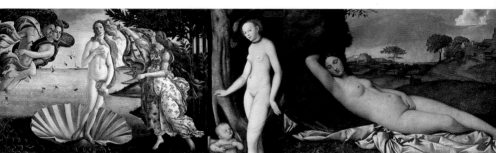

c. 1482	c. 1531	1509
Sandro Botticelli, *The Birth of Venus.* Florence, Galleria degli Uffizi	Lucas Cranach, *Venus with Cupid Stealing Honey.* Rome, Galleria Borghese	Giorgione, *Sleeping Venus.* Dresden, Staatliche Gemäldegalerie

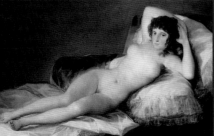

1797–1800	1804–1808
Francisco de Goya y Lucientes, *The Nude Maja.* Madrid, Museo del Prado	Antonio Canova, *Pauline Bonaparte.* Rome, Galleria Borghese

First century AD	Fourth–fifth century AD	c. 1360	Fourteenth century	1470–1480
Mars and Venus, from the House of Mars and Venus in Pompeii. Naples, Museo Archeologico Nazionale	*Venus Rising from the Sea*. Cairo, Coptic Museum	Master of St. Martin, *Venus Worshipped by Six Legendary Lovers*, Florentine plate. Paris, Musée du Louvre	*Vision of the Great Whore, Tapestry of the Apocalypse*, detail. Angers, Castle of King René of Anjou	Unknown painter from the Lower Rhineland, *The Magic of Love*. Leipzig, Museum der bildenden Künste

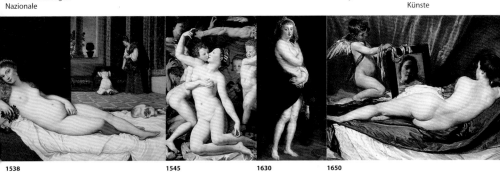

1538		1545	1630	1650
Titian, *Venus of Urbino*. Florence, Galleria degli Uffizi		Agnolo Bronzino, *An Allegory of Venus and Cupid*. London, National Gallery	Peter Paul Rubens, *The Fur (Helena Fourment as Venus)*. Vienna, Kunsthistorisches Museum	Diego Velásquez, *Venus at the Mirror*. London, National Gallery

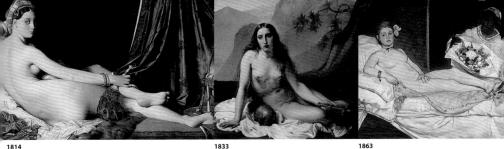

1814	1833	1863
Jean-Auguste-Dominique Ingres, *La Grande Odalisque*. Paris, Musée du Louvre	Francesco Hayez, *The Repentent Magdalen*. Milan, Civica Galleria d'Arte Moderna	Édouard Manet, *Olympia*. Paris, Musée d'Orsay

17

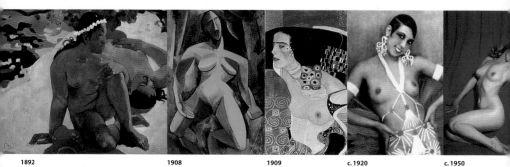

1892		1908	1909	c. 1920	c. 1950
Paul Gauguin, *Aha oe feii?* Moscow, Pushkin State Museum of Fine Arts		Pablo Picasso, *The Dryad.* St. Petersburg, State Hermitage Museum	Gustav Klimt, *Salomé*, detail. Venice, Galleria Internazionale d'Arte Moderna, Ca' Pesaro	Josephine Baker	Marilyn Monroe

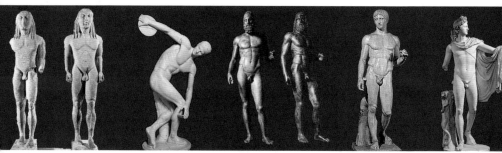

Sixth century BC	460–450 BC	470–400 BC	450–440 BC	Fourth century BC
Kouros. Athens, National Archaeological Museum	Myron, *Discobolus*, Roman copy. Rome, Museo Nazionale Romano	Master of Olympia (?), *Bronzes of Riace.* Reggio Calabria, Museo Archeologico Nazionale	Polyclitus, *Doryphorus*, Roman copy. Naples, Museo Archeologico Nazionale	*Apollo Belvedere*, Roman second-century AD copy of a statue from the fourth century BC. Vatican City, Musei Vaticani

1842	1906	1907	1923
Francesco Hayez, *Samson.* Florence, Galleria d'Arte Moderna, Palazzo Pitti	Pablo Picasso, *The Adolescents.* Paris, Musée de l'Orangerie	Henri Matisse, *Sketch for "Music."* New York, Museum of Modern Art	Frederick Cayley Robinson, *Youth.* Private collection

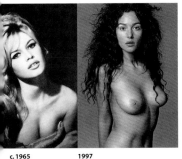

c. 1965 **1997**

Brigitte Bardot Monica Bellucci

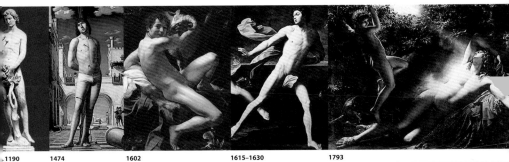

.1190 **1474** **1602** **1615–1630** **1793**

dam. Antonello Caravaggio, Guido Reni, Anne-Louis Girodet-
aris, da Messina, *St. John the Baptist.* *Atalanta* Trioson, *The Sleep of*
athedral of *St. Sebastian.* Rome, *and Hippomenes.* *Endymion.*
ôtre-Dame Dresden, Staatliche Pinacoteca Capitolina Naples, Paris,
 Gemäldegalerie Museo Nazionale di Musée du Louvre
 Capodimonte

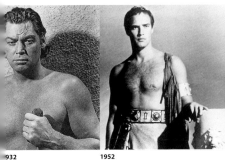

932 **1952** **1985**

ohnny Weissmuller, Marlon Brando Arnold Schwarzenegger in
arzan as Mark Anthony *Commando*
 in *Julius Caesar*

Seventh century BC	First century AD	Sixth century BC	470 BC	c. 1340
Auxerre Kore, Minoan-Mycenaean. Paris, Musée du Louvre	*Flora*, fresco from the Villa of Ariadne, Stabiae. Naples, Museo Archeologico Nazionale	*Kore*. Athens, National Archaeological Museum	*Sappho and Alcaeus*, Attic red-figure two-handled crater. Munich, Staatliche Antikensammlungen	*Game with a Hood*, detail of an embroidered purse crafted in Paris. Hamburg, Museum für Kunst und Gewerbe

c. 1540	1606–1607	1650	1740	1756
Titian, *La Bella*. Florence, Galleria Palatina, Palazzo Pitti	Peter Paul Rubens, *Veronica Spinola Doria*. Karlsruhe, Staatliche Kunsthalle	Michel Gatine, *Madame de Sévigné* from *Galerie française de femmes célèbres* (Paris, 1827)	Jean-Étienne Liotard, *French Lady with Turkish Headdress*. Geneva, Musées d'Art et d'Histoire	François Boucher, *Madame de Pompadour*. Munich, Alte Pinakothek

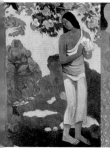

1899	1902	1910	1917	c. 1920
Paul Gauguin, *Te avae no Maria*. St. Petersburg, State Hermitage Museum	Gustav Klimt, *Beethoven Frieze*, detail of the choir of heavenly angels. Vienna, Österreichische Galerie Belvedere	Ferdinand Hodler, *Walking Woman*. Thomas Schmidheiny Collection	Egon Schiele, *Seated Woman with Bent Knee*. Prague, Národní Galerie	Colette

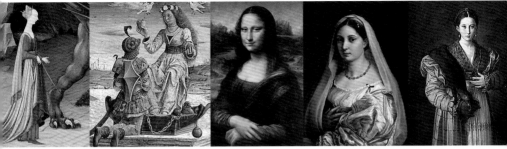

c.1456	1469	1503–1506	c.1514	1530–1535
Paolo Uccello, *St. George and the Dragon*, detail. London, National Gallery	Francesco del Cossa, *Allegory of April*, detail, Hall of the Months. Ferrara, Palazzo Schifanoia	Leonardo da Vinci, *Mona Lisa*. Paris, Musée du Louvre	Raphael, *La Donna Velata*. Florence, Galleria Palatina, Palazzo Pitti	Parmigianino, *Antea*. Naples, Museo di Capodimonte

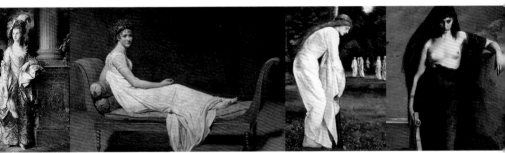

1760	1800	1866	1877
Thomas Gainsborough, *The Hon. Mrs. Lady Graham*. Edinburgh, National Gallery of Scotland	Jacques-Louis David, *Madame Récamier*. Paris, Musée du Louvre	Edward Burne-Jones, *The Princess Chained to the Tree*. New York, formerly Forbes Collection	Charles-Auguste Mengin, *Sappho*. Manchester, Manchester Art Gallery

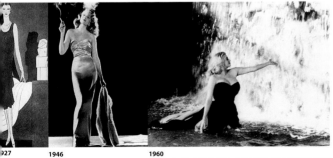

)27	1946	1960
)co ›anel, ›del	Rita Hayworth	Anita Ekberg in *La Dolce Vita*

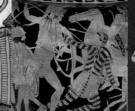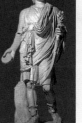

2000 BC	1300 BC	470–450 BC	First century AD	Fourteenth century
Silver figurine of a man. Aleppo, National Museum	Sennedjem, detail. Egypt, Necropolis of Deir el-Medina	Niobid Painter, *Greeks Fighting Amazons* (detail), volute crater. Naples, Museo Archeologico Nazionale	Figure of a Lar, Roman. Naples, Museo Archeologico Nazionale	Illuminator of the Anjou court, *Music and Its Connoisseurs*, detail, from Boethius, *De arithmetica, De musica*. Naples, Biblioteca Nazionale

1593–1594	1609–1610	1634	1640s	c. 1668
Caravaggio, *Boy with a Basket of Fruit*. Rome, Galleria Borghese	Peter Paul Rubens, *Self-Portrait with Isabella Brant*, detail. Munich, Alte Pinakothek	Rembrandt, *Portrait of Maerten Soolmans*. Paris, private collection	Jan Cossiers, *Fortune Telling*. St. Petersburg, State Hermitage Museum	Jan Vermeer, *The Geographer*. Frankfurt, Städelsches Kunstinstitut

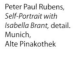

1844	1897	1901	c. 1947	1954
Émile Deroy, *Portrait of Baudelaire*. Versailles, Musée National du Château de Versailles	Giovanni Boldini, *Count Robert de Montesquiou-Fézensac*. Paris, Musée d'Orsay	Aubrey Beardsley, *Et in Arcadia Ego*, from *The Savoy*, no. 8	Humphrey Bogart	Marlon Brando in *On the Waterfront*

| c. 1360 | 1411–1416 | 1433 | 1500 | 1573 |

Guariento di Arpo,
*Ranks of Armed
Angels*, detail.
Padua,
Museo Civico

Limbourg Brothers,
April, detail, from the
*Très riches heures du Duc
de Berry*.
Chantilly, Musée Condé

Jan van Eyck,
*Man with Red
Turban*.
London,
National Gallery

Albrecht Dürer,
Self-Portrait in Fur, detail.
Munich, Alte Pinakothek

Paolo Veronese,
*Feast in the House
of Levi*, detail.
Venice, Gallerie
dell'Accademia

| 1720 | 1787 | 1800 | 1818 |

Fra Galgario,
*Portrait
of a Gentleman*.
Milan,
Pinacoteca di Brera

Johann Heinrich Wilhelm Tischbein,
Goethe in the Roman Campagna.
Frankfurt, Städelsches Kunstinstitut

Jacques-Louis David,
*Napoleon at the Great
St. Bernard Pass*, detail.
Paris, Musée National du
Chateau de La Malmaison

Joseph Severn,
*Shelley at the Baths
of Caracalla*.
Rome, Keats-Shelley House

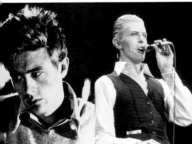

| 1954 | 1975 | 1989 | 2002 | 2002 |

James Dean

David Bowie

Mick Jagger

David Beckham

George Clooney

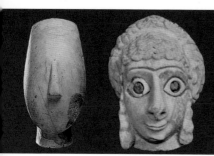

2700–2300 BC	2500 BC	1391–1353 BC	Fifth century BC	Second century AD	First century AD
Female head, Cycladic from Keros. Paris, Musée du Louvre	Female head from Chafadji. Kansas City, Nelson-Atkins Museum of Art	*Tuya,* Egyptian, New Kingdom. Paris, Musée du Louvre	Antefix in the form of a female head, Etruscan. Paris, Musée du Louvre	*Portrait of a Woman,* from Antinoe (?), Roman Egypt. Paris, Musée du Louvre	Bust of a Woman wi... *Flavian Hairstyle,* Roman. Naples, Museo Archeologic... Nazionale

c. 1540	c. 1530–1535	1703	1780	c. 1782
Agnolo Bronzino, *Lucrezia Panciatichi.* Florence, Galleria degli Uffizi	Titian, *The Penitent Magdalen.* Florence, Galleria Palatina, Palazzo Pitti	Nicolas de Largillière, *The Strasbourg Belle.* Strasbourg, Musée des Beaux-Arts	Joshua Reynolds, *The Ladies Waldegrave,* detail. Edinburgh, National Gallery of Scotland	George Romney, *Lady Hamilton as Circe.* London, Tate Britain

1927	1929	1931	1931	c. 1949
Louise Brooks	Tamara de Lempicka, *St. Moritz,* detail. Orléans, Musée des Beaux-Arts	Greta Garbo	Greta Garbo in *Mata Hari*	Rita Hayworth

First century BC	Sixth century AD	c. 1300	Fifteenth century	1480	c. 1490
Portrait, called *The Poetess (Sappho?)* from Pompeii. Naples, Museo Archeologico Nazionale	So-called *Head of Theodora*. Milan, Civiche Raccolte d'Arte del Castello Sforzesco	*The Poet Konrad von Altstetten as both Hunter and Prey*, detail of a miniature in the *Codex Manesse*. Heidelberg, Universitätsbibliothek	Master of the Baroncelli Portraits, *Portrait of Maria Bonciani*, Flemish. Florence, Galleria degli Uffizi	Piero di Cosimo, *Simonetta Vespucci*, detail. Chantilly, Musée Condé	Leonardo da Vinci, *Lady with an Ermine*. Krakow, The Princes Czartoryski Museum

(row of images)

1800	1829	c. 1864	1867	1922
Marie-Guillemine Benoist, *Portrait of a Black Woman*. Paris, Musée du Louvre	Giuseppe Tominz, *The Moscon Family*, detail. Ljubljana, Narodna Galerija	Félix Nadar, *Sarah Bernhardt*	Dante Gabriel Rossetti, *Lady Lilith*, detail. New York, Metropolitan Museum of Art	Rina De Liguoro, *Messalina*

 (images)

1954	c. 1960	c. 1970
Audrey Hepburn	Brigitte Bardot	Twiggy

 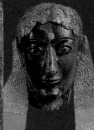

2500–2000 BC	Seventh century BC	Sixth century BC	550 BC	Fifth century BC
Head of Sargon of Akkad. Lost; formerly Baghdad, National Museum of Iraq	*Head of a Ruler,* wall painting in the Governor's Palace in ancient Tel Barsip, Assyria. Aleppo, National Museum	Chryselephantine head, called *Apollo.* Delphi, Archaeological Museum	*Rampin Rider.* Paris, Musée du Louvre	*Head of an athlete.* Naples, Museo Archeologico Nazionale, Astarita Collection

c. 1635-1640	c. 1740	c. 1815	c. 1923	1932
Style of Anthony van Dyck, *Portraits of Two Young Englishmen.* London, National Gallery	Fra Galgario, *Portrait of a Knight of the Constantinian Order.* Milan, Museo Poldi Pezzoli	Thomas Lawrence, *Portrait of Lord Byron.* Milan, private collection	Rudolph Valentino	John Barrymore in *Mata Hari*

1975	c. 1998
John Travolta in *Saturday Night Fever*	Dennis Rodman

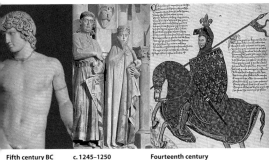

Fifth century BC	c. 1245–1250	Fourteenth century	1498	c. 1512
Antinous. Naples, Museo Archeologico Nazionale	Master of Naumberg, *Hermann,* from the west choir. Naumberg Cathedral	Neapolitan illuminator, *Knight of the Anjou Court* from *Ad Robertum Siciliae regem.* Florence, Biblioteca Nazionale	Albrecht Dürer, *Self-Portrait with Gloves.* Madrid, Museo del Prado	Bartolomeo Veneto, *Portrait of a Gentleman,* detail. Rome, Galleria Nazionale d'Arte Antica

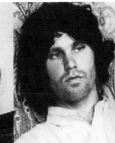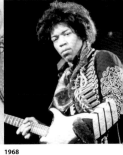

c. 1935	1951	c. 1954	c. 1968	1968
Tyrone Power	Marlon Brando	James Dean	Jim Morrison	Jimi Hendrix

Comparative Tables

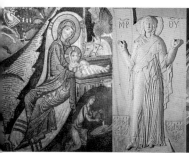

1132–1140	Twelfth century	Twelfth century	Twelfth century	1285
Nativity. Palermo, Capella Palatina	Praying Virgin, Byzantine icon. Messina, Museo Regionale	The Virgin and Two Angels, lunette. Formis, Basilica of Sant'Angelo	Florentine School, Virgin and Child. Florence, Galleria degli Uffizi	Duccio di Buoninsegna, Rucellai Madonna. Florence, Galleria degli Uffizi

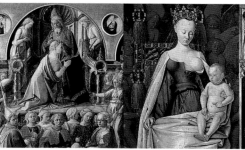
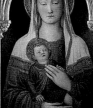

1439–1447	after 1452	c. 1450	c. 1470
Filippo Lippi, Coronation of the Virgin. Florence, Galleria degli Uffizi	Jean Fouquet, Virgin and Child, from the Melun Diptych. Antwerp, Koninklijk Museum voor Schone Kunsten	Jacopo Bellini, Virgin and Child. Florence, Galleria degli Uffizi	Hans Memling, Madonna Enthroned with Child and Two Angels, detail. Florence, Galleria degli Uffizi

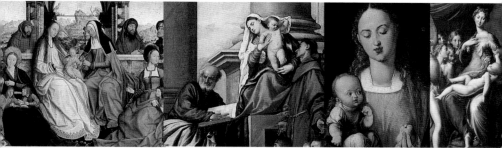

1509	1519–1526	c. 1526	1534–1540
Quinten Metsys, Triptych of St. Anne, detail. Brussels, Musées Royaux des Beaux-Arts	Titian, Pesaro Madonna, detail. Venice, Church of Santa Maria Gloriosa dei Frari	Albrecht Dürer, Virgin and Child with a Pear, detail. Florence, Galleria degli Uffizi	Parmigianino, The Madonna of the Long Neck. Florence, Galleria degi Uffizi

c. 1310

Giotto,
Ognissanti Madonna.
Florence,
Galleria degli Uffizi

1333

Simone Martini,
*Annunciation and Two
Saints,* detail.
Florence,
Galleria degli Uffizi

1411–1416

Limbourg Brothers,
The Visitation
from the *Très riches
heures du Duc de Berry.*
Chantilly,
Musée Condé

1425–1430

Masolino,
Madonna of Humility.
Florence,
Galleria degli Uffizi

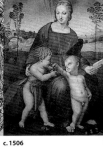

c. 1478

Hugo van der Goes,
Portinari Triptych, detail.
Florence,
Galleria degli Uffizi

1487

Sandro Botticelli,
*Madonna
of the Pomegranate.*
Florence,
Galleria degli Uffizi

c. 1505–1507

Michelangelo Buonarroti,
Tondo Doni.
Florence,
Galleria degli Uffizi

c. 1506

Raphael,
*Madonna
of the Goldfinch.*
Florence,
Galleria degli Uffizi

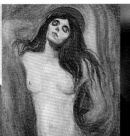

c. 1604

Caravaggio,
*Madonna of the
Pilgrims,* detail.
Rome,
Church of
Sant'Agostino

c. 1686

Luca Giordano,
Madonna of the Canopy, detail.
Naples,
Museo Nazionale di
Capodimonte

1859

Dante Gabriel
Rossetti,
Ecce ancilla Domini!
London, Tate Britain

1894–1895

Edvard Munch,
Madonna.
Oslo,
Nasjonalgalleriet

1991

Madonna

29

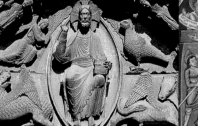

c. 1173–1182	c. 1145–1150	c. 1156	1180–1194
Christ in Majesty, book cover of the *Gospels of Bishop Alfano of Capua*, detail. Capua, Cathedral Treasury	*Christ in Majesty*, detail of Royal Portal. Cathedral of Nôtre-Dame, Chartres.	*Crucifixion*, illumination from the *Floreffe Bible*. London, British Museum	*The Baptism of Christ*, mosaic. Monreale, Cathedral of Santa Maria Assunta

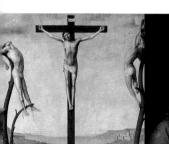

1475	1475	c. 1492	1490–1500
Antonello da Messina, *Crucifixion*, detail. Antwerp, Koninklijk Museum voor Schone Kunsten	Antonello da Messina, *Salvator mundi*. London, National Gallery	Hans Memling, *Diptych with the Deposition*, left panel. Granada, Capilla Real	Andrea Mantegna, *Lamentation over the Dead Christ*. Milan, Pinacoteca di Brera

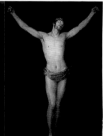

1550	1625	1780	1973	2004
Agnolo Bronzino, *The Deposition*. Florence, Galleria degli Uffizi	Giovanni Battista Caracciolo, *The Flagellation*. Naples, Museo Nazionale di Capodimonte	Francisco de Goya y Lucientes, *Christ on the Cross*. Madrid, Museo del Prado	Ted Neeley in *Jesus Christ Superstar*	James Caviezel in *The Passion of the Christ*

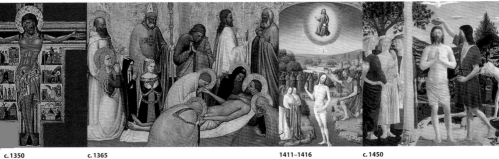

c. 1350	c. 1365	1411–1416	c. 1450
School of Lucca, *Crucifix with scenes of the Passion.* Florence, Galleria degli Uffizi	Giottino, *Pietà*, detail. Florence, Galleria degli Uffizi	Limbourg Brothers, *The Baptism of Christ* from the *Très riches heures du Duc de Berry.* Chantilly, Musée Condé	Piero della Francesca, *The Baptism of Christ,* detail. London, National Gallery

c. 1500	c. 1508	c. 1510	c. 1517
Gian Francesco Maineri, *Christ Bearing the Cross.* Florence, Galleria degli Uffizi	Lorenzo Lotto, polyptych of the *Pietà*, from the Recanati, Museo Civico e Pinacoteca Communale	Cima da Conegliano, *Christ Crowned with Thorns.* London, National Gallery	Raphael, *The Transfiguration*, detail. Rome, Pinacoteca Vaticana

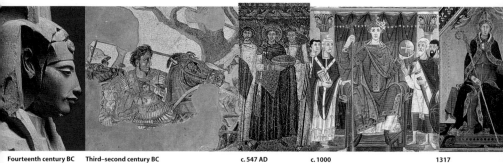

Fourteenth century BC	Third–second century BC		c. 547 AD	c. 1000	1317

Colossal bust of Akhenaten, New Kingdom. Cairo, Egyptian Museum

Alexander the Great, detail of a mosaic. Naples, Museo Archeologico Nazionale

Emperor Justinian with His Court. Ravenna, Church of San Vitale

Otto III Surrounded by Religious and Lay Dignitaries, from the *Gospels of Otto III.* Munich, Bayerische Staatsbibliothek

Simone Martini, *St. Louis of Toulouse,* d Naples, Museo Nazion Capodimonte

1540	1542		c. 1637		c. 1635

Hans Holbein the Younger, *Henry VIII,* detail. Rome, Galleria Nazionale d'Arte Antica

Dosso Dossi, *Alfonso I d'Este.* Modena, Galleria Estense

Anthony van Dyck, *Equestrian Portrait of Charles I,* detail. London, National Gallery

Anthony van Dyck, *Charles I Hunting.* Paris, Musée du Louvre

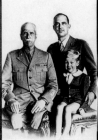
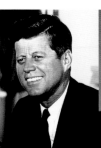
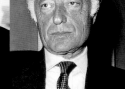

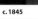

c. 1845	1938	1961	1974

Louis Philippe d'Orléans. Versailles, Musée du Château de Versailles

Vittorio Emanuele III, King of Italy, with his son Umberto and his nephew Vittorio

John Fitzgerald Kennedy, 35th President of the United States

Gianni Agnelli, president of the Fiat corporation.

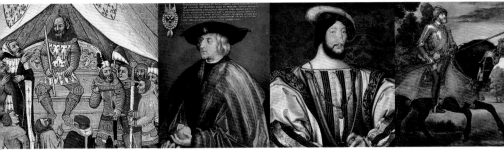

1373	1519	c. 1530	c. 1547
Niccolò da Bologna, *Caesar in His Camp,* illumination from *De bello phasalico.* Milan, Biblioteca Trivulziana	Albrecht Dürer, *Emperor Maximilian I.* Vienna, Kunsthistorisches Museum	Jean Clouet, *Francis I,* detail. Paris, Musée du Louvre	Titian, *Charles V at Mühlberg.* Madrid, Museo del Prado

1641	c. 1670	c. 1780	1806	1841–1845
Anthony van Dyck, *Princess Mary Stuart and Prince William of Orange.* Amsterdam, Rijksmuseum	Pierre Mignard, *Louis XIV Crowned by Fame.* Turin, Galleria Sabauda	*King George III.* Versailles, Musée du Château de Versailles	Jean-Auguste-Dominique Ingres, *Napoleon I on the Imperial Throne.* Paris, Musée de l'Armée, Hôtel National des Invalides	Edwin Landseer, *Windsor Castle in Modern Times.* Windsor Castle, Royal Collection

Comparative Tables

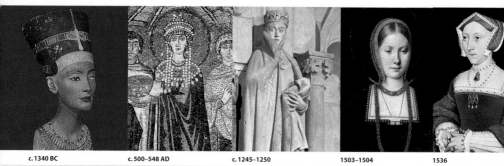

c. 1340 BC	c. 500–548 AD	c. 1245–1250	1503–1504	1536
Nefertiti, New Kingdom. Berlin, Ägyptisches Museum und Papyrussammlung	Empress Theodora with Her Court, detail. Ravenna, Church of San Vitale	Master of Naumberg, Uta, from the choir. Naumburg Cathedral	Michiel Sittow, Catherine of Aragon. Vienna, Kunsthistorisches Museum	Studio of Hans Holbein Younger, Jane Seymour. The Hague, Mauritshuis

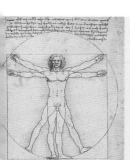
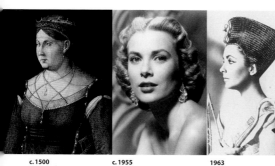
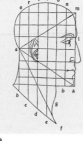

c. 1500	c. 1955	1963	1990
Gentile Bellini, Caterina Cornaro, Queen of Cyprus. Budapest, Szépmuvészeti Múzeum	Grace Kelly	Liz Taylor in Cleopatra	Princess Diana of Wales

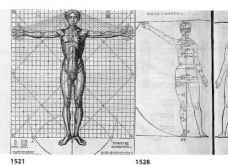

c. 1485–1490	1509	1521	1528
Leonardo da Vinci, Study of the Proportions of the Human Body. Venice, Gallerie dell'Accademia	Luca Pacioli, head inscribed in a geometrical grid, from De Divina proportione. Venice	Cesare Cesariano, Vitruvian Figure from Di Lucio Vitruvio Pollione: de architettura. Milan, Biblioteca Nazionale Braidense	Albrecht Dürer, Anthropometric Figures, from Vier Bücher von menschlicher Proportionen

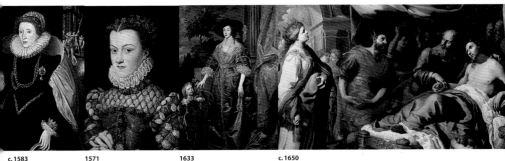

c. 1583	1571	1633	c. 1650
Quinten Metsys the Younger, *Elizabeth I of England.* Siena, Pinacoteca Nazionale	François Clouet, *Elisabeth of Austria.* Paris, Musée du Louvre	Anthony van Dyck, *Queen Henrietta Maria with Sir Jeffrey Hudson.* Washington, National Gallery of Art	Bernardino Mei, *Antiochus and Stratonice.* Siena, Monte dei Paschi Collection

PROPORTIONS

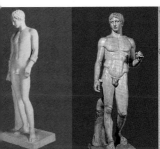 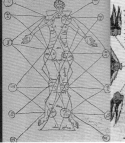 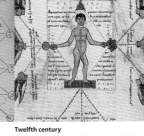

Fourth century BC	440 BC	Eleventh century	Twelfth century	1411–1416
Polyclitus, *Boxer,* Roman copy of a Greek original. Rome, private collection	Polyclitus, *Doryphorus,* Roman copy of a Greek original. Naples, Museo Archeologico Nazionale	*Corporal Humors and Elementary Qualities of Man in Relation to the Zodiac.* Spain, Burgo de Osma	*Winds, Elements, Humors,* from an *Astronomical Manuscript,* Bavaria	Limbourg Brothers, *Homo zodiacus* from the *Très riches heures du Duc de Berry.* Chantilly, Musée Condé

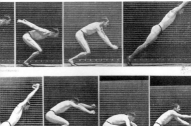 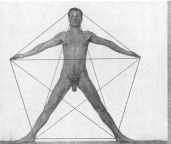 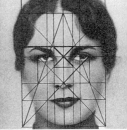

1901	1931	1931
Eadweard Muybridge, *The Human Figure in Motion*	Matila Ghyka, *Microcosmos,* from *Le Nombre d'or*	Matila Ghyka, *Harmonic Analysis of a Face,* from *Le Nombre d'or*

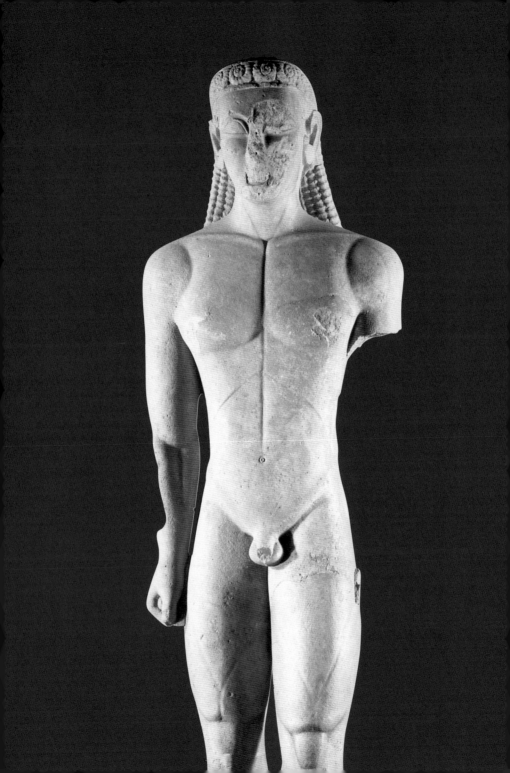

The Aesthetic Ideal in Ancient Greece

1. The Chorus of the Muses

According to Hesiod, at the wedding of Cadmus and Harmony in Thebes the Muses sang some verses in honor of the bride and groom, a refrain that was immediately picked up by the gods attending the ceremony: "Only that which is beautiful is loved, that which is not beautiful is not loved." These proverbial verses, which recur frequently in the work of later poets (including Theognis and Euripides) are to a certain extent an expression of a commonly held opinion regarding the sense of Beauty in ancient Greece. In fact, Beauty had no autonomous stature in ancient Greece: we might also say that, at least until the age of Pericles, the Greeks lacked a real aesthetics and a theory of Beauty.

It is no accident that we almost always find Beauty associated with other qualities. For example, in answer to a question on the criterion for appraising Beauty, the Delphic Oracle replied: "The most beautiful is the most just." Even in the golden age of Greek art, Beauty was always associated with other values, like "moderation," "harmony," and "symmetry." The Greeks also had a latent mistrust of poetry, which was to become explicit with Plato: art and poetry (and consequently Beauty) may gladden the eye or the mind, but they are not directly connected to truth. Nor is it an accident that the theme of Beauty is so frequently associated with the Trojan War.

There is no definition of Beauty to be found in Homer; but despite this, the legendary author of the *Iliad* provides an implicit justification for the Trojan War, anticipating the scandalous *Encomium of Helen* written by the sophist Gorgias: **Helen's irresistible Beauty** absolves her of the suffering she has caused. Troy having been taken by storm, Menelaos swoops down on his unfaithful spouse to kill her, but his sword arm is left paralyzed when his glance falls upon her beautiful, naked breasts.

Kouros,
sixth century BC.
Athens,
National Archaeological
Museum

The Irresistible Beauty of Helen

Homer (eighth-seventh century BC)
Iliad, III, 156-165
"It's no surprise that the Trojans and the Achaeans have endured so much suffering: just look at her and you will see that she looks terribly like an immortal goddess! Still, beautiful as she is, let them take her away on a ship before she causes us and our children great sorrow." This was what they said: and Priam summoned Helen to him. "My child," he said, "take a seat here next to me so that you may see your former husband, your allies and your friends. The fault is certainly not yours, it is the gods who are to blame. They are the ones that have brought about this awful war with the Achaeans [...]."

Art and Truth

Plato (fifth-fourth century BC)
The Republic, X, trans. Benjamin Jowett
Then the imitator, I said, is a long way off the truth, and can do all things because he lightly touches on a small part of them, and that part an image. For example: a painter will paint a cobbler, carpenter, or any other artist, though he knows nothing of their arts; and, if he is a good artist, he may deceive children or simple persons, when he shows them his picture of a carpenter from a distance, and they will fancy that they are looking at a real carpenter. [...] This was the conclusion at which I was seeking to arrive when I said that painting or drawing, and imitation in general, when doing their own proper work, are far removed from truth, and the companions and friends and associates of a principle within us which is equally removed from reason, and that they have no true or healthy aim. [...] The imitative art is an inferior who marries an inferior, and has inferior offspring.

Classicism

Johann Joachim Winckelmann
Thoughts on Imitation in Greek Painting and Sculpture, 1755
Like men, the fine arts have their youth, and the early days of these arts appear similar to the early period of all artists who appreciate things only if they are magnificent and marvelous. [...] Perhaps the first Greek painters drew in a manner not unlike the style of their first great tragic poet. In all human endeavors impetuousness and inaccuracy appear first; poise and exactitude follow, and it takes time to learn to admire them. Such qualities are characteristics of great masters only, whereas for learners the violent passions are even advantageous. The noble simplicity and serene grandeur of Greek statuary constitutes the true distinguishing mark of the finest Greek writing, that is to say the works of the School of Socrates, and it was these same qualities that contributed to the greatness of Raphael, which he attained by imitating the Ancients. It required a beautiful soul like his, in a beautiful body, to be the first in modern times to sense and discover the true character of the Ancients, and it was all the luckier for him that he did so at an age when vulgar and imperfect souls are still insensible to true greatness.

Capitoline Venus,
Roman copy of a
Greek original,
300 BC.
Rome, Musei Capitolini

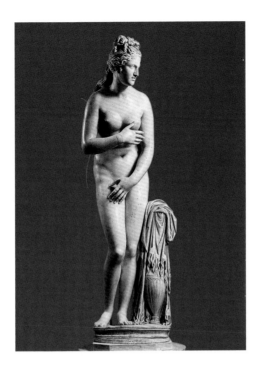

Despite this and other mentions of the Beauty of bodies, male and female alike, we nevertheless cannot state that the Homeric texts reveal a conscious understanding of Beauty. The same holds true for the successive lyric poets, in whose works—with the important exception of Sappho—the theme of Beauty does not seem to be relevant. But this early point of view cannot be fully understood if we look at Beauty through modern eyes, as was often the case in the various epochs that assumed as authentic and original a "Classical" representation of Beauty that was in reality engendered by projecting a modern point of view onto the past (think, for example, of Winckelmann's **Classicism**).

The very word *Kalón*, which only improperly may be translated by the term "beautiful," ought to put us on our guard: **Beauty is all that pleases,**

Beauty Is All That Pleases
Theognis (sixth-fifth century BC)
Elegies, I, vv. 17-18
Muses and Graces, daughters of Zeus, you who one day
At Cadmus' wedding sang the fair words:
"What is beautiful is loved; what is not beautiful, is not loved."

What Is Fair Is Ever Dear
Euripides (fifth century AD)
The Bacchae, III, vv. 880-884
What wisdom, what gift of the gods is held fairer by men than a hand placed on the bowed head of the vanquished foe?
What is fair is ever dear.

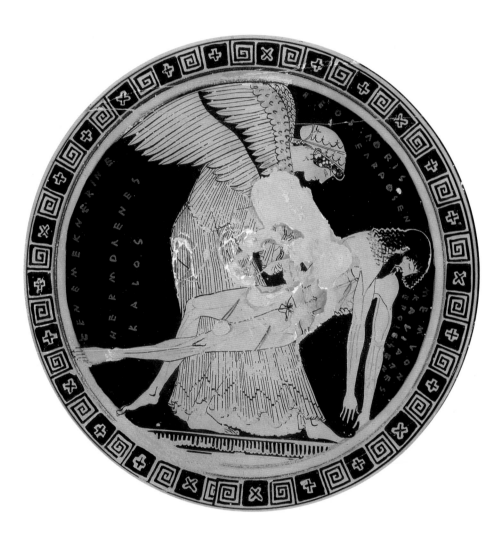

opposite
Attic red-figure cup
depicting Eos with the
body of her son Memnon,
490-480 BC.
Paris, Musée du Louvre

Black-figure amphora
depicting Achilles
and Ajax playing *astragali*,
540 BC.
Vatican City, Musei
Vaticani

arouses admiration, or draws the eye. The beautiful object is an object that by virtue of its form delights the senses, especially sight and hearing. But those aspects perceivable with the senses are not the only factors that express the Beauty of the object: in the case of the human body an important role is also played by the qualities of the soul and the personality, which are perceived by the mind's eye more than by the eye of the body.

On the basis of these remarks we can talk of an early understanding of Beauty, but it was a Beauty bound up with the various arts that conveyed it, devoid of any unitary stature: in paeans Beauty is expressed as the harmony of the cosmos, in poetry it is expressed as that enchantment that makes men rejoice, in sculpture as the appropriate measure and symmetry of its elements, and in rhetoric as the right phonetic rhythm.

The Glance
Plato (fifth-fourth century BC)
Symposium, 211e
But what if man had eyes to see the true beauty—the divine beauty, I mean, pure and clear and unalloyed, not clogged with the pollutions of mortality and all the colors and vanities of human life—thither looking, and holding converse with the true beauty simple and divine? Remember how in that communion only, beholding beauty with the eye of the mind, he will be enabled to bring forth, not images of beauty, but realities (for he has hold not of an image but of a reality), and bringing forth and nourishing true virtue to become the friend of God and be immortal, if mortal man may. Would that be an ignoble life?
These things, O Phaedrus and all of you, did Diotima say to me, and I was convinced by them. And, being thus convinced, I also tried to convince the others that, regarding the attainment of this end, human nature will not easily find a better helper than love.

2. The Artist's Idea of Beauty

During the rise of Athens to the status of a great military, economic, and cultural power a clearer notion of aesthetic beauty began to take shape. The age of Pericles, which reached its apogee in the victorious wars against the Persians, was a time of great developments in the arts, especially in painting and sculpture. The reasons for this development may be seen principally in the need to reconstruct the temples destroyed by the Persians, in the proud exhibition of Athenian power, and in the favor accorded artists by Pericles.

To these extrinsic causes we must add the particular technical development of the figurative arts in ancient Greece. Compared to Egyptian art, Greek sculpture and painting had made enormous progress, which was to some extent fostered by the link between art and common sense.

In their architecture and in their pictorial representations, the Egyptians gave no consideration to perspective, an aspect that was subjected to abstract and rigidly respected canons. But Greek art attached primary

Temple of Apollo, Delphi, pediment sculptures depicting *The Battle of Centaurs and Lapiths*, sixth century BC. Delphi, Archaeological Museum

opposite
The Charioteer, fifth century BC. Delphi, Archaeological Museum

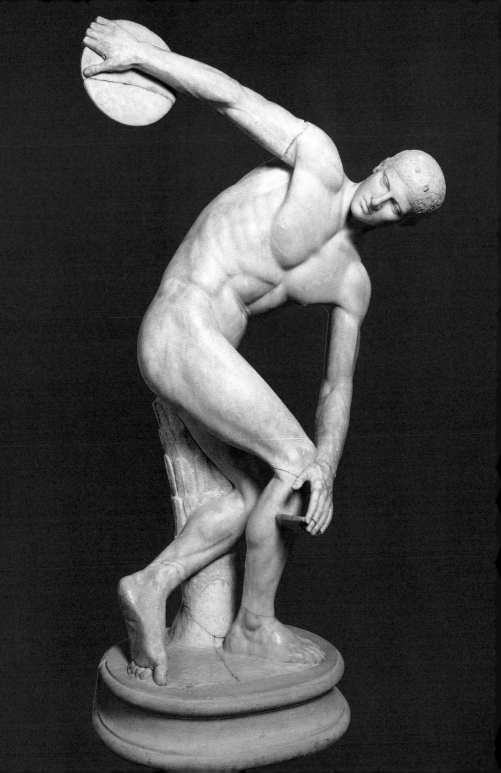

opposite
Myron,
Discobolus, Roman copy
of a Greek original,
460-450 BC.
Rome, Museo
Nazionale Romano

importance to subjective perspective. Greek painters invented foreshortening, which does not respect the objective precision of beautiful forms: the perfect circularity of a shield can be adapted to the point of view of the observer, who sees it in flattened perspective.

Similarly, in sculpture we can certainly talk in terms of empirical research, whose objective was the living Beauty of the body. The generation whose members included Phidias (many of whose works are known to us only from later copies) and Myron and the subsequent generation of Praxiteles created a sort of equilibrium between the realistic representation of Beauty— especially that of human forms, since the Beauty of organic forms was preferred to that of inorganic objects—and the adherence to a specific canon (*kanon*), analogous to the rules (*nómos*) of musical composition.

Contrary to what was later believed, Greek sculpture did not idealize an abstract body, but rather sought an ideal Beauty through a synthesis of living bodies, a synthesis that became the vehicle for the expression of a psychophysical Beauty that harmonized body and soul. In other words the Beauty of forms and the goodness of the soul was the ideal underpinning *Kalokagathía,* the noblest expressions of which are the poems of Sappho and the sculptures of Praxiteles.

This Beauty finds its finest expression in static forms, in which a fragment of action or movement finds equilibrium and repose, and for which simplicity of expression is more suitable than a wealth of detail. Despite this, however, one of the most important Greek sculptures constitutes a radical breach of this rule. In the *Laocoon* (from the Hellenic period) the scene is dynamic, dramatically described and anything but simplified by the artist. And indeed, upon its discovery in 1506, it aroused amazement and bewilderment.

Phidias,
reliefs from the
Parthenon, 447-432 BC.
London, British Museum

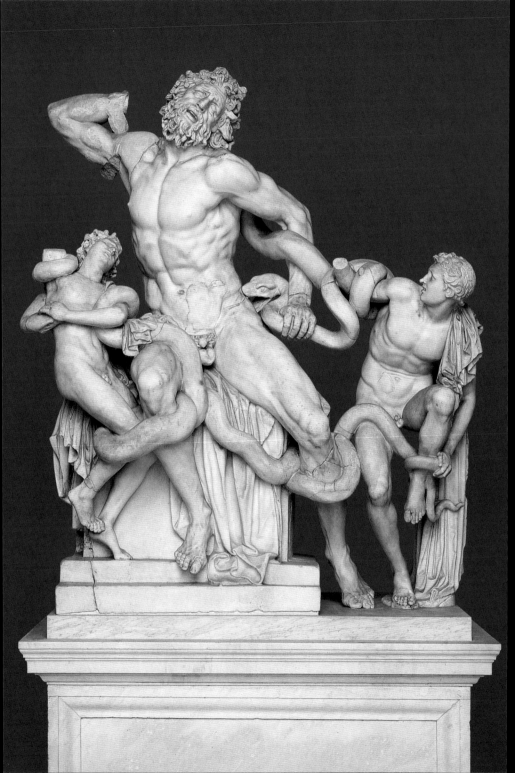

 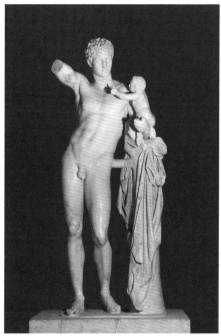

above left
Praxiteles,
Aphrodite Cnidia,
Roman copy,
375-330 BC.
Rome, Museo
Nazionale Romano

above right
Praxiteles,
*Hermes with Young
Dionysus*,
Roman copy,
375-330 BC.
Rome, Museo
Nazionale Romano

Laocoon,
first century BC.
Vatican City,
Musei Vaticani

Kalokagathía

Sappho (seventh-sixth century BC)
For some the most beautiful thing on earth is a cavalry squadron, others say an army of foot soldiers, others again say a fleet of ships, but I think beauty is what you fall in love with. It's so easy to explain. Helen, the most beautiful of all, chose the man who doused the lights of Troy: forgetful of her daughter and her parents she went far away, where Aphrodite willed, out of love for him […] He who is beautiful is so for as long as he stands before us, he who is also good is good now and will always be so.

Laocoon

Johann Joachim Winckelmann
Monumenti antichi inediti, I, 1767
Finally, the general and principal characteristic of the Greek masterpieces is a noble simplicity and a calm grandeur, both in pose and expression. Just as the depths of the sea always remain motionless no matter how rough the surface may be, the expressions of the Greek figures, regardless of how much they may be stirred by the passions, always reveal a great and poised spirit.
This spirit, despite the most atrocious torments, is not evident in Laocoon's face alone. His suffering, which is shown in every muscle and tendon of his body and which can be seen merely on observing his convulsively contracted belly, without troubling to consider either the face or the other parts, makes us feel as if his pain were ours. And this pain, I say, is not at all conveyed by signs of rage in either the face or the pose. This Laocoon does not cry out horribly as in Virgil's poem: the way in which his mouth is set does not allow of this; all that may emerge, rather, is an anguished and oppressed sigh, as Sadoleto says. Suffering of the body and greatness of spirit are distributed in equal measure throughout the body and seem to keep each other in equilibrium. Laocoon is suffering; but he is suffering like Sophocles' Philoctetus: his torments touch our hearts, and we would like to be able to bear pain the way this sublime man bears it.

3. The Beauty of the Philosophers

The theme of Beauty was further elaborated by Socrates and Plato. The former, according to what we learn from Xenophon in his **Memorabilia** (whose veracity is now the subject of some doubt, given the author's partisan stance), apparently wanted to legitimize artistic praxis on a conceptual level by identifying at least three aesthetic categories: *Ideal Beauty*, which represents nature by means of a montage of the parts; *Spiritual Beauty*, which expresses the soul through the eye (as in the sculptures of Praxiteles, who painted the eyes to make them look more realistic); and *Useful*, or *Functional, Beauty*.

Plato's position was a more complex one, and it led to the two most important concepts of Beauty elaborated over the centuries: Beauty as **harmony and proportion** between the parts (derived from Pythagoras), and Beauty as **splendor,** as expounded in the *Phaedrus*, which was to

Memorabilia
Xenophon (fifth-fourth century BC)
Memorabilia, III
Aristippus questioned him [Socrates] again if he knew of any thing beautiful.
"Many things," he replied.
"And are they all like one another?"
"No: on the contrary, some are often very unlike."
"How then can a thing be beautiful if it is unlike the beautiful?"
"By Zeus!" replied Socrates, "a man who is a beautiful runner can be quite unlike another man who is a beautiful wrestler while a beautiful shield for defense is in no way like a javelin that may be thrown with speed and power."
"There is no difference between this reply and the previous one," observed Aristippus, "when I asked you if you knew of any good thing."
"And do you think that one thing is good and another beautiful? Are you not aware that with regard to the same things all things are at once beautiful and good? In the first place, virtue is not a good thing in reference to one standard while beautiful things refer to another; further, men are said to be beautiful and good in the same respect and in relation to the same things, and, in relation to the same things, even the bodies of men are shown to be beautiful and good; and in general all things capable of being used by man are considered at once beautiful and good with respect to the things they happen to be useful for."
"And so even a basket for carrying rubbish is thus a beautiful thing?"
"For sure. And a golden shield may be an ugly thing, if the former is well-suited and the latter ill-suited to their respective purposes."
"Do you mean to say that the same things may be beautiful and ugly?"
"Of course I do," replied Socrates, "and good and bad too if it come to that: for example, what is good for hunger may be bad for fever, and what is good for fever bad for hunger; or again, what is good for a wrestler is often bad for a runner. If, therefore, a thing is well-suited to its purpose, with respect to this it is beautiful and good; and, should the contrary be the case, then it is bad and ugly." [...]

And if Socrates chanced to converse with artists who were about their craft, he would try to be useful to these persons. Once, having gone one day to Parrhasius the painter, and on chatting with him, he asked: "Parrhasius, is painting not a representation of what we see? In other words, you painters represent bodies tall and short, in light or in shadow, surfaces hard or soft, rough or smooth, the bloom of youth and the wrinkles of age all through the medium of colors, do you not?"

"True," said Parrhasius, "this is what we do."

"And when you portray ideal types of beauty, since it is hard to find any one man who is devoid of blemish, you take from many models the most beautiful traits of each, and so make your figures appear completely beautiful?"

"Yes, this is the way we work," said Parrhasius.

"Really? Do you also think it possible to portray the characteristic moods of the soul, its charm, sweetness, amiability, pleasantness and attractiveness? Or can none of this be depicted?"

"But Socrates," replied Parrhasius, "how can we imitate that which possesses neither linear proportion nor color, nor any of the qualities you have just named, and—what's more—can in no way be seen?"

"Yet," continued Socrates, "may a man not look at someone with liking or enmity?"

"I believe so," said Parrhasius.

"And cannot all this be shown through the expression of the eyes?"

"Undoubtedly."

"And do those who have at heart the good or ill fortunes of their friends wear the same expression as those who care nothing for them?"

"By no means. Those who care wear a happy look when their friends are well, and look troubled when they are not."

"So such looks may be portrayed?"

"Indeed they may."

"And are magnificence, generosity, miserliness, ignobility, temperance, prudence, arrogance and vulgarity, nobility and freedom not evident in the face and the ways of men—be they at rest or in movement?"

"That's true."

"Then these things too may be portrayed?"

"They may indeed."

"And is it more agreeable to look on a face whose features suggest a beautiful, good, and amiable disposition, or on one that bears the signs of ugliness, evil and hatred?"

"Oh, Socrates, there is a huge difference between the two."

Another time Socrates went to the sculptor Cleiton, and said:

"I can see that your runners and wrestlers, boxers, and pancratists are beautiful. This much I see and know. But how do you give life to your creations? How is this impression perceived by the beholder's sight?"

And since Cleiton, who was baffled, did not answer immediately, Socrates added:

"Do your statues not have that sense of life because you closely imitate the forms of living beings?"

"Without a doubt," said Cleiton.

"And is it through an accurate portrayal of the various parts of the body in different poses, I mean when these are raised or lowered, drawn up or outstretched, tensed or relaxed, that you succeed in making your statues look like real living beings, and attractive as them too?"

"Certainly."

"And does not the faithful representation of what happens to the body in movement produce particular pleasure in the beholder?"

"Naturally."

"So shouldn't we also portray the threatening look in the eyes of warriors, shouldn't we imitate the look of a conqueror flushed with success?"

"Indeed we should."

"In this way, then, the sculptor can depict the workings of the soul through external forms."

49

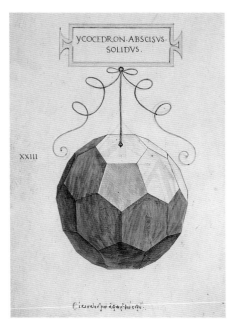

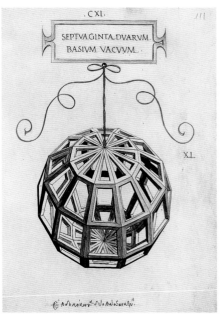

Leonardo da Vinci, *Ycocedron abscisus solidus* and *Septuaginta duarum basium vacuum*, platonic solids from Luca Pacioli, *De divina proportione*, 1509. Milan, Biblioteca Ambrosiana

influence Neoplatonic thinking. In Plato's thinking Beauty has an autonomous existence, distinct from the physical medium that accidentally expresses it; it is not therefore bound to any sensible object in particular, but shines out everywhere.

Beauty does not correspond to what we see (while Socrates was notoriously ugly, he was said to shine with an inner Beauty). Since in Plato's view the body is a dark cavern that imprisons the soul, the sight of the senses must be overcome by intellectual sight, which requires a knowledge of the dialectical arts, in other words philosophy. And so not everyone is able to grasp true Beauty. By way of compensation, art in the proper sense of the term is a false copy of true Beauty and as such is morally harmful to youth: better therefore to ban it from the schools, and substitute it with the **Beauty of geometrical forms,** based on proportion and a mathematical concept of the universe.

Harmony and Proportion

Plato (fifth-fourth century BC)

Timaeus, V

For the Deity, intending to make this world like the fairest and most perfect of intelligible beings, framed one visible animal comprehending within itself all other animals of a kindred nature [...]

And the fairest bond is that which makes the most complete fusion of itself and the things which it combines; and proportion is best adapted to effect such a union.

Splendor

Plato (fifth-fourth century BC)

Phaedrus, XXX

For there is no light of justice or temperance or any of the higher ideas which are precious to souls in the earthly copies of them: they are seen through a glass dimly; and there are few who, going to the images, behold in them the realities, and these only with difficulty. There was a time when with the rest of the happy band they saw beauty shining in brightness— we philosophers following in the train of Zeus, others in company with other gods; and then we beheld the beatific vision and were initiated into a mystery which may be truly called most

blessed, celebrated by us in our state of innocence, before we had any experience of evils to come, when we were admitted to the sight of apparitions innocent and simple and calm and happy, which we beheld shining in pure light, pure ourselves and not yet enshrined in that living tomb which we carry about, now that we are imprisoned in the body, like an oyster in his shell.

The Beauty of Geometrical Forms

Plato (fifth-fourth century BC)

Timaeus, 55e-56c

But, leaving this inquiry, let us proceed to distribute the elementary forms, which have now been created in idea, among the four elements.

To earth, then, let us assign the cubic form, for earth is the most immovable of the four and the most plastic of all bodies, and that which has the most stable bases must of necessity be of such a nature. Now, of the triangles which we assumed at first, that which has two equal sides is by nature more firmly based than that which has unequal sides, and of the compound figures which are formed out of either, the plane equilateral quadrangle has necessarily a more stable basis than the equilateral triangle, both in the whole and in the parts. Wherefore, in assigning this figure to earth, we adhere to probability, and to water we assign that one of the remaining forms which is the least movable, and the most movable of them to fire, and to air that which is intermediate. [...]

We must imagine all these to be so small that no single particle of any of the four kinds is seen by us on account of their smallness, but when many of them are collected together, their aggregates are seen. And the ratios of their numbers, motions, and other properties, everywhere God, as far as necessity allowed or gave consent, has exactly perfected and harmonized in due proportion.

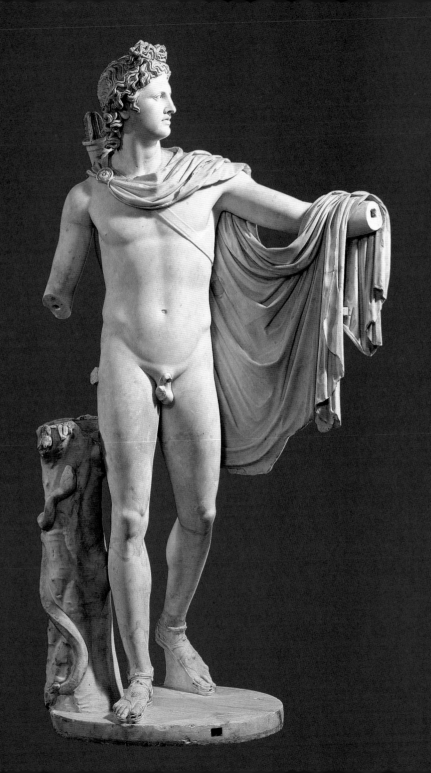

Apollonian and Dionysiac

1. The Gods of Delphi

According to mythology, Zeus assigned an appropriate measure and a just limit to all beings: the government of the world thus coincides with a precious and measurable harmony, expressed in the four mottoes on the walls of the temple at Delphi: "The most beautiful is the most just," "Observe the limit," "Shun hubris (arrogance)," and "Nothing in excess." It was on the basis of these rules that the common Greek sense of Beauty was established, in accordance with a world view that interpreted order and harmony as that which applies a limit to "yawning Chaos," from whose maw Hesiod said that the world sprang. This was an idea placed under the protection of **Apollo,** who is in fact portrayed among the Muses on the western façade of the temple at Delphi. But on the opposite, eastern side of

opposite
Apollo Belvedere, Roman second-century AD copy of a statue from the fourth century BC. Vatican City, Musei Vaticani

Red-figure vase depicting Apollo and the Muses, 500 BC. St. Petersburg, State Hermitage Museum

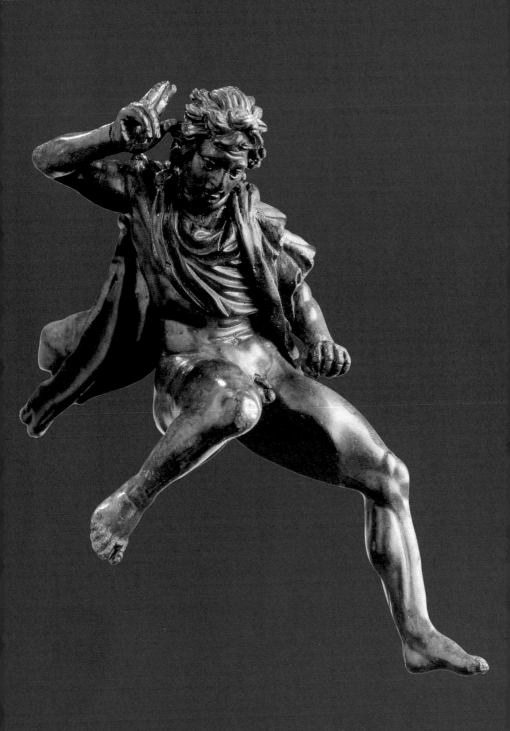

opposite
Lysippus,
Alexander as Hunter,
300-250 BC.
Rome,
Museo Nazionale
Etrusco di Villa Giulia

the same temple (dating from the fourth century BC) there is a portrayal of Dionysus, god of Chaos and the unbridled breach of all rules.

This co-presence of two antithetical divinities is not accidental, even though it was not topicalized until modern times, when Nietzsche tackled the issue. In general, it expresses the possibility, always present and periodically occurring, of an irruption of chaos into the beauty of harmony. More specifically, this marks the expression of certain important antitheses that remain unresolved within the Greek concept of Beauty, which emerges as being far more complex and problematical than the simplifications of the Classical tradition would suggest.

A first antithesis is that between Beauty and sensible perception. While

Apollo
Friedrich Wilhelm Nietzsche
The Birth of Tragedy, I, 1872
And so, in one sense, we might apply to Apollo the words of Schopenhauer when he speaks of the man wrapped in the veil of Maya (*The World as Will and Representation*, 1,

p. 416): "Just as in a stormy sea, unbounded in every direction, rising and falling with howling mountainous waves, a sailor sits in a boat and trusts in his frail barque: so in the midst of a world of sorrows the individual sits quietly, supported by and trusting in his *principium individuationis*."

Kleophrades Painter,
red-figure amphora
depicting Dionysus
among Satyrs and
Maenads, 500-495 BC.
Munich, Staatliche
Antikensammlungen

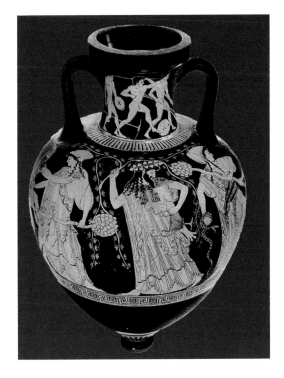

Barberini Faun,
Roman copy of a Greek
original, c. 220 BC.
Munich, Staatliche
Antikensammlungen

Beauty is certainly perceivable, but not completely, because not all of it is
expressed in sensible forms, a perilous divide opens up between appearance
and Beauty: a divide that artists tried to keep closed, but one that the
philosopher Heraclitus was to open up to its maximum extent, by stating
that the harmonious Beauty of the world manifests itself as random flux.

A second antithesis is that between sound and vision, the two forms of
perception preferred by the Greeks (probably because, unlike smell and taste,
they can be referred to in terms of measurements and numerical orders): and
although music was acknowledged the privilege of expressing the soul, only
visible forms were accorded the definition of beauty (*Kalón*), in the sense of
"that which pleases and attracts." Chaos and music thus came to constitute a
sort of dark side of Apollonian Beauty, which was harmonious and visible, and
as such they fell within the sphere of the god Dionysus.

This difference is understandable if we consider that a statue had to
represent an "idea" (and hence a sense of serene contemplation) while
music was understood as something that aroused the passions.

Visible Forms
Friedrich Wilhelm Nietzsche
The Birth of Tragedy, I, 1872
In fact, we might say of Apollo, that in him the
unshaken faith in this principium and the
calm repose of the man wrapped therein
receive their sublimest expression; and we
might consider Apollo himself as the glorious
divine image of the principium
individuationis, whose gestures and
expression tell us of all the joy and wisdom of
"appearance," together with its beauty.

2. From the Greeks to Nietzsche

A further aspect of the antithesis between Apollo and Dionysus concerns the dyad distance/nearness. Unlike certain Eastern forms, Greek and Western art in general favor a certain distance from the work, whereby we do not come into direct contact with it: in contrast, a Japanese sculpture is made to be touched, while a Tibetan sand mandala requires interaction. For the Greeks, however, Beauty was expressed by those senses that permit a distance to be maintained between the object and the observer: sight and hearing rather than touch, taste, and smell. But those forms that could be heard, like music, aroused suspicion because of the involvement they evoke in the soul of the listener. The rhythm of music refers to the perennial flux of things, considered discordant because devoid of a limit.

Meidias Painter, hydra depicting Phaon and the Women of Lesbos, c. 410 BC.
London, British Museum

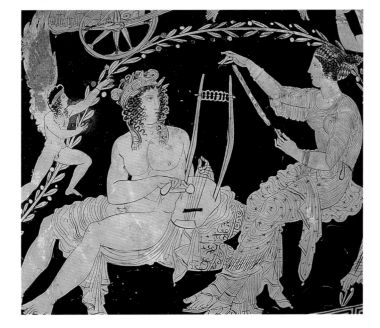

This is substantially the thrust of Nietzsche's analysis of the antithesis between the Apollonian and the Dionysiac modes, leaving aside its youthful ingen-uousness (acknowledged, moreover, by the author) and some adventurous guesswork rightly stigmatized by philologists. Serene harmony, understood as order and measure, is expressed in a Beauty that Nietzsche called **Apollonian Beauty.**

But this Beauty was at the same time a screen that attempted to conceal the presence of a disquieting, **Dionysiac Beauty,** which was not expressed in apparent forms, but over and above appearances. This was a joyous and dangerous Beauty, antithetical to reason and often depicted as possession and madness: it is the nocturnal side of the mild Attic sky, populated by initiation mysteries and obscure sacrificial rites, like the Eleusinian Mysteries and Dionysiac rites. This disturbing nocturnal Beauty was to remain concealed until the modern age (cf. Chapter XIII), only to emerge as the secret and vital reservoir of contemporary expressions of Beauty, thus revenging itself on the beautiful harmony of the Classical world.

Silenus with Two Satyrs, wall painting of the Dionysiac Mysteries, first century BC. Pompeii, Villa of the Mysteries

Apollonian Beauty

Friedrich Wilhelm Nietzsche
The Birth of Tragedy, III, 1872
The Homeric "naivety" can be understood only as the complete victory of the Apollonian illusion: an illusion similar to those which Nature so frequently employs to achieve her own ends. The true goal is veiled by a phantasm: and while we stretch out our hands for the latter, Nature attains the former by means of your illusion. In the Greeks the "will" wished to contemplate itself in the transfiguration of genius and the world of art; in order to glorify themselves, its creatures had to feel themselves worthy of glory; they had to behold themselves again in a higher sphere, without this perfect world of contemplation acting as a command or a reproach. Such is the sphere of beauty, in which they saw their mirrored images, the Olympians. With this mirroring of beauty the Hellenic will combated its artistically correlative talent for suffering and for the wisdom of suffering: and, as a monument of its victory, we have Homer, the naive artist.

Dionysiac Beauty

Friedrich Wilhelm Nietzsche
The Birth of Tragedy, XVI, 1872
"We believe in eternal life," exclaims tragedy; while music is the immediate idea of this life. Plastic art has an altogether different aim: here Apollo overcomes the suffering of the individual by the radiant glorification of the *eternity of the phenomenon*: here beauty triumphs over the suffering inherent in life; pain is obliterated by lies from the features of nature. In Dionysian art and its tragic symbolism the same nature cries to us with its true, undissembled voice: "Be as I am! Amid the ceaseless flux of phenomena I am the eternally creative primordial mother, eternally impelling to existence, eternally finding satisfaction in this change of phenomena!"

Beauty as Proportion and Harmony

1. Number and Music

According to common sense we judge a well-proportioned thing beautiful. This allows us to explain why since ancient times Beauty has been identified with proportion—even though we must remember that the common definition of Beauty in the Greek and Roman world also encompassed the notion that proportion must always be accompanied by the pleasantness of color (and of light). When the pre-Socratic philosophers of ancient Greece— such as Thales, Anaximander, and Anaximenes, who lived between the seventh and sixth centuries BC—began to discuss what might be the origin of all things (they held that reality originated in water, in original infinity, and in the air), their aim was to give a definition of the world as an ordered whole governed by a single law. This also meant thinking of the world as a form, and the Greeks clearly perceived the correspondence between Form and Beauty. However, the man who was to state these things in an explicit fashion, by bringing cosmology, mathematics, natural science, and aesthetics under the same rubric, was Pythagoras and his school, from the sixth century BC.

Pythagoras (who in the course of his travels probably came into contact with the mathematical reflections of the Egyptians) was the first to maintain that the origin of all things lay in **number.** The Pythagoreans had a sort of holy dread of the infinite and of that which cannot be reduced to a limit, and so they looked to numbers for the rule capable of limiting reality, of giving it order and comprehensibility. Pythagoras marks the birth of an aesthetico-mathematical view of the universe: all things exist because they are **ordered** and they are ordered because they are the realization of mathematical laws, which are at once a condition of existence and of Beauty.

Rabanus Maurus,
*Four Elements, Four
Seasons, Four Regions of
the World, Four Quarters
of the World… Are
Arranged in the Form of
a Cross and Sanctified
through It,* from *De
laudibus sanctae crucis,*
MS. 223 F, fol. 10, detail,
ninth century.
Amiens, Bibliothèque
Municipale

Franchino Gaffurio,
diagram from *Theorica
musicae*, 1492.
Milan, Biblioteca
Nazionale Braidense

Lasus of Hermione, so they say, and the
Pythagorean Hippasus of Metapontum, used
the speed and slowness of the movements
from which the chords derive … Lasus
transferred these numerical ratios onto vases.
Taking two vases of the same size and shape,
he left one completely empty and filled the
other half full of liquid: on striking both vases
he got the octave. When he again left one of
the vases empty and filled the other only one
quarter full, on striking them he got a fourth,
and likewise a fifth when he filled the vase one
third full, since the ratio of the empty [spaces]
was two to one for the octave, three to two for
the fifth, and four to three for the fourth.

Proportion
Bonaventure of Bagnoregio (1217-1274)
Itinerarium mentis in Deum, II, 7
Since, therefore, all things are beautiful and to
some measure pleasing; and [since] there is no
Beauty and pleasure without proportion, and
proportion is to be found primarily in numbers:
all things must have numerical proportion.
Consequently, "number is the principal
exemplar in the mind of the Creator" and as
such it is the principal trace that, in things,
leads to wisdom. Since this trace is extremely
clear to all and is closest to God, it leads us to
Him through the seven differences and it
causes us to know Him in all corporeal and
sensible things; and, while we learn that things
have numerical proportion, we take pleasure in
this numerical proportion and we judge things
irrefutably by virtue of the laws that govern it.

Number
Philolaos (fifth century BC)
Fragments from the Pre-Socratics, D44B4
All things that are known have a number:
without number it would not be possible to
know or think anything whatsoever.

Order
Pythagoras (fifth-fourth century BC)
from Diogenes Laertius, *The Lives of the
Philosophers*
Virtue is harmony, likewise health, all good
things, and divinity. Consequently all things
are formed in accordance with harmony.

Mathematical Ratios
Theon of Smyrna (first-second century)
Fragments from the Pre-Socratics, D47A19a
Eudoxus and Architas believed that the ratios
constituting the chords could be expressed in
numbers: and they thought that such ratios
consisted in movements. Hence a speedy
movement gives a high-pitched sound, like
something continuously and rapidly beating
at the air; while a slow movement gives a low-
pitched sound, like something less rapid.

Musical Sounds
Theon of Smyrna (first-second century)
Fragments from the Pre-Socratics, D18A13

Musical Modes
Boethius (c. 480-526)
De Musica, I, 1
Nothing is more proper to human nature than
to abandon oneself to sweet modes and to be
vexed by modes that are not; and this does not
refer solely to individuals of a certain age or
temperament, but regards all inclinations:
children, young people and the old are
naturally and spontaneously affected by the
modes of music and thus we can say that no
age is averse to the pleasures of sweet
melodies. Hence we may recognize the
soundness of Plato's dictum that the soul of the
world was composed with musical harmony.
Thanks, therefore, to what is harmonious in us
we perceive the harmonious composition of
sounds, and we delight in them for we
understand that we are made in their likeness.
Similarity is pleasing, therefore, whereas
dissimilarity is odious.

The Pythagoreans were the first to study the that govern **musical sounds,** the proportions on which intervals are based, and the relationship between the length of a string and the pitch of a note. The idea of musical **proportion** was closely associated with all rules for the production of the Beautiful. This idea of proportion runs throughout antiquity and was transmitted to the Middle Ages through the works of Boethius, written between the fourth and fifth centuries AD. Boethius tells how one morning Pythagoras observed that a blacksmith's hammers produced different sounds as they struck the anvil, causing him to realize that the relationships between the sounds of the scale thus obtained were proportionate to the weight of the hammers. Boethius also observes that the Pythagoreans knew that the various **musical modes** have a different effect on the psychology of individuals, and that they spoke of hard and temperate rhythms, suitable for the education of youths, as well as suave, lascivious rhythms. Pythagoras is said to have restored the self-control of a drunken adolescent by having him listen to a melody in the Hypophrygian mode with a spondaic rhythm (since the Phrygian mode had been overexciting the boy).

Franchino Gaffurio,
*Pythagoras'
Experimentations with
the Relationships
between Sounds,*
from *Theorica musicae,*
1492.
Milan, Biblioteca
Nazionale Braidense

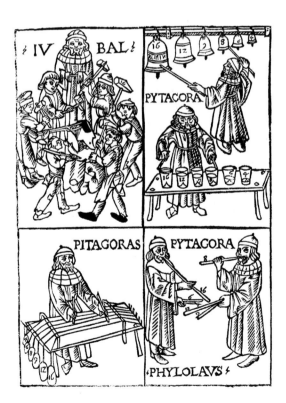

2. Architectonic Proportion

The proportions that govern the dimensions of Greek temples, the intervals between the columns or the relationships between the various parts of the façade, correspond to the same ratios that govern musical intervals. And in fact the idea of passing from the arithmetical concept of number to the spatio-geometrical concept of the ratios between a variety of points is a Pythagorean concept.

The *Tetraktys* is the symbolic figure by which Pythagoreans swore their oaths, and it represents a perfect and exemplary reduction of the numerical to the spatial and of the arithmetical to the geometrical. Each side of this triangle is formed by four points and at its center there stands a sole point, unity, from which all other numbers are generated. Four thus becomes synonymous with strength, justice, and solidity; the triangle formed by three series of four numbers is and remains a symbol of perfect equality. The sum of the points that form the triangle is the number ten, and with the first ten numbers all possible numbers can be expressed. If number is the essence of the universe, then the *Tetraktys* (or decade) represents a condensation of all universal wisdom, all numbers, and all possible numerical operations. If we go on to establish numbers according to the model of the *Tetraktys*, broadening the base of the triangle, we obtain numerical progressions in which there is an alternation of even numbers (a symbol of infinity, since it is impossible to find any point that divides the line of points into two equal parts) and odd numbers (finite, because the line always has a central point that separates an equal number of points). But these arithmetical harmonies also correspond to geometrical harmonies and the eye can continuously

Construction of the Pythagorean *Tetraktys*. The central point is equidistant from the points that form the equilateral triangle of the tetrahedron. Extending the series from each point a potentially infinite grid is obtained, on which an equally infinite series of equilateral triangles can be inscribed

Matila C. Ghyka,
*Relationship between the
Pythagorean Range and
the Intervals Separating
Columns in the Greek
Temples (Parthenon),*
from *Le nombre d'or,*
Paris, 1931

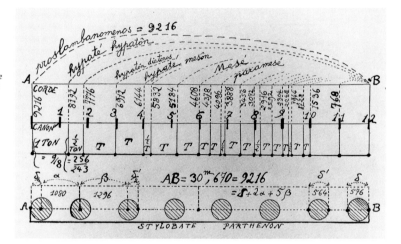

Michelangelo
Buonarroti,
*Study for the Rare Book
Room in the Laurentian
Library, Florence,*
c. 1516.
Florence, Casa
Buonarroti

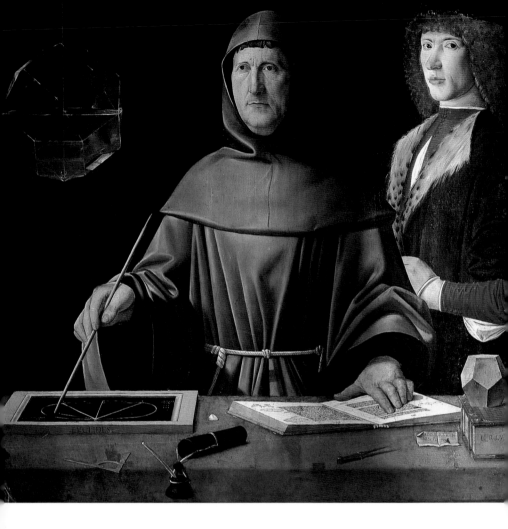

Jacopo de' Barbari,
*Portrait of Fra Luca
Pacioli and a Young
Unknown*, c. 1495.
Naples, Museo
Nazionale
di Capodimonte

link up these points to form an indefinite series of connected perfect equilateral triangles. This **mathematical conception** of the world is later found in Plato and especially in the dialogue *Timaeus*.

Between the Humanist movement and the Renaissance, an epoch that witnessed a return to Neoplatonism, the standard Platonic works were studied and celebrated as ideal models by Leonardo, by Piero della Francesca in his *De perspectiva pingendi*, by Luca Pacioli in his *De divina proporzione*, and by Dürer in his *On the Symmetry of Human Bodies*. The divine proportion discussed by Pacioli is the Golden Section, in other words the ratio that is realized in a segment AB when—once a point of division, C, has been established—AB is to AC as AC is to CB.

The *De architectura* of Vitruvius (first century BC) was to transmit instructions—both to the Middle Ages and to the Renaissance—for the

The Golden Section as principle of the harmonic rectangle. It has been found that this relationship is also the principle of the growth of some organisms and is at the base of many architectural and artistic compositions. The Golden Section is considered "perfect," as it has the potential to be infinitely reproduced.

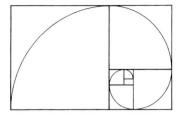

Mathematical Conception

Plato (fifth-fourth century BC)
Timaeus, XX

And next we have to determine what are the four most beautiful bodies which could be formed, unlike one another, yet in some instances capable of resolution into one another, for having discovered thus much, we shall know the true origin of earth and fire and of the proportionate and intermediate elements. For we shall not be willing to allow that there are any distinct kinds of visible bodies fairer than these. Wherefore we must endeavor to construct the four forms of bodies which excel in beauty, and secure the right to say that we have sufficiently apprehended their nature. Now of the two triangles, the isosceles has one form only; the scalene or unequal-sided has an infinite number. Of the infinite forms we must again select the most

Leonardo da Vinci, *Vigintisex basium elevatus vacuus*, platonic solid, from Luca Pacioli, *De divina proportione*, 1509. Milan, Biblioteca Ambrosiana

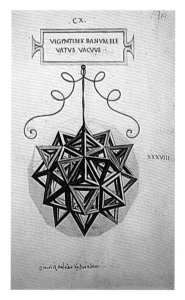

beautiful, if we are to proceed in due order, and anyone who can point out a more beautiful form than ours for the construction of these bodies, shall carry off the palm, not as an enemy, but as a friend. Now, the one which we maintain to be the most beautiful of all the many triangles—and we need not speak of the others—is that of which the double forms a third triangle which is equilateral. [...] Then let us choose two triangles, out of which fire and the other elements have been constructed, one isosceles, the other having the square of the longer side equal to three times the square of the lesser side [...]. I have now to speak of their several kinds, and show out of what combinations of numbers each of them was formed. The first will be the simplest and smallest construction, and its element is that triangle which has its hypotenuse equal twice the lesser side. When two such triangles are joined at the diagonal, and this is repeated three times, and the triangles rest their diagonals and shorter sides on the same point as a center, a single equilateral triangle is formed out of six triangles, and four equilateral triangles, if put together, make out of every three plane angles one solid angle, being that which is nearest to the most obtuse of plane angles. And out of the combination of these four angles arises the first solid form which distributes into equal and similar parts the whole circle in which it is inscribed. The second species of solid is formed out of the same triangles, which unite as eight equilateral triangles and form one solid angle out of four plane angles, and out of six such angles the second body is completed. And the third body is made up of one hundred and twenty triangular elements, forming twelve solid angles, each of them included in five plane equilateral triangles, having altogether twenty bases, each of which is an equilateral triangle. The one element [that is, the triangle which has its hypotenuse twice the lesser side], having generated these figures, generated no more, but the isosceles triangle produced the fourth elementary figure, which is compounded of four such triangles, joining their right angles in a center, and forming one equilateral quadrangle. Six of these united form eight solid angles, each of which is made by the combination of three plane right angles; the figure of the body thus composed is a cube, having six plane quadrangular equilateral bases. There was yet a fifth combination which God used in the delineation of the universe with figures of animals.

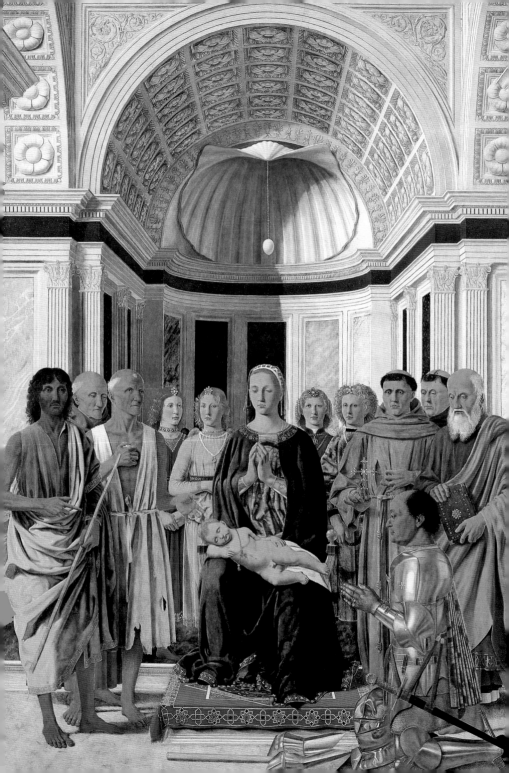

opposite
Piero della Francesca,
Montefeltro Altarpiece,
1472-1474.
Milan, Pinacoteca
di Brera

Andrea Palladio,
Villa Rotonda, c. 1550.
Vicenza

page 70
Cathedral
of Nôtre-Dame, Paris,
southern façade,
c. 1163-1197.

page 71
Cathedral of
Nôtre-Dame, Paris,
northern rose window
with *Stories from the Old
Testament*, c. 1163-1197.

realization of optimal architectonic proportions. After the invention of printing his work appeared in numerous editions, with steadily more accurate diagrams and drawings.

Vitruvius's work inspired Renaissance theories of architecture (from the *De re aedificatoria* by Leon Battista Alberti to Piero della Francesca, and from Pacioli to Palladio's *Quattro libri dell'architettura*).

The principle of proportion also reappears in architectonic practice in the form of a symbolic and mystical allusion. Perhaps this is how we should understand the taste for pentagonal structures in Gothic art, especially the tracery of rose windows in cathedrals. This is also how we should see masons' marks, in other words the personal ciphers that each cathedral builder cut into the most important stones in his construction, such as the keystones. They are geometrical patterns based on set diagrams or grids.

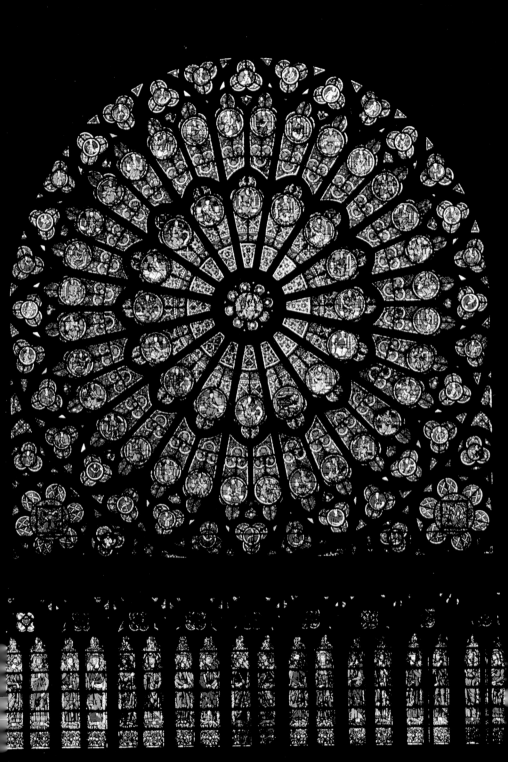

3. The Human Body

For the early Pythagoreans, while harmony consisted not only in the opposition between odd and even, as well as in that between limited and unlimited, unity and multiplicity, right and left, male and female, straight and curved, and so on, it would seem that Pythagoras and his immediate disciples thought that when two opposites are in contrast to each other, only one of them represents perfection: the odd number, the straight line, and the square are good and beautiful; the elements placed in opposition to them represent error, evil, and disharmony.

Heraclitus was to propose a different solution: if the universe contains opposites, elements that appear to be incompatible, like unity and multiplicity, love and hate, peace and war, calm and movement, harmony between these opposites cannot be realized by annulling one of them, but by leaving both to exist in a state of continuous tension. Harmony is not the absence of but the equilibrium between opposites.

Later Pythagoreans like Philolaus and Architas, who lived between the fifth and fourth centuries BC, accepted these suggestions and introduced them into the corpus of their doctrines.

This marks the birth of an idea of equilibrium between two opposed entities that neutralize each other, a polarity between two apparently contradictory aspects that become harmonious only because they are in opposition to each other. And, once these aspects are transported to the level of visual relationships, the result is symmetry. Pythagorean speculation therefore expressed a need for symmetry, which had always been alive in Greek art and which became one of the finest aesthetic principles in the art of classical Greece.

Harmony
Philolaos (fifth century AD)
Fragments from the Pre-Socratics, D44B6
Regarding nature and harmony, this is how matters stand. The substance of things, which is eternal, and nature itself, require knowledge that is not human, but divine; except for the fact that neither the things that are nor those we know could have come into being, were it not for the substance of things—limited and unlimited ones—constituting the cosmos. Now, as principles are neither equal or of the same sort, they could not have been ordered into a cosmos without the addition of harmony, regardless of how it be added. If principles were similar and of the same sort then there would be no need for harmony: but those elements, the substance of the things that make up the cosmos, limiting and unlimited factors, which are dissimilar and of different sorts and diversely ordered, must allow for the envelopment by harmony, which can hold them firmly within the cosmos.

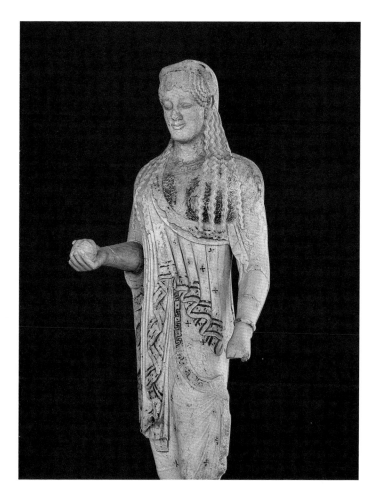

Kore,
sixth century BC.
Athens,
National Archaeological
Museum

Let us take a look at one of those statues of young women as sculpted by the artists of the sixth century BC. Were these the same girls of whom Anacreon and Sappho were enamored? The same girls whose smiles, gaze, gait, and braided hair they found beautiful? The Pythagoreans would have explained that the girl is beautiful because in her a correct equilibrium of the humors produces a pleasing complexion, and because her limbs are arranged in correct and harmonious relation to one another, given that they are governed by the same law that governs the distance between the planetary spheres. The artist of the sixth century BC found himself obliged to create that imponderable Beauty of which the poets sang and that he himself had seen one spring morning on observing the face of his beloved, but he had to create it in stone, and fix the image of the girl in a form. One of the first requisites of

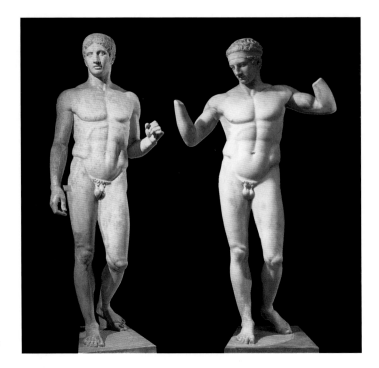

from left to right

Polyclitus,
Doryphorus,
Roman copy of a Greek
original,
450-440 BC.
Naples, Museo
Archeologico Nazionale

Polyclitus,
Diadumenus,
Roman copy of a Greek
original,
430 BC.
Athens, National
Archaeological Museum

good form was precisely that of correct proportion and symmetry. And so the artist made the eyes equal, distributed the tresses equally, and made the breasts and the arms and legs of equal proportions. At the same time, he made the folds of her dress equal and symmetrical while the same applied to the corners of her lips, turned up in that vague smile typical of such statues.

Apart from the fact that **symmetry** alone cannot account for the charm of that smile, we are still dealing with a fairly rigid notion of proportion. Two centuries later, in the fourth century BC, Polyclitus produced a statue that later became known as **the *Canon*** because it embodies all the rules of correct **proportion among the parts;** but the principle underpinning the *Canon* is not based on the equilibrium of two equal elements. All the parts of a body had to conform reciprocally in accordance with proportional ratios in a geometrical sense: A is to B as B is to C. Vitruvius was later to express correct bodily proportions as fractions of the entire figure: the face was to be $^1/_{10}$ of the total length, the head $^1/_8$, the length of the torso $^1/_4$, and so on.

The Greek proportional canon was different from the Egyptian one. The Egyptians used a grid whose mesh was made of equal-sized squares that prescribed fixed quantitative measures. If, for example, a human figure had to be eighteen units tall, the length of the foot was automatically three units, that of the arm five, and so on.

But the *Canon* of Polyclitus no longer featured fixed units: the head was to the body as the body was to the legs, and so on. The criterion was organic, and the proportions of the parts were determined according to the movement of the body, changes in perspective, and the adaptation of the figure in relation to the position of the viewer.

A passage from Plato's *Sophist* allows us to understand that sculptors did not respect proportions in a mathematical way, but adapted them to the requirements of vision, from the standpoint of which the figure was viewed. Vitruvius was to distinguish proportion, which is the technical application of the principle of symmetry, from **eurhythmy** ("venusta species commodusque aspectus"), which is the adaptation of proportions to the requirements of sight, in the sense of the above-mentioned Platonic text.

Symmetry
Vitruvius (first century AD)
De architectura, III, 1
Symmetry is a proper agreement between the members of the work itself, and the metric correspondence between the separate parts and the scheme as a whole [...]. Symmetry springs from the proportion that the Greeks called analogy: no building can be satisfactorily ordered in the absence of analogy with the correct proportions of the human body.

The *Canon*
Pliny the Elder (first century AD)
Natural History, XXXIV, 55
Polyclitus of Sicyon, a pupil of Agelades, made the *Diadumenus*, an effeminate figure of a youth, renowned for having been valued at one hundred talents. He also made the *Doryphorus*, a virile figure of a young man. The same Polyclitus also created the piece that artists call the *Canon*, a figure that artists turn to in search of the rules of art, much as one might consult the laws. And he is considered to be the only man to have produced a work of art that embodied art itself.

Proportion Among the Parts
Galen (second century AD)
Placita Hippocratis et Platonis, V, 3
Chrysippus [...] states that Beauty does not lie in the individual elements, but in the harmonious proportion of the parts, in the proportion of one finger in relation to another, of all the fingers to the whole hand, of the rest of the hand to the wrist, of this last to the forearm, of the forearm to the whole arm, and finally of all the parts to all the others, as is written in the *Canon* of Polyclitus.

Eurhythmy
Plato (fifth-fourth century BC)
The Sophist, XXIII
Stranger: One is the art of likeness-making; generally a likeness of anything is made by producing a copy which is executed according to the proportions of the original, similar in length and breadth and depth, each thing receiving also its appropriate color.
Theaetetus: Is not this always the aim of imitation?
Stranger: Not always; in works either of sculpture or of painting, which are of any magnitude, there is a certain degree of deception; for artists were to give the true proportions of their fair works, the upper part, which is farther off, would appear to be out of proportion in comparison with the lower, which is nearer; and so they give up the truth in their images and make only the proportions which appear to be beautiful, disregarding the real ones. [...] And that which being other is also like, may we not fairly call a likeness or image? [...]And may we not, as I did just now, call that part of the imitative art which is concerned with making such images the art of likeness making? [...] And what shall we call those resemblances of the beautiful, which appear such owing to the unfavourable position of the spectator, whereas if a person had the power of getting a correct view of works of such magnitude, they would appear not even like that to which they profess to be like? May we not call these "appearances," since they appear only and are not really like? [...] There is a great deal of this kind of thing in painting, and in all imitation. [...] And may we not fairly call the sort of art, which produces an appearance and not an image, phantastic art?

ORIENS

IGNIS

Macrocosmos constat ex quatuor elementis. igne aere. aqua. et tra. id homo constat ex igne. aere. aqua.

Sic et mictocosmos. isdē. IIII. elemtis 7 tra.

De — sumit calore deaqua humo pus. Sz iiii. hec ele eugsia q̄ p̄ iiii. partes totī gns humani p ex epos 7 phbos

igne de aere spm rē. de tra cor mta significat in mundi ad saluatione xii. aplos 7 successores predicantur.

OCCIDENS

Apparently, Medieval man did not apply a mathematics of proportions to the appraisal or reproduction of the human body. One might think that this lack of interest was partly due to a devaluation of corporeal in favor of spiritual Beauty. Naturally, the world of the High Middle Ages was not unacquainted with evaluations of the human body as a prodigy of Creation, as may be found in Thomas Aquinas. Nevertheless, in the majority of cases, Pythagorean-proportional criteria were applied in order to define moral Beauty, as in the symbolism of the *homo quadratus*.

Medieval culture started from an idea of Platonic origin (which, moreover, was also being developed at the same time within the Jewish mystical tradition) whereby the world is seen as a huge animal, and therefore as a human being, while a human being was like the world; in other words, the cosmos is like a large man and man is like a small cosmos. This marked the birth of the theory called the *homo quadratus,* in which number, the principle of the universe, came to assume symbolic meanings based on a series of numerical correspondences that were also aesthetic correspondences.

The ancients reasoned it this way: as it is in nature so must it be in art. But in many cases nature was divided into four parts. The number four became a key resolving number. Four are the cardinal points, the principal winds, the phases of the moon, the seasons; four is the constituent number of the tetrahedron of fire in the *Timaeus*, and four letters make up the name 'Adam.' And four was to be, as Vitruvius taught, the number of man, since the breadth of a man with arms outstretched corresponds to his height, thus giving him the base and height of an ideal square.

Four was to be the number of moral perfection, just as in some languages 'tetragonal' was to come into figurative use for a person of steadfast morality. But *homo quadratus* was also to become pentagonal

The Number Four
Anonymous Carthusian (twelfth century)
Tractatus de musica plana
For the Ancients reasoned in this manner: as it is in nature, so must it be in art: but in many cases nature is divided into four parts [...]. Four are the regions of the world, four the elements, four the primary qualities, four the principal winds, four the physical constitutions, four the faculties of the soul and so on.

Seasons
Boethius (480-526)
De arithmetica, I,2
All things that have been constructed by primeval nature appear to be formed according to the proportion of numbers. In the soul of the Creator this was in fact the principal model, whence sprang the host of the four elements, the cycle of the seasons, the motion of the stars, and the rotation of the heavens.

The Leaders of the Twelve Tribes of Israel, from the *Commentary on the Apocalypse, Beatus* of Ferdinand I and Queen Sancha, MS. Vit. 14-2, eleventh century. Madrid, Biblioteca Nacional

Rabanus Maurus,
De laudibus sanctae crucis,
MS. Reg. lat. 124,
ninth century.
Vatican City, Biblioteca
Apostolica Vaticana

Rabanus Maurus,
De laudibus
sanctae crucis, MS. 652, f.
33v, ninth century.
Vienna, Österreichische
Nationalbibliothek

man, because five too is a number full of arcane correspondences and the
pentad is an entity that symbolizes mystical and aesthetic perfection. Five is
the circular number that, when multiplied, continually comes round to itself
(5 x 5 = 25 x 5 = 125 x 5 = 625, etc.). Five are the essences of things, the
elementary zones, the living species (birds, fish, plants, animals, men); the
pentad is the matrix of God and it is also found in the Scriptures (the
Pentateuch, the five Holy Wounds); all the more so is it to be found in man,
inscribable within a circle whose center is the navel, while the perimeter
formed by the straight lines that unite the various extremities gives the
figure of a pentagon. The mysticism of St. Hildegard (with her concept of
anima symphonizans) is based on the symbolism of the proportions and the
mysterious allure of the pentad. In the twelfth century, Hugh of Saint Victor
stated that body and soul reflect the perfection of divine Beauty, the former
basing itself on the even number, imperfect and unstable, and the latter on
the odd number, determined and perfect.

Nevertheless, all we need do is compare the studies on the proportions
of the human body as found in the work of a medieval artist like Villard de
Honnecourt with those of artists like Leonardo and Dürer, and we can see all
the importance of more mature mathematical reflections of the theorists of

Humanism and the Renaissance. In Dürer the proportions of the body are based on rigorous mathematical modules. While people discussed proportion both in Villard's and in Dürer's day alike, it is clear that changes occurred in the accuracy of calculations and that the ideal model of Renaissance artists was not the medieval philosophical notion of proportion but rather the one embodied by the *Canon* of Polyclitus.

Albrecht Dürer,
Anthropometric Figures,
from *Vier Bücher von
menschlicher
Proportionen*, 1528.

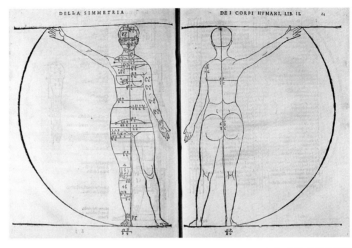

from left to right

Cesare Cesariano,
Vitruvian Figure,
*Di Lucio Vitruvio Pollione:
de architettura*, 1521.
Milan, Biblioteca
Nazionale Braidense

*Corporal Humors and
Elementary Qualities
of Man in Relation to
the Zodiac,*
eleventh century.
Spain, Burgo de Osma

Leonardo da Vinci,
*Study of the Proportions
of the Human Body*,
c. 1485-1490.
Venice, Gallerie
dell'Accademia

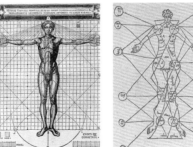

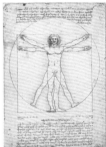

4. The Cosmos and Nature

In the Pythagorean tradition (and the concept was to be retransmitted to the Middle Ages by Boethius), the soul and body of man are subject to the same laws that govern musical phenomena, and those same proportions are to be found in cosmic harmony in such a way that both micro- and macrocosm (the world in which we live and the entire universe) appear bound by a single rule that is at once mathematical and aesthetic. This rule is manifested in the music of the spheres: according to Pythagoras, this was the musical scale produced by the planets, each of which, in rotating around the motionless world, produces a sound whose pitch depends on the distance of the planet from the earth and, consequently, on the speed at which the planet in question is moving. The system thus emits the sweetest music, but one that we cannot hear owing to the inadequacy of our senses. Medieval man was to develop an infinity of variations on this theme of

Cosmic Harmony
Plutarch (first-second century)
On the Cessation of Oracles, XXII
Petron says that there are […] 183 worlds arranged in the form of an equilateral triangle whose every side contains 60 worlds. The three remaining worlds are situated respectively at the three angles, but they touch those that follow one another along the sides, revolving without irregularity, as in a dance. This is proven by the number of the worlds, which is neither Egyptian nor Indian, but of Doric origin, from Sicily, through a man of Himera called Petron. I haven't read his booklet, and I don't know if it is still extant, but Hippys of Rhegium, cited by Phaneas of Eresos, says that this was the opinion and doctrine of Petron, i.e., that there were 183 worlds "which touch one another at a point," but he does not explain what it means to say "to touch one another at a point," nor does he adduce any other plausible elements to support this.

Order and Measure
Bonaventure of Bagnoregio (thirteenth century)
Commentary on the Four Books of Sentences, I, 43, 1

Since God can only make things that are ordered according to their nature, since order presupposes number and number presupposes measure, and since only numbered things are ordered and only limited things are numbered, then God must needs have made things according to number, weight, and measure.

The Cosmos
William of Conches (twelfth century)
Glosae super Platonem
The Beauty of the world is all that which appears in its single elements, like the stars in the sky, the birds of the air, the fishes of the sea, and men on the earth.

Kósmos
Isidore of Seville (560-636 AD)
Etymologies, XIII
In truth the Greeks named the world after ornament, for the diversity of the elements and the Beauty of the stars. In fact their way of calling it is *Kósmos*, which means ornament. For nothing more beautiful than the world may be seen with the eyes of the flesh.

the musical Beauty of the world. In the ninth century, John Scotus Eriugena spoke of the Beauty of Creation, which he thought was generated by the simultaneous playing of the Same and the Different to produce a harmony in which the voices, listened to in isolation, say nothing, but once merged into a single concert produce a natural sweetness. In his *Liber duodecim quaestionum*, Honorius of Autun (twelfth century) devotes a chapter to explaining how the cosmos is organized like a cithara in which the different types of strings play harmoniously together.

In the twelfth century the authors of the School of Chartres (William of Conches and Thierry of Chartres, Bernard Silvestre, Alain of Lille) re-examined the ideas found in Plato's *Timaeus*, together with the Augustinian idea (of Biblical origin) whereby God has arranged all things in accordance with order and measure. For these men, the cosmos was a sort of continuous union made up of reciprocal consensus among things, bolstered by a divine principle that is soul, providence, and destiny. The Work of God was in fact the *kósmos,* the order of all things, which stands in opposition to primordial chaos. The mediator of this work is Nature, a force inherent in things, which produces similar things from similar things, as William of Conches says in the *Dragmaticon*. And the ornament of the world, that is to say its Beauty, is the work of consummation that Nature, through an organic

Geometrical Representations of the Notions of God, the Soul, Virtue and Vice, Predestination, from *Ars demonstrativa,* thirteenth century. Bergamo, Biblioteca Civica "Angelo Mai"

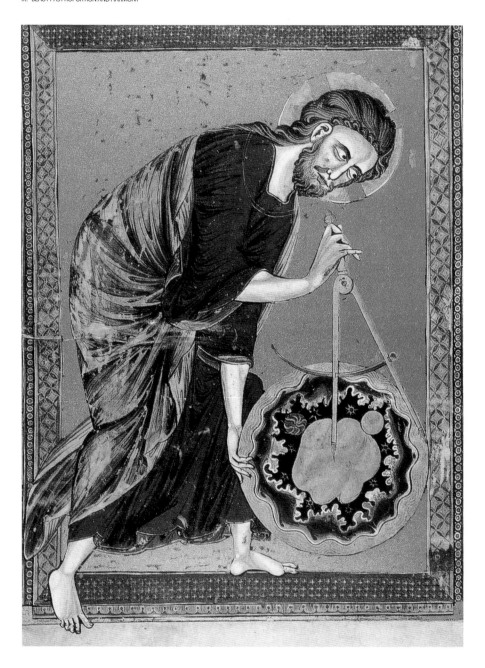

complex of causes, brought about in the world once it was created.

Beauty begins to appear in the world when matter created becomes differentiated in terms of weight and number, circumscribed by its outlines, and takes on shape and color; in other words, Beauty is based on the form that things assume in the creative process. The authors of the School of Chartres do not speak of a mathematically immobile order, but of an organic process, the development of which can always be reinterpreted by working back to the Originator. Nature, not number, underpins this world.

Even ugly things are part of the harmony of the world, thanks to proportion and contrast. Beauty (and this was to become a persuasion common to all medieval philosophy) also springs from **the contrast of opposites,** and thus even monsters have a reason and a dignity in the concept of Creation; likewise, evil within the order becomes good and beautiful because evil springs from good and, alongside it, good shines out all the better (cf. Chapter V).

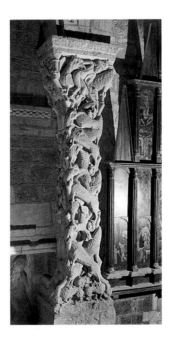

opposite
God Measuring the World with a Compass
from a moralized Bible, c. 1250.
Vienna, Österreichische Nationalbibliothek

Column with the *Sacrifice of Isaac,* eleventh-twelfth century.
Souillac, Cathedral of St. Marie

The Contrast of Opposites
John Scotus Eriugena (ninth century)
De divisione naturae, V
For any thing that is considered deformed in itself as a part of a whole not only becomes beautiful in the totality, because it is well ordered, but is also a cause of Beauty in general; thus wisdom is illuminated by the relation with foolishness, knowledge by comparison with ignorance, which is merely imperfection and wanting, life by death, light by the opposition of the shadows, worthy things by the lack of praise for them; and, to be brief, all virtues not only win praise [by comparison with] the opposite vices but without this comparison they would not be worthy of praise … As true reason does not hesitate to state, all the things that in one part of the universe are wicked, dishonest, shameful, and wretched and are considered crimes by he who cannot see all things are, when seen from a universal standpoint, neither crimes nor shameful or dishonest things; nor are they wicked. As is the case with a beautiful painting, for example. For all that is ordered according to the design of divine Providence is good, beautiful, and just. Indeed, what could be better than [the fact that] the comparison of opposites lets us sing the ineffable praises of both the universe and the Creator?

5. The Other Arts

The aesthetics of proportion took on a variety of steadily more complex forms and we find this in painting too. All the treatises on the figurative arts, from the Byzantine works written by the monks of Mt. Athos to Cennini's *Tractatus* (fifteenth century), reveal an ambition within the plastic arts to attain the same mathematical level as music. In this sense it is worth taking a look at a document like the *Album* or *Livre de portraiture* of Villard de Honnecourt (thirteenth century): here, every figure is determined by geometrical coordinates.

Villard de Honnecourt,
*Drawings: Study of
Heads, Men, Horses …*
from the *Livre de
portraiture*, thirteenth
century

Albrecht Dürer,
Portula optica,
1525

Mathematical studies reached the apogee of precision in the
Renaissance theory and practice of perspective. In itself, perspectival
representation is a technical problem, but it interests us because the artists
of the Renaissance saw good perspectival representation not only as correct
and realistic, but also as beautiful and pleasing to the eye. The influence of
the Renaissance theory and practice of perspective was to prove so strong
that for many years the representations of other cultures, or of other
centuries, in which these rules were not observed were considered
primitive, incompetent, or even downright ugly.

6. Conformity with the Purpose

In the most fully developed phase of medieval thinking, Thomas Aquinas said that, for Beauty to exist, there must be not only due **proportion** but also integrity (in other words, all things must have all the parts that rightly belong to them, and hence a mutilated body is ugly), as well as **splendor**— because things of a clear color are said to be beautiful. In Aquinas's view, however, proportion is not merely the correct disposition of matter, but the perfect adaptation of matter to **form,** and hence a human body in conformity with the ideal conditions of humanity is to be considered in proportion. Aquinas saw proportion as an ethical value, in the sense that virtuous actions bring about correctly proportioned words and deeds in accordance with a rational law, and so we must also talk of **moral Beauty** (or of moral turpitude).

The principle is that things must be **suited to the purpose** for which they are intended, and so Aquinas would not have hesitated to define a crystal hammer as ugly because, despite the superficial Beauty of the material of which it is made, the thing would have appeared unsuited to its proper function. Beauty is the **mutual collaboration** between things, and so we can define as "beautiful" the reciprocal action of stones that, by supporting one another and thrusting against one another, provide a building with a solid base. It is the correct relationship between the intelligence and the object that the intelligence comprehends. In other words proportion becomes a metaphysical principle that explains the unity of the cosmos itself.

Proportion
Thomas Aquinas (thirteenth century)
Summa theologiae, I, 5, 4
Beauty consists of due proportion, for the senses delight in well-proportioned things.

Splendor
Thomas Aquinas (thirteenth century)
Summa theologiae, I, 39, 8
Three qualities are required for Beauty. In the first place integrity or perfection: since incomplete things, precisely because they are such, are deformed. Due proportion or harmony among the parts is also required. Finally clarity or splendor: in fact we describe things whose colors are clear and brilliant as beautiful.

Form
Thomas Aquinas (thirteenth century)
Contra gentiles, II, 81
Matter and form are of necessity mutually proportioned and adapted to one another.

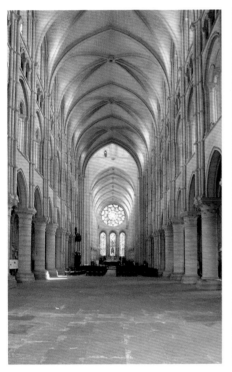

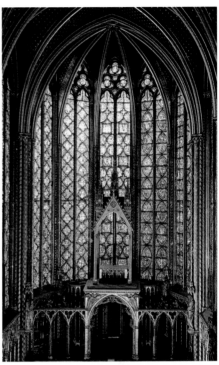

above left
Cathedral
of Nôtre-Dame, Laon,
twelfth century

above right
Sainte-Chapelle,
Paris, thirteenth century

Moral Beauty
Thomas Aquinas (thirteenth century)
Summa theologiae, II-II, 145, 2
Spiritual Beauty consists in the fact that the
conduct and the deeds of a person are well
proportioned in accordance with the light of
reason.

Suitability to the Purpose
Thomas Aquinas (thirteenth century)
Summa theologiae, I, 91, 3
Every craftsman tends to confer the best
order upon his work, not in an absolute sense,
but in relation to the desired purpose.

Mutual Collaboration
Thomas Aquinas (thirteenth century)
Commentary on the Divine Names, IV, 6
Just as many stones are suited to one another
and from them the house is born […], for the
same reason it is said that not only Beauty
requires every thing to remain equal unto
itself, but also that all things together
establish a reciprocal communion each
according to its own properties.

7. Proportion in History

If we consider many expressions of medieval art and compare them with the models of Greek art, at first sight it is hard for us to think that these statues or these architectonic structures, which after the Renaissance were considered barbarous and out of proportion, could embody criteria of proportion.

The fact is that the theory of proportion has always been bound up with a philosophy of a Platonic stamp for which the model of reality was ideas, of which real things are only pale and imperfect imitations. Greek civilization seems to have done its best to embody the perfection of the idea in a statue or in a painting, even though it is difficult to say whether Plato, when he pondered the idea of Man, was thinking of the bodies of Polyclitus or of the preceding figurative arts. Plato thought that art was an imperfect imitation of nature, in its turn an imperfect imitation of the ideal world. In any event, this attempt to make artistic representation conform to the Platonic idea of Beauty was common to Renaissance artists. But there have been periods in which the schism between the ideal and the real world was more marked.

Boethius, for example, did not seem interested in concrete musical phenomena, which should embody proportion, but in archetypal rules wholly separated from concrete reality. For Boethius, the composer was one who knew the rules that govern the world of sound, while the musician was often considered a mere slave devoid of any theoretical knowledge, an instinctive character who was all unaware of those ineffable beauties that

Piet Mondrian,
Composition with Yellow, Red, Black, Blue, and Gray,
1920.
Amsterdam,
Stedelijk Museum

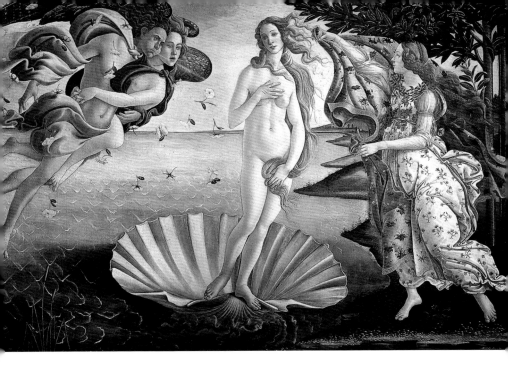

Sandro Botticelli,
The Birth of Venus,
c. 1482.
Florence, Galleria
degli Uffizi

only theory could reveal. Boethius almost seems to congratulate Pythagoras for having undertaken a study of music "leaving aside the judgment of the hearing." The lack of interest in the physical world of sound and in the "judgment of the ear" is seen in the notion of the music of the spheres. Actually, if each planet produced a sound in the musical scale, all the planets together would produce a highly unpleasant discord. But Medieval theorists, wholly taken with the perfection of numerical correspondences, were unworried by this incongruity.

This clinging to a purely ideal notion of harmony was typical of an epoch marked by great crises, as was the case in the early centuries of the Middle Ages, a period in which people sought refuge in the knowledge of certain stable and eternal values, while regarding with suspicion all that was linked to corporeality, the senses, and physicality. For moralistic reasons, Medieval man reflected on the transitory nature of earthly beauties and on the fact that, as Boethius says in *The Consolation of Philosophy*, external Beauty is "yet more fleeting than the passing of flowers of spring."

Nonetheless, it must not be thought that these theorists were insensible to the physical pleasantness of sounds, or of visible forms, nor that they were unable to reconcile abstract speculation about the mathematical Beauty of the universe with a highly pronounced taste for worldly Beauty. Proof of this lies in the enthusiasm that the same authors showed for the Beauty of light and color (cf. Chapter IV). Nevertheless it appears that in the Middle Ages there was a manifest disparity between an ideal of proportion and that which was represented or constructed as proportioned.

Jacopo Palma Vecchio,
Nymph in a Landscape,
1518-1520.
Dresden,
Gemäldegalerie

opposite
Lucas Cranach,
*Venus with Cupid
Stealing Honey*, c. 1531.
Rome, Galleria Borghese

But this does not hold only for the Middle Ages. If we take the Renaissance treatises on proportion as a mathematical rule, the relationship between theory and reality appears satisfactory only as far as concerns architecture and perspective.

When, through painting, we try to understand the Renaissance ideal of human Beauty, there would seem to be a gap between the perfection of the theory and variations in tastes. What were the proportional criteria common to a series of men and women considered beautiful by different artists? Can we find the same rules of proportion in the Venuses of Botticelli and Lucas Cranach and in that of Giorgione?

It is possible that artists who portrayed famous men were more interested in powerful physiques or the spiritual strength and the will to power conveyed by facial expression rather than in a correspondence with any proportional canon; but this takes nothing away from the fact that many of these men also represented an ideal of physical good looks, and one just cannot see what the proportional criteria common to the heroes of the age might have been.

Consequently, it seems that throughout the centuries there was talk of the Beauty of proportion but, despite the dominant arithmetical and

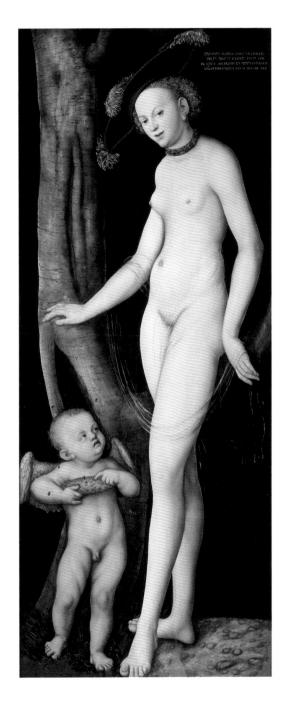

Alleluia jubilus,
musical manuscript,
ninth-tenth century.

Tu patris sempiternus,
musical manuscript,
c. 900.

geometrical principles of the various epochs, the sense of this proportion changed. It is one thing to assert that there must be a correct relationship between the length of the fingers and the hand, and between these and the rest of the body; but establishing this correct relationship was a question of taste that could change with the passing centuries.

In the course of time many different ideals of proportion have been produced. Proportion as it was understood by the first Greek sculptors was not the same as the proportion of Polyclitus; the musical proportions that Pythagoras wondered about were not the same as those of Medieval times, because the music that Medieval man considered pleasant was different. When the composers of the end of the first millennium had to adapt the syllables of a text to suit that form of vocalese known as the "Alleluia jubilus" they found themselves faced with a problem related to the proportion between word and melody. In the ninth century, when the two voices of the diaphony abandoned unison and each began to follow its own melodic line, but without losing the consonance of the whole, once again a need arose to find a new proportional rule. The problem grew more complex with the shift from diaphony to discant and from the latter to the polyphony of the twelfth century.

In the case of an *organum* by Pérotin—when from the background of a generating note there arises the complex movement of a counterpoint of truly Gothic boldness, and three or four voices hold sixty consonant measures on the same pedal tone to generate a variety of sounds that soar up like the pinnacles of a cathedral—the Medieval musician who turned to the texts of the tradition gave a really concrete meaning to those categories that Boethius saw as Platonic abstractions. And so things went as the history of music gradually unfolded. In the ninth century the interval of a fifth (C-G) was still held to be an imperfect consonance, but by the twelfth century it had been admitted.

In literature, Bede in his *De arte metrica* (eighth century) makes a distinction between meter and rhythm, between Latin quantitative meter and the syllabic meter that was later to supersede it, noting how the two poetic modes each possessed a type of proportion of their own. Geoffroy de Vinsauf, in *Poetria nova* (around 1210), talks of proportion as appropriateness, and so it became right to use adjectives like "fulvum" for gold, "nitidum" for milk, "praerubicunda" for the rose, and "dulcifluum" for honey. Every style had to suit the subject matter. It is clear that here we are no longer talking about proportion as a mathematical quantity, but as a quality. The same came to hold for word order, the coordination of descriptions and arguments, and for narrative composition.

The builders of cathedrals followed their own proportional criterion, which was different from that of Palladio. Nonetheless, many contemporary scholars have tried to demonstrate how the principles of ideal proportion, including the realization of the Golden Section, are to be found in the works of all centuries, even when the artists did not know the corresponding mathematical rules. When proportion is seen as a strict rule, then it is noted that it does not exist in nature, and it is possible to arrive at a position like that of Edmund Burke (seventeenth century), who denied that proportion was a criterion for Beauty.

In the twilight of Renaissance civilization, a significant idea began to gain ground: Beauty did not so much spring from balanced proportion, but from a sort of torsion, a restless reaching out for something lying beyond the mathematical rules that govern the physical world. Hence Renaissance equilibrium was followed by the restless agitation of Mannerism. But for this change to occur in the arts (and in the concept of natural Beauty), the world

Cathedral of Nôtre-Dame, Chartres, mid-twelfth century

Andrea Palladio, *Church of Il Redentore*, from *I Quattro libri dell'architettura*, edited by Vincenzo Scamozzi, c. 1615

Andreas Cellarius,
*Harmonia
macrocosmica*,
Amsterdam, 1660

had to be seen as less ordered and geometrically obvious. Ptolemy's model of the universe, based on the perfection of the circle, seemed to embody the Classical ideals of proportion. Even Galileo's model, in which the earth was shifted from the center of the universe and made to revolve around the sun, did not disturb this most ancient idea of the perfection of the spheres. But with Kepler's planetary model, in which the earth revolves along an ellipse of which the sun is one of the foci, this image of spherical perfection was thrown into crisis. This was not because Kepler's model of the cosmos did not obey mathematical laws, but because—in a visual sense—it no longer resembled the "Pythagorean" perfection of a system of concentric spheres.

Moreover, if we consider that toward the end of the sixteenth century Giordano Bruno had begun to suggest the idea of an infinite cosmos and a plurality of worlds, it is evident that the very idea of cosmic harmony had to take another path.

Andreas Cellarius,
*Harmonia
macrocosmica,*
Amsterdam,
1660

Against Proportion
Edmund Burke
*A Philosophical Inquiry into the Origin of Our
Ideas of the Sublime and Beautiful,* III, 4, 1756

For my part, I have at several times very
carefully examined many of those proportions,
and found them hold very nearly or altogether
alike in many subjects, which were not only
very different from one another, but where one
has been very beautiful, and the other very
remote from beauty. With regard to the parts
which are found so proportioned, they are
often so remote from each other, in situation,
nature, and office, that I cannot see how they
admit of any comparison, nor consequently
how any effect owing to proportion can result
from them. The neck, say they, in beautiful
bodies, should measure with the calf of the leg;
it should likewise be twice the circumference
of the wrist. But what relation has the calf of
the leg to the neck; or either of these parts to
the wrist? These proportions are certainly to be
found in handsome bodies. They are as
certainly in ugly ones; as any who will take the
pains to try may find. Nay, I do not know but
they may be least perfect in some of the most
beautiful. You may assign any proportion you
please to every part of the human body; and I

undertake that a painter shall religiously
observe them all, and notwithstanding
produce, if he pleases, a very ugly figure. The
same painter shall considerably deviate from
these proportions, and produce a very
beautiful one. And indeed it may be observed
in the master-pieces of the ancient and
modern statuary, that several of them differ
very widely from the proportions of others, in
parts very conspicuous and of great
consideration; and that they differ no less from
the proportions we find in living men, of forms
extremely striking and agreeable. And after all,
how are the partisans of proportional beauty
agreed amongst themselves about the
proportions of the human body? Some hold it
to be seven heads; some make it eight; whilst
others extend it even to ten; a vast difference in
such a small number of divisions! Others take
other methods of estimating the proportions,
and all with equal success. But are these
proportions exactly the same in all handsome
men? Or are they at all the proportions found
in beautiful women? Nobody will say that they
are; yet both sexes are capable of beauty, and
the female of the greatest; which advantage I
believe will hardly be attributed to the superior
exactness of proportion in the fair sex.

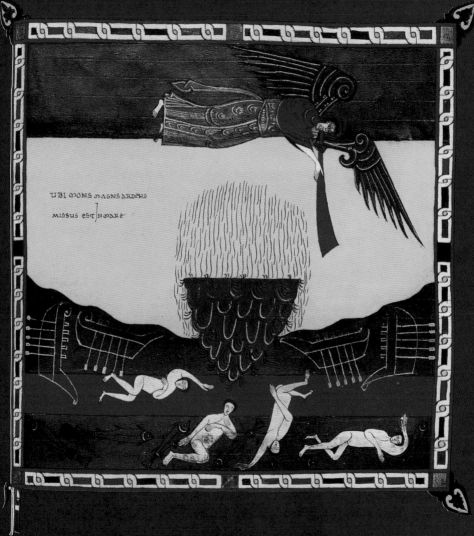

Light and Color in the Middle Ages

1. Light and Color

To this day, many people, victims of the conventional "Dark Ages" image, think of the Medieval period as a somber epoch, even as far as color was concerned. When evening fell, in those days, people lived in poorly lit surroundings: in huts illuminated—at best—by the fire in the hearth; in enormous castle chambers lit by torches; or in monastery cells lit by the feeble light of a lantern, while the streets of the villages and cities were dark, as well as treacherous. But these were also characteristics of the Renaissance, of the Baroque age, and of successive periods that extend to the discovery of electricity.

Medieval people, however, saw themselves (or at least portrayed themselves in poetry and painting) as living in extremely bright surroundings. The striking thing about Medieval illuminated manuscripts is that, while they were probably executed in surroundings where the gloom was barely relieved by the light from a single window, they nevertheless brim with light, with a

opposite
Opening of the Well in the Abyss and Ascent of the Locusts,
detail, from the *Commentary on the Apocalypse of Beatus of Liébana, Beatus* of Ferdinand I and Queen Sancha,
MS. Vit. 14-2,
eleventh century.
Madrid, Biblioteca Nacional

Manuscript with the liturgy of St. John Chrysostom, detail, tenth-eleventh century.
Vatican City,
Biblioteca Apostolica
Vaticana

particular effulgence engendered by the combination of pure colors: red, azure, white, and green, lar devoid of nuances or chiaroscuro.

The art of the Middle Ages played on primary colors, on well-defined chromatic zones inimical to nuance, and on the combination of hues that engender light by overall concordance in preference to producing light by enveloping colors in chiaroscuro or having them ooze beyond the limits of the figure.

In Baroque painting, for example, objects are struck by the light, and the play of volumes gives rise to bright and dark areas (see, for example, the light in Caravaggio or in Georges de la Tour). But in Medieval illumination the light seems to radiate out from the objects. They are luminous in themselves.

This is evident not only in the heyday of Flemish and Burgundian illumination (consider the *Très riches heures du Duc de Berry*), but also in works from the late Middle Ages, like Mozarabic illuminations, a play of violent color contrasts between yellow and red or blue, or the Ottonian illuminations, in which the splendor of gold is brought out by cold and clear tones such as lilac, blue-green, sand yellow, or blued white.

In the late Middle Ages Thomas Aquinas said (retrieving ideas that were in widespread circulation even before his time) that beauty requires three things: proportion, integrity, and *claritas*—in other words clarity and luminosity.

Limbourg Brothers,
The Visitation,
from the *Très riches heures
du Duc de Berry,*
1411-1416.
Chantilly, Musée Condé

Georges de La Tour,
Repenting Magdalen,
1630-1635.
Washington,
National Gallery of Art

Claritas
Thomas Aquinas (thirteenth century)
Summa Theologiae, II-II, 145, 2
As can be seen from the words of Dionysius, Beauty comprises both splendor and suitable proportions: and in fact he states that God is beautiful "as the cause of the splendor and the harmony of all things." Thus the Beauty of the body consists in having well-proportioned limbs, with the brightness of the appropriate color.

Angel of the Fifth Trumpet,
detail, from the *Commentary
on the Apocalypse of Beatus of
Liébana, Beatus* of Ferdinand I
and Queen Sancha,
MS. Vit 14-2,
eleventh century.
Madrid, Biblioteca Nacional

2. God as Light

One of the origins of the aesthetic of clarity certainly derives from the fact that in numerous cultures God is identified with light: the Semitic deity Baal, the Egyptian deity Ra, and the Persian deity Ahura Mazda are all personifications of the sun or the beneficial action of light, personifications that arrive naturally at the Platonic concept of Good as the sun of ideas; through Neoplatonism these images found their way into the Christian tradition.

From the Greek tradition, Plotinus inherited the idea that Beauty consists first and foremost of proportion (cf. Chapter III). Since the Greek tradition affirms that Beauty is not only *symmetria* but also *chroma*, color, he wondered how it was possible to have a Beauty that we would define today as "qualitative" and capable of manifesting itself in a simple chromatic sensation. In the *Enneads* (I, 6) Plotinus wonders why it is that we ascribe beauty to colors and the light of the sun, or the splendor of the night stars, which are simple and do not draw their beauty from a symmetry of parts. The answer he arrives at is that "the simple beauty of a color is given by a form that dominates the darkness of matter, by the presence of an incorporeal light that is none other than reason and idea." Hence the beauty of fire, which shines in a way similar to an idea. But this observation acquires sense only within the framework of Neoplatonic philosophy, for which matter is the final (decayed) stage of the descent by "emanation" from an unattainable and supreme One. And so the light that shines out over matter can only be attributed to the reflection of the One from which it emanates. God is therefore identified with the splendor of a sort of luminous current that permeates the entire universe.

These ideas were taken up by the obscure writer Dionysius the Pseudo-Areopagite, who was probably active in the fifth century AD but who became identified by the Medieval tradition with the Dionysius converted by St. Paul in the Aeropagus in Athens. In his works *The Heavenly Hierarchy* and *On Divine Names*, the Pseudo-Areopagite represents God as "light," "fire," and "fountain of light." The same images are found in the greatest exponent of Medieval Neoplatonism, John Scotus Eriugena. The entire later Scholastic movement was influenced by the contribution of Arabic philosophy and poetry, which handed down visions of substances refulgent with light, ecstasies of resplendent beauty, while the ninth-century sage al-Kindi introduced a complex cosmological scheme based on the power of stellar rays.

Binding of an
evangeliarium, detail,
seventh century.
Monza,
Treasury of the Cathedral

The Simple Beauty of a Color
Plotinus (third century)
Enneads, I, 6
The simple beauty of a color is derived from a
form that dominates the obscurity of matter
and from the presence of an incorporeal light
that is reason and idea. Hence, of all bodies,
fire is beautiful in itself and among the other
elements it occupies the place of the idea. Its
position makes it the highest [of the
elements] and the lightest of all bodies,
because it is nearly incorporeal; it is alone and
does not accept the other elements unto
itself, while the others accept it. They can be
heated, but fire cannot be cooled. It is fire that
first possesses color, while the other things
receive the form of color from it. Fire is
resplendent and brilliant, like an idea. Things
inferior to fire fade in the absence of its light
and are no longer beautiful, because they do
not partake of the total idea of color.

The Beauty of Fire
Dionysius the Pseudo-Aeropagite
(fifth-sixth century)
The Celestial Hierarchy, XV
I believe that fire manifests that which is most
divine in the celestial intelligence; for the holy
authors often describe the supersubstantial
substance—which has no form at all—with
the symbol of fire, because fire has many
aspects of the divine character, if this may
fairly be said, insofar as that divine character
may be described in visible things. In fact,
sensible fire is present, so to speak, in all
things and passes through all of them
without mixing with them and is detached
from all of them, and, being wholly radiant, it
remains at once concealed and unknown in
itself and for itself. In the absence of any
material through which it may manifest its
own action, fire may not be grasped or seen,
but it can seize all things.

A Luminous Current

Dionysius the Pseudo-Aeropagite
(fifth-sixth century)
On Divine Names, IV

And what shall we say of the sun's rays taken as themselves? Light derives from Good and is the image of Goodness, hence Good is celebrated with the name of Light as the archetype that manifests itself in the image. Just as the divine Good superior to all things penetrates from the highest and noblest substances down to the lowest and yet remains above them all, without the highest of them being able to attain its excellence and without the lowest being able to escape its influence; but illuminates, produces, enlivens, contains and perfects all things suited to receiving it; and [just as] it is the measure, duration, number, order, container, cause, and end of beings, so does the manifest image of divine Goodness—in other words this great sun wholly bright and ever radiant according to the most tenuous resonance of Good—illuminate all those things able to partake of it, and its light is diffused over all things while it spreads the splendors of its rays over all the visible world. And if some thing does not partake of this light, this is not to be ascribed to its obscurity or to the inadequacy of its distribution, but to the things that tend not to partake of it because of their unfitness to receive it. In reality, the ray [of light], on passing through many of the things in this condition, illuminates the things that come after and there is no visible thing that it may not reach, owing to the exceeding greatness of its splendor.

God as "Light"

John Scotus Eriugena (ninth century)
Commentary on The Celestial Hierarchy, I

Hence it happens that this universal architecture of the world is an exceedingly great light made up of many parts and many lights to reveal the pure species of intelligible things and to intuit them with the mind's eye, as divine grace and the help of the reason work together in the heart of the wise believer. When theologians call God the father of Lights they do well, because from Him come all things, through which and in which He manifests himself and in the light of His wisdom they are unified and made.

Stellar Rays

al-Kindi (ninth century)
De radiis, II

For every star pours forth in all directions rays whose diversity, having so to speak been blended into one, varies the contents of each place, since in each diverse place the tenor of the ray—which derives from the overall harmony of the stars—will differ in its turn. Moreover, since this harmony is continuously modified by the continuous movement of the planets and the other stars, the world of the elements and all its contents are continuously moved into a different condition, coming into being in accordance with the exigencies of the harmony of the moment, although as far as concerns the human senses certain aspects of the world seem permanent. [...] It is clear, therefore, that all the different places and times constitute different individuals in this world and that this is the work of the celestial harmony through the rays it projects, which change continuously, a fact that is also manifest to the senses with regard to this and other phenomena. [...] Therefore the diversity of things that appear in the world of elements in any given moment proceeds mainly from two causes: the diversity of matter and the different action of the stellar rays. Since the disparity affecting [the various forms of] matter may vary greatly, different things are produced in the various places and times. Hence we find that some things differ in genus, others in species, and others again only in number.

3. Light, Wealth, and Poverty

The concept of *claritas* is underpinned by more than just philosophical reasons. Medieval society was made up of the rich and powerful, and the poor and the underprivileged. Although this is not a characteristic of Medieval society alone, in the societies of Antiquity and the Middle Ages in particular the difference between the rich and poor was more marked than it is in modern western and democratic societies, also because in a society with scant resources and a system of trade based on barter, periodically scourged by endemic plagues and famines, power finds its exemplary manifestation in arms, armor, and sumptuous clothing.

In order to manifest their power, Medieval nobles adorned themselves

Limbourg Brothers,
May, from the *Très riches heures du Duc de Berry,*
1411-1416.
Chantilly, Musée Condé

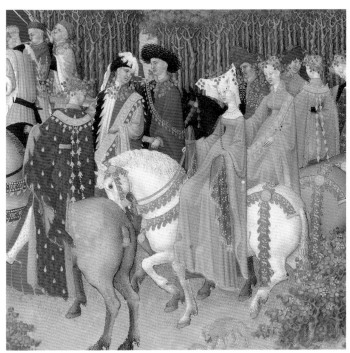

with gold and jewels and wore **clothing** dyed with the most precious colors, like **purple**. Artificial colors derived from minerals or vegetables thus represented wealth, while the poor wore only fabrics in drab and modest colors. It was normal for a peasant to wear gray or brown clothes made of rough natural fabrics, not dyed, threadbare, and almost always dirty. A green or red surcoat, not to mention an ornament made of gold or **precious stones** (which were often what we would now call hard stones, like agate or onyx), were rare and admirable things. The richness of **colors** and the splendor of the **gems** were marks of power, and thus objects of desire and marvel.

And since even the castles of the period, which we are by now accustomed to see as fabulous turreted affairs thanks to Romantic and Disneyesque transformations, were in reality crude strongholds— sometimes even made of wood—at the center of a defensive bailey, poets and travelers dreamed of splendid castles of marble and gemstones. They invented them, as St. Brendan and Mandeville did in the course of their travels, and sometimes perhaps they really did see them but described them as they ought to have been in order to be beautiful, as Marco Polo did.

To understand how expensive dyestuffs were, just think of the work required for the production of illuminated texts and for the manufacture of

Clothing
Jean de Meung and Guillaume de Lorris (thirteenth century)
Le Roman de la rose, vol. 1, vv 1051-1097
Wealth wears purple and gold. This outfit is worth a fortune. Now I'm no sycophant and I can't tell tall stories or lies. In fact, I confound all liars, but I never saw an outfit like this in all my life. The red suit with fringes all over and studded with scenes in gold and glittering gems: stories of dukes and sovereigns. The neckline is adorned, I see, and richly too, with a gold-inlay border: enamel and niello work. Enhanced by this, the fabric sparkles and glitters. Oh so very many marvelous things, I can assure you: precious stones, pearls, rubies, amber, diamonds. Lights and reflections that all but dazzle you. All is of fine, rare workmanship. The waist is clasped tight by a belt, also splendid and really elegant, very grand. I look at the buckle: a stone masterfully cut and faceted. This not merely precious, as it should be, but also has virtue. Yes, I mean to say, the possessor may live tranquilly, without the fear of being poisoned one day: he is protected, insured, be he prince or emperor. This is a stone of great value and it's worth more to the powerful than all the gold of Rome. Mordant stones are a different matter for they cure toothache, and if you look at them for a few minutes your missing teeth will grow in again. The big heavy studs are of gold and each one must be worth one

bezant. A pretty circlet of spun gold holds the hair in place. I have introduced you to Dame Riches, gold and splendor.

Purple
Chrétien de Troyes (twelfth century)
Erec et Enide, vv. 1583-1617
He who received the order bore the mantle and the tunic, which was lined with white ermine as far as the sleeves; at the cuffs and neck, so that nothing might be concealed, there were over a hundred marks in beaten gold, with stones of the greatest power, violet and green, turquoise and amber, set all over the golden surface … There was an ounce of gold in the buckles; on the one side there was a hyacinth, and on the other a ruby that glowed with greater radiance than a carbuncle. The lining was of white ermine, the finest and most beautiful you could see. The purple robe was cunningly worked with little crosses in various colors, violet and vermilion and turquoise, white and green, violet and yellow.

Precious Stones
Unknown (fourteenth century)
The Este Lapidary
Let us also say that stones adorn vases and instruments and likewise apparel and that they aid those who carry them, as is convenient, in many perilous situations, and thus they procure many benefits.
Hence the nobles and the wealthy seek them

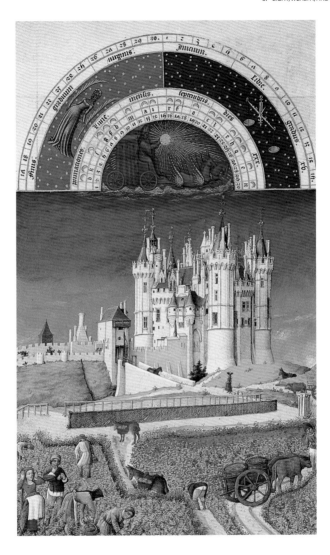

Limbourg Brothers,
September,
from the *Très riches
heures du Duc de Berry,*
1411-1416.
Chantilly, Musée Condé

vivid and brilliant colors, as is borne out by works like the *Schedula diversarum artium* of Theophilus, or the *De arti illuminandi* written by an unknown author of the fourteenth century. On the other hand the underprivileged, whose lot was to live in a natural environment that was certainly harsher and tougher, but more wholesome than it is today, could enjoy only the spectacle of nature, the sky, sunlight and moonlight, and flowers. And hence it is natural that their instinctive concept of Beauty was closely linked with the variety of colors that nature offered them.

out and wear them for this purpose, although they do not serve as much as they think. And this comes about because they buy them without thinking and carry them on their person. And while these stones cannot serve for all things, they nonetheless have some efficacy, and precisely for this reason such people are honored, received, and appreciated; but sometimes these [stones] cannot really do what people believe them capable of, and while those who have doings with such people see the reasons for this want of success, they dare not tell them so out of great wickedness of heart.
Stones and the words said about them do all these things, for those who possess them.

Colors

Giovanni Boccaccio (1313-1375)
Filocolo, IV, 74,
This light came from above him, and on looking into it, he saw a woman of beauteous and gracious aspect, clothed in that same light, and in her hands she bore a small golden bottle, full of a most precious water with which it seemed to him that she washed his face and then all of his person, after which she immediately vanished: and as soon as this was done, he felt as if his sight had improved, and that he knew both worldly and divine things better than before, and likewise bitter things each to its due. And so, amazed by all this, he found himself among three women he did not know before, and with them he thought he glimpsed his own Biancifiore, which made him wondrously happy: of the three he could see, the apparel of one was of a crimson so intense that she seemed all ablaze, and the other wore a green to surpass any emerald, while the whiteness of the last outdid that of the snow.

Gems

Giacomo da Lentini (thirteenth century)
Nor Diamond, Nor Emerald, Or sapphire
Or any other precious stone;
Topaz or hyacinth or ruby,
Or the heliotrope, which certainly has much virtue;
Nor the amethyst, or the fine carbuncle,
That most resplendent thing,
Possess the beauty of my beloved.
With her joyous love,
She who in virtue surpasses all things
And resembles a star in her splendor
Is more beautiful than any rose or flower.
May the Lord Jesus give her life and gaiety,
And may her great esteem and honor increase.

Gran Kaan's Palace

Marco Polo (thirteenth century)
Travels, LXXI
In the middle of these circuits of walls rises the Great Kaan's palace, which is built as I shall tell you. It is the largest that was ever seen. Towards the north, it touches the last of the walls we have spoken of, but, on the south side, there is an empty space before it, where the barons and soldiers walk. It has no upper floor, but the basement is ten palms higher than the ground surroundings it, and the roof is surpassingly high. The inside walls of the halls and rooms are all covered with gold and silver, and on them are painted beautiful pictures of ladies and knights and dragons and beasts and birds and divers other things. The ceiling is also made in such a way that one sees nothing else on it, but pictures and gold. The great hall is so vast and large that quite six thousand men could banquet there. There are many rooms as to surpass all belief. The beauty and size of this palace are so great that no one on earth, who had the necessary skill, could have planned or built it better. The roof is varnished in vermillion, green, blue, yellow, and all other colours; and so well and cunningly is this done, that it glitters like crystal, and can be seen shining from a great way all round. And you must know that the roof is so strongly and firmly built that it lasts for years without number.
Moreover, behind the palace there are great houses, and halls, and rooms where the personal effects of the Kaan are kept, namely all this treasure—gold, silver, gems, and pearls, and gold and silver dishes; and there his ladies and concubines live; and there, too, he has all things done for his personal convenience. And no one may enter that place. The space between the two walls is all full of these fine beasts, with the sole exception of the roads along which the people pass.

Illumination

Unknown (fourteenth century)
De arte illuminandi, I
I intend to describe, first of all without any contention, but in a friendly way and in a simple form, some things about the art of illuminating books with both pen and paintbrush; and although this has been divulged before by many writers, nonetheless, in order to clarify the most expeditious and rational processes, so that the experts may find their opinions corroborated and go on to greater things, while the unskilled, desirous of learning this art, may easily and clearly understand and practice it, I shall give a

succinct explanation of the colors and the various methods of mixing them, concentrating on those things that have been tried and tested and are thus acknowledged to be good.

According to Pliny, there are three principal colors, that is to say black, white, and red; all the others are thus intermediate shades of these three, as is defined in the books of all the learned doctors, etc. There are eight colors most naturally necessary for illumination, namely black, white, red, yellow, light blue, violet, pink, and green. Some of these are natural, others artificial. The natural ones include ultramarine blue and Prussian blue. The color black is a certain black earth or natural stone; red is also a certain red earth sometimes commonly called 'macra'; green or blue-green is earth, and yellow is yellow earth, or orpiment, or fine gold, or saffron.

All the other colors are artificial: the black made from grapevine charcoal, or with the smoke from wax or oil candles, or from cuttlefish [ink] collected in a basin or a glazed bowl. Reds such as vermilion, which is obtained from sulfur and quicksilver, and minium known as "stoppio," which is made from lead; white extracted from lead, that is to say from ceruse or from the incinerated carcasses of dead animals […] The binding medium used to fix gold on parchment is made in many ways. I shall deal with only one of these, however, an excellent tried and tested method. Take, then, some of that baked and purged fine chalk that painters use to fix oils on the canvas, and a fourth part of high quality Armenian bole: grind it up on a porphyry slab with clear water until it is completely pulverized; then, leave it to dry on the aforesaid slab, take the quantity you wish, and put aside the remainder; grind it with water of animal glue or of parchment and add enough honey to sweeten it as much as necessary; in doing this you must be careful neither to add too much or too little, but in accordance with the quantity of material, so that when you put a tiny amount in your mouth, there should only be a hint of sweetness. And you can be sure that, for a small jar like the painters use, all you need is the quantity you can pick up with the tip of the paintbrush handle. Less than this would spoil the substance. When it is well ground, put it in a glazed jar and immediately cover it with crystal clear water, delicately, taking care not to mix the material again; and the substance will be instantly rectified thus

preventing the formation of blisters or cracks when it dries. And when you wish to use it, after a brief wait, remove the water covering it, without remixing the substance. Before fixing the binding medium at the exact point where you want to work on the parchment you should always test it on a similar parchment to see if it has been well mixed; once it has dried, put a little gold over it and see if it burnishes well. If there is an excess of honey, you can remedy matters by taking the jar and pouring ordinary fresh water over the substance, without remixing. It will become better if it is kept for some time; then remove the water again, still without any shaking. And if you require a stronger mix, add more gum, that is to say sugar or honey water, according to requirements and as you please. And since in these matters practice is better than theory, thus I shall not trouble to explain my knowledge in detail: "a word is enough to the wise."

The Beauty of Nature
Dante Alighieri (1265-1321)
Purgatorio VII, vv. 70-78
Twixt hill and plain there was a winding path
Which led us to the margin of that dell,
Where dies the border more than half away
Gold and fine silver, and scarlet and pearl-white,
The Indian wood resplendent and serene,
Fresh emerald the moment it is broken,
By herbage and by flowers within that hollow
Planted, each one in colour would be vanquished,
As by its greater vanquished is the less.

A White Deer
Francesco Petrarch (1335-1374)
Canzoniere, CXC
A white doe appeared before me
On the greensward, with horns of gold,
Between two river banks, in the shade of a laurel tree
As the sun rose over the springtime.
She looked so sweetly proud,
That I left all my toil to follow her:
As the miser whose delight in seeking treasure
Assuages all his pains.
Around her fair neck was writ in diamond and topaz
"Touch me not, for Caesar wills my freedom"
The sun was already nearing the noonday peak,
And my eyes were weary from gazing, but not sated
When I fell into the water, and she vanished.

109

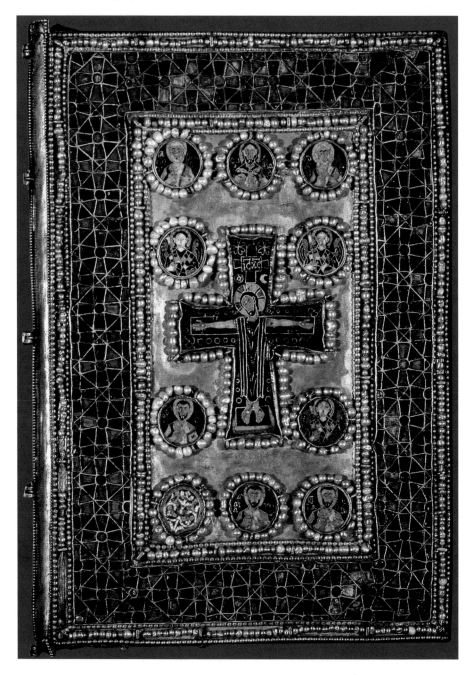

4. Ornamentation

One of the first documents concerned with the Medieval sense of color is to be found in a work, written in the seventh century, which was to have a remarkable influence on successive civilization, the *Etymologies* of Isidore of Seville. In Isidore's view, the purpose of some things in the **human body** is utility, while that of others is *decus*, that is to say ornamentation, beauty, and pleasure. Later authors, like Thomas Aquinas for example, thought that a thing was beautiful provided that it was suited to its function, in the sense that a mutilated body—or an excessively small one—or an object incapable of correctly performing the function for which it was conceived (like a crystal hammer for example) was to be considered ugly even if produced with valuable materials. But let us accept Isidore's distinction between useful and beautiful: just as the decoration of a façade adds Beauty to buildings and rhetorical decoration adds Beauty to discourses, so does the

opposite
Binding of an evangeliarium, front cover, Cod. Marc. Lat. I, 101, ninth century. Venice, Biblioteca Nazionale Marciana

Ark of San Calmin, eleventh-twelfth century. Mozac, near Riom, Abbey church of St. Pierre

The Human Body
Isidore of Seville (560-636)
Etymologies, XI, 25
In our body some things are made for a useful purpose, like the bowels; others both for usefulness and Beauty, like the face, and the feet, and the hands, members of great usefulness and of most comely aspect. Others are made only for ornament, like the nipples of men and the navel in both sexes. Some are made for discretion, such as the genitalia, flowing beards, and broad chests of men, and the delicate gums, small breasts, and wide child-bearing hips of women.

111

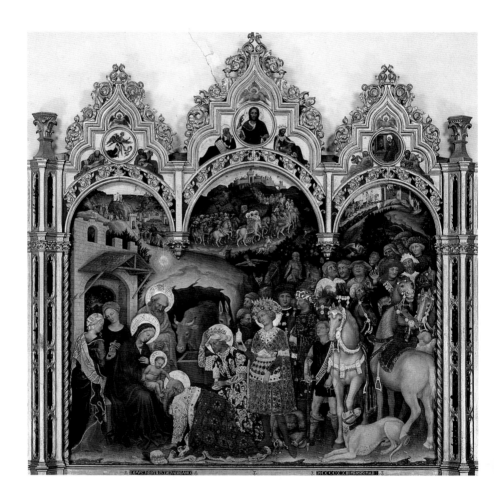

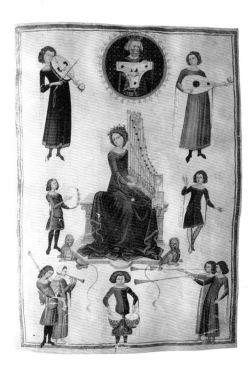

opposite
Gentile da Fabriano,
The Adoration of the Magi,
1423.
Florence, Galleria
degli Uffizi

Illuminator
of the Anjou court,
Music and Its Connoisseurs,
from Boethius,
De arythmetica,
de musica,
fourteenth century.
Naples, Biblioteca
Nazionale

human body appear beautiful thanks to natural ornaments (the navel, the gums, the breasts), as well as artificial ones (clothing and jewelry).

Among ornaments in general the fundamental ones are those based on light and color: marble is beautiful because of its whiteness, and metals for the light that they reflect. The air itself is beautiful, because *aes-aeris* (states Isidore with his highly debatable etymological technique) is thus called for the splendor of *aurum*, i.e., gold. Precious stones are beautiful because of their color, and color is simply captured sunlight and purified matter.

The eyes are beautiful if they are bright and the most beautiful of all are blue-green eyes. One of the prime qualities of a beautiful body is pink skin and, according to Isidore the etymologist, the word *venustas*, "physical Beauty," comes from *venis*, i.e., the blood, while *formosus*, "beautiful," derives from *formo*, which is the heat that moves the blood; from *sangue* (blood) also comes *sanus*, said of those whose complexion was not pale, but healthily pink. Furthermore, Isidore says that the expression *delicatus* (delicate), when used to describe a person's aspect, derives from the *deliciae* (delicacies) served with a good meal and he even hazards a classification of the character of some peoples based on the way they lived and fed, still employing far-fetched etymologies. Hence the Gauls, whose name allegedly derived from *gala*, "milk" in Greek, on account of the whiteness of their skins, were ferocious because of the climate in which they lived.

5. Color in Poetry and Mysticism

In poetry this sense of brilliant color is ever present: grass is green, blood is red, milk is pure white. Superlatives exist for every color (like *praerubicunda* for roses) and a single color has many shades, but no color fades away in zones of shadow. We might quote Dante's "sweet color of **oriental sapphire**," or Guinizzelli's "snow-white countenance tinted in carmine," or the sword Durandal in the *Song of Roland* that glittered "clère et blanche" in the sunlight. In Dante's *Paradiso* we find **luminous visions** like "flames magnificent may follow from one spark's first feebleness," or "Then, as they cried, a further brilliance came, faint at the first, as comes at evenfall." The mystical pages of St. Hildegard of Bingen contain visions of **coruscating flame.** In describing the Beauty of the first angel, Hildegard talks of a Lucifer

St. Hildegard of Bingen, *The Creation with the Universe and the Cosmic Man,* from *Revelationes,* c. 1230.
Lucca, Biblioteca Statale (Governativa)

The Oriental Sapphire
Dante Alighieri (1265-1321)
Purgatorio, I, vv. 13-24
Sweet color of the oriental sapphire,
That was upgathered in the cloudless aspect
Of the pure air, as far as the first circle,
Unto mine eyes did recommence delight
Soon as I issued forth from the dead air,
Which had with sadness filled mine eyes and breast.
The beauteous planet, that to love incites,
Was making all the orient to laugh,
Veiling the Fishes that were in her escort.
To the right hand I turned, and fixed my mind
Upon the other pole, and saw four stars
Ne'er seen before save by the primal people.

Luminous Visions
Dante Alighieri (1265-1321)
Paradiso, XIV, vv. 67-75
And lo! all round about of equal brightness
Arose a lustre over what was there,
Like an horizon that is clearing up.
And as at rise of early eve begin
Along the welkin new appearances,
So that the sight seems real and unreal,
It seemed to me that new subsistences
Began there to be seen, and make a circle
Outside the other two circumferences.

O very sparkling of the Holy Spirit,
How sudden and incandescent.

Coruscating Flame
St. Hildegard of Bingen (1098-1179)
Liber Scivias, II, vision 2
Then I saw a bright light, and in this light the figure of a man the color of a sapphire, which was all blazing with a gentle glowing fire. And that bright light bathed the whole of the glowing fire, and the glowing fire bathed the bright light, and the bright light and the glowing fire poured over the whole human figure, so that the three were one light in one power of potential.
And again I heard the living Light, saying to me: "This is the perception of God's mysteries, whereby it can be distinctly perceived and understood what is that Fullness, Whose origin was never seen, and in Which that lofty strength never fails that founded all the sources of strength. For if the Lord were empty of His own vitality, what then would have been His deeds? And therefore in the whole work it is perceived Who the Maker is. Therefore you see a bright light, which without any flaw of illusion, deficiency, or deception, designates the Father; and in this light the figure of a man the color of a

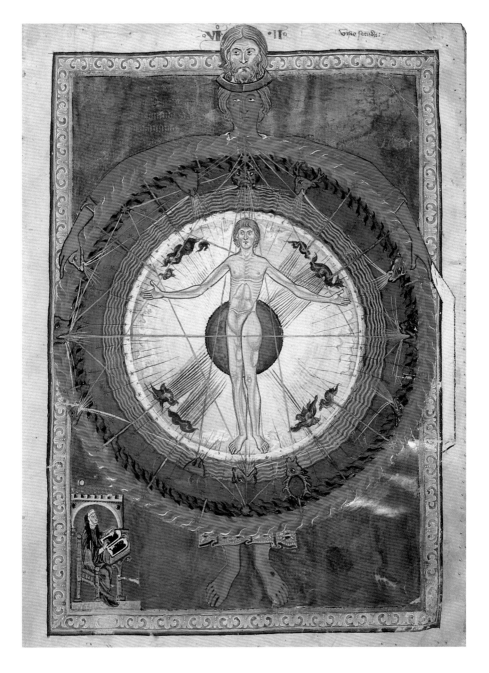

Tree of Jesse,
stained-glass window
on the right of the Royal
Portal, twelfth century.
Chartres, Cathedral of
Nôtre-Dame

(before the Fall) adorned with gems that sparkled like a starry sky, so that the countless glittering beams that shone out from the splendor of all his ornaments flooded the world with light (*Liber divinorum operum*).

Indeed, it is in the Middle Ages that we find the figurative technique that best exploits the vividness of simple color allied to the vividness of the light that permeates it: the stained-glass windows of Gothic cathedrals. Gothic churches are swept by blades of light that penetrate from the windows, but are filtered by stained glass elements connected by lead strips. These were already present in Romanesque churches, but with the advent of the Gothic style the walls became higher and came together in the ogival vault.

The space for stained-glass windows and rose windows was increased and the walls, thus pierced, were supported more by the counter-thrust of the flying buttresses. The cathedral was built specifically to enhance the effects of the light that flooded in through a tracery of structures.

Archbishop Suger, who, for the greater glory of the faith and of the kings of France, designed the Abbey of Saint Denis (initially in the Romanesque style) tells us how this spectacle entranced Medieval men and women. Suger describes his church in highly emotive tones, thrilled both by the Beauty of the treasures it contained, and by the play of light entering by the windows.

sapphire, which without any flaw or obstinacy, envy, or iniquity designates the Son, Who was begotten of the Father in Divinity before time began, and then within time was incarnate in the world in Humanity; which is all blazing with a gentle glowing fire, which fire without any flaw or aridity, mortality, or darkness designates the Holy Spirit, by Whom the Only-Begotten of God was conceived in the flesh and born of the Virgin within time and poured the true light into the world. And that bright light bathes all of the glowing fire, and the glowing fire bathes the bright light; and the bright light and the glowing fire pour over the whole human figure, so that the three are one light in one power of potential. And this means that the Father, Who is Justice, is not without the Son or the Holy Spirit; and the Holy Spirit, Who kindles the heart of the faithful, is not without the Father or the Son; and the Son, Who is the plenitude of fruition, is not without the Father or the Holy Spirit: they are inseparable in Divine Majesty." […]

As the flame has three qualities, so there is one God in three Persons. How? A flame is made up of brilliant light and red power and fiery heat. It has brilliant light that it may shine, and red power that it may endure, and fiery heat that it may burn. Therefore, by the brilliant light understand the Father, Who with paternal love opens His brightness to His faithful; and by the red power which is in the flame that it may be strong, understand the Son, Who took on a body born from a Virgin, in which His divine wonders were shown; and by the fiery heat understand the Holy Spirit, Who burns ardently in the minds of the faithful. But there is no flame seen where there is neither brilliant light nor red power nor fiery heat; and thus also where neither the Father nor the Son nor the Holy Spirit is known God is not properly worshipped. Therefore as these three qualities are found in one flame, so Three Persons must be understood in Unity of the Divinity.

6. Color in Everyday Life

This taste for color was manifested in fields other than art, namely in life and in everyday habits, in dress, in decorations, and in weapons. In his fascinating analysis of late Medieval tastes in colors (*The Waning of the Middle Ages*), Huizinga mentions the enthusiasm of the chronicler Froissart for "ships with their fluttering flags and pennants and the colorful coats of arms glittering in the sun. Or the play of the sunlight on the helmets, armor, spear points, plumes, and standards of knights on the march." Then there are the color preferences mentioned in the *Blason des couleurs*, where the author praises the combinations of pale yellow and azure, orange and white, orange and pink, pink and white, and black and white; and the representation described by La Marche, in which a damsel dressed in purple silk appears on a mule caparisoned in light-blue silk, led by three men dressed in vermilion silk with green cloaks in the same material.

Limbourg Brothers, *January*, from the *Très riches heures du Duc de Berry*, 1411-1416. Chantilly, Musée Condé

opposite
Limbourg Brothers, *April*, from the *Très riches heures du Duc de Berry*, 1411-1416. Chantilly, Musée Condé

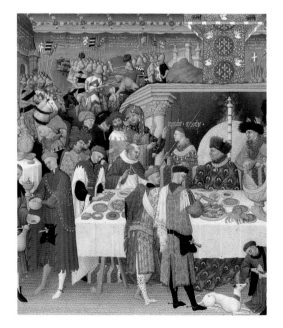

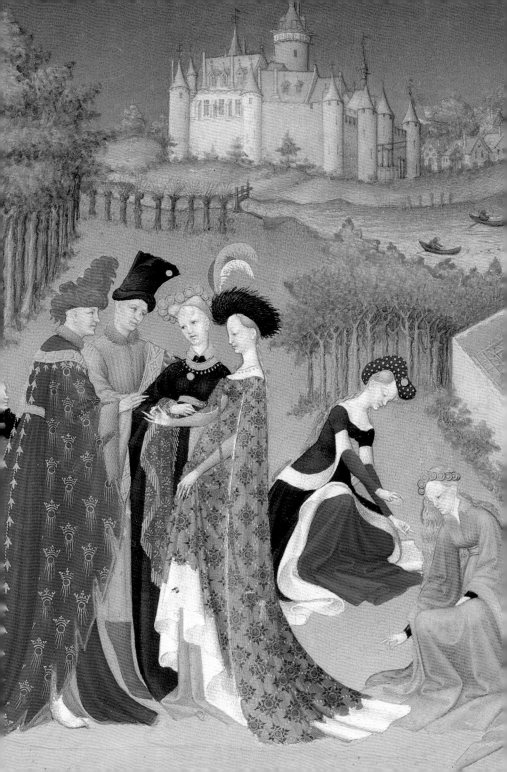

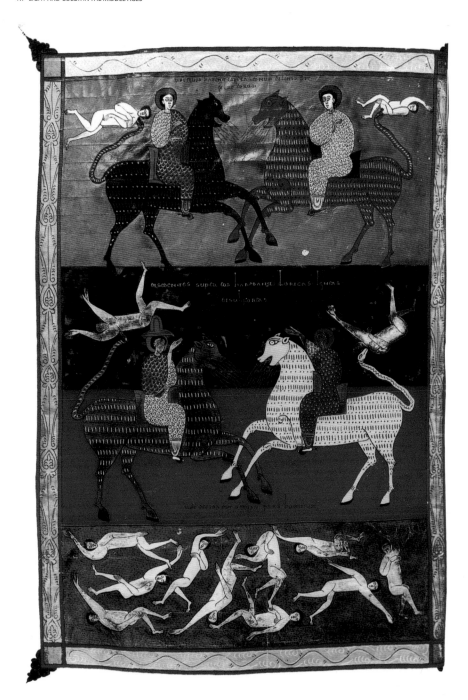

7. The Symbolism of Color

Medieval man firmly believed that everything in the universe had a supernatural significance, and that the world was like a book written by the finger of God. Every animal had a moral or mystical significance, as did every stone and every plant (and this is recounted in the bestiaries, lapidaries, and the herbals). Hence there was a tendency to attribute positive or negative significance to colors too, despite the fact that scholars occasionally disagree on the significance of a given color. This happened for two reasons: in the first place because in Mediev-al symbolism one thing could have two opposite meanings depending on the context in which it was seen (and thus the lion sometimes symbolized Christ and sometimes the Devil); and in the second place because the Middle Ages lasted almost ten centuries, and over such a long period of time changes occurred in taste and persuasions regarding the significance of colors. It has been observed that in the early centuries blue, together with green, was a color held in low esteem, probably because of the fact that at first it had proved im-possible to obtain vivid and brilliant shades of blue, with the result that clothes of this color looked drab and dull.

opposite
Riders on Lion-Headed
Horses Vomiting Fire,
from the *Commentary on*
the Apocalypse of Beatus of
Liébana, Beatus of
Ferdinand I and Queen
Sancha, MS. Vit. 14-2,
eleventh century,
Madrid, Biblioteca Nacional

Lombard illuminator,
illumination from
Historia plantarium,
fourteenth century.
Rome, Biblioteca
Casanatense

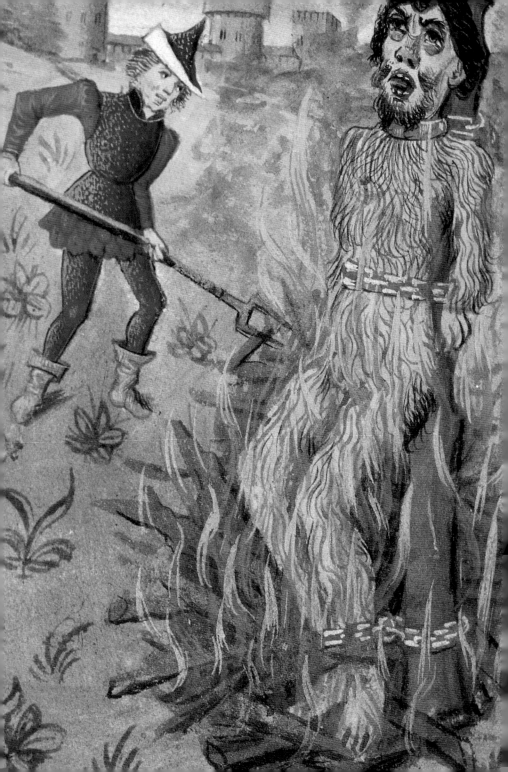

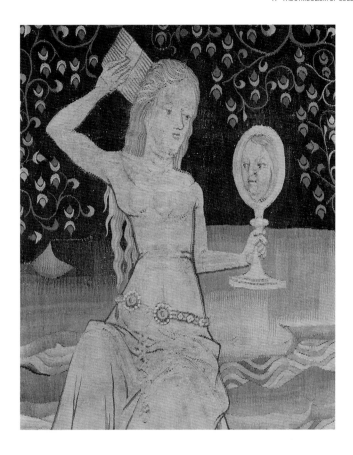

But from the twelfth century onward blue became a prized color: it suffices to think of the mystical value and the aesthetic splendor of the blue used in the stained-glass windows of cathedrals, which dominates the other colors and contributes to filtering the light in a "celestial" manner. In certain periods and in certain places black was a regal color, in others it was the color of mysterious knights who concealed their identities. It has been noted that in the romances of the Arthurian cycle red-haired knights are cruel, traitorous knaves, while some centuries previously Isidore of Seville thought that of all the hair colors blond and red were the finest.

In the same way red surcoats and caparisons expressed courage and nobility, despite the fact that red was also the color of executioners and harlots. Yellow was considered the color of cowardice and was associated with pariahs and social outcasts, the insane, Muslims, and Jews; nevertheless it was also celebrated as the color of gold, seen as the brightest and most precious of metals.

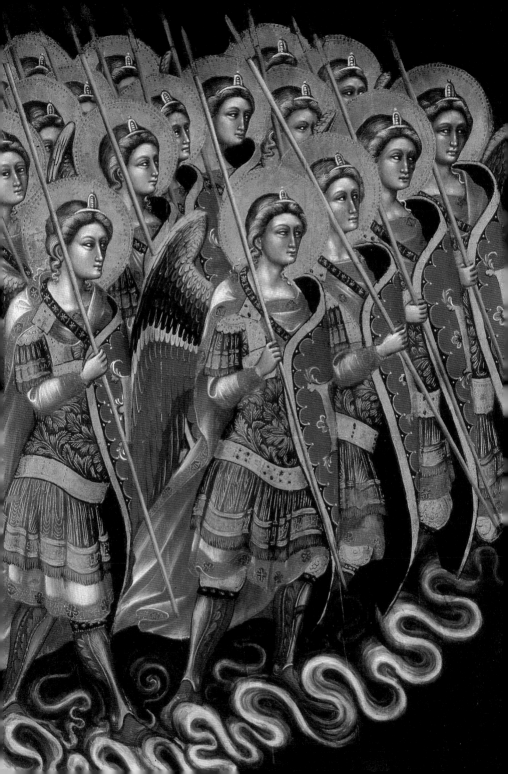

8. Theologians and Philosophers

These references to the tastes of the epoch are necessary in order to understand the full import of theoretical observations on **color as the cause of Beauty**. If these widespread tastes are not borne in mind, then remarks like those made by Thomas Aquinas (*Summa theologicae*, I, 39, 8), according to whom beauty is associated with brightly colored things, would risk seeming superficial. Yet it is precisely in cases like this that theorists were influenced by common sensibilities. In this sense Hugh of Saint Victor (*De tribus diebus*) praises the **color green** as the most beautiful of all, symbol of springtime, image of future rebirth (in which the mystical reference does not cancel out the gratification of the senses), while the same marked preference was shown by William of Auvergne, who backed up his point of view with arguments based on psychological grounds, in the sense that green was allegedly midway between white, which dilates the pupil, and black, which contracts it. We are in the century in which Roger Bacon was proclaiming that optics was the new science destined to solve all problems. Scientific speculation on light came to the Middle Ages by way of *De aspectibus* or *Perspectiva*, written by the Arab Alhazen between the tenth and eleventh centuries, a work taken up again in the twelfth century by Vitellione in his *De perspectiva*. In the *Roman de la rose*, the allegorical summa of the most progressive branch of Scholasticism, Jean de Meung, speaking through the mouth of Nature, expatiates at length on the marvels of the rainbow and the

opposite
Guariento di Arpo,
Ranks of Armed Angels,
c. 1360.
Padua, Museo Civico

Color as the Cause of Beauty
Hugh of Saint Victor (twelfth century)
Eruditionis didascaliae, XII
With regard to the color of things there is no need for lengthy discussion, since sight itself demonstrates how much Beauty it adds to nature, when this last is adorned by many different colors. What is more beautiful than the light, although colorless in itself, that none the less brings out the color in all things, by illuminating them? What is more pleasing than the sight of the sky when it is serene and sparkles like sapphire and with the most pleasing proportions of its splendor attracts and delights the eye? The sun shines like gold, the moon is pale as amber, some stars burn like flames, others palpitate with a rosy light, others

again emit from time to time a brilliance that varies from pink to green and white.

The Color Green
Hugh of Saint Victor (twelfth century)
Eruditionis didascaliae, XII
The color green surpasses all other colors for Beauty and ravishes the souls of those who look upon it; when in the fresh springtime the buds open to new life and, reaching upward with their pointed leaves, almost thrusting death downward in an image of the future resurrection, all rise up together toward the light. What more can we say of the works of God, when we so admire even false imitations of them, fruit of the human mind, which deceive the eyes?

miracle of curved **mirrors,** in which dwarfs and giants find their respective proportions reversed and their figures distorted or turned upside down. Medieval man was aware that the qualitative concept of Beauty was not compatible with its proportional definition. As long as pleasing colors were appreciated without critical pretensions and as long as use was made of metaphors within the ambit of a mystical discourse or of vague cosmologies, a glaring contradiction of this sort might well have passed unnoticed. But the Scholastic movement of the thirteenth century was to address this problem too.

At this point we ought to consider **the cosmology of light** proposed by Robert Grosseteste. In the commentary to the *Hexaémeron* he tries to resolve the contrast between qualitative and quantitative principles, and he defines light as the maximum expression of proportion, since it is identity. And, as identity is proportion *par excellence*, this therefore justifies the undivided Beauty of the Creator as the source of light, given that God, who is supremely simple, is the greatest harmony and **proportion unto itself.** Grosseteste's Neoplatonic approach led him to conceive an image of the universe formed by a single flux of luminous energy that was at once the source of Beauty and Being. Through a progressive process of rarefaction and condensation, the heavenly bodies and the natural zone of the elements derive from this single light. The proportion of the world, therefore, is the mathematical order in which light, in its creative diffusion, materializes according to the various resistances imposed by matter (cf. Chapter III). As a whole, the concept of creation emerges as a concept of Beauty, both for its proportions and for the immediate effect of light, which is *maxime pulchrificativa.*

Mirrors
Jean de Meung and Guillaume de Lorris
(thirteenth century)
Le Roman de la rose, vv. 18123-18146
To get back to mirrors: some make a large, close thing seem tiny and distant, even if it were that mountain between France and Cerdagna. When you hold a mirror up to it, it suddenly becomes very small, so that even if you gaze at it intensely you can barely see it. Other mirrors show the true dimensions of objects. If you look into a normal mirror you see things as they are, real. I know of others again in which objects burn, but only when you place them right where the sun's rays are all reflected and trained on that point. Then all seems ablaze. Some [mirrors] form many quite different figures: single or doubled and sometimes quadrupled, prone, supine, shortened, lengthened. They make one figure a hundred.

The Cosmology of Light
Robert Grosseteste
(twelfth-thirteenth century)

Commentary on the Divine Names, VII
This good in itself is praised by the holy theologians, as is the Beautiful and Beauty […]. Now Beauty is harmony and proportion of itself unto itself and of all the single parts unto itself and among them and is the harmony of all, and entirely the same to all things. Now, God, who is supremely simple, is the greatest harmony and proportion, without any possibility of dissonance or discrepancy, not only in harmony with all things, but also the source of the harmony of being for all things. For evil, which is in disharmony with goodness, is nothing. Thus God is Beauty and Beautiful in Himself.

Proportion unto Itself
Robert Grosseteste
(twelfth-thirteenth century)
Commentary on the Hexaémeron
John Damascene says: "if you take away the light all things remain unknown in the shadows, since they cannot manifest their own Beauty." Light, therefore, is "the Beauty and the order of all visible creatures." And, as

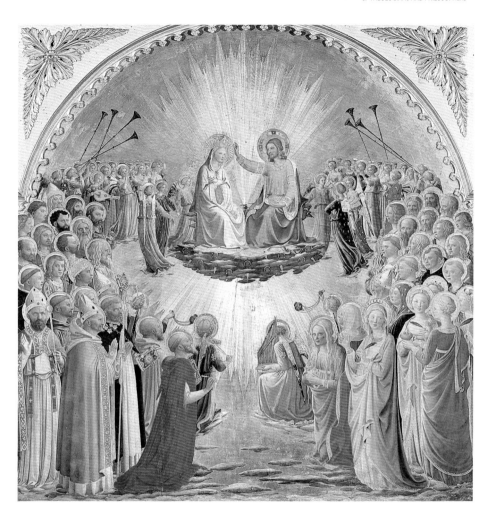

Fra Angelico,
The Coronation of the Virgin,
c. 1435.
Florence, Galleria degli
Uffizi

Basil says: "this nature is created in such a manner that there can be nothing more pleasing to the thoughts of the mortals who enjoy it. The first word of God created nature from light and dispelled darkness and sorrow, instantly making all species happy and joyful." Light is beautiful in itself, since "its nature is simple, and it has in itself all things together." Hence it is above all unity and proportion unto itself in a most harmonious way by virtue of likeness; but the harmony of proportions is Beauty. Hence, even without the harmonious proportion of corporeal forms, light is beautiful and most pleasing to the eye. Thus the golden Beauty of the light is beautiful for its scintillating radiance and the stars appear most beautiful to the sight, even though we cannot see any Beauty deriving from the composition of the parts or from the proportions of the figure, but only the Beauty that derives from the splendor of the light. For, as Ambrose says: "the nature of light is such that its graces do not consist in number, measure, or weight, as it is with other things, but in its aspect. It is light itself that makes the other parts of the world worthy of praise."

127

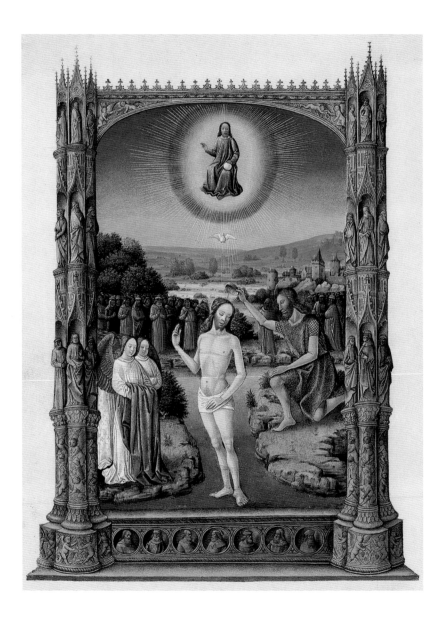

Bonaventure of Bagnoregio takes up a **metaphysics of light** in Aristotelian terms. In his view, light is the **substantial form** of bodies. In this sense light is the principle of all Beauty. Light is *maxime delectabilis* because it is through this medium that we have the creation of the range and variety of colors and of luminosity, on earth and in the heavens. Light can be considered from three points of view. As *lux* it is considered in itself, as pure diffusion of creative force and the origin of all movement; from this standpoint it penetrates even into the bowels of the earth forming therein minerals and the seeds of life, conferring upon stones and minerals that *virtue of the stars*. As *lumen* it possesses *luminous being* and is conveyed by transparent means through space. As *color* or *splendor* it appears reflected by the opaque body that it strikes. Visible color basically comes into being when two lights meet, in other words when the light irradiated through diaphanous space brings to life the light incorporated in the opaque body. Bonaventure is inclined to emphasize the cosmic and ecstatic aspects of an aesthetics of light. The finest pages on Beauty are in fact those in which he describes the beatific vision and celestial glory: in the body of the individual regenerated in the resurrection of the flesh, light will shine out in its four fundamental qualities: *claritas,* which illuminates; invulnerability, which means that nothing can corrupt it; agility; and penetrability.

Thomas Aquinas held that light was to be reduced to an active quality that ensues from the substantial form of the sun and that finds in the diaphanous body a preparedness to receive and transmit it. This *affectus lucis in diaphano* is called *lumen*. For Bonaventure, therefore, light was fundamentally a metaphysical reality, while for Aquinas it was a physical reality. Merely by reflecting upon these philosophical speculations, it is possible to understand the significance of light in Dante's *Paradiso*.

Limbourg Brothers,
The Baptism of Christ,
from the *Très riches heures
du Duc de Berry,*
1411-1416.
Chantilly, Musée Condé.

The Metaphysics of Light
Bonaventure of Bagnoregio (1217-1274)
Sermons, VI
What a splendor there will be when the light of the eternal sun shall illuminate the souls in glory … An extraordinary joy cannot be concealed, if it break out in delight or in rejoicing and song for all those for whom the kingdom of heaven will come.

Substantial Form
Bonaventure of Bagnoregio (1217-1274)
Commentary on the Four Books of Sentences, II, 12, 1; II, 13, 2
Light is the common nature found in all bodies, be they celestial or of this world. […] Light is the substantial form of bodies and, as far as bodies partake of it, they possess being.

Dante and Light
Dante Alighieri (1265-1321)
Paradiso, XXX, vv. 97-120

O splendor of God! by means of which I saw
The lofty triumph of the realm veracious,
Give me the power to say how it I saw!
There is a light above, which visible
Makes the Creator unto every creature,
Who only in beholding Him has peace,
And it expands itself in circular form
To such extent, that its circumference
Would be too large a girdle for the sun.
The semblance of it is all made of rays
Reflected from the top of Primal Motion,
Which takes therefrom vitality and power
And as a hill in water at its base
Mirrors itself, as if to see its beauty
When affluent most in verdure and in flowers,
So, ranged aloft all round about the light,
Mirrored I saw in more ranks than a thousand
All who above there have from us returned
And if the lowest row collect within it
So great a light, how vast the amplitude
Is of this Rose in its extremest leaves!

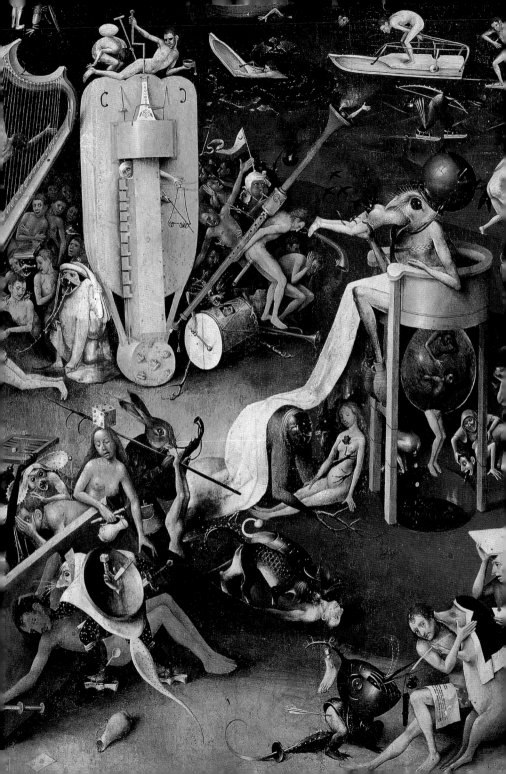

The Beauty of Monsters

1. A Beautiful Portrayal of Ugliness

Every culture has always accompanied its own concept of Beauty with its own idea of Ugliness, even though—in the case of archaeological finds—it is hard to establish whether the thing portrayed was really considered ugly or not: to Western eyes, certain fetishes and certain masks from other cultures seem to represent horrible or deformed creatures, while for natives they can be or could have been portrayals of positive values.

Greek mythology possesses a wealth of creatures like fauns, Cyclopes, chimeras, and minotaurs, or divinities like Priapus, considered monstrous and extraneous to the canons of Beauty as expressed in the statuary of Polyclitus or Praxiteles; nonetheless, the attitude toward these entities was

opposite
Hieronymus Bosch,
The Garden of Earthly Delights, detail of *Hell*,
c.1506.
Madrid,
Museo del Prado

Antefix in the shape
of a gorgon's head
from Santa Maria
Capua Vetere,
fourth century BC.
Naples, Museo
Archeologico Nazionale

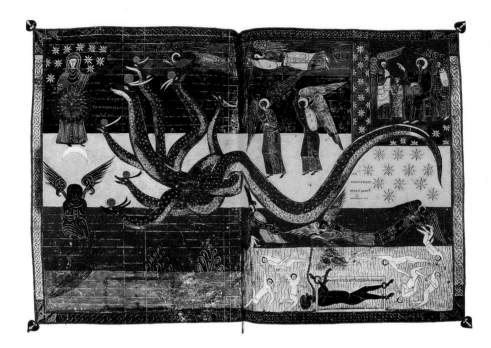

Struggle among the Dragon, the Woman, Her Son, the Archangel Michael, and His Angels, from the *Commentary on the Apocalypse of Beatus of Liébana*, *Beatus* of Ferdinand I and Queen Sancha, MS. Vit. 14-2, eleventh century. Madrid, Biblioteca Nacional

Socrates as Silenus

Plato (fifth-fourth century BC)
Symposium, 215-222
I say, that he is exactly like the busts of Silenus, which are set up in the statuaries' shops, holding pipes and flutes in their mouths; and they are made to open in the middle, and have images of gods inside them. I say also that he is like Marsyas the satyr. You yourself will not deny, Socrates, that your face is like that of a satyr. […] See you how fond Socrates is of the fair? He is always with them and is always being smitten by them, and then again he knows nothing and is ignorant of all things—such is the appearance which he puts on. Is he not like a Silenus in this? To be sure he is: his outer mask is the carved head of the Silenus; but, O my companions in drink, when he is opened, what temperance there is residing within!

Lack

William of Auvergne (thirteenth century)
Tractatus de bono et malo
We would say that a man with three eyes or a man with only one eye is physically displeasing; the former for having that which is improper, the latter for not having what is fit and suitable …

Beautiful Representation of the Devil

Bonaventure of Bagnoregio (1217-1274)
Commentary on the Four Books of Sentences, I, 31, 2
The Beauty of the image or the painting refers to its model in a manner that is not worthy of veneration in itself, as when the image of the Blessed Nicholas is venerated; but Beauty refers to the model in such a way that it is to be found in the image too, and not solely in the subject it represents. Thus two modes of Beauty may be found in the image, although it is obvious that there is only one subject of the image. For it is clear that the image is called beautiful when it is well painted, and it is also called beautiful when it is a good representation of the person whose image it is. And that this is another cause of Beauty emerges from the fact that one [mode of Beauty] can be present in the absence of the other: which is precisely why we may say that the image of the devil is beautiful when it well represents the

not always one of repugnance. In his *Dialogues*, Plato frequently discusses Beauty and Ugliness, but faced with the moral greatness of **Socrates** he smiles at the latter's ill-favored appearance. Various aesthetic theories, from Antiquity to the Middle Ages, see Ugliness as the antithesis of Beauty, a discordance that breaks the rules of that proportion (cf. Chapter III) on which both physical and moral Beauty is based, or a **lack** of something that a creature should by nature possess. In any case a principle is admitted that is observed almost uniformly: although ugly creatures and things exist, art has the power to portray them in a beautiful way, and the Beauty of this imitation makes Ugliness acceptable. There is no lack of evidence regarding this concept, from Aristotle to Kant. If we go no farther than these reflections, the question is simple: the Ugliness that repels us in nature exists, but it becomes acceptable and even pleasurable in the art that expresses and shows "beautifully" the ugliness of Ugliness. But up to what point does a beautiful **representation of Ugliness** (or of monstrosity) lend it some degree of fascination? Medieval man had already set himself the problem of **a beautiful representation of the Devil,** a problem that was to resurface in all its intensity in the Romantic period.

It is no accident, in the late Classical period and above all in the Christian period, that the problem of Ugliness becomes more complex. Hegel puts this very well when he remarks that, with the advent of the Christian sensibility and of the art that conveyed it, central importance is reserved (especially as far as Christ and his persecutors are concerned) for pain, suffering, death, torture, Hell, and the physical deformations suffered both by victims and their tormentors.

turpitude of the devil and as a consequence of this aspect it [the image] is also repugnant.

The Representation of Ugliness
Immanuel Kant
Critique of Judgment, I, 2, 48, 1790
A natural beauty is a *beautiful thing;* artistic beauty is a *beautiful representation* of a thing. In order to appraise a beauty of nature, as such, I do not require any previous concept of what sort of thing the object is meant to be, i.e., I do not have to know its material finality (its end), for it is the form itself—and not knowledge of the end—that pleases us on its own account. But, however, if the object is presented as a product of art, and is as such to be defined as beautiful, then, given that art always presumes an end in the cause (and in its causality), we must first found our view on a concept of what the thing is intended to be. And, since the agreement of the manifold within a thing for its internal definition as an end constitutes the perfection of the thing, in any appraisal of the beauty of art the perfection of the thing must be also taken into account—an aspect that is wholly irrelevant when appraising a beauty of nature as such. It is true, especially when appraising animate objects of nature, e.g., men or horses, that objective finality is commonly taken into account in order to make a judgment of their beauty; but such judgments are no longer purely aesthetic, i.e., mere judgments of taste. Nature is no longer evaluated because it appears like art, but because it really *is* art, albeit of a superhuman sort; and the teleological judgment serves as a basis and condition of the aesthetic [judgment], which the latter must take into account. In such a case, when we say, for example, "There is a beautiful woman," what we are actually thinking is that nature has made her in such a way that her form is an excellent portrayal of the ends present in the female figure. For we must look beyond mere form to a concept if we are to enable the object to be thought of in such a way through a logically conditioned aesthetic judgment.

Fine art reveals its superiority in the beautiful descriptions it gives of things that in nature would be ugly or unpleasant. Even though they are evils, The Furies, diseases, war's

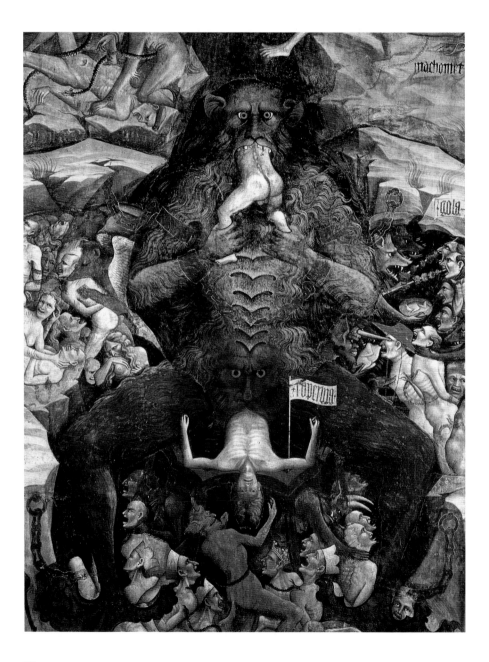

devastation, and so on can be very beautifully described, and even represented in pictures. Only one kind of ugliness can be represented in conformity with nature without destroying all aesthetic pleasure, and therefore artistic beauty: namely, that which arouses *disgust*. For, in this singular sensation that depends solely on the imagination, the object is represented as if—so to speak—our enjoyment of it were obligatory, while we reject it violently: thus, as far as our sensation is concerned, the artificial representation of the object may no longer be distinguished from the nature of the object itself, and hence it cannot possibly be considered beautiful.

The Representation of Suffering

Georg Wilhelm Friedrich Hegel
Aesthetics, III, 1, c, 1798-1800
The true critical point in this life of God is the one in which he abandons his individual existence as *this* man, the Passion, suffering on the cross, the Calvary of the spirit, the torments of death. Now, insofar as here it is implicit in the content itself that corporeal, outward appearance, immediate existence as an individual, is revealed by the pain of its own negativity as the negative, so that the spirit may attain its own truth and its own heaven through the sacrifice of the sensible and of subjective singularity, this sphere of representation is more detached than any other from the classical plastic ideal.
In fact, on the one hand, the earthly body and the fragility of human nature are generally elevated and honored for the fact that it is God himself that appears in them; on the other hand, however, it is precisely this humanity and corporeality that is posited as a negative and appears through suffering, while in the classical ideal it loses none of its undisturbed harmony with the spiritual and the substantial. The forms of Greek Beauty cannot be used to portray the flagellation of Christ, crowned with thorns, dragging the cross to the appointed place of torment, crucified and dying amid the torments of a long and martyred agony.
But the superiority of these situations is given by sanctity in itself, by the profundity of the intimate, by the infinity of suffering as an eternal moment of the spirit, and by the divine calm and resignation.
Around this figure stand the circle both of friends and enemies. Not even the friends are ideals, but, according to the concept, particular individuals, ordinary men led to Christ by the impulses of the spirit; but the enemies, insofar as they are opposed to God,

condemn, mock, martyr, and crucify him, are represented as wicked inside, and the representation of inner wickedness and hostility toward God brings in its train outer ugliness, coarseness, barbarity, rage, and the deformation of the figure. In all these regards the non-beautiful is represented here as a necessary phase, which is not the case with classical [concepts of] Beauty.

The Aesthetic Inferno

Karl Rosenkranz
The Aesthetics of Ugliness, Introduction, 1852
Great connoisseurs of the human heart have plunged into horrifying abysses of evil, describing the terrifying figures that they encountered in that darkness. Great poets, like Dante, have highlighted such figures even more; painters like Orcagna, Michelangelo, Rubens, and Cornelius have set them before our eyes, while musicians, like Spohr, have let us hear the atrocious sounds of perdition, in which the wicked howl out all the discordance of their spirit.
The inferno is not only ethical and religious, it is also aesthetic. We are steeped in evil and in sin, but also in ugliness. The terror of the formless and of deformity, of vulgarity and atrocity, surrounds us in innumerable figures, from pygmies to those gigantic deformities from which hellish evil observes us, gnashing its teeth. It is into this inferno of Beauty that we wish to descend. And it is impossible to do so without entering at the same time the inferno of evil, the real inferno, because the ugliest ugliness is not that which disgusts us in nature—swamps, distorted trees, salamanders and toads, sea monsters that stare at us with goggling eyes, and massive pachyderms, rats, and apes: it is the egoism that manifests its folly in perfidious and frivolous deeds, in the wrinkled lines of passion, in grim looks and in crime. […]
It is not hard to understand that since ugliness is a relative concept, it may only be understood in relation to another concept. This other concept is that of Beauty: ugliness exists only because of Beauty, which is its positive premise. If there were no Beauty, there would be no ugliness, because the latter exists only as the negation of the former. Beauty is the original divine idea and its negation, ugliness, as it is a negation, has only a secondary existence. Not in the sense that the beautiful, because it is beautiful, may be ugly at the same time, but in the sense that the very properties that constitute the necessity of Beauty are converted into its opposite.

Giovanni da Modena, *Inferno*, detail, c. 1410. Bologna, Church of San Petronio

Limbourg Brothers,
Hell, from the *Très riches heures du Duc de Berry*,
1411-1416.
Chantilly, Musée Condé

There is an intimate connection between the beautiful and the ugly, inasmuch as the self-destruction of the former is the basis of the possibility that the latter, in its turn, may negate itself: for, insofar as ugliness exists as the negation of Beauty, it may then resolve its contradiction by returning to unity with Beauty. In this process Beauty reveals itself as the force that brings the rebellion of ugliness back under its control and dominion. From this reconciliation there springs an infinite serenity, which arouses in us smiles and laughter. Ugliness frees itself in this movement of its hybrid, egoistic nature; it recognizes its own impotence and becomes *comic*. The comic always contains within itself a negative impulse toward the pure, simple ideal; in the comic, this negation is reduced to appearance, to nothingness. The comic has a positive ideal because its negative manifestation vanishes away. [...]
Ugliness is relative, however, because it cannot find its measure in itself, but only in Beauty. In day-to-day life everyone can follow his own taste and what may seem beautiful to one man may seem ugly to another and vice-versa. But if we wish to elevate this accidental quality of aesthetic-empirical judgment above its lack of certainty and clarity, we must needs subject it to criticism, and therefore to the light of the supreme principles. The sphere of conventional Beauty, of fashion, is full of phenomena that, judged by the idea of Beauty, can only be defined as ugly, and nevertheless they pass temporarily for beautiful. Not because they are [beautiful] in and of themselves, but only because the *Zeitgeist* finds in such forms an adequate expression of its specific character and thus becomes accustomed to them.
The *Zeitgeist* is more often in correspondence with fashion than anything else: here even ugliness may serve as a suitable means of expression. Fashions of the past, especially of the recent past, are usually deemed ugly or comical—and this is because shifts in sensibility can develop only by opposition. The citizens of republican Rome, who subjugated the world, used to shave. Caesar and Augustus did not affect beards and it was only from the romantic age of Hadrian, when the empire began to succumb more and more to barbarian dominion, did full beards become fashionable, as if, on sensing their own weakness, the Romans wanted to reassure themselves about their virility and boldness.

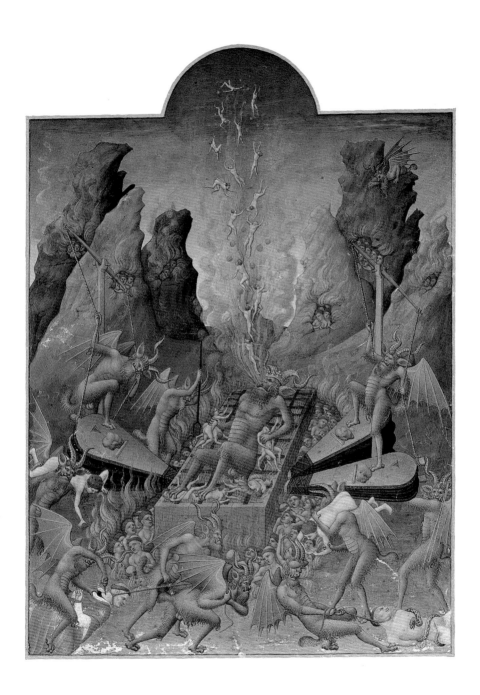

2. Legendary and Marvelous Beings

Ugliness possesses another source of attraction. During the Hellenic period contacts with distant lands intensified, accompanied by the spread of descriptions that were sometimes overtly legendary and other times informed by pretensions to scientific accuracy. For the first case we might cite the *Romance of Alexander* (an imaginative account of the travels of Alexander the Great), which enjoyed widespread popularity in the Christian west after the tenth century AD, but whose origins have been traced back to Callisthenes, Aristotle, or to Aesop—even though some maintain that the oldest text dates from the first centuries of the Christian era.

Mappa Mundi
from the *Beatus super Apocalypsim of Beatus of Liébana*, eleventh century, Burgo de Osma, archive of the Cathedral (at right: a Sciapod in a distant land)

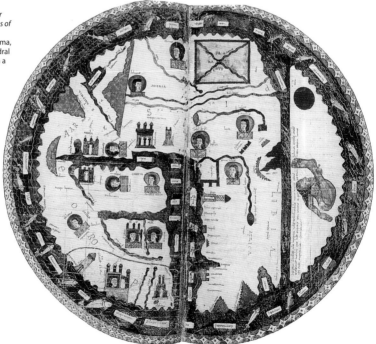

Nuremberg Chronicle,
details, fifteenth century.
Milan, private collection

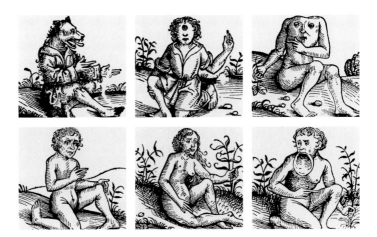

For the second case we may consider Pliny the Elder's *Natural History,* that immense encyclopedia of all the wisdom of the age. In these texts there appear the monstrous men and animals that later populated the Hellenic and Medieval bestiaries (starting with the renowned *Physiologus,* written between the second and fifth centuries AD) before spreading into the various encyclopedias of the Middle Ages and even into the reports written by later travelers.

We find, therefore, **Fauns;** creatures with eyes on their shoulders and two holes in their breasts by way of a nose and mouth; the **Androgynes,** beings with a single female breast and both types of genital organs; the Artabants of Ethiopia who go prone like sheep; the Astomati, creatures with only a small

Fauns
Unknown author (thirteenth century)
Liber monstrorum
At the dawn of the world, the Fauns sprang from the ancient shepherds, and they populated the land upon which Rome was later founded. The poets sang and wrote of Fauns.
Today, Fauns are born from worms that form between the bark and the wood of trees; then they creep down to the ground, where they sprout wings and then finally lose them. Then they transform themselves into wild men: and it was about these [creatures] that the poets composed so many verses. […]
And thus the Fauns are denizens of the woods, and are called thus because they can *fantur,* that is to say they have the power to prophesy the future. They have human form

from the head to the navel, although they also have two horns that curve down to the base of the nose thereby concealing the head. Their extremities, down to the feet, are described as goat-like in form. The poet Lucan, drawing on the Greek tradition, wrote in his verses that fauns were attracted by the sound of Orpheus's lyre, together with innumerable other wild creatures.

Androgynes
Unknown author (thirteenth century)
Liber monstrorum
Among these incredible things there is also a race with two sexes, where the right breast is that of a man so that they can work unhindered, while the left is that of a woman so that they can nurse their young. Some say that they mate between themselves reciprocally and thus succeed in reproducing.

139

hole for a mouth who feed themselves through a straw; the **Astomori**, entirely devoid of a mouth, who feed only on smells; the Blemmyae, who are headless with eyes and mouth on their breasts; Centaurs; Unicorns; Chimeras, tripartite beasts with the head of a lion, the hindquarters of a dragon, and a central part like a goat; Cyclopes; the dog-headed **Cynocephali**; women with wild boars' tusks and a tail like that of a cow; Griffins with the head and foreparts of an eagle and the hindquarters of a lion; men with straight legs and no knees, horse's hoofs, and the phallus on the chest; creatures whose lower lip is so large that when they sleep they cover their head with it; the Leucrococa, which has the body of a donkey, the hindquarters of a deer, the breast and thighs of a lion, horse's hoofs, a forked horn, a mouth stretching from ear to ear, a quasi-human voice, and a single bone instead of teeth; the Manticore, with three rows of teeth, the body of a lion, the tail of a scorpion, light blue eyes, a complexion the color of blood, and a serpent's hiss; the Panoti, whose ears are so large they hang down to their knees; creatures with extremely long necks, long feet, and arms like saws; the **Pygmies**, forever at war with the cranes, three spans tall, who live for seven years at most and marry and procreate at six months; Satyrs with hooked noses, horns, and goat-like hindquarters; crested Serpents that walk on legs and always keep their mouths agape while poison drips from their throats; rats the size of greyhounds, captured by mastiffs because cats cannot catch them; men who walk on their hands; men who walk on their knees and have eight toes on each foot; men with two eyes in front and two behind; men whose testicles are so large they reach their knees; and finally the **Sciapods**, creatures with a single leg on which they run very fast indeed and which they hold upright when they sleep, in order to enjoy the shade cast by the single enormous foot.

The Sciapod, from the
Nuremberg Chronicle,
fifteenth century.
Milan, private collection

Astomori
Unknown author (eighth century)
Liber monstrorum
The accounts of the Greeks say that there are also men devoid of a mouth, unlike all the others, and thus they allegedly cannot eat anything: according to the sources, moreover, they stay alive only by breathing through their nostrils.

Cynocephali
Unknown author (eighth century)
Liber monstrorum
In India there live the Cynocephali, dog-headed creatures that cannot say a single word without breaking off to bark, thus mixing baying and discourse. And, in eating raw flesh, they do not imitate men, but animals.

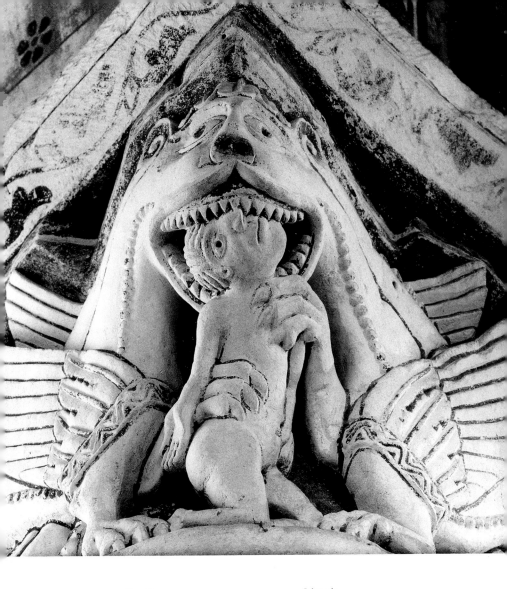

Monster Devouring a Man, capital of the Church of St. Pierre, Chauvigny, twelfth century.

Pygmies
Unknown author (eighth century)
Liber monstrorum
There is mention of a shadowy race of men who spend their lives in caves and ravines in the mountains. They stand only a few cubits tall and the sources say that they are obliged to make ruthless war on the cranes, at harvest time, to prevent them from pillaging the crops. In Greek they are called Pygmies, from the word for cubit in that language.

Sciapods
Unknown author (eighth century)
Liber monstrorum
Mention is also made of a race of men known by the Greeks as Sciapods, since they shelter from the blazing sunshine by lying down supine in the shadow of their own feet. They are truly very fast and have only one foot and one leg: the knee, rigid at the joint, can in no wise be flexed.

Boucicaut Master,
illustration in Marco
Polo, *Livre des merveilles*,
c. 1410. Paris,
Bibliothèque Nationale
de France

This is the population of legendary beings, all extraordinarily deformed, whose images we find in illuminated manuscripts, in the sculptures decorating the portals and capitals of Romanesque abbeys, right down to later works and printed publications.

Medieval culture did not pose itself the problem whether these monsters were "beautiful" or not. Medieval people were fascinated by the Marvelous, which was merely the form that was to become the Exotic in successive centuries. Many travelers of the late Middle Ages threw themselves into the search for new lands partly because they were fascinated by this idea of the Marvelous, and they contrived to find it even when it was not there. For example, Marco Polo in his *Travels* (*Il Milione*) identifies the rhinoceros, an animal Europeans had never seen before, with the legendary unicorn (even though unicorns were supposed to be white and graceful, and rhinoceroses appeared as clumsy, massive, and dark).

Unicorn
Marco Polo (thirteenth century)
The Travels, CXLIII
When you leave this kingdom, you come to the realm of Basman: an independent kingdom, with a special language. The inhabitants live like animals. They recognize the suzerainty of the Great Khan, but they pay him no tribute because they live so far distant that the Khan's men cannot reach them. But despite this all the inhabitants of the island recognize his suzerainty and every so often, through the travelers that pass through those places, they send the Khan something beautiful and strange—especially certain black goshawks of a particular species. They have great numbers of wild elephants and unicorns, far smaller than the elephants. The coat of the unicorn is like that of the buffalo; their hooves are like those of the elephant. The have a big black horn in the center of their brow. They do not use this horn for offense, but only their tongues and knees. On their tongues, in fact, they have long sharp spines and thus, when they wish to attack, they trample and crush the victim with their knees and then wound him with their tongues. Their head is like that of the wild boar and they hold it bowed down toward the ground; they like to wallow in the mud. They are very ugly beasts to see and are not at all as we describe them: according to a widespread belief in our countries, unicorns let themselves be captured by virgins. It's really not like that all.

3. Ugliness in Universal Symbolism

Nevertheless, the mystical and theological thought of the epoch had in some way to justify the presence in creation of these monsters, and it chose two paths. On the one hand it included them in the great tradition of **universal symbolism.** Starting from St. Paul's maxim, according to which we see supernatural things *in aenigmate,* in allusive and symbolic form, we arrive at the idea that every worldly thing, be it animal, vegetable, or mineral, has a **moral significance** (because it teaches us about virtues and vices), or allegorical, insofar as it symbolizes supernatural realities through its form or its components. It is for this reason that, along with the Bestiaries

Universal Symbolism
Hugh of Saint Victor (twelfth century)
De scripturis et script. sac., V
Some say that meaning is to be had according to the letter [of the word], others according to allegory. According to history, lion means an animal, according to allegory it means Christ: therefore this word *lion* means Christ. I ask you, therefore, to prove why lion means Christ. Perhaps you will reply, as people do, because of the fitness of the proposed simile with the meaning; because the lion sleeps with his eyes open or something like that; therefore lion means Christ because he sleeps with his eyes open. So you have said that this word lion means Christ because he sleeps with his eyes open. Hence either you cancel the sentence you have uttered or you change the reason you put forward. For either your sentence about this word lion meaning Christ is false, or the reason put forward—in support of [the idea that] lion means Christ because he sleeps with his eyes—is ill suited. For it is not the word that sleeps with eyes open, but the animal indicated by the word. You see therefore that when someone says that lion means Christ, he means the animal itself and not the word. So do not boast of your knowledge of the Scriptures while you know nothing of the letter. Knowing nothing of the letter is not knowing what the letter means and what is meant by the letter. […]

When therefore the very things that the letter means are signs of spiritual intelligence, in what way can they be signs if you have not yet been shown these things? Do not leap if you do not wish to fall from the precipice. He who proceeds in the straightest line is he who proceeds in an orderly fashion. […]
In so saying we wish to warn the reader not to reject these first notions. Nor should he think to disdain knowledge of those things that Holy Writ puts before us through the primary meanings of the letter because they are the same things that the Holy Spirit—for [the benefit of] those who have only the carnal senses and visible things with which to get closer to invisible things—portrayed as simulacra of spiritual intelligences, and through these proposed similarities clearly represented the things that are to be understood spiritually. For if, as these people say, we were to pass instantly from the letter to the spiritual intelligence, then the Holy Spirit would have worked in vain to include in the divine word the figures and the semblances of the things through which the spirit is to be guided to spiritual things. As the Apostle bears witness, in fact, *quod carnale est, prius est, deinde quod spirituale* (Cor. I, 15). And as for the wisdom of God himself, were it not known physically, then no woolly mind could ever have been led to comprehend it spiritually.

that seem merely to have a predilection for the marvelous and the unusual (like the *Liber de monstrorum diversi generibus*), right from *The Physiologus* mentioned earlier we begin to find the "moralized" bestiaries, in which not only every known animal but also every legendary monster was associated with mystic and moral teachings.

In this way monsters were included in the providential design of God and so, as Alain de Lille maintained, all the creatures of this world, as in a book or an image, appear to us as a mirror held up to life and death, to our present condition and our future destiny. But if God has included them in his plan, how can monsters be "monstrous" and insinuate themselves into the harmony of creation as a source of disturbance and deformation? St. Augustine addressed this very problem in a paragraph of his *City of God*: Even monsters are divine creatures and in some way they too belong to the providential order of nature.

Figural tribune
of the Church of San
Pietro in Gropina,
twelfth century.

Moral Significance
Unknown author (twelfth century)
The Cambridge Bestiary
Originating in the river Nile, the crocodile gets its name from the yellowish color known as crocean. It is an amphibian quadruped. Generally twenty cubits long, it has a series of sharp fangs and claws and its hide is so tough that it will resist any stone, without a scratch, even if it be cast with violent force. It squats on the ground during the day and spends the night in the water. The male and the female take turns at covering the eggs laid in the sand. Some fish, equipped with a hard carapace and tough serrated scales, can kill it by gutting its soft underbelly. It is the only animal that can stand motionless on its paws while moving the upper part of its body. Crocodile dung is used by old and wrinkled prostitutes who cover their faces with it, thereby obtaining a temporary improvement in their looks, which lasts until the sweat washes away the mask. The crocodile is the image of the hypocrite, licentious or avaricious as he may be, but inwardly infected with pride, tainted by lust and corrupted by avarice, who nonetheless affects before the eyes of men an austere gait and the mien of an honest and law abiding person. The crocodile's [habit of] hiding itself on the land and beneath the surface of the water is like the behavior of the hypocrite who, although he may live in complete dissipation, nevertheless delights in simulating a sainted and honest life. Aware of

his own wickedness, the hypocrite beats his breast in the "mea culpa," even though habit has by then led him to indulge continually in evil. What's more, the peculiarity of the crocodile whereby it can move the upper part of its snout is reminiscent of the pomposity of hypocrites, when in the presence of others they spout an abundance of holy writ despite the fact that in them there is not the slightest trace of what they say.

Moralized Bestiaries
Anonymous (second-third century)
The Physiologus
The Psalm says: "But my horn shalt thou exalt like the horn of an unicorn" (Psalms, 92:10). The Physiologus has said that the unicorn has this nature: it is a small animal, like a kid, but extremely fierce. The hunter may not approach it because of its extraordinary power; it has a single horn in the middle of its head. So how then can it be hunted? They show the animal an immaculate virgin, and it will leap to the virgin's breast, and she will nurse it, and lead it to the palace of the king. The unicorn is an image of the Savior: in fact "And hath raised up a horn of salvation for us in the house of his servant David" (Luke, 1:69), and he is become for us a horn of salvation. The angels and the powers were unable to have dominion over Him, but He took up his abode in the womb of the true and immaculate Virgin Mary, "and the Word was made Flesh, and dwelt among us" (John, 1:14).

Carlo Crivelli,
The Archangel Michael,
panel from the San
Domenico Polyptych of
Ascoli Piceno, 1476.
London, National Gallery

Apocalypse: The Seven-Headed Dragon Cast Down into Hell, c. 1230. Cambridge, Trinity College

It was the task of many medieval mystics, theologians, and philosophers to show how, in the great symphony concert of cosmic harmony, monsters contribute, albeit purely by way of contrast (like shading and chiaroscuro in a picture) to the Beauty of the whole. Rabanus Maurus held that monsters were not against nature because they spring from the divine will. Hence, they are not against nature, but against the nature to which we are accustomed. *Portenta* (which come into being to signify something superior) are different from *portentuosa*, who are the bearers of minor and accidental mutations, like children born with six fingers, out of a material defect but not out of obedience to a divine plan.

4. Ugliness as a Requirement for Beauty

In the *Summa* attributed to Alexander of Hales, the created universe is a whole that is to be appreciated in its entirety, where the contribution of shadows is to make the light shine out all the more, and even that which can be considered ugly in itself appears beautiful within the framework of the general Order. It is this order as a whole that is beautiful, but from this standpoint even monstrosity is redeemed because it contributes to the equilibrium of that order. William of Auvergne said that variety increases the Beauty of the universe, and thus even the things that strike us as unpleasant are necessary to the universal order, including monsters.

On the other hand, while even the most radical rigorists complained about the tendency of artists to portray monsters, they were themselves unable to resist the appeal of such figures. Proof of this lies in a celebrated text by St. Bernard, who had always been strenuously against the excessive ornamentation of churches and who inveighed against the overabundance of monsters portrayed therein. His words are of condemnation, but the description he gives of this evil brims with a sense of fascination. And so it was that monsters, loved and feared, kept at bay but freely admitted at the same time, began to take a steadily more important place in literature and painting, from Dante's descriptions of hell to the later pictures of Bosch. It was not until a few centuries later, in the decadent Romantic period, that the appeal of the horrendous and the Beauty of the Devil were acknowledged without hypocrisy.

Angel Chaining the Devil in the Abyss, from the *Commentary on the Apocalypse of Beatus of Liébana*, Beatus of Ferdinand I and Queen Sancha, MS. Vit. 14-2, eleventh century. Madrid, Biblioteca Nacional

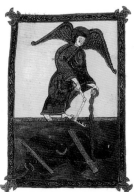

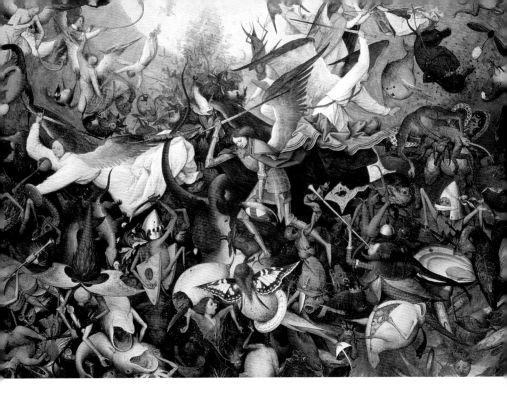

Pieter Brueghel the
Elder,
*The Fall of the Rebel
Angels*, 1562.
Brussels,
Musée des Beaux-Arts

The Monsters of the Church
St. Bernard (twelfth century)
Apologia ad guillelmum
Moreover, what place is there in the cloisters,
where the monks read the holy offices, for
that ridiculous monstrosity, that strange kind
of deformed shape or shaped deformity?
What are foul apes doing there? Or ferocious
lions? Or monstrous centaurs? Or half-men?
Or dappled tigers? Or soldiers in battle? Or
hunters with their horns? You can see many
bodies beneath a single head and, vice-versa,
many heads atop a single body. On the one
side you can see a quadruped with a
serpent's tail, and on the other a fish with a
quadruped's head. Here, a beast that looks
like a horse with the hind-quarters of a goat,
there a horned animal with the hind-
quarters of a horse. In short there is
everywhere such a great and strange variety
of heterogeneous forms that there is more
pleasure to be had in reading the marbles
than the codices and in spending the whole
day admiring one by one these images
rather than meditating on the law of God.

Monstrosity Redeemed
Alexander of Hales (thirteenth century)
Summa halesiana, II
Evil as such is misshapen [...]. Nevertheless,
since from evil comes good, it is therefore well
said that it contributes to good and hence it is
said to be beautiful within the order [of
things]. Thus it is not called beautiful in an
absolute sense, but beautiful within the order;
in fact, it would be preferable to say: "the
order itself is beautiful."

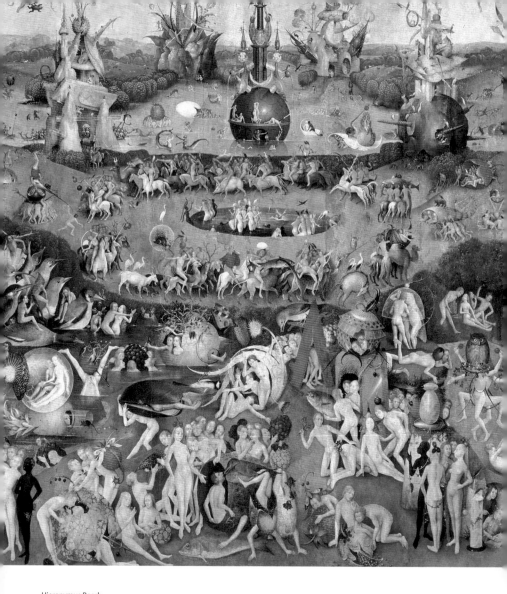

Hieronymus Bosch,
*The Garden of Earthly
Delights, Earthly
Paradise*, c. 1506.
Madrid, Museo del Prado

opposite
Hieronymus Bosch,
*The Garden of Earthly
Delights, Hell*, c. 1506.
Madrid, Museo del Prado

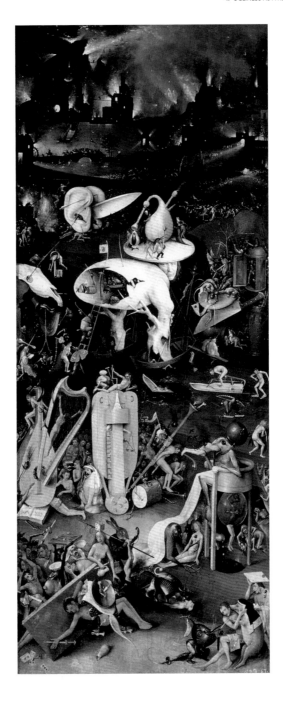

5. Ugliness as a Natural Curiosity

In the passage from the Middle Ages to modern times the attitude toward monsters changed. Between the sixteenth and seventeenth centuries, doctors like Ambroise Paré, naturalists like Ulisse Aldrovandi and John Johnston, and collectors of marvels and curiosities like Athanasius Kircher and Caspar Schott could not free themselves of the fascination of certain traditional items and in their treatises they listed, together with harrowing malformations, authentic monsters like the siren or the dragon.

Nevertheless, monsters lost their symbolic power and came to be seen as natural curiosities. The problem was no longer whether they should be seen as beautiful or ugly, but to study their form, and sometimes their anatomy. The criterion, while it was still fanciful, had become "scientific," the interest was not mystical but naturalistic. The monsters that populated the new collections of prodigies fascinate us today as a work of fantasy, but they fascinated contemporaries as the revelation of mysteries of the natural world that were still to be fully explored.

Ulisse Aldrovandi,
Animal africanum deforme,
from *Monstrorum historia,*
1642. Bologna

Athanasius Kircher,
Dragon, from *Mundus subterraneus,* 1665.
Amsterdam

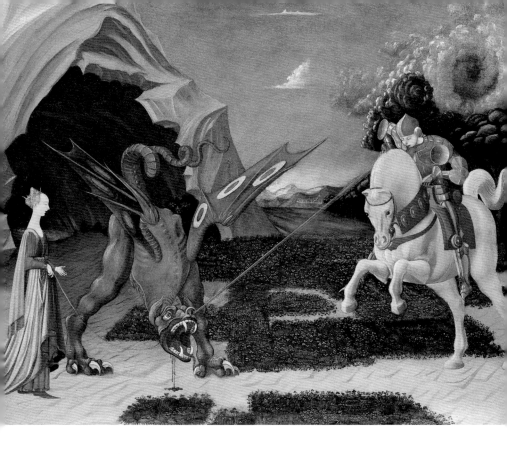

Paolo Uccello,
*St. George and the
Dragon*, 1470.
London, National
Gallery

Jacopo Ligozzi,
*Horned Viper and
Avicenna Viper*, 1590.
Florence, Gabinetto dei
Disegni e delle Stampe
degli Uffizi

restrained, but not compressed, gently bound so that they are not free to jounce about." It does not take much to relate this ideal of Beauty to the

Game with a Hood,
detail of a linen purse
embroidered with gold
and silver threads,
crafted in Paris, c. 1340.
Hamburg, Museum für
Kunst und Gewerbe

opposite
Hans Memling,
*King David and
Bathsheba,* detail,
c. 1485-1490.
Stuttgart, Staatsgalerie

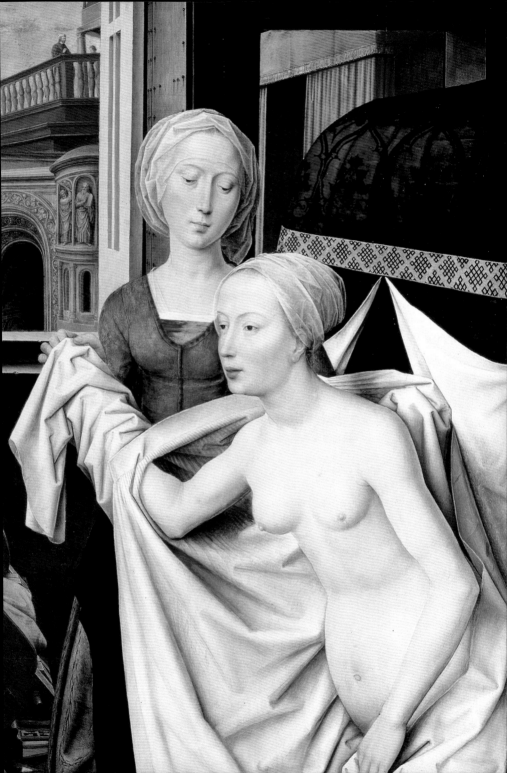

Madonna with Child,
fourteenth century.
Paris, Musée du Moyen
Âge, Thermes de Cluny

How Thou Art Fair

Solomon (tenth century BC)
The Song of Songs

Behold, thou art fair, my love; behold, thou art fair; thou hast doves' eyes within thy locks: thy hair is as a flock of goats, that appear from mount Gilead.

Thy teeth are like a flock of sheep that are even shorn, which came up from the washing; whereof every one bear twins, and none is barren among them.

Thy lips are like a thread of scarlet, and thy speech is comely: thy temples are like a piece of a pomegranate within thy locks.

Thy neck is like the tower of David builded for an armory, whereon there hang a thousand bucklers, all shields of mighty men.

Thy two breasts are like two young roes that are twins, which feed among the lilies.

Until the day break, and the shadows flee away, I will get me to the mountain of myrrh, and to the hill of frankincense.

Thou art all fair, my love; there is no spot in thee.

Come with me from Lebanon, my spouse, with me from Lebanon: look from the top of Amana, from the top of Shenir and Hermon, from the lions' dens, from the mountains of the leopards.

Thou hast ravished my heart, my sister, my spouse; thou hast ravished my heart with one of thine eyes, with one chain of thy neck.

How fair is thy love, my sister, my spouse! how much better is thy love than wine! and the smell of thine ointments than all spices!

Thy lips, O my spouse, drop as the honeycomb: honey and milk are under thy tongue; and the smell of thy garments is like the smell of Lebanon.

A garden inclosed is my sister, my spouse; a spring shut up, a fountain sealed.

Thy plants are an orchard of pomegranates, with pleasant fruits; camphire, with spikenard, spikenard and saffron; calamus and cinnamon, with all trees of frankincense; myrrh and aloes, with all the chief spices:

A fountain of gardens, a well of living waters, and streams from Lebanon (4, 1-15).

Thou art beautiful, O my love, as Tirzah, comely as Jerusalem, terrible as an army with banners. Turn away thine eyes from me, for they have overcome me: thy hair is as a flock of goats that appear from Gilead.

Thy teeth are as a flock of sheep which go up from the washing, whereof every one beareth twins, and there is not one barren among them.

As a piece of a pomegranate are thy temples within thy locks.

There are threescore queens, and fourscore concubines, and virgins without number.

My dove, my undefiled is but one; she is the only one of her mother, she is the choice one of her that bare her. The daughters saw her, and blessed her; yea, the queens and the concubines, and they praised her.

Who is she that looketh forth as the morning, fair as the moon, clear as the sun, and terrible as an army with banners? (6, 4-10)

How beautiful are thy feet with shoes, O prince's daughter! the joints of thy thighs are like jewels, the work of the hands of a cunning workman.

Thy navel is like a round goblet, which wanteth not liquor: thy belly is like an heap of wheat set about with lilies.

Thy two breasts are like two young roes that are twins.

Thy neck is as a tower of ivory; thine eyes like the fishpools in Heshbon, by the gate of Bathrabbim: thy nose is as the tower of Lebanon which looketh toward Damascus.

Thine head upon thee is like Carmel, and the hair of thine head like purple; the king is held in the galleries.

How fair and how pleasant art thou, O love, for delights!

This thy stature is like to a palm tree, and thy breasts to clusters of grapes.

I said, I will go up to the palm tree, I will take hold of the boughs thereof: now also thy breasts shall be as clusters of the vine, and the smell of thy nose like apples;

And the roof of thy mouth like the best wine for my beloved, that goeth down sweetly, causing the lips of those that are asleep to speak.

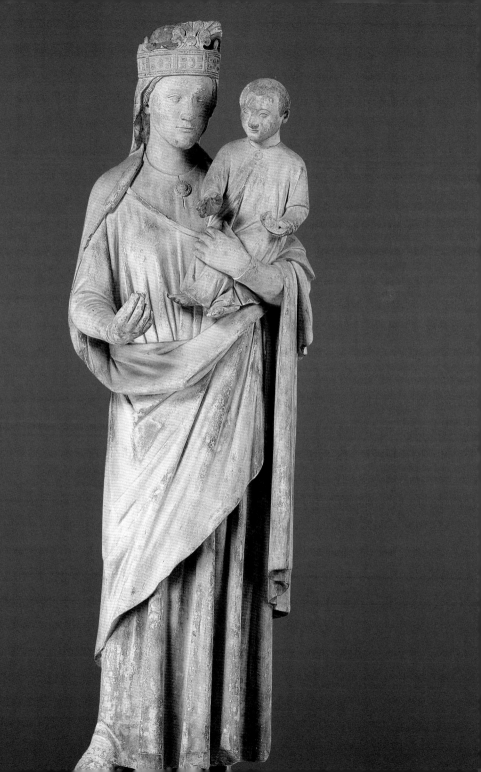

Illumination from the
Codex Manesse,
c. 1300. Heidelberg,
Universitätsbibliothek

aspect of many ladies as portrayed in the illustrations of knightly romances, and even to many sculptures of the Virgin with the Child in her arms, her close-fitting bodice modestly restraining her bosom, as prescribed by the dress code of many ladies of that time.

Outside the doctrinal milieu, we have some delightful descriptions of womanly beauty in goliardic verse (the *Carmina burana*), and in those poetic compositions known as *pastourelles*, in which students or knights seduce and enjoy the charms of shepherdesses they chance to meet.

But this was the Medieval period, a world that praised meekness in public while offering public manifestations of ferocity, a world that— together with works of extreme moralistic rigor—also offers us pages of frank sensuality, and not just in Boccaccio's novellas.

Medieval Sensuality
Anonymous (twelfth-thirteenth century)
Carmina burana
There is no frost that can chill love, which is the source of intimate warmth and can revive what the slumberous winter has numbed. I suffer bitterly and I die for the wound I glory in. Oh!, if only she who is pleased to pierce my heart with her sweet darts would heal me with a kiss.

Her joyful and lovable smile draws all eyes to her. Her lips, tender and sensual but innocent at the same time, fill me with a subtle ecstasy when her kisses instill all the sweetness of honey; in those moments I feel almost like a god! Her brow, serene and white as the snow, the sparkling light of her eyes, the golden highlights in her hair, her hands, whiter than lilies, make me sigh. […]

The damsel granted that I see her, talk to her, fondle her, and finally kiss her; but love's ultimate and sweetest goal was lacking. If I shall not attain it, what she has granted me thus far will only add new flames to my burning desire.

I get closer to the goal, but with her sweet tears, my girl arouses me even more, while she hesitates to open the gate to her virginity. She weeps and I drink her sweet tears, and so the more I am inebriated and the more I burn with passion.

Kisses wet with tears have an even sweeter taste and excite my mind with thoughts of more intimate caresses. I am overwhelmed by passion and the flame of desire burns ever more fiercely within me. Coronide meanwhile gives vent to her suffering with heavy sobs and will not be soothed by my pleas. I add plea upon plea and add kiss upon kiss; she adds tears to tears, arguing and insulting me, looking at me with eyes that are sometimes hostile and sometimes almost imploring, and as I plead with her and caress her she becomes even deafer to my requests.

I grow bold and use force. She scratches me with her nails, pulls out my hair and repulses me with all her might, she bends over and clamps her knees together so as not to open the door of modesty. I struggle more and more, until I triumph. I clutch her close to me, blocking her limbs, I seize her wrists and kiss her passionately; and thus the realm of Venus opens.

We both enjoyed it. My beloved no longer holds me off but, having calmed down, she gives me kisses sweet as honey.

Handsome Masetto

Giovanni Boccaccio (1313-1375)

The Decameron, Third Day, First Novella

Last of all the abbess, still witting nought of these doings, happened one very hot day, as she walked by herself through the garden, to find Masetto, who now rode so much by night that he could stand very little fatigue by day, stretched at full length asleep under the shade of an almond-tree, his person quite exposed in front by reason that the wind had disarranged his clothes. Which the lady observing, and knowing that she was alone, fell a prey to the same appetite to which her nuns had yielded: she aroused Masetto, and took him with her to her chamber, where, for some days, though the nuns loudly complained that the gardener no longer came to work in the kitchen-garden, she kept him, tasting and re-tasting the sweetness of that indulgence which she was wont to be the first to censure in others. And when at last she had sent him back from her chamber to his room, she must needs send for him again and again, and made such exorbitant demands upon him, that Masetto, not being able to satisfy so many women, bethought him that his part of mute, should he persist in it, might entail disastrous consequences. So one night, when he was with the abbess, he cut the tongue-string, and thus broke silence: "Madam, I have understood that a cock may very well serve ten hens, but that ten men are sorely tasked to satisfy a single woman; and here am I expected to serve nine, a burden quite beyond my power to bear; nay, by what I have already undergone I am now so reduced that my strength is quite spent; wherefore either bid me Godspeed, or find some means to make matters tolerable." Wonder-struck to hear the supposed mute thus speak, the lady exclaimed: "What means this? I took thee to be dumb." "And in sooth, Madam, so was I," said Masetto, "not indeed from my birth, but through an illness which took from me the power of speech, which only this very night have I recovered; and so I praise God with all my heart." The lady believed him; and asked him what he meant by saying that he had nine to serve. Masetto told her how things stood; whereby she perceived that of all her nuns there was not any but was much wiser than she; and lest, if Masetto were sent away, he should give the convent a bad name, she discreetly determined to arrange matters with the nuns in such sort that he might remain there. So, the steward having died within the last few days, she assembled all the nuns; and their and her own past errors being fully avowed, they by common consent, and with Masetto's concurrence, resolved that the neighbours should be given to understand that by their prayers and the merits of their patron saint, Masetto, long mute, had recovered the power of speech; after which they made him steward, and so ordered matters among themselves that he was able to endure the burden of their service. In the course of which, though he procreated not a few little monastics, yet 'twas all managed so discreetly that no breath of scandal stirred, until after the abbess's death, by which time Masetto was advanced in years and minded to return home with the wealth that he had gotten; which he was suffered to do as soon as he made his desire known. And so Masetto, who had left Lamporecchio with a hatchet on his shoulder, returned thither in his old age rich and a father, having by the wisdom with which he employed his youth, spared himself the pains and expense of rearing children, and averring that such was the measure that Christ meted out to the man that set horns on his cap.

The Beautiful Woman

Giovanni Boccaccio (1313-1375)

Rime

Snow white pearls of the orient
Between rubies of bright vermilion
Whence an angelic smile
Twinkling beneath two dark lashes
Often seem Venus and Jove together
As the crimson roses and the lilies white
Spread their colors everywhere
Without any art diminishing it:
Her golden locks and curls an aura make
Above her joyful forehead, at sight of which
Love is dazzled by wonder;
And all the other parts do match
Those mentioned before, in equal proportion
In her who resembles a true angel.

2. Ladies and Troubadours

The advent of the poetry of the troubadours of Provence began around the eleventh century, followed by the knightly romances of the Breton cycle and the Italian *stilnovo* school of poetry. In all these texts there emerges a particular image of Woman as a chaste and sublimated love object, **desired and unattainable,** and often desired precisely because she was unattainable. A first interpretation of this attitude (and this holds especially for the poems of the troubadours) is that it was a manifestation of feudal deference: the Seigneur, by that time committed to the adventure of the Crusades, is absent, and the deference of the troubadour (who is always a knight) is shifted to the Lady, adored but respected, whose **servitor and vassal** the poet becomes, seducing her platonically with his poesy. The Lady takes on the role reserved for the Seigneur, but loyalty to the latter ensures that she may not be touched.

Desired and Unattainable
Jaufré Rudel (twelfth century)
He Cannot Sing Who Makes No Tune
He cannot sing who makes no tune,
Nor verses make he who masters not
The word and cannot rhyme:
Such a man will never get anywhere.
So I'll begin my song like this,
And the mor you hear it, the more
You'll like it.

Small wonder, then,
If I love her who will see me never,
That my heart will rejoice in no other love
Save that of her whom I will never see:
No other joy will ever gladden me
But I don't know where that's going to get
me.

The good that struck me plagues and kills me,
This pang of love that seizes all.
My flesh and my body shall waste away,
None has ever wounded me thus,
Nor does my body languish for a blow

And that is neither fair nor good.
Sweet slumber never came to me here
Without my soul flying straightaway there.
Nor did I ever suffer so here
Without flying straightaway there,
And when I wake to the new day
All pleasure flees away.

I know well that I will never have her,
While she will never have me,
Her troth to me she'll never pledge
Nor will she say yes to me like a friend:
Never has she told me true nor ever lied,
And I cannot say if she ever will.

The song is sweet and without error ends,
And what there is of it is surely fairly made;
So let he who learns it now
Beware of fiddling with it:
I want it Messer Bertrand in Quercy to hear it
And the Count of Toulouse.

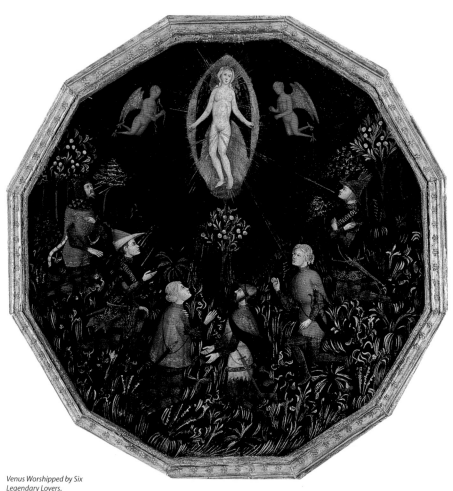

Venus Worshipped by Six Legendary Lovers, Florentine plate attributed to the Master of St. Martin, c. 1360. Paris, Musée du Louvre

Illumination from the
Codex Manesse,
c. 1300. Heidelberg,
Universitätsbibliothek

Another interpretation would have it that the troubadours were inspired by the Catharist heresy, whose influence on them is manifested by their disdain for the flesh; another school of thought again would have them under the influence of the poetry of Arab mysticism, while yet another sees the poetry of courtly love as a sign of a process of refinement at work in a knightly and feudal class previously characterized by ferocity and violence. The twentieth century produced a wealth of psychoanalytical disquisitions on the inner conflicts of courtly love, in which the Woman is at once desired and spurned because she embodies a maternal image, or the knight falls narcissistically in love with the Lady because she is a reflection of his own image.

Servitor and Vassal
Bernart de Ventadorn (twelfth century)
And It's No Wonder that I Sing
And it's no wonder that I sing
Better than other poets
Of that which more than anything draws my heart
Toward Love,
The better to be at its command.
He who feels not some sweet tang
Of Love in his heart is surely dead.
What price life without love
If not to trouble people?
By my good and guileless faith
I love the most beautiful woman and the best.
Tears fall from my eyes while my heart races
For I love her so much it hurts.
What more can I do, if Love has seized me
And the only key that will open
The prison in which it has cast me

Is pity, that very pity that none will grant me?
All the gold and silver of the world
Would I have given, were it mine to give,
If only my woman might finally know
How much I love her!
On seeing her, I gladden at the sight
Of her eyes, her face, and complexion
So much, that I do shake with fear
Like a leaf in the wind.
O my good lady, I ask no more
Than you take me as your servitor
And I will serve you nobly
No matter what your reward may be
Then see me at your command
A forthright courtly heart, humble and gay!

3. Ladies and Knights

But there is no point in getting involved here in a historic debate that has already been widely discussed. What does interest us, however, is the development of an idea of female Beauty, and of courtly love, in which desire is amplified by prohibition: the Lady fosters in the Knight a permanent state of suffering, which he joyfully accepts. This leads to fantasies about a possession forever deferred, in which the more the Woman is seen as unattainable, the more the desire she has aroused grows, and her Beauty is transfigured. This interpretation of courtly love does not take into consideration the fact that the **troubadour** frequently does not stop short on the threshold of renunciation, and that the knight errant does not always forbear from adultery, as is the case with Tristan, who—overwhelmed by his passion for Isolde—betrays King Mark. Despite this, however, all these stories of passion contain the idea that love, apart from

The Troubadour

Unknown author (thirteenth century)
You have heard about Raimbaut de Vaqueiras and how he came to high rank and thanks to whom. But now I want to tell you how, when the good Marquis of Monferrato had knighted him, he fell in love with the Lady Beatrice, the Marquis's sister and sister of the Lady Alazais of Saluzzo.

He loved her very much and desired her, being very careful not to let her or others know this; he extolled her merits and worth and he found her many friends, men and women from far and near. And she gave him a welcome that did him great honor. And he was dying of desire and dread, so much so he dared not ask her for her love nor show her that he was in love with her.

But one day, like a man tormented by love, he presented himself before her, and told her that he loved a young noblewoman of great worth, and enjoyed a most intimate relationship with her, but dared not confess or show his love for her, nor ask for her love, so deeply was he in awe of her great wealth and of the great consideration and honor in which she was held by all; and he begged her in the name of God and compassion to counsel him: ought he to open his heart and reveal his desire to her, and ask her for her love, or should he die in silence, fearing and loving?

That noble woman, the Lady Beatrice, on hearing Raimbaut's words and knowing of his desire for love—and she was already well aware that he was dying of languor and love for her—was seized by compassion and love and she said to him: "Raimbaut, it is right that every faithful friend, if he love a noble woman, use her reverence and fear to reveal the love he feels for her; but before he dies, I would advise him to make his love and his desire known to her and to ask her to accept him as her servitor and friend. And I assure you that, if the woman is intelligent and courteous, she will not take it badly nor will she feel diminished, on the contrary, she will appreciate him even more and will hold him in even greater esteem.

"And I advise you to open your heart to the woman you love and show her the desire you have for her, and beg her to accept you as her servitor and knight; since you are such an esteemed knight that no woman in the world would be unhappy to have you at her side as knight and servitor. And I have seen that the Lady Alazais, the countess of Saluzzo, accepted the courtship of Pierre Vidal; and the countess of Burlatz that of Arnaut de Maroill; and the lady Maria, that of Gaucelm Faidit; and the lady of Marseilles, that of Folquet of Marseilles. And so I advise and I authorize you, on the strength of my words

The Offer of the Heart and *A Lover Offering Silver to His Lady*, scenes from the *Romance of Alexander*, MS. Bodl. 264, Bruges, atelier of Jehan de Grise, 1338-1344. Oxford, Bodleian Library

the ravishment of the senses, brings **unhappiness and remorse** in its train. Consequently, as far as regards the interpretation of courtly love in the centuries that followed, the moments of moral weakness (and of erotic success) undoubtedly took second place to the idea of an infinitely protracted round of frustration and desire, in which the dominion the Woman acquires over the lover reveals certain masochistic aspects and, the more passion is humiliated, the more it grows.

and my reassurance, to beg her and ask her for her love."
When Raimbaut heard the advice she gave him and the reassurance and authorization that she offered him, he told her that she was the woman he loved and about whom he had asked her opinion. And the Lady Beatrice said that he was welcome, and that he should try to act nobly and to speak well and to show his worth, and that she was prepared to accept him as her knight and servitor and that he should buckle down to his task. And Raimbaut tried to speak and act worthily, and to enhance the prestige of the Lady Beatrice whenever this was possible. And then he composed the song that you will find written here as follows:
(Love) now asks me to follow its wont and its customs.

Unhappiness and Remorse
Guido Cavalcanti (c. 1250 -1300)
Never Would I Have Thought That the Heart
Never would I have thought that the heart
Could suffer so from sighing,
Nor that from my soul the welling tears
Could mirror death in my gaze.
I no longer had rest or repose
Upon finding Love and my lady,
And Amor said: "You shall not live,
For the grandeur of this woman is too great."
My reason abandoned me forlorn,
After having left my heart in the tumult
Of the battle over my Lady:
And she, with her looks, came to hurt me
In such a way that Love
Routed all my spirits and set them to flight.
I cannot speak of this woman
For she is by such great beauty adorned
That human reason cannot bear it,
Nor may our wits be made to imagine her.

So noble is she, that when I think upon her,
I feel my spirit trembling in my heart
As if it could not withstand
The great power manifest in her.
Her splendor smites the eye
In such a way that, at sight of me, people say
"Do you not see this man worthy of compassion
Who seems more dead than alive
So much does he plead for mercy?"
And my lady never noticed this!
When I am inspired to explain in poesy
The virtue of that noble heart, I feel incapable
And dare not carry through my task.
Love, who has seen her beauties,
Dismays me so and, on sensing her coming,
My heart cannot bear the sight of her; and, sighing,
Love says "There is no hope for you,
For her smile has cast a keen dart
That has pierced your heart and driven off mine.
You know, when you came to me,
I told you that, on seeing her once,
It were better had you died."
Song, you know that I composed you
On dipping into the book of Love
When first I saw my Lady:
Now let me put my trust in you
And go to her, that she may hear you;
And I beg you humbly to lead to her
All the spirits flown from my heart,
Which for the overwhelming power
Of her worth could do naught else
But fly to her or face destruction;
And they go alone, without company,
And they are filled with fear.
So lead them on a safe road
And when you are before her, say:
"These spirits are here in lieu
Of one who dies of love's devastating blow."

4. Poets and Impossible Loves

We might say that this concept of impossible love was more the effect of a Romantic interpretation of the Middle Ages than a fully-rounded product of the Medieval period itself, and thus it has been said that the "invention" of love (understood as eternally unfulfilled passion and source of sweet unhappiness) dates from that very period, thence to migrate to inhabit modern art, from poetry to the novel to lyric opera.

Let us take a look at the story of **Jaufré Rudel.** He was, in the twelfth century, the lord of Blaye, and he had taken part in the second Crusade. It is difficult to establish whether that was the occasion on which he met the object of his desire, who might have been Odierna, the countess of Tripoli in Syria (today in Lebanon), or her daughter Melisenda. Whatever the case may be, the legend soon arose that, smitten by love for this **"distant princess"** whom he had never seen, Rudel took steps to seek her out. On this journey toward the hitherto unseen object of his uncontrollable desire, Rudel falls ill and, only when he is on the point of death, the Lady, informed of the existence of this

The Small Death, Jaufré Rudel Dies in the Arms of the Countess of Tripoli, from a northern Italian songbook, thirteenth century. Paris, Bibliothèque Nationale de France

Jaufré Rudel
Unknown author (thirteenth century)
Jaufré Rudel de Blaye
Jaufré Rudel de Blaye was a most noble man, the prince of Blaye. And he fell in love with the countess of Tripoli, without ever having seen her, out of the good he heard of her from the pilgrims that came from Antioch. And he composed many songs about her with fair melodies, but with mediocre words. Out of his desire to see her he became a crusader and set off by sea, and on the boat he was taken ill, and was taken to Tripoli, to a place of shelter, and given up for dead. Word of this was sent to the countess and she came to his bedside and took him in her arms. And he realized that it was the countess and suddenly recovered his hearing and his sense of smell and he set to praising God for having allowed him to live long enough to see her; and so he died in her arms. And she had him buried with great pomp in the house of the Temple; and then, on that day, she became a nun for the sorrow that his death had caused her.

The Distant Princess
Jaufré Rudel (twelfth century)
Songs
When the days grow long in May
The distant birdsong is sweet,
And if I journey far from here
My thoughts stray to my distant love.
Desire has left me gloomy and forlorn
And birdsong and the blooming hawthorn
Please me no more than icy winter

I shall never profit more from Amor
If I may not enjoy this distant love.
For I know of no finer
Or fairer woman, far or near.
Her merit is so true and noble
That there, in the realm of the Saracen,
For her would I be thrown in chains

New things, joy and sorrow, would I taste
Just to see this distant love,
But I know not when I shall see her
For our lands lie too far apart!
So many roads, so many mountain passes!
And the way is long,
Thus I cannot know my fate:
May what God wills be granted me complete.
Joy, were I bold enough to ask her
Some refuge in that distant land;
And if she would I'd find shelter there,
By her side, though I come from afar.
And consolation shall be mine
When I draw near my distant lover
To engage in noble conversation

I know that God's word is true
And so I'll see my distant love;
I await this like a holy day
But I have two ills, so far away is she.
Oh! would I were a pilgrim there
Where my staff and coarse habit
Might be kissed by her beauteous eyes.

God who made the world,
And fashioned this distant love:
Grant that my heart, of good lineage,
Shall soon see this distant love:
In real life, in some pleasance
Or splendid garden that
Would strike me as a new palace.

In truth, my desire is all untamed,
And I yearn for this distant love;
A hostage to that joy alone,
I desire the pleasure of distant love.
But my vineyard gives no wine,
For my stepfather cast a spell on me
To have me love, but unrequited.

Love of Distant Lands
Jaufré Rudel (twelfth century)
Songs
When the fountain stream runs clear
And the rose is queen of the woods
And the nightingale on his bough
Trills and beautifies his sweet song
It's only right that I join in with mine.

Distant love,
For you all my heart aches
Nor may I have remedy
If I hearken not to your call:
Oh, for the warmth of love and soft wool,
Among the flowers or between the sheets
With my heart's desire for company.
But I can never have her near
Small wonder then that love's fire consumes
me
A nobler Christian, Jew, or Saracen
There never was, by God's decree.

He who wins her love
Feeds on manna sublime
I yearn for her night and day,
But desire robs me of that sun
And sharper than any thorn
Is the pain that only joy can heal.

Having no paper, I send
this verse to be sung by Filhol
in the goodly romance tongue
To Messer Hugo,
And the men of Poitou,
Of Berry and Guiana,
And, with joy, to the Bretons.

tormented lover, hastens to his death bed, where she has just enough time to give him the chastest of kisses before he expires. The legend was evidently inspired not only by certain aspects of Rudel's real life but also by his songs, which speak of his passion for a Beauty he had never seen but only dreamed of.

In Rudel's case we find ourselves face to face with the glorification of impossible love, a love he wanted to be that way, and this is why, more than any other poet, he held an irresistible appeal for the Romantic imagination of later centuries. It is therefore interesting to read, along with this troubadour's works, those of **Heinrich Heine, Giosuè Carducci,** and **Edmond Rostand,** who in the nineteenth century took up the original songs, quoting them almost word for word, thus turning Rudel into a Romantic legend.

Certainly influenced by the troubadours, the Italian poets of the *stilnovo* school reworked the legend of the unattainable woman, transforming the

Heinrich Heine
Romancero- Last Poems, 1851

The walls of castle Blaye
Are hung with tapestries
Woven by the expert hand
Of her who was countess of Tripoli.

Her heart she wove into them
And with tears of love
She bound with spells
This scene of sorrow:

The countess who Rudel
Dying on the strand
Saw and in seeing knew
The face of his every tormented dream,

And Rudel, who for the first time
And the last, now truly
Sees that Lady
Who in dreams possesses him.

The countess bends over him
Embracing him with love
And kisses the bloodless mouth
That had praised her gloriously.

But oh! That kiss is now transformed
Into a kiss of farewell
As she the cup of sorrow
And of pleasure drained.

In castle Blaye, at night
The figures on the tapestries
Tremble, rustle, whisper
As suddenly they return to life.

And the Lady and the Troubadour
Their spectral limbs arouse
And come down from the walls
To stroll through the halls.

Sweet pleasantries, whispers

Languorous confidences
And the dead courtesies
Once dear to the troubadours.

"O Jaufré! The dead heart
Warms at your speech
In embers long spent
I feel the fire crackling."

"Melisenda! Joy and bloom!
In your eyes I return to life
Dead is only my sorrow
And my bodily affliction."

"O Jaufré! One day we did love
As in dream, and now in death
We love each other: it is the god of Love
Who has decreed this prodigy.

"Melisenda! What is dream,
Or death? Vain words
Truth lies only in love
And I love you, O Ever beauteous!"

"O Jaufré! How sweet is
The tender moonbeam!
I had liefer not return
Beneath the fine sun of May."

"Melisenda! O sweet and fond
You are the sun and the light
Where you pass, it is Spring
May and love are reproduced."

Thus these gentle ghosts
Stroll up and down in talk
While the moonlight hearkens
As it filters through the arches.

Until finally comes the Dawn
To banish the gentle spirits
As, fearful, to the tapestries
It drives them back.

Giosuè Carducci
Jaufré Rudel, 1888
From Lebanon the new morning
Trembles rosy over the sea
As out of Cyprus sails
The crusader ship.
Gasping with fever in the stern
Lies the prince of Blaye, Rudel
Seeking to glimpse
The castle high in Tripoli.

With the Asian shore in sight
The song rings out
"Love from a distant land,
For you my heart aches."
The flight of a gray halcyon
Carries this sweet lament,
And above the white sails
The sun is afflicted with clouds.

Sails furled, the ship
Moors in the peaceful harbor
Solitary and pensive, Bertrand takes
The road for the hill
The shield of Blaye he bears
Veiled with funereal drape
As he hastens to the castle to seek
Melisenda
The countess of Tripoli.

I come a messenger of love
I come a messenger of death
A message am I from the lord
Of Blaye, Jaufré Rudel
News of you was brought him
He loves and sings of you unseen
And he lies dying here
Lady, the faithful poet greets you.

The lady looked long upon the squire
With pensive gaze.
Then she rose, covering with a black veil
That face with starry eyes:
"Squire," said she in haste, "we go,
Where does Jaufré lie dying?"
The first faithful to the call
And the last to the word of love.

Beneath a fine pavilion
Lay Jaufré on the shore.
In tender poesy he made
Rise up his supreme desire:
"O Lord who decreed for me
This distant love,
Be it Thy will that at her gentle touch
I draw my dying breath!"

Betimes with the trusty Bertrand
Came the woman thus invoked,

And on hearing the final note,
Moved, she stood on the threshold;
But speedily, with trembling hand,
She drew back the veil to reveal
Her face; and to the wretched lover
"Jaufré," said she, "I am come."

Turning, raising himself up
On the thick carpets, the Lord Jaufré
Gazed upon that most beautiful face
And sighed long as he gazed.
"Are these the beautiful eyes that once
Did promise me love in thought?
Is this the brow to which
My beautiful dream did fly?"

Thus as on a May night
When the moon sends out
Its silvery beams over the pulsing
world;
So did that serene beauty
Seem to the ravished lover
To drip like some divine sweetness
Into the heart of the dying man.

Countess, what is this life?
But the shadow of a fleeting dream.
The brief tale is over,
The true immortal is love.
Open your arms to the sufferer.
Despite this latest banishment I await
you;
And now, Melisenda, with a kiss
Commend you this dying spirit.

Over the wan lover the lady
Stooped and took him to her bosom
Thrice to the trembling lips
She gave the kiss of love.
And from the cloudless sky the sun
Set smiling over the flowing waves
Of her blonde tresses,
Limning the dead poet
In a pool of light.

Edmond Rostand
The Distant Princess, 1895
It is no great fortune
To sigh for a betrothed,
Blonde, chestnut, or brunette,
When, blonde or brunette
Are for the taking.
But I love a distant princess!

No, what praise is there
In continuing to love
When you may kiss
Her tresses, and hold
A hand freely bestowed …

And I, I love the distant princess!

What a sublime tale it is
To love who loves you not,
To love without fear
Of a gamble,
Only the fragile renown
Of a beautiful lady.
And I love a distant princess!

And it is a divine thing
To love, to be able
To invent a queen
However illusory …
Only the dream is our concern,
And without it, all things cease.
I love the distant princess!

Donna Angelicata
Lapo Gianni (thirteenth century)
Angelic Figure
Angelic figure descended anew
From heaven to dispense your
Benisons,
The supreme god of Love
Has imbued you with all his virtue.
Your heart unleashed an emotion,
That, through your eyes, came forth
To wound me
When I looked upon your loving face;
And it entered my eyes with
Such sure and nimble speed
That my heart and soul
Were put to flight, the heart
Amazed, the soul in fear;
And when they felt this emotion
Proudly approaching,
And felt the power
Of the sudden shock,
They feared in that moment
That Death would supervene.
Then, when my soul regained
Its strength, it set to calling my heart
Crying out to it: "Are you dead,
perchance,
For I cannot hear your beating?"
My heart, in which scant life remained
(Alone, forlorn and devoid of comfort,
And trembling so it could barely
speak),
Replied: "Oh, soul, lend me succor,
And lead me back to the tower of
reason."
And thus, together, they made their way
Back to whence the heart had been
driven out.
At that point my lips were turned to
stone, alas,
And I seemed to live no more

*Dante with Beatrice
in Paradise,
Cod. Marc. It. IX, 276,
fifteenth century.
Venice, Biblioteca
Nazionale Marciana*

*following pages
Dante Gabriel Rossetti,
Dante's Dream,* 1871.
Liverpool,
Walker Art Gallery

experience of repressed carnal desire into a mystic state of mind. In this case too, the interpretations of the ideal *donna angelicata* ("angel-like woman") of the *stilnovisti* gave rise to a plethora of interpretations, including the fanciful idea that they belonged to the heretical sect the *Fedeli d'Amore* (Faithful of Love), and that the womanly ideal they advocated was an allegorical veil covering complex philosophical and mystical concepts. But there is no need to follow these interpretative adventures in order to realize that in Dante the *donna angelicata* certainly was not the object of desire repressed or endlessly deferred, but a path to salvation, a means of ascending to God; no longer an opportunity to err, sin, or betray, but a path to a higher spirituality.

When I felt my heart dying of pain;
At every beat, it said over and over:
"Oh, wretched Love, I never thought
You would have been so pitiless with me!
Ah, what a cruel wrong and what a great sin
You do me, and I your loyal servitor!
For no requital will serve me
If you will torment me ever."

Beatrice
Dante Alighieri (1265-1321)
La vita nuova, II (1292-1293)
The luminous heavens had already returned almost to the same place some nine times since my birth and the time when I first set eyes upon the glorious woman of my mind, who was known to many as Beatrice—although they did not know the meaning of this name. In this life she had lived for the span it takes the star-studded firmament to move east for one

twelfth of a degree, and thus she had just turned nine when she first appeared before me, and when I saw her I was nearly ten. She came clad in vermilion, the noblest color, modest and virtuous; girdled and adorned in harmony with her tender years. In that moment I must truly say that the vital spark, which abides in the most secret chamber of my heart, set to trembling with such violence that even the slightest beat of my heart seemed horribly strong as, trembling, it uttered these words: *"Ecce deus fortior me, qui veniens dominabitur mihi."* (Behold a god stronger than I, and he shall come to rule over me).
In that moment the animal spirit, which abides in the high chamber whence all the sensible spirits take their perceptions, set to marvelling greatly, and speaking especially to the spirits of the sight, it said these words: "Apparuit iam beatitudo vostra" (Now your beatitude

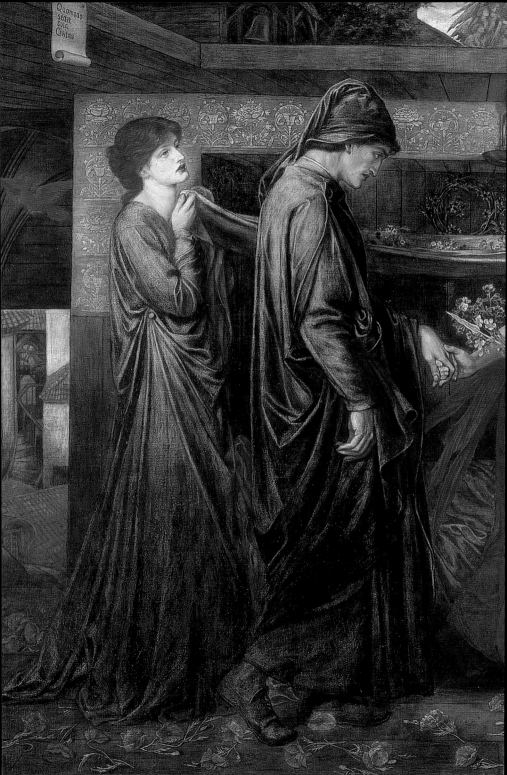

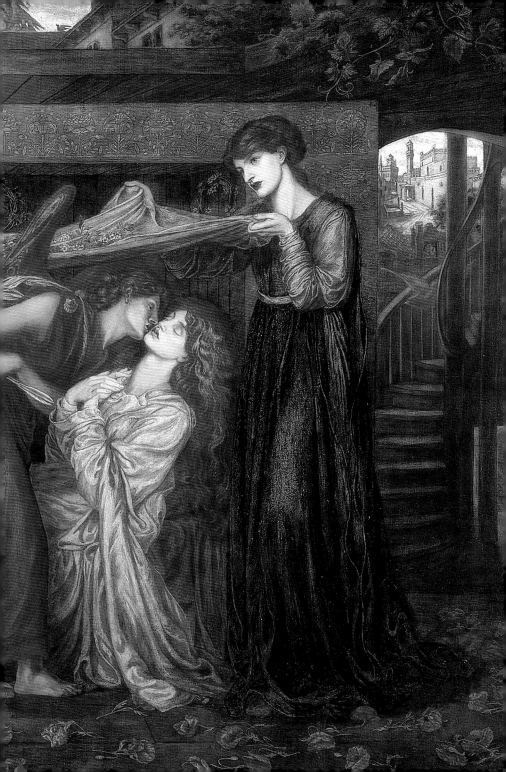

It is in this sense that we have to follow the transformation of Dante's Beatrice, who in his *Vita nuova* is still seen as an object of amorous passion, albeit of the chaste variety, so much so that her death plunges the poet into grief, but in the *Divine Comedy* she has become the only woman who can allow Dante to attain the supreme contemplation of God. Of course Dante does not stop praising her Beauty, but this Beauty, by this point wholly spiritualized, takes on an increasingly paradisiacal tone and merges with the Beauty of the angelic cohorts.

Nonetheless, the *stilnovista* ideal of the angel-like woman was picked up again, on the eve of the Decadent movement (cf. Chapter XIII), in the atmosphere of ambiguous religiosity, mystically carnal and carnally mystical, of the Pre-Raphaelite school, which imagined (and portrayed) Dantean beings who were diaphanous and spiritualized, but imbued with a morbid sensuality and made more desirable in a carnal sense because celestial glory or death has delivered them from the doleful and languid erotic drive of the lover.

appears). At that point the natural spirit, the one that abides in the part where our nourishment is attended to, set to weeping, and sobbing spoke these words: "Heu miser, quia frequenter impeditus ero deinceps!" (Alas, wretch that I am, from now on I shall often be troubled). From then on Love was master of my soul, which was so straightway wed to him that he began to dominate me with such certainty and dominion, through the power vouchsafed him by my fantasy, that I was obliged to satisfy him in all things. He commanded me many times to seek out this most youthful angel and gaze upon her; so that many's the time and oft in my childhood I sought her and saw that she was of such noble and laudable demeanor that of her it could truly be said, as Homer did: "She seemed not the daughter of mortal man, but of a god." And though her image, which was ever with me, was a ruse of Love's the better to rule me, yet it was of such noble virtue it never suffered Love to govern me without the faithful counsels of reason in all those things that make it meet to hearken to such counsels. But since it may seem fantastic to dwell on the passions and deeds of my tender years, I shall leave them, omitting the many things that could be taken from the sample whence they sprang, and thus come to those words inscribed in my memory under more important headings.

So Gracious
Dante Alighieri (1265-1321)
La vita nuova, XXVI (1292-1293)
So gracious and so virtuous seems
My Lady when she greets others

That all tongues tremble and are stilled,
And no eye dares to look upon her.
She passes by, hearing their praises,
Clad in benign humility;
And, it seems, heaven has sent her
Down to earth to manifest a miracle.
Most pleasing is she to look upon for those who see her,
Through the eyes she sends a sweetness to the heart,
That must be felt to be believed:
And from her lips there seems to come
A sweet spirit full of love that
Says to the soul: sigh.

Spiritualized Beauty
Dante Alighieri (1265-1321)
Paradiso, XXIII, vv. 1-34
Even as a bird, 'mid the beloved leaves,
Quiet upon the nest of her sweet brood
Throughout the night, that hideth all things from us,
Who, that she may behold their longed-for looks and find the food wherewith to nourish them,
In which, to her, grave labors grateful are,
Anticipates the time on open spray
And with an ardent longing waits the sun,
Gazing intent as soon as breaks the dawn:
Even thus my Lady standing was, erect
And vigilant, turned round towards the zone
Underneath which the sun displays less haste;
So that beholding her distraught and wistful,
Such I became as he is who desiring
For something yearns, and hoping is appeased.
But brief the space from one

School of Fontainbleau,
*Gabrielle d'Estrées with
One of Her Sisters*,
c. 1595. Paris, Musée du
Louvre

When to the other;
Of my awaiting, say I, and the seeing
The welkin grow resplendent more and more.
And Beatrice exclaimed: "Behold the hosts
Of Christ's triumphal march, and all the fruit
Harvested by the rolling of these spheres!"
It seemed to me her face was all aflame;
And eyes she had so full of ecstasy
That I must needs pass on without describing.
As when in nights serene of the full moon
Smiles Trivia among the nymphs eternal
Who paint the firmament through all its gulfs,
Saw I, above the myriads of lamps,
A Sun that one and all of them enkindled,
E'en as our own doth the supernal sights,
And through the living light transparent shone
The lucent substance so intensely clear
Into my sight, that I sustained it not.
O Beatrice, thou gentle guide and dear!

Pre-Raphaelite School
Dante Gabriel Rossetti
Sybilla Palmifera, c. 1860
Under the arch of Life, where love and death,
Terror and mystery, guard her shrine, I saw
Beauty enthroned; and though her gaze struck
awe,
I drew it in as simply as my breath.
Hers are the eyes which, over and beneath,
The sky and sea bend on thee—which can draw,
By sea or sky or woman, to one law,
The allotted bondman of her palm and wreath.
This is that Lady Beauty, in whose praise
Thy voice and hand shake still—long known to
thee
By flying hair and fluttering hem—the beat
Following her daily of thy heart and feet,
How passionately and irretrievably,
In what fond flight, how many ways and days!

Magic Beauty between the Fifteenth and Sixteenth Centuries

1. Beauty Between Invention and Imitation of Nature

In the fifteenth century, under the influence of distinct but convergent factors—the discovery of perspective in Italy, the spread of new painting techniques in Flanders, the influence of Neoplatonism on the liberal arts, the climate of mysticism promoted by Savonarola—Beauty was conceived according to a dual orientation that today strikes us as contradictory, but that contemporaries found coherent.

Those contemporaries saw Beauty both as an imitation of nature in accordance with scientifically established rules and as the contemplation of a supernatural degree of perfection that could not be perceived by the eye because it was not fully realized in the sublunary world. Knowledge

Sandro Botticelli,
Madonna of the Magnificat, c. 1482.
Florence,
Galleria degli Uffizi

opposite
Bartolomeo Veneto,
Flora,
detail, c. 1507-1510.
Frankfurt, Städelsches
Kunstinstitut

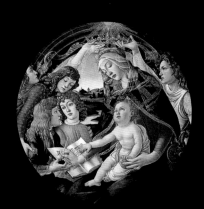

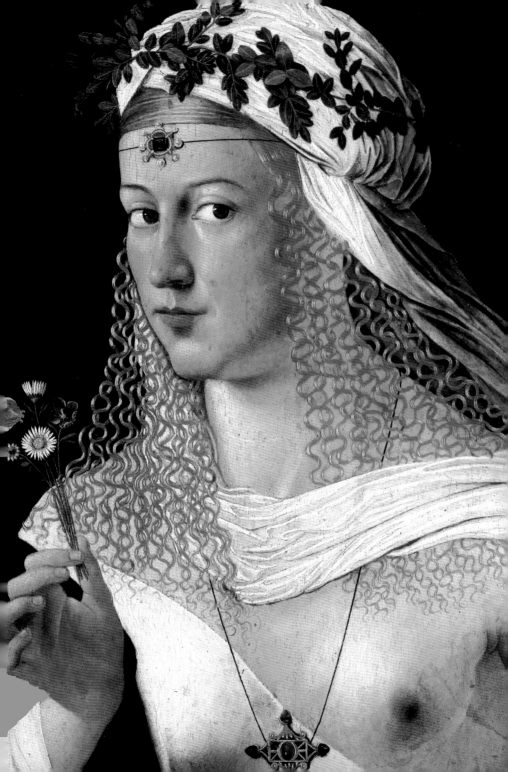

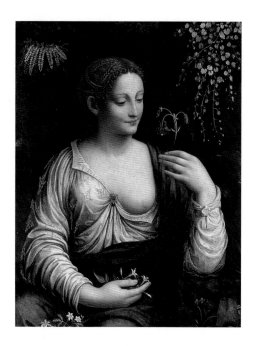

Francesco Melzi,
Flora,
1493-1570.
St. Petersburg, State
Hermitage Museum

opposite
Leonardo da Vinci,
The Virgin of the Rocks,
c. 1482. Paris, Musée du
Louvre

of the visible world became the path toward knowledge of a suprasensible reality governed by logically coherent rules. The artist was therefore at once—and without this seeming contradictory—a *creator* of new things and an *imitator* of nature. As Leonardo da Vinci states clearly, imitation is, on the one hand, a form of study and inventiveness that remains faithful to nature because it recreates the integration of single figures with the natural element and, on the other hand, an activity that also requires technical innovation (like Leonardo's renowned sfumato technique, which lent an enigmatic air to the Beauty of women's faces) and not a passive repetition of forms.

Painter's Power
Leonardo da Vinci
On Painting, VI, 1498
The painter is master of all the things that may come to man's mind, and so if he wishes to see beauties of which he may become enamored he has the power to make them, and if he wishes to see monstrous things that terrify him, or clownish and comical things, or truly pitiful things, he is the lord and creator of them. If he wishes to produce deserted places, or spots that offer cool shade in hot weather, he portrays them, and it is the same for warm places in cold weather. The same

goes for valleys: if from the high mountain peaks he wishes to reveal the open countryside, and if after that he wishes to see the horizon over the sea, he has the power to do so; and the same also goes if from the lowlying valleys he wishes to see the high mountains, or from the high mountains the low valleys and the beaches. And indeed that which is present in the universe in essence, presence, or imagination he has first in mind, and then in his hands, and these are of such excellence that, as they make things, they create a proportioned harmony as instantly apparent as the harmony of nature.

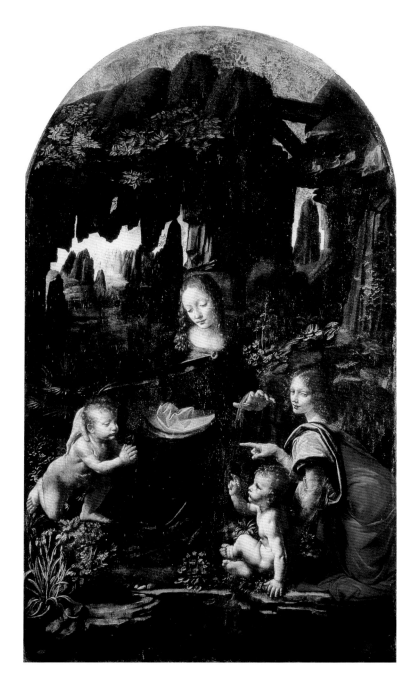

2. The Simulacrum

Reality imitates nature without being a mere mirror to it and, in the detail (*ex ungue leonem*, as Vasari put it, "you may tell the lion by his claws"), it reproduces the Beauty of the whole. This ennoblement of the simulacrum would not have been possible without some decisive progress in pictorial and architectonic techniques: the perfection of perspectival representation on Brunelleschi's part and the spread of oil painting in Flanders.

The use of perspective in painting implies a coincidence of invention and imitation: reality is reproduced with precision, but at the same time in accordance with the subjective point of view of the observer, who in a certain sense "adds" to the exactitude of the object the Beauty contemplated by the beholder.

In Alberti's view, a picture is an open window within which perspectival space increases the number of planes. Space is no longer ordered

Domenico Ghirlandaio,
Young Woman,
c. 1485.
Lisbon, Museu
Calouste Gulbenkian

Invention and Imitation
Leon Battista Alberti
On Painting, 1435
I want young people [...] to learn how to draw the outlines of the planes well and to practice this almost as they did when learning the rudiments of painting. Then they should learn how to join the planes together, after which they should learn each distinct form of every member, and commit to memory anything that may be different about each member. The differences between members are many and quite distinct. You will see that some people have upturned or humped noses; others have flaring, ape-like nostrils; others have pendulous lips; some others again are adorned with small, thin lips. And hence the painter should examine each memeber carefully, for faces always differ to some degree. He should likewise note that, as we can see, in youth the limbs are rounded and delicate, as if turned, but with age they become coarser and angular. The studious painter may learn all these things from nature, and he should study all of them most assiduously, while he should always conduct this research with an alert mind and eyes ever

attentive. He should commit to memory the lap of a seated subject, and he should also remember the graceful position of the legs when a person is seated. With standing persons he should note that all parts of the body are aware of their purpose and measure. Further, he will take pleasure in making all the parts true to his subject, but he should also add beauty; for in painting, gracefulness is as appreciated as it is requested. Demetrius, a painter of olden times, failed to win great praise because he was far more interested in making things look natural than beautiful. This is why it is worth taking from all beautiful bodies the part that is most praised. The understanding and expression of beauty is to be had only through study and diligence. And this is by no means easy, for complete beauty is never found in a single body, but is a rarity distributed in many bodies. Hence we should make every effort to discover and learn beauty. Those who give themselves over to learning and pondering over difficult things will have little trouble with simpler tasks. For nothing is ever so difficult that it may not be gained through study and application.

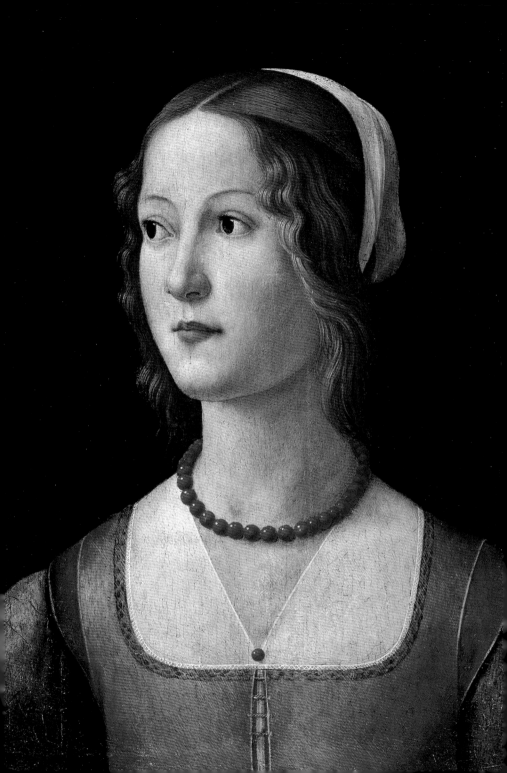

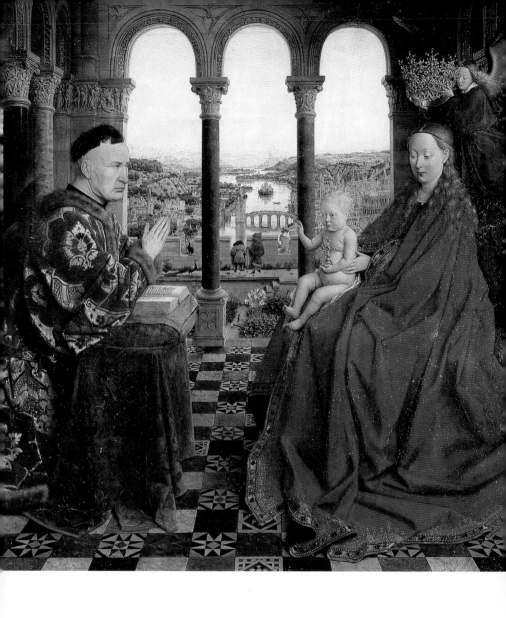

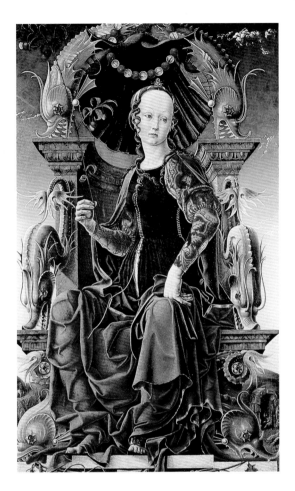

opposite
Jan van Eyck,
The Virgin and Chancellor Rollin, c.1435.
Paris, Musée du Louvre

Cosmè Tura,
Spring, 1463.
London, National Gallery

empirically, but is organized into a series of carefully integrated receding planes, brimming with light and color, which give the impression of depth.

At the same time, in Flanders, the use of oil paints (apparently already known in the Middle Ages) was spreading, a technique that reached its apogee with Jan van Eyck. Oil paints confer a magical effect on figures, which seem to be immersed in a quasi-supernatural luminosity, as is the case with the Ferrara cycle of paintings by Cosmè Tura, even though Tura's intentions were quite different from van Eyck's.

3. Suprasensible Beauty

In the process of rehabilitating the concept of Beauty as the imitation of nature and as such condemned by Plato, a decisive role was played by the Neoplatonic movement, promoted in Florence by Marsilio Ficino. Within the framework of a vaguely mystical concept of the All organized into harmonious and graduated spheres, Ficino set himself three tasks: to spread and modernize ancient wisdom; to coordinate the many apparently discordant aspects within the ambit of a coherent and intelligible symbolic system; and to show that this system was in harmony with Christian symbolism. Thus Beauty acquired a high symbolic value, in contrast with the concept of Beauty as proportion and harmony.

It is not the Beauty of the parts, but the **suprasensible Beauty** that is contemplated *in* sensible Beauty (even though the first of the two is superior), which constitutes the real nature of Beauty. Divine Beauty is diffused not only through humankind, but also through nature. Hence the magical character

Sandro Botticelli,
Allegory of Spring, detail,
c. 1478.
Florence,
Galleria degli Uffizi

Suprasensible Beauty
Plotinus (third century)
Enneads, V, 8
In truth there is no beauty more authentic than the wisdom we find and love in some individual. We should leave aside his face, which may be ugly, nor should we pay any heed to his appearance, but look for his inner beauty. But if that [inner beauty] does not move you to call such a man beautiful, when you look inside yourself you will not perceive yourself as beautiful either. If you seek beauty in this way then you seek it in vain, because you are looking for it in something ugly and impure. This discourse is not aimed at all people; but should you too see yourself as beautiful, remember it.

The Splendor of God
Marsilio Ficino
Platonica theologia, XIV, I, 1482
Thè splendor of God often shines out in single things and, where it shines out most perfectly, it stimulates especially those who

see that thing, arouses those who contemplate it, attracts and absorbs wholly those who go near it, obliging them to worship a splendor of that kind above all others, as one would worship a divinity, and finally to reach out only for those things that God may transform into splendor. And this emerges clearly from the fact that the sight of, or contact with, the beloved person is never enough to content a man, who will often exclaim: "This man has something in himself that burns me, while I myself do not understand what I desire!" Here it is clear that the spirit is kindled by the divine splendor that shines out in the handsome man as in a mirror and that, captured by unknown ways, the spirit is—as it were—hooked and transported on high until it loses itself in God. But God would be, so to speak, an iniquitous tyrant if he urged us to attempt to reach for things that we could never obtain. So it must be said that he urges us to seek Him in the act in which He kindles human desires with His [divine] spark.

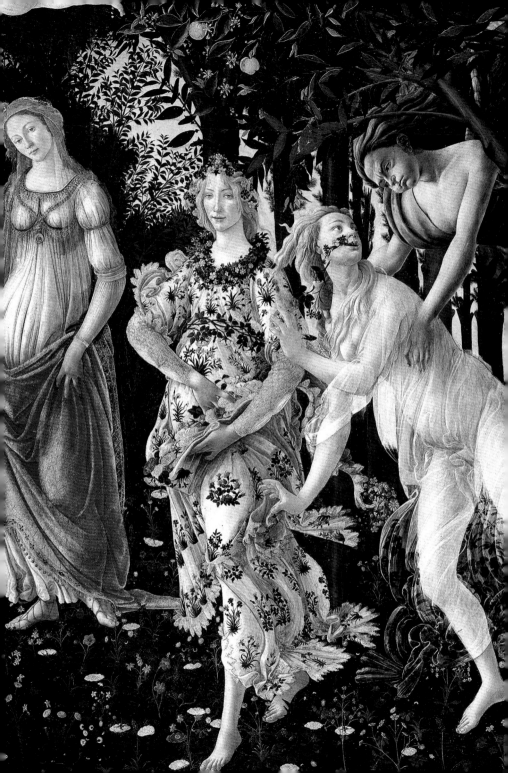

Francesco del Cossa,
Allegory of April,
Hall of the Months,
1469. Ferrara, Palazzo
Schifanoia

assumed by natural Beauty both in the work of philosophers like Pico and Bruno and in the paintings of the Ferrara school. Nor is it a coincidence that in the works of these authors hermetic alchemy, and likewise physiognomics, are more or less overtly present as keys to the understanding of nature, within a more general correspondence between Macrocosm and Microcosm.

This was the source of many treatises on love, in which Beauty was attributed a dignity and an autonomy on a par with Good and Wisdom. These writings found their way into the studios of many artists, who, thanks to growing numbers of commissions, were gradually able to free themselves of the strict rules laid down by the guilds, and, in particular, by the rule that prescribed the *non*-imitation of nature, a breach of which was now tolerated.

In the literary field, the spread of these treatises was due especially to Bembo and Castiglione and the general thrust of such writings was toward a relatively free use of Classical symbolism. At the root of all this lay the intention, typical of Marsilio Ficino, to apply the canons of Biblical exegesis to ancient mythology, allied to a relative independence of the authority of the ancients (whose work, according to Pico, was to be imitated for its overall style rather than for its concrete forms). This is what underpins the great symbolic complexity of the culture of the period, which could take concrete form in sensual images—as in the fantastic *Hypnerotomachia poliphili* (The Strife of Love in a Dream of Poliphilus) or in the Venuses of Titian or Giorgione, which are characteristic of Venetian iconography.

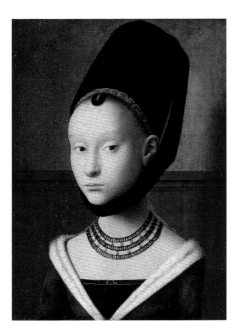

Petrus Christus,
*Portrait of a Young
Woman,*
1460-1470.
Berlin,
Gemäldegalerie

On Your Divine Image
Francesco Colonna
Hypnerotomachia poliphili, XII, 1499
[The mark] of your divine image, impressed
in this most noble creature whom Zeuxis,
had he gazed on her alone—she who was
praised far and away above all the maidens of
Agrigentum and of the whole world—would
have deemed the most fitting and singular
example of supreme and absolute perfection.
And as this most beautiful and heavenly
nymph now approached me with great joy
and gladness, and on gazing more clearly
upon her rarest beauty, which I had carefully
observed from a distance, I was left amazed
and ravished. And no sooner did her fond
aspect and most pleasing looks penetrate my
eyes and thence my soul, the memory
reawakened, showing and offering for its
contemplation she who had made of that
same heart an industrious smithy, a quiver full
of piercing darts and the permanent domicile
of her sweet image, and my heart recognized
her as she who had for many's the year
consumed my tender youth with the first,
ardent, and most passionate of loves. And so
I felt my heart bound forth as it immediately
began to beat incessantly in my wounded
breast like a raucous drum. And although

that most dearly beloved Polia—for love of
whom I have never been able to escape for
so much as a moment the flames of love's
blaze nor free myself of its tempests—of the
golden hair appeared before me looking
marvelous and most pleasing with her
blonde tresses and her brow framed by the
sweet waves of dancing locks that gladly
crowned it, nonetheless, her superb and
virginal aspect, which was unwonted to me,
and the unknown place left me greatly
amazed, apprehensive, and uncertain. In her
snow-white left hand she was holding the
narrow end of a blazing torch resting against
her milk-white bosom. This torch extended to
some degree above her golden head, and she
held out her free arm, which was far whiter
even than Pelope's and in which the fine
cephalic and basilic veins stood out like
reddish lines the color of sandalwood drawn
on a well-scrubbed parchment.
And taking my left hand with her delicate
right, with her broad and splendid brow and
with her smiling mouth perfumed with
cinnamon and her dimpled cheeks, and in
sublimely elegant tones, with pleasing and
gentle sweetness she said to me:"O
Poliphilus, come to me surely and without
hesitation …"

4. The Venuses

Neoplatonic symbolism laid particular emphasis on the image of Venus, which sprang fundamentally from Ficino's reinterpretation of mythology. All we need do is consider the "Twin Venuses" of the *Convivio*, which express two degrees of love equally "honorable and worthy of praise." In his *Sacred and Profane Love*, Titian makes specific reference to the Twin Venuses in order to symbolize the celestial Venus and the terrestrial Venus, two distinct manifestations of a single ideal of Beauty (between which Pico inserted a second celestial Venus, in a central position).

For his part, Botticelli, who was spiritually close to Savonarola (for whom Beauty was not a quality springing from the proportion of the parts, but something that shone out all the more brightly the nearer it got to divine Beauty), put the *Venus Genitrix* at the center of the dual allegory of *Spring* and the *Birth of Venus*.

Giovanni Bellini,
Young Woman at Her Toilette, 1515.
Vienna,
Kunsthistorisches
Museum

opposite, top
Giorgione,
Sleeping Venus, 1509.
Dresden,
Gemäldegalerie

bottom
Titian,
Venus of Urbino, 1538.
Florence, Galleria
degli Uffizi

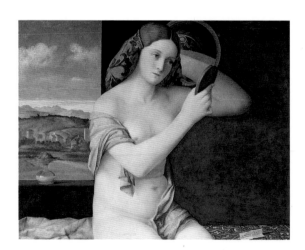

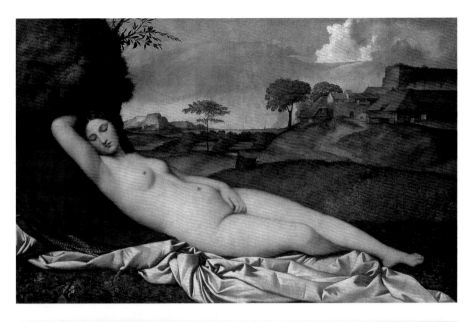

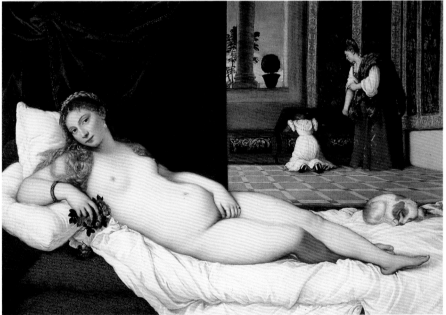

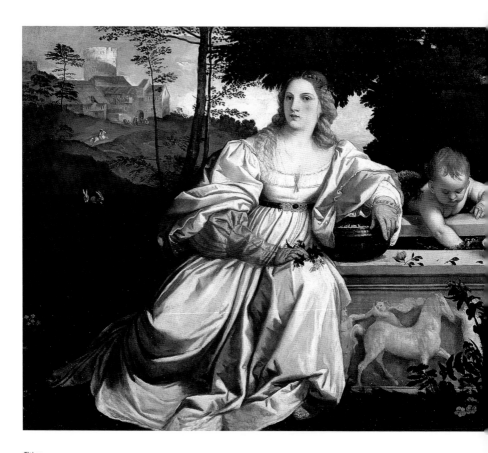

Titian,
Sacred and Profane Love,
1514.
Rome, Galleria Borghese

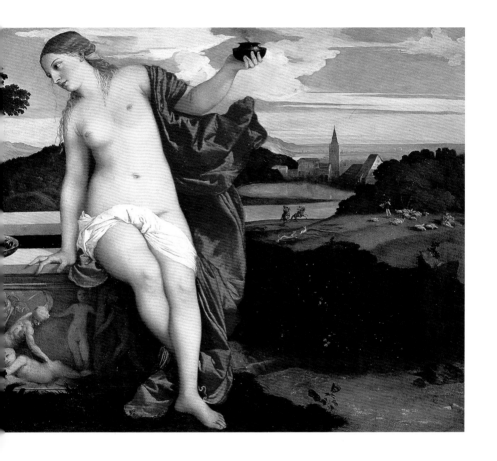

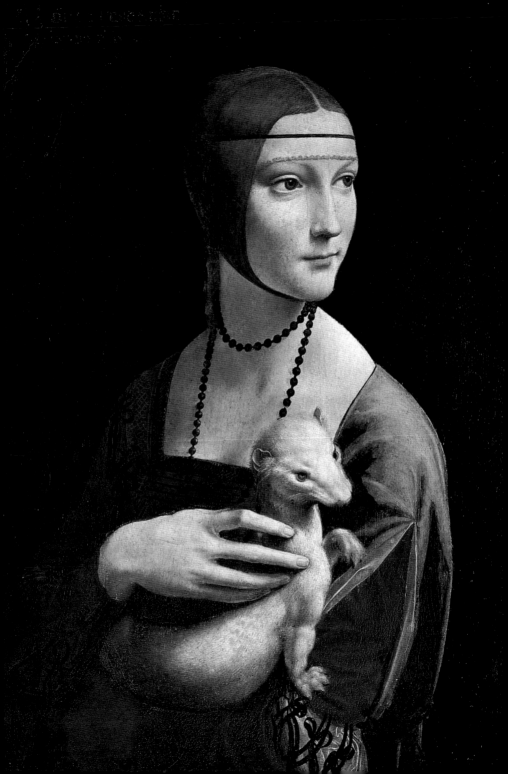

Ladies and Heroes

For a painter, portraying the Beauty of a body means responding to theoretical exigencies—what is Beauty and under what conditions is it knowable?—as well as practical ones—which canons, which tastes and social mores, allow us to describe a body as "beautiful"? How does the image of Beauty change over time, and how does it do so with regard to man and woman? In order to explain this, let us compare some images.

1. The Ladies ...

Leonardo da Vinci,
Lady with an Ermine,
1485-1490.
Krakow, The Princes
Czartoryski Museum

If we compare different Venuses, we note that a rather complex discourse is going on around the nude female body. Baldung Grien's Venus, with her sensual white complexion highlighted by the darkness of the background, clearly alludes to a physical and material Beauty made even more realistic by the imperfection (with respect to the Classical canons) of the form. Although Death is lurking at her back, this Venus marks the advent of a Renaissance woman who knows how to care for and show her body without shame.

Leonardo da Vinci's female faces are particularly elusive and inscrutable: this can be seen clearly in the *Lady with an Ermine*, where a deliberately ambiguous symbolism is expressed by the lady's unnaturally long fingers, which caress the animal. Nor does it seem fortuitous that, in this very portrait, Leonardo opted for freedom of proportions and realism in his depiction of the animal; the elusive and inscrutable character of woman's nature, which was expressed through the concept of "grace," refers again to a theoretical problem typical (but not exclusively so) of Mannerist painting and of the conditions of construction of an image within a space.

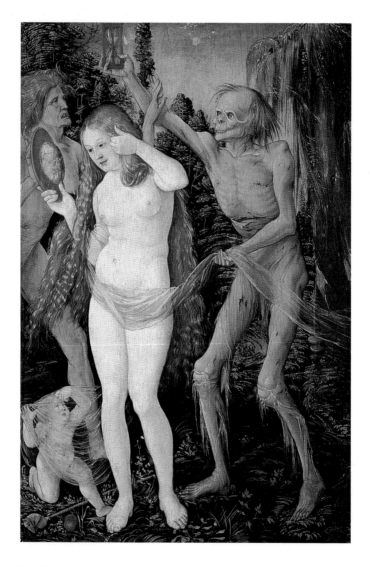

Hans Baldung Grien,
*The Three Ages of Woman
and Death*, c. 1510.
Vienna, Kunsthistorisches
Museum

opposite
Titian,
Flora, 1515-1517.
Florence, Galleria degli Uffizi

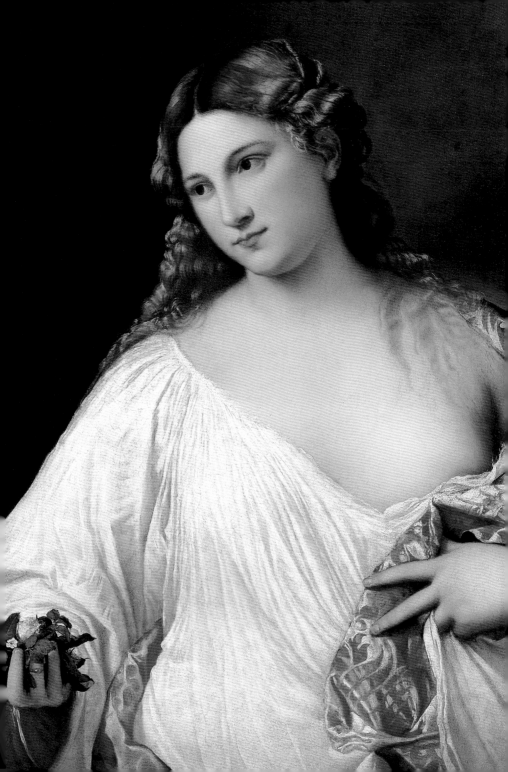

Correggio,
Danaë,
1530-1531.
Rome, Galleria Borghese

opposite
Giorgione,
The Tempest, detail,
1507
Venice, Gallerie
dell'Accademia

Renaissance woman used cosmetics and devoted particular attention to her hair (a refined art, especially in Venice), dyeing it a shade of blonde that often tended toward red. Her body was made to be enhanced by the products of the goldsmith's art, which were also objects created according to canons of harmony, proportion, and decoration. The Renaissance was a period of enterprise and activity for women, who decreed fashion trends at court and conformed with the taste for luxurious display, but did not forget to cultivate their minds, playing an active role in the fine arts and showing ability in discourse, polemics, and philosophy.

Domenichino,
Diana, detail,
1616-1617.
Rome, Galleria Borghese

Diego Velásquez,
The Toilet of Venus,
1647-1651.
London, National
Gallery

Later, by way of a foil to the female body, which was publicly displayed, there came the private, intense, quasi-egoistic expression to be found on women's faces, not easy to decipher on a psychological level and sometimes deliberately mysterious, as may be seen in the *Venus of Urbino* by Titian, or in the woman portrayed in Giorgione's *The Tempest*.

The Venus of Velásquez is seen from behind, and we see her face only as a reflection in the mirror. This artificiality of space and the elusive nature of womanly Beauty came together, in later centuries, in the women of Fragonard, where the dreamlike character of Beauty is already a harbinger of the extreme freedom of modern painting: if there are no objective constraints for the representation of Beauty, then why not depict a bourgeois picnic on the grass complete with a beautiful nude?

Jean-Honoré Fragonard,
The Removed Shirt,
1760.
Paris, Musée du Louvre

opposite
Édouard Manet,
Le déjeuner sur l'herbe,
detail, 1863.
Paris, Musée d'Orsay

2. ... and the Heroes

The male body was also beset by these problems, and the way it was represented bears out the truth of this. Renaissance man put himself at the center of the world and loved to have himself portrayed in all his haughty power, not detached from a certain toughness: Piero della Francesca gave the face of Federico da Montefeltro the expression of a man who knows exactly what he wants. The form of the body neither conceals his strength nor the effects of pleasure: the man of power, fat and stocky when not muscular, bears and flaunts the marks of the power he wields. Lodovico il Moro, Alessandro Borgia (who was an object of desire for the women of his day), Lorenzo il Magnifico, and Henry VIII of England were certainly not slim. And while Francis I of France, in Jean Clouet's portrait, conceals his unfashionable slimness beneath flowing robes, his mistress La Belle Ferronière, portrayed by Leonardo, represents another addition to the gallery of inscrutable and elusive female expressions.

Hans Holbein
the Younger,
Henry VIII, 1540.
Rome, Galleria
Nazionale d'Arte Antica

Follower of
Agnolo Bronzino,
Lorenzo de' Medici,
Florence, Museo degli
Argenti, Palazzo Pitti

opposite
Piero della Francesca,
Federico da Montefeltro,
c. 1465. Florence,
Galleria degli Uffizi

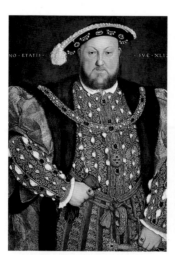

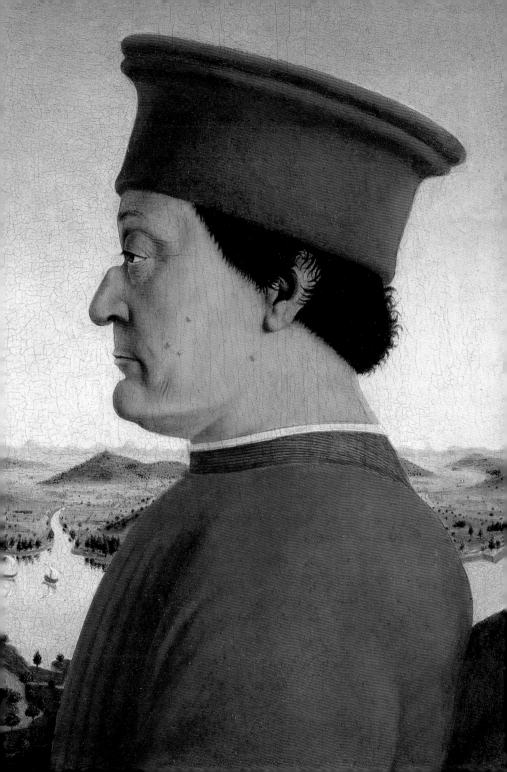

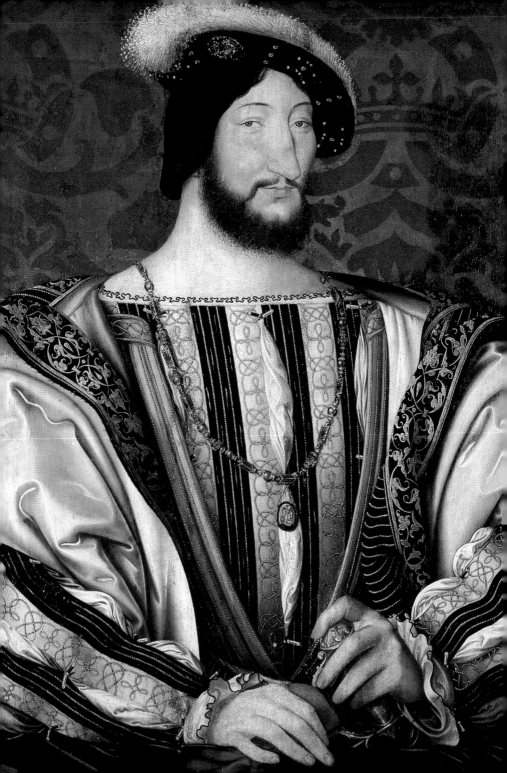

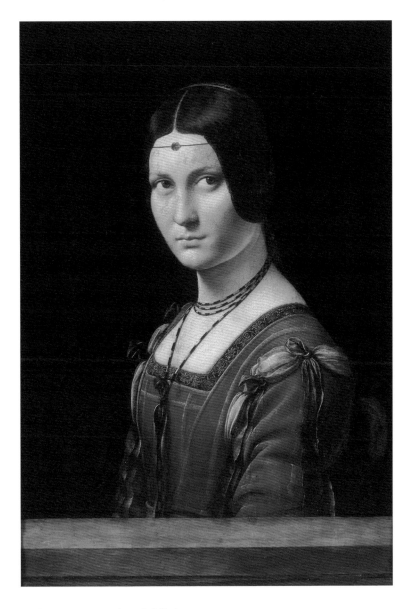

opposite
Jean Clouet,
Francis I, 1525-1530.
Paris, Musée du Louvre

Leonardo da Vinci,
La Belle Ferronière,
1490-1495.
Paris, Musée du Louvre

Andrea del Verrocchio,
Monument to
Bartolomeo Colleoni,
detail, 1479-1488.
Venice, Campo SS.
Giovanni e Paolo

Caravaggio,
The Conversion of St.
Paul, 1601.
Rome, Church of Santa
Maria del Popolo

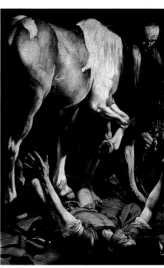

opposite
Pieter Brueghel the
Younger, *Wedding Feast,*
detail, 1568.
Ghent, Museum voor
Schone Kunsten

While aesthetic theory was grappling with the rules of proportion and symmetry of the body, the powerful men of the day were a living breach of these rules: the male figure too played its part in enhancing the artist's freedom from Classical canons.

Let us consider Verrocchio's statue of Bartolomeo Colleoni: imposing physique, a cold, self-assured expression, the *condottiero* sits firmly astride his charger, in homage to that Classical iconography in which man was seen as the master of horses, dogs, or falcons (or lions, as in the numerous portraits of St. Jerome), while the greater variety of animals portrayed together with women (from the rabbit in Titian's *Madonna del Coniglio* to ermines, from goldfinches to the pet dog in Velásquez's *Las Meninas*), alludes at times to their docility, and at others to their impenetrable ambiguity.

Nonetheless, when painting freed itself from its respect for Classical style and iconography, men could be shown unhorsed and tumbling to the ground, while they took on a realistic, even popular appearance, as in Caravaggio's The Conversion of *St. Paul.* Finally, in the works of Brueghel, another great painter of the poor peasant body whose formal Beauty is smothered by the harshness of material life, animals lose all mystical significance to embody the figures of the folk proverbs of the Flemish countryside.

3. Practical Beauty ...

There is no doubt that this transition was a result of a commingling of the Reformation and, more generally, the changes in social mores that took place between the sixteenth and seventeenth centuries. The image of woman underwent progressive change: woman was clothed once more, to become housewife, governess, and administrator. For example, from the sensual Beauty of Anne Boleyn we move on to the stiffness of Jane Seymour, Henry VIII's third wife: her portraits show her with the thin lips and the expression of a competent mistress of the house, without any passionate traits, like many of Dürer's women for that matter.

Johannes Vermeer,
Woman Pouring Milk,
1658-1660.
Amsterdam,
Rijksmuseum

opposite
Hans Holbein the
Younger, *Portrait of Jane
Seymour*, 1536.
Vienna,
Kunsthistorisches
Museum

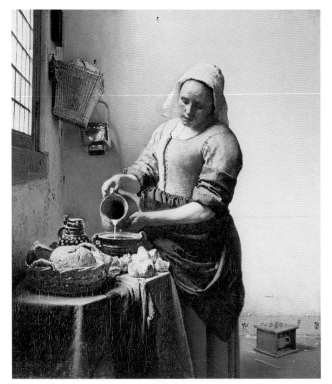

Jan Steen,
As the Old Sing, So Pipe the Young (The Christening), c. 1660. Berlin, Nationalgalerie

Despite this, it was precisely Flanders, subject to the contradictory tensions created by the rigidity of Calvinistic morality on the one hand, and the customs of an emancipated lay bourgeoisie on the other, which witnessed the generation of new human types, in which Beauty was allied to the useful and the practical.

In the emblem-books of Jacob Cats, with their entirely practical and down-to-earth orientation, or in the settings of Steen's paintings, where domestic interiors are indistinguishable from those of taverns, we can clearly see how a culture oriented toward the "privations of abundance" shows women who can be sensual temptresses but efficient housewives at the same time, while the simple austerity of male dress refers to the need to foreswear unnecessary frills that might get in the way if, for example, one had to dash off to repair a dyke that had suddenly broken its banks.

4. ...AND SENSUAL BEAUTY

4. ... and Sensual Beauty

Dutch Beauty was, in short, freely practical, while the Beauty expressed by Rubens at the court of the Sun King was freely sensual. Untrammeled by the dramatic events of the century (Rubens was at work during the Thirty Years' War) and by the moral impositions of the Counter Reformation, Rubens's woman (like Helena Fourment, his extremely young second wife) expresses a Beauty devoid of recondite meanings, glad to be alive and to show herself. On the other hand, in his *Self-Portrait*, in a typical pose inspired by the great portraits of Titian (*The Young Englishman*), Rubens distances himself from

Raphael and
Giulio Romano,
La Fornarina,
1518-1519.
Rome, Galleria
Nazionale d'Arte Antica.

page 210
Peter Paul Rubens, *The
Fur (Helena Fourment
as Venus)*, 1630-1640.
Vienna,
Kunsthistorisches
Museum

page 211
Peter Paul Rubens,
*Self-Portrait
with Isabella Brant*,
detail, 1609-1610.
Munich, Alte Pinakothek

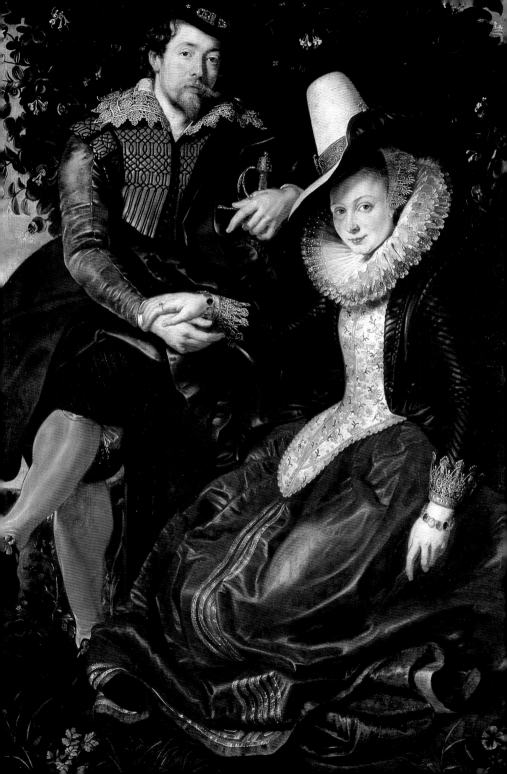

the model in the serene awareness of his expression, which seems to want to communicate itself and nothing else, devoid of the intense spirituality of certain figures painted by Rembrandt and of the acute, penetrating gaze of those portrayed by Titian.

The world of courtly life was thus on its way to dissolving into that spiral of stately dances that wound its way through the century that followed; the dissolution of Classical Beauty, in the forms of Mannerism and the Baroque, or in the realism of Caravaggio and the Flemish school, was already showing the signs of other forms of the expression of Beauty: dream, wonderment, disquiet.

Caravaggio,
Magdalen in Ecstasy,
detail, 1606.
Rome, private collection

Gracious and Sacred Beauty
Baldassare Castiglione
Book of the Courtier, IV, 62, 1513-1518
[He must also reflect that] just as a man cannot hear with his palate or smell with his ears, beauty can in no way be enjoyed nor can the desire it arouses in our souls be satisfied through the sense of touch but solely through what has beauty for its true object, namely, the faculty of sight. So he should ignore the blind judgment of these senses and enjoy with his eyes the radiance, the grace, the loving ardour, the smiles, the mannerisms, and all the other agreeable adornments of the woman he loves. Similarly, let him use his hearing to enjoy the sweetness of her voice, the modulation of her words, and, if she is a musician, the music she plays. In this way, through the channels of these two faculties, which have little to do with corporeal things and are servants of reason, he will not nourish his soul on the most delightful food and will not allow desire for the body to arouse in him any appetite that is at all impure.

Superhuman Beauty
Miguel de Cervantes
Don Quixote, I, Chapter XIII, 1605-1615
At this Don Quixote heaved a deep sigh and said, "I cannot say positively whether my sweet enemy is pleased or not that the world should know I serve her; I can only say in answer to what has been so courteously asked of me, that her name is Dulcinea, her country El Toboso, a village of La Mancha, her rank must be at least that of a princess, since she is my queen and lady, and her beauty superhuman, since all the impossible and fanciful attributes of beauty which the poets apply to their ladies are verified in her; for her hairs are gold, her forehead Elysian fields, her eyebrows rainbows, her eyes suns, her cheeks roses, her lips coral, her teeth pearls, her neck alabaster, her bosom marble, her hands ivory, her fairness snow, and what modesty conceals from sight such, I think and imagine, as rational reflection can only extol, not compare."

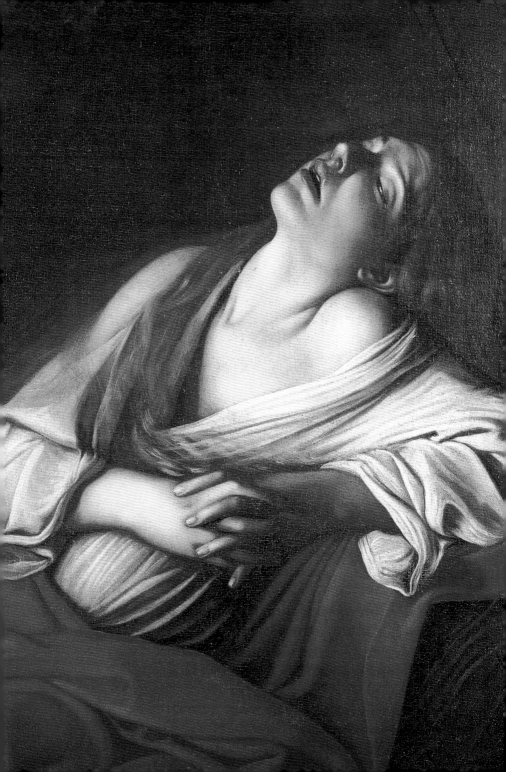

From Grace to Disquieting Beauty

1. Toward a Subjective and Manifold Beauty

During the Renaissance, the so-called "Grand Theory"—according to which Beauty consists in the proportion of the parts—reached a high level of perfection. At the same time, however, in Renaissance culture and mentality, there came into being centrifugal forces whose thrust was toward a disquieting, nebulous, and surprising Beauty. This was a dynamic movement, which only for explanatory purposes can be boiled down to academic categories like Classicism, Mannerism, Baroque, or Rococo. What ought to be emphasized is the fluid character of a cultural process that permeated the arts and society alike, a process that only briefly and often only apparently crystallized into set, clearly defined figures. Thus it happened that the Renaissance "manner" spilled over into Mannerism; that progress in mathematics and the related sciences, used during the Renaissance to relaunch the Grand Theory, led to the discovery of harmonies

Caravaggio,
Head of Medusa,
c. 1597
Florence, Galleria
degli Uffizi

opposite
Agnolo Bronzino,
Lucrezia Panciatichi,
c. 1540.
Florence, Galleria
degli Uffizi

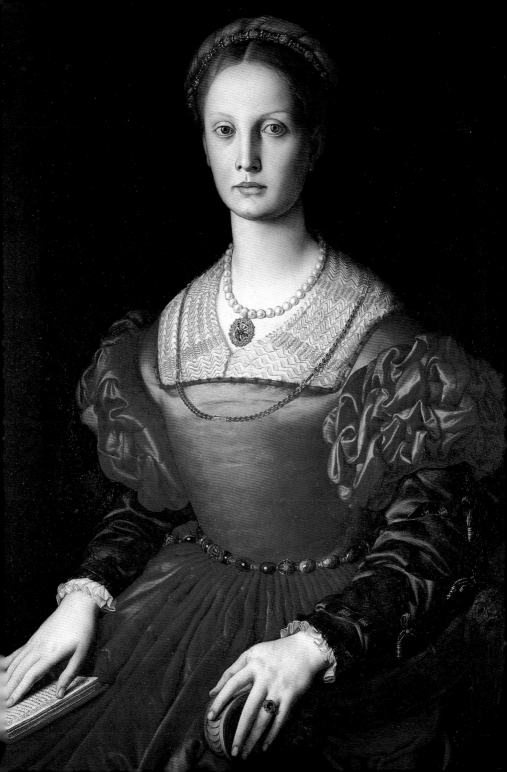

Hans Holbein the Younger, *The Ambassadors*, with anamorphic skull in lower center, 1533. London, National Gallery

more complex and disturbing than foreseen; that dedication to knowledge was not expressed by the tranquillity of the soul, but by its gloomy and melancholic aspects; and that the progress of knowledge removed man from the center of the world, hurling him into some peripheral point of Creation.

None of this should surprise us. From a social point of view, the Renaissance was incapable of settling down into an equilibrium that was not fragile and transient: the image of the ideal city, of the new Athens, was corroded from the inside by factors that were to lead to political catastrophe for Italy, as well as economic and financial ruin. Within this process there was no change in either the figure of the artist or the social composition of the public, but both were pervaded by a sense of anxiety that was to have repercussions on all material and spiritual aspects of life. The same thing happened in philosophy and the arts. The theme of Grace, closely connected to that of Beauty, paved the way for subjectivist and particularist concepts of Beauty.

Gracefulness Unseen
Pietro Bembo
Rime, V, 1522
Wavy golden locks,
Pure and clear as yellow amber,
That the wind on the snow
Makes sway and flutter;
Gentle eyes brighter than the sun,
Can dark night into sunny day transform;
A smile, balm for all suffering;
Pearly teeth and ruby lips from which fall words

So noble that the soul desires
No other good;
Hands of ivory, fit to seize
And ravish any heart;
Song paradisiacal, divine;
Mind judicious in one so young;
Purity never before seen by men;
Supreme beauty to supreme dignity wed,
Have kindled my fire, and in you
There are gifts that the generous heavens
Confer but rarely in such abundance.

Grace

Agnolo Firenzuola, (1493-c. 1543)
On the Beauty of Women
And, as we have mentioned above, we see frequently faces that, while they do not have the parts in accordance with the common measure of Beauty, nonetheless radiate that splendor of grace of which we speak (like Modestina, who, while she is not as large and as well proportioned as the example shown above, nonetheless is possessed of an extraordinarily pretty little face that everyone admires); when, contrariwise, we see a woman with well-proportioned features, who might justly be deemed beautiful by everyone, yet she may not be so pleasing, as is the case with the Lady Ancilia's sister; therefore we must perforce believe that this splendor springs from some hidden proportion and from a measure that is not in our books and about which we know nothing, nor can we even imagine it and this, as we say about things that we cannot express, is a *je ne sais quoi*. And although we may say that this [hidden proportion] is a ray of love or other quintessences, no matter how subtle or ingenious [our words may be], they will nonetheless fail to stand the test of truth. And this is called grace, as it makes dear her in whom this ray shines out and in whom this concealed proportion is present; much as thanks rendered for benefits received make dear those who offer them. And this is as far as I can or will discuss the matter at present, but, if you would know grace, seek for it in the eyes of her in whose eyes the splendor of this ray shines out.

The Right Feminine Beauty

Baldassare Castiglione
Book of the Courtier, I, 40, 1513-1518
Haven't you noticed how much prettier a woman is if, when she makes up, she does so with so little that those who see her cannot tell whether she is made up or not? But others are so bedaubed that it looks like they're wearing a mask and dare not laugh because they fear that it will crack. Such women never change color except when they dress in the morning, and must spend the rest of the day like motionless wooden images, showing themselves only by torch light or, as crafty merchants do when they show their cloth, in dimly lit places.
How much nicer it is to see a woman, a good looking one I mean, who obviously has nothing on her face, neither white nor red, but just her natural color, which may be pale or sometimes slightly tinged with a blush caused by embarrassment or the like, maybe

with her hair tousled and whose gestures are simple and natural, without working at being beautiful? This is that disparaged purity that pleases the eye and the spirit, which always fear the deceptions of art.
White teeth are good to see in a woman, for since they are not in plain view as the face is, but are most often concealed, one may think she spends less time making them white, which is not the case with her face. Yet a woman who laughs without any reason, just to show her teeth, would reveal the art and even if she really did have good teeth everyone would think that she was most ill favored, like Egatius in Catullus.
The same holds for the hands. If they are delicate and beautiful, and if they are shown openly when there is some need to use them and not just to flaunt them, they are very desirable—especially after they are sheathed in gloves again, for by doing so a woman shows that she cares little whether her hands are in view or not and that they are beautiful by nature rather than by artifice.
And haven't you ever seen—either on the way to Church, or to any other place, or in play or whatever—a woman lifting up her skirts so far that she shows her foot, and even a little bit of leg without realizing that she's doing so? Does she not seem most beautiful and womanly to you then, spic and span in her close-fitting velvet slippers and clean stockings? I certainly enjoy this very much and I think you all do too, for all men presume that cleanliness and a close fit, in such a secret place and one so seldom seen, must be natural and proper to that woman and shows that she is not seeking any kind of approval.

Nonchalance

Baldassare Castiglione
Book of the Courtier, I, 26, 1513-1518
After wondering many times where this gracefulness comes from, apart from those who think it a gift of the heavens, I have found a universal rule, which I think holds good for the things people say or do more than anything else: and that is to avoid affectation as far as possible, as one would dangerous shoals, and at the same time to use a certain nonchalance—if I may coin a phrase—which conceals artifice and shows that what one does or says is done or said effortlessly and almost without thinking.

2. Mannerism

A dynamic of this type also lay behind the contradictory relationship between Mannerists and Classicism: the disquiet felt by artists, caught between the impossibility of rejecting the artistic heritage of the previous generation and a sense of extraneousness to the Renaissance world, led them to hollow out from the inside those forms that had just been established according to Classical canons, which ended up by dissipating in much the same way as the crest of a breaking wave is scattered in a thousand different directions.

Giorgione,
Double Portrait,
1508. Rome,
Museo Nazionale di
Palazzo Venezia

opposite
Albrecht Dürer,
Self-Portrait in Fur, 1500.
Munich, Alte Pinakothek

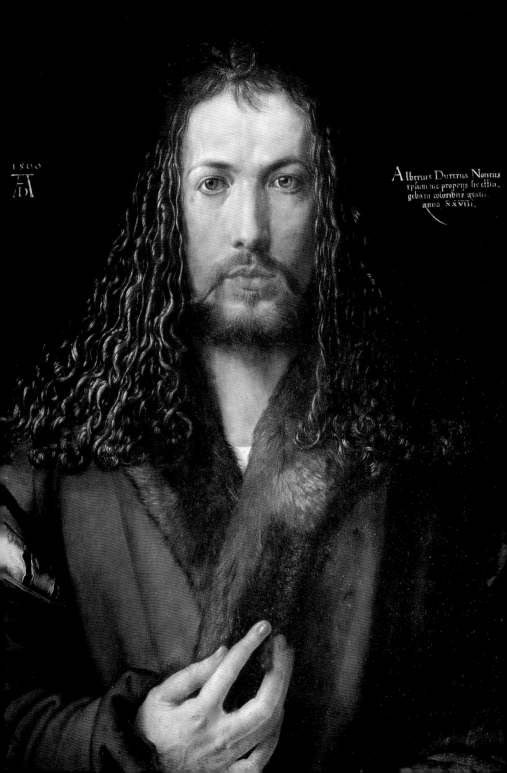

1500

\overline{AD}

Albertus Durerus Noricus
ipsum me proprys sic effin-
gebam coloribus ætatis
anno XXVIII.

Parmigianino,
Self-Portrait in a Convex,
c. 1522. Vienna,
Kunsthistorisches
Museum

Proof of this is to be found in certain violations of the canonical rules already present in the work of the Classical artist *par excellence*: Raphael. It is also evident in the troubled faces of painters who made self-portraits, like Dürer and Parmigianino. By apparently imitating the models of Classical Beauty, the Mannerists dissolved its rules. Classical Beauty is perceived as empty, soulless. The Mannerists opposed this with a spiritualization that, in order to elude the void, launched itself toward the fantastic: their figures move within the bounds of an irrational space, and permit the emergence of a dimension that is dreamlike or, in modern terms, "surreal."

Already present in Renaissance Neoplatonism, especially with Michelangelo—criticism of the doctrines that reduced Beauty to proportion then revenged itself on the beautiful proportions painstakingly calculated by Leonardo or Piero della Francesca: the Mannerists preferred flowing figures, the *S* in particular, the serpentine figure that is not inscribed in circles or quadrilaterals, but reminds one rather of tongues of flame. And it is significant that this change in attitude toward mathematics was to find, retrospectively, its genealogical origin in Dürer's *Melencolia I.*

Calculability and measurability ceased to be criteria of objectivity and were reduced to mere instruments for the creation of steadily more complex ways of representing space (perspectival alterations, anamorphoses) that bring about a suspension of proportionate order. It is no accident that a full understanding of the value of Mannerism did not come along until modern times: if Beauty is deprived of criteria of measure, order, and proportion, it is inevitably destined to fuzzy, subjective criteria of judgment. An emblematic example of this trend is Arcimboldo, an artist considered minor and marginal in Italy, who enjoyed fame and success at the court of the Hapsburgs. His surprising compositions, his portraits, in which the faces are composed of objects (fruit, vegetables, and so on) delight and amuse viewers. The Beauty of Arcimboldo is stripped of all appearances of Classicism and is expressed through surprise and wit. Arcimboldo shows that even a carrot can be beautiful: but at the same time

Giuseppe Arcimboldo,
Summer,
1573.
Paris, Musée du Louvre

he portrays a Beauty that is such not by virtue of an objective rule, but only thanks to the consensus of the public, of the "public opinion" of the court.

The distinction between proportion and disproportion no longer held, while the same applied to that between form and formless, visible and invisible: the representation of the formless, the invisible, and of the vague transcended the opposition between beautiful and ugly, true and false. The representation of Beauty grew in complexity, artists appealed to the imagination more than the intellect, giving themselves new rules on their own initiative.

Mannerist Beauty expresses a thinly veiled **conflict within the soul:** it is a refined, cultured, and cosmopolitan Beauty, like the aristocracy that appreciated it and commissioned its works (whereas the Baroque was to have more popular and emotional features). Mannerism opposed the strict rules of the Renaissance, but rejected the unrestrained dynamism of Baroque figures; it looks superficial, but it cultivated this superficiality with a

study of anatomy and a deepening of the relationship with the Ancients that went beyond similar tendencies during the Renaissance: in short, it outstripped and deepened the Renaissance at the same time.

For a long time Mannerism was confined to a brief interlude between the Renaissance and the Baroque: today, however, it is recognized that much of the Renaissance period—from the death of Raphael in 1520, if not before—was Mannerist. Over a century later, Madame de La Fayette was to revive the sentiments of this epoch in her novel *The Princess of Clèves*.

Marcantonio Raimondi,
The Sorcerer, 1518-1520.
Florence, Gabinetto dei
Disegni e delle Stampe,
Galleria degli Uffizi

The Sorrows of the Soul
Madame de La Fayette
The Princess of Clèves, I-IV, 1678

Magnificence and gallantry was never seen with such splendor in France as it was in the last years of the reign of Henry II. This prince was gallant, handsome, and made for love: although his passion for Diana of Poitiers, the Duchess of Valentinois, had begun some twenty years before it had not dimmed for all that, nor were the signs he gave of it any less evident. Since he excelled at all sports, he made this one of his principle activities: every day there were hunting parties, tennis matches, balls, running at the ring, or other amusements. The colors and emblems of Madame de Valentinois were to be seen all over and she herself would appear decked with adornments that would have suited her granddaughter, Mademoiselle de la Marck, who was as yet unmarried.

But the queen's presence authorized hers. The queen was beautiful, although she was no longer in the first bloom of youth; she loved luxury, splendor, and pleasure. The king had married her when he was still the Duke of Orleans and the Dauphin, his elder brother who died at Tournon, seemed—thanks to his birth and his great qualities—destined to be a worthy successor to Francis I, his father. [...]
On the day after her arrival, Mademoiselle de Chartres went to choose some jewelry from an Italian who traded in gems with everyone. He

had come from Florence with the queen and had become so wealthy that his house looked more like that of a great lord than that of a merchant. While she was there the Prince of Clèves arrived. He was so taken by her beauty that he could not conceal his surprise: and Mademoiselle de Chartres could not forebear from blushing at his amazement. But she regained her composure, without paying any more heed to the prince than his apparent rank and the laws of courtesy required. The Prince of Clèves gazed at her in admiration and could not understand who this beautiful creature might be, as he did not know her. But he certainly saw from her air and her retinue that she was of the nobility. Her youthfulness made him think that she was still a maiden; but, on seeing that she was not accompanied by her mother, and since the Italian, who did not know her, called her Madame, he didn't know what to think and he continued to stare at her in wonder. He noticed that his looks embarrassed her, unlike other young ladies who are always pleased when someone remarks on their beauty. He even thought that he was the cause of her impatience to leave and, in fact, she soon left. On losing sight of her, the Prince of Clèves consoled himself with the hope that he might learn who she was, but he was most surprised when he found out that she was unknown. He was so moved by her beauty and by her modest air that it may fairly be said, from that moment, he conceived an

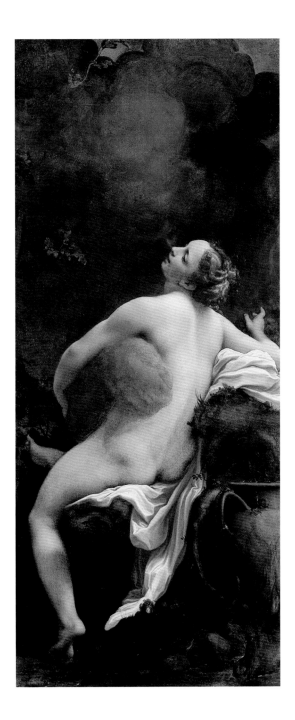

Correggio,
Jupiter and Io,
c. 1530. Vienna,
Kunsthistorisches
Museum

extraordinary passion and esteem for her. That evening he went to visit the princess, the king's sister. […]

The gentleman, who was well suited for such a mission, acquitted himself of it with great punctiliousness. He followed the Duke of Nemours as far as a village, half a league from Coulommiers, where the duke stopped and the gentleman had no trouble in deducing that he intended to wait for nightfall. He did not think it opportune to wait in his turn and so he went past the village and headed for the forest, to a place where he thought the Duke of Nemours might pass. Nor was he proved mistaken in this assumption. As soon as night fell, he heard the sound of footsteps and, although it was dark, he easily recognized the Duke of Nemours. He saw him skirt round the park, as if listening to hear if anyone were around, and to choose the place where he would enter. The palisades were very high and behind them there were others, to prevent people from gaining entrance. Nonetheless, the Duke of Nemours succeeded. As soon as he was inside the garden, he had no trouble discovering where Madame de Clèves was. He saw many lights in her bower and all the windows were open; so, slipping along the palisade, he came closer in the grip of emotions we can easily imagine. Squeezing himself into a space behind a French window, he was able to see what Madame de Clèves was doing. She was alone but she was so wondrously beautiful that he could barely master the ecstasy that the sight of her aroused in him. It was warm and she wore nothing on her head or breast save her hair, which was hanging down loosely. She was lying on a sofa, beside which stood a table with several baskets full of ribbons; she selected some and the Duke of Nemours saw that they were the very colors he had worn in the tournament. She was making knots for an unusual Indian cane, which had been his before he gave it to his sister. But Madame de Clèves had taken it from her not knowing that it had belonged to the Duke of Nemours. After she had completed her task, with a grace and a sweet look on her face that sprang from the feelings she had in her heart, she took a candle and went up to a large table, facing a painting showing the siege

of Metz, in which the Duke of Nemours was portrayed. She sat down and set to gazing at that portrait with the pensive attention that may arise only from passion. It is impossible to express what the Duke of Nemours felt in that moment. To see, in the heart of the night, in the most beautiful place in the world, a woman who adored him; to see her without

her knowing that he was there; and to see her wholly absorbed in things that referred to him and her secret passion for him, this had never been enjoyed or imagined by any other lover. The duke too was so rapt that he lingered motionless contemplating Madame de Clèves, without thinking that precious time was passing. When he was somewhat recovered, he thought that—if he was to talk to her—he would have to wait until she went into the garden. He thought that this could be done in greater safety because she would be farther away from her women. But, on seeing that she remained in her bower, he decided to enter. When he made this decision, his agitation was great as he was afraid of displeasing her. How fearful the thought of seeing that face, in which so much tenderness had resided, transformed by anger and severity! […] Madame de Clèves turned her head and, whether her fancy was full of the duke or whether he was standing in a place where the light was sufficient for her to make him out, she thought she recognized him and, without hesitating, or looking in his direction, she went into the room where her women were. Such was her agitation when she went in there that, to conceal this, she had to say that she was feeling unwell. She also said this to keep all her retinue busy and to give the duke the time to withdraw. When she had thought this over a little, she felt that she had deceived herself and that the sight of the Duke of Nemours had been but a figment of her imagination. She knew that he was in Chambord; it seemed unlikely to her that he would have run such a dangerous risk. Many times she was tempted to return to her bower, and to look in the garden to see if anyone was there. She wished and feared, in equal measure, that she might find the Duke of Nemours there, but in the end reason and prudence got the better of all her other feelings and she felt it better to remain in doubt than to risk finding out the truth. A long time went by before she resolved to leave a place while the duke might perhaps be in the vicinity and it was almost a day before she returned to the castle. […]

Passion has never been so tender and so ardent as it was then in the duke's bosom. He went off beneath some willow trees, alongside a little stream that ran behind the house where he had hidden. He went off as far as he could, in order that none might see or hear him; he yielded to the transports of his love, and his heart was so overcome that he could not but weep. But they were not merely tears of suffering: they were mixed with a certain sweetness and of that enchantment that is found only in love.

3. The Crisis of Knowledge

Whence this anxiety, this restlessness, this continuous search for novelty? If we take a look at the knowledge of the time, we can find a general answer in the "narcissistic wound" inflicted on the humanist ego by the Copernican revolution and successive developments in physics and astronomy. Man's dismay on discovering that he had lost the center of the universe was accompanied by the decline of humanist and Renaissance utopias regarding the possibility of constructing a pacified and harmonious world. Political crises, economic revolutions, the wars of the "iron century," the return of the plague: everything concurred in reinforcing the discovery that the universe had not been specifically tailored for humanity, and that man was neither its artifice, nor its master.

Paradoxically, it was the enormous progress of knowledge that caused this very crisis of knowledge: the search for an evermore complex Beauty was accompanied, for example, by Johannes Kepler's discovery that celestial laws do not follow simple Classical harmonies, but require a steadily growing complexity.

Andreas Cellarius,
Harmonia macrocosmica,
1660. Amsterdam

225

4. Melancholy

An emblem of the period is certainly Dürer's extraordinary *Melencolia I*, in which melancholy is associated with geometry. A whole epoch seems to separate this representation from the harmonious and serene portrayal of the geometrician Euclid in the *School of Athens*: while Renaissance man investigated the universe with the instruments of the practical arts, the Baroque man foreshadowed here investigates libraries and books and, sunk in melancholy, leaves on the floor (or holds idly in his hand) the instruments.

The idea that melancholy is the fate of the studious was not in itself a novelty: the theme had already been dealt with, albeit in different ways, by Marsilio Ficino and Heinrich Cornelius Agrippa von Nettesheim. What was original was the commingling of *ars geometrica* and *homo melancolicus*, in which geometry acquires a soul and melancholy a full intellectual dimension: it is this double attribution that creates the melancholic Beauty that draws to

Raphael,
The School of Athens,
detail, 1510.
Vatican City, Stanze
Vaticane

opposite
Albrecht Dürer,
Melencolia I,
1514. Florence,
Gabinetto dei Disegni
e delle Stampe, Galleria
degli Uffizi

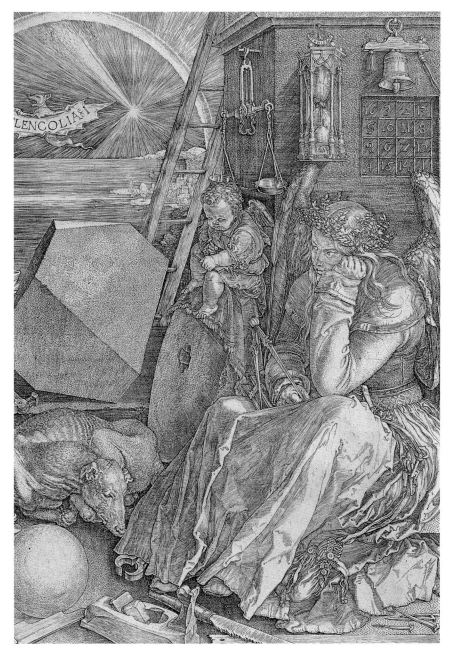

Francesco Borromini,
interior of the dome
of the Church of
Sant'Ivo della Sapienza,
Rome,
1642-1662.

Guarino Guarini,
interior of the dome
of the Chapel of the
Holy Shroud, Turin,
1666-1681.

itself, as in a vortex, previous traits such as the disquiet of soul typical of the Renaissance, and sets itself up as the point of origin of the Baroque human type.

The shift from Mannerism to the Baroque was not so much a change of school as an expression of this dramatization of life, closely connected to the search for new expressions of Beauty: things amazing, surprising, apparently out of proportion. With the Church of Sant'Ivo della Sapienza, Borromini amazed his contemporaries by designing a structure cunningly concealed within the inner courtyard of the Palazzo della Sapienza. The surprise effect was achieved through a play of contrasting concave and convex structures that hide the inner cupola, the whole thing being topped by a spiral lantern of extremely bold design. Shortly after this, Guarini designed the amazing Chapel of the Holy Shroud in Turin, whose cupola—thanks to a structure composed of superimposed hexagons—opens up to form a twelve-pointed star.

5. *Agudeza*, Wit, Conceits …

One of the characteristic features of the Baroque mentality was the combination of precise fancy and surprising effect, which was known by a variety of names—*agudeza, concettismo,* Wit, Marinism—and found its noblest expression in Gracián. This new form of eloquence was encouraged by the scholastic curricula produced by the Jesuits immediately after the Council of Trent: the *Ratio studiorum* of 1586 (renewed in 1599) required, at the end of a five-year period of preuniversity studies, a two-year course in rhetoric that assured the student a perfect eloquence, aimed not only at usefulness, but also at beauty of expression. Conceits, while they have no form of their own, nonetheless must possess a subtlety or perspicacity capable of surprising and penetrating the soul of the listener. Wit calls for a nimble and creative mind capable of seeing connections invisible to the common eye with the facility of the **intellect.** Thus the Beauty of conceits opened up entirely new perceptual spaces, while sensible Beauty moved steadily closer to a significant and nebulous forms of Beauty. Wit in poetry ("Gongorism" in Spain, from the poet Luis de Góngora, "Marinism" in Italy, from the poet Giambattista Marino) found its expression in virtuoso works,

Wit
Baltasar Gracián
The Art of Worldly Wisdom, I, 2, 1642-1648
The essence of wit is one of those things we know more in general than in detail: it allows of perception, not of definition; and any description of such a slippery matter may be held valid; as is Beauty to the eye and harmony to the ear, so is the conceit to the intelligence.

Intellect
Emanuele Tesauro
The Aristotelian Telescope, 1654-1670
Natural wit is a marvelous force of the intellect, comprising two natural talents: perspicacity and versatility. Perspicacity penetrates the most varied and minute circumstances of any subject, like substance, matter, form, accident, property, causes, effects, ends, affinities, the similar, the dissimilar, the equal, the superior,

the inferior, signs, correct names, and misunderstandings: all of which things lie curled up and hidden within all subjects, as we shall say in due course.

Perspicacity
Emanuele Tesauro
The Aristotelian Telescope, 1654-1670
A divine product of the intelligence, better known by its appearance than by its origins, has in every century and among all men been held in such admiration that, by some strange miracle, when it is read or uttered, it is received with great joy and applause by those who do not know it. This is wit, the great mother of all ingenious conceits; the clearest light of oratory and poetic elocution; the living spirit of dead pages; the most enjoyable salt of civil conversation; the ultimate effort of the intellect; the trace of divinity in the human spirit.

Pietro da Cortona,
*Triumph of Divine
Providence*,
1633-1639.
Rome, Palazzo Barberini

where the surprising nature of the style and its pungent, concise ingenuity far overshadow the content. In such poems the most important thing is to convey the multiplicity of details and associations of a woman's Beauty, even those aspects that may seem insignificant, like a **mole** or hair—a multiplicity of forms and details in which the reader becomes enmeshed.

The Serpent in the Bosom
Giambattista Marino
Adonis, VIII, 1623
Here on the edge of a bed I saw
A libidinous and lascivious satyr
Clutching in his close embrace
A most beautiful nymph, as he
Furtively plucked the flower of all pleasure.
For his comfort, those fine white flanks
He pressed, one hand on the living ivory,
The other, bent on different work,
Sought betimes a hidden, sweeter part.
Locked in this robust lover's strong arms
The maiden moaned, and her languid, modest eyes
Flashed with her spite and disdain.
From his countless avid kisses
She turned her face, denying her sweetness;
And, the more it was denied him, the more
His desire was kindled;
But while she withdrew, denying him her kisses,
He proffered anew his kisses scorned.

With studied shyness and with sly wheedling
She feigned at times to elude his grasp,
And all the while the shackles
Of that coarse and knotty embrace
Grew faster and closer than any bolt
That locks and binds wood.
I know not any Flora, Phryne, or Thaïs,
Harlots all, capable of such depravity.
In the youthful and fair breast there writhes
The great pleasure of the shameless sight,
For the power of Love, that tyrant and seducer,
Must ever overwhelm a faint heart;
Nay, aroused by the lure of that sweet image,
Desire kindled grows in strength apace,
So wonder not when, prompted to follow its natural course,
It breaks its bonds.

And his goddess, who with loving knots
Has bound his heart, begins to provoke him
With witty speech and sly ways, and,
Mocking, goads and tempts him.
Go on, enjoy (I said to myself) the fruit
Of your sweet sighs, O happy couple.
Sighs well strewn and tears well shed,
Make happy loves and happier lovers!

The Mole
Giambattista Marino
The Lyre, 1608
That mole, that fair mole,
Makes 'neath golden locks
A charming shadow,
For the loving cheek,
A copse it is of Love.
Oh, flee, incautious heart,
Even if you would pluck
The lily or the rose!
For cruelty lurks there, there it casts
Its net to trap and seize the soul.

The Tresses
Federico della Valle (seventeenth century)
O Blonde Tresses
O blonde tresses, O broad serene brow,
O shining eyes, nay, O twin stars,
O cheeks of pink and snow and fresh beauty,
O most modest and charming air,
O ruby lips, full of gems,
O smile, O sweetest voice,
O milky hands, O members fair and slim,
O figure of beauty more than earthly,
O noble and singular bearing
O sagacious ways, O great decorum,
O motion, O quasi-divine gait,
O new spirit of the heavenly choir
O sweet name, O goddess I bow before,
What shall I say of you? But hush,
I keep silent and adore you.

The Bosom
Giambattista Pucci (seventeenth century)
On Her White Bosom, Between Her Breasts
On her white bosom, between her breasts,
My Lady laid her hand upon her heart,
And the bright light of her shining eyes
Turned upon both hand and breasts.
Snow and flames gleamed white and glittered
From her fair eyes and her bosom, fire and ice
Transformed in a blend of light and whiteness
Like the stars in the milk-white sky.
The whiteness of her bosom and her breasts,
Like that of milk, then glistened in splendor
Along with the gleam of her shining eyes.
This gleaming and that whiteness
Blazed out in such a way
That eyes and breasts did seem
A dizzying whirl of light and white.

6. Reaching Out for the Absolute

A network of relationships and forms, to be created and recreated every time, took the place of natural, binding, and objective models: the **Beauty of the Baroque** period is, so to speak, beyond good and evil. This model allows Beauty to be expressed through ugliness, truth through falsehood, and life through death. The theme of death, moreover, is obsessively present in the Baroque mentality. Incidentally, this can be seen even in a non-Baroque author like Shakespeare, and it cropped up again, in the following century, in the staggering macabre figures in the Chapel of Sansevero in Naples.

Giuseppe Sanmartino,
Veiled Christ, detail,
1753. Naples,
Cappella di Sansevero

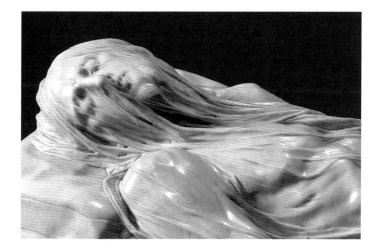

Beauty of the Baroque
William Shakespeare
Romeo and Juliet, III, 2, 1594-1597
Juliet: O serpent heart, hid with a flow'ring face! Did ever dragon keep so fair a cave? Beautiful tyrant! fiend angelical! Dove-feather'd raven! wolvish-ravening lamb! Despised substance of divinest show! Just opposite to what thou justly seem'st;

A damned saint, an honourable villain! O nature, what hadst thou to do in hell When thou didst bower the spirit of a fiend In mortal paradise of such sweet flesh? Was ever book containing such vile matter So fairly bound? O! that deceit should dwell In such a gorgeous palace.

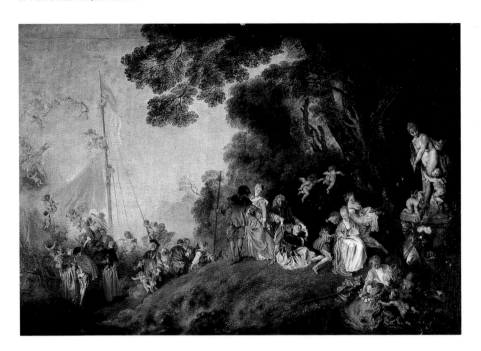

Jean-Antoine Watteau,
Pilgrimage to Cythera,
1718. Berlin,
Nationalgalerie

opposite
Gianlorenzo Bernini,
Ecstasy of St. Theresa,
1652. Rome, Church of
Santa Maria della
Vittoria

But this is not to say that Baroque Beauty was amoral or immoral. Anything but: the profoundly ethical nature of this Beauty does not lie in any adherence to the rigid canons of the religious and political authorities of the Baroque period, as much as in the totality of artistic creation. Just as the heavenly bodies in the firmament redesigned by Copernicus and Kepler refer to one another within ever more complex relationships, so does every detail of the Baroque world contain within itself a condensed and an expanded vision of the cosmos. There is no line that does not guide the eye toward a "beyond" still to be reached, there is no line that is not charged with tension. The motionless and inanimate Beauty of the Classical model was replaced by a Beauty of dramatic intensity.

If we compare two apparently distant works—Bernini's *Ecstacy of St. Theresa* and Watteau's *Pilgrimage to Cythera*—in the first case we can see lines of tension that run from the suffering face to the outer margins of the folds in her robe and, in the second, a diagonal line that, starting from the outermost cherub, runs from arm to dress and from leg to stick, as far as the group of cherubim playing ring-around-a-rosy. In the first case a dramatic, suffering Beauty; in the second, a melancholy, dreamlike Beauty. In both cases, a concatenation that respects no hierarchy between center and periphery, that expresses the full dignity of the Beauty of both the hem of a dress and a facial expression, of reality and dream, in a reciprocal reference to the whole and the detail.

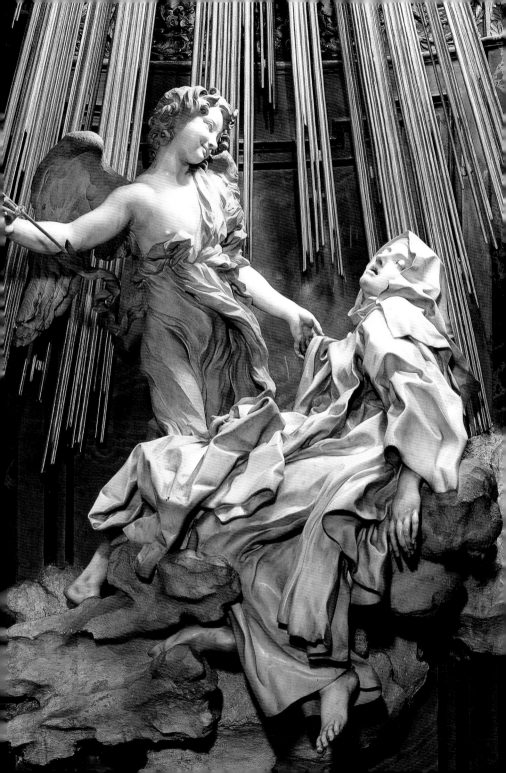

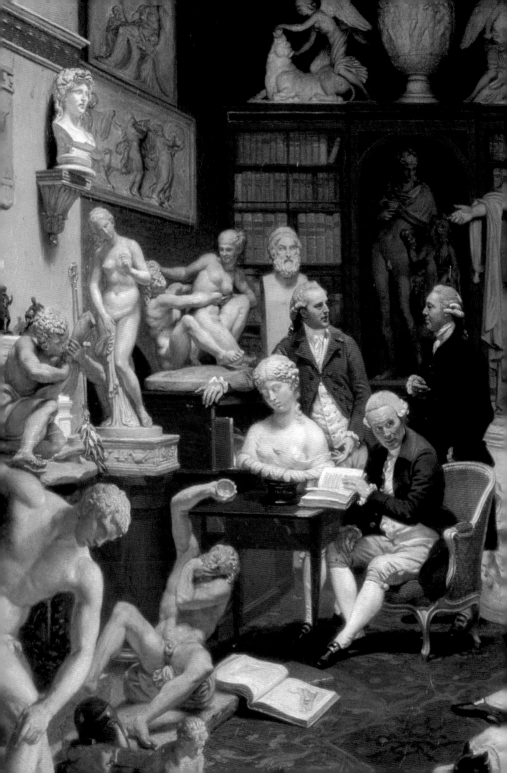

1. The Dialectic of Beauty

The eighteenth century is normally represented as a rational century, coherent, a little cold and detached, but this image, bound up with the way in which modern tastes perceive the painting and music of the epoch, is decidedly misleading. In his film *Barry Lyndon,* Stanley Kubrick shrewdly showed how, beneath the frigid and aloof veneer of the Age of Enlightenment, there ran a tumultuous undercurrent of unbridled, violent passions in a world where men and women were as refined as they were cruel. Kubrick sets the unheard of violence of the duel between father and son in a barn with the architectonic structure of a classic Palladian edifice: this is how, more realistically, we should try to think of and show the eighteenth century, the century of Jean-Jacques Rousseau, Immanuel Kant, and the Marquis de Sade, of *douceur de vivre* and the guillotine, of the

Johan Zoffany,
*Charles Townley
and His Friends in the
Park Street Gallery,*
detail, 1781-1783.
Burney, Lancashire,
Townley Hall Art Gallery
and Museum

Beauty in Action
Jean-Jacques Rousseau
Julie, or the New Héloïse, 1761
I have always believed that good is none other than Beauty in action, that the one is inextricably bound up with the other and that both have a common source in well-ordered nature. From this idea it follows that taste is perfected with the same means as wisdom, and that a soul open to the seduction of the virtues will be sensible in like measure to all the other kinds of Beauty. We are trained to see and to feel, or rather, an exquisite landscape is none other than a delicate and fine sentiment. Thus a painter who beholds a fair landscape or a beautiful picture is ecstatic

about things that a vulgar beholder does not even notice. How many things are perceived only thanks to the sentiments, and it is impossible to make sense of this! How many of these "je ne sais quoi" frequently present themselves to us, things that only taste may judge! In a certain sense, taste is the microscope of judgment, because the former reveals to the latter the tiny things, and its work begins where that of judgment ends. What must be done, therefore, to cultivate taste? Must we learn to see the way we feel, to judge Beauty by inspection, as [we judge] good through our sentiments? No, I maintain that it is not even granted to all hearts to be moved at Julie's first glance.

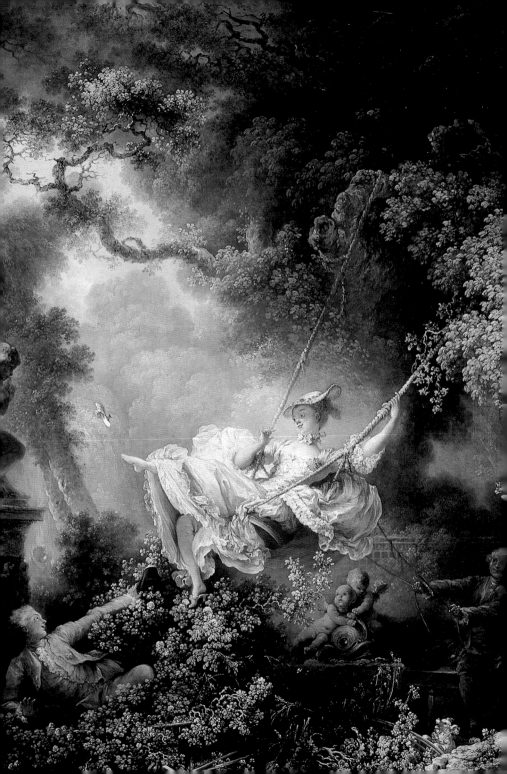

exuberant High Baroque and Rococo concepts of Beauty and of Neoclassicism. We might say that in the eighteenth century the persistence of Baroque Beauty was justified by the aristocratic taste for giving oneself over to the sweetness of life, while the austere rigor of Neoclassicism was well suited to the cult of reason, discipline, and calculability typical of the rising bourgeoisie. However, a more attentive eye will have no trouble in descrying a younger and more dynamic entrepreneurial nobility, whose tastes had by that time become effectively bourgeois, modernist, and reformist. But that same eye will struggle to identify among the multiplicity of social strata occupied by merchants, notaries and lawyers, writers, journalists, and magistrates those traits that a century later were to enable the identification of the bourgeois social type.

To this complex dialectic of social strata and classes there corresponds an equally complex dialectic of taste: the variegated Beauty of the Rococo period was not opposed by one Classicism, but by many Classicisms, which responded to different requirements, sometimes in contradiction to one another. The enlightened philosopher called for the mind to be freed from the mists of obscurantism, but unhesitatingly supported absolute monarchy and authoritarian governments; enlightened reason had its **bright side** in the genius of Kant, but a **dark and disturbing side** in the cruel theater of the Marquis de Sade; likewise, the Beauty of Neoclassicism was a refreshing reaction to the tastes of the ancien régime, but was also a search for rules that were certain, and therefore rigid and binding.

Maurice Quentin de La Tour, *Portrait of Madame de Pompadour Consulting the Encyclopédie*, 1755. Paris, Musée du Louvre

opposite
Jean-Honoré Fragonard, *The Swing*, 1767. London, Wallace Collection

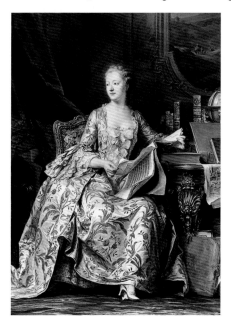

Jean-Baptiste-Siméon
Chardin, *Boy with a Top*,
1738. Paris, Musée
du Louvre

The Bright Side of Reason …

Immanuel Kant
*Observations on the Feeling of the Beautiful and
Sublime*, II, 1764

The man of sanguine temperament has a
prevalent feeling for beauty: his joys are
pleasant and full of life; when he is not
cheerful, he is dissatisfied and knows the
pleasures of silence but little. Variety is
beautiful and he loves change. He seeks joy in
himself and around himself, he cheers others
and is a boon companion. He has a strong
feeling for moral sympathy: the happiness of
others gladdens him, their sorrows arouse his
compassion. His moral sentiment is beautiful,
but without principles and aways depends
directly on the immediate impressions that
reality kindles in him. He is a friend to all men
or, and this is the same thing, he is never really
a friend, even though he is always cordial and
benevolent. He is incapable of pretence: today
he will entertain you with friendship and
courteous manners, tomorrow, should you be
ill or in trouble, he will feel genuine and
authentic compassion, but when things come
to such a pass he will gradually make himself
scarce until they take a turn for the better.

… and the Dark Side

Donatien-Alphonse-François de Sade
Justine, I, 1791

"What does it matter, as long as I am
satisfied?" and he gave me five or six blows
that, luckily, I parried with my hands. Then he
bound my hands behind my back; I had only
my looks and my tears with which to beg for
mercy; I had been strictly forbidden to speak. I
tried to soften his heart… in vain: on my
unprotected breasts a dozen blows fell; they
were terrible lashes, which immediately
striped me with blood; the pain wrested tears
from me that blended with the traces left by
that raving monster, making them, he said, a
thousand times more attractive… He kissed
them, bit them and, from time to time he
turned to my mouth, to my eyes brimming
over with tears that he licked lubriciously. In
her turn, Armande got into position; her
hands were tied; sweetly rounded was the
alabaster bosom she offered; Clément
pretended to kiss her but he bit her instead…
In the end he used the canes, and soon that
fine flesh, so white and tender, was no more
than a mass of bruises and excoriations
before her tormentor's gaze. "One moment,"
said the monk in his furious passion. "I want to
flog both the finest of asses and the finest of
breasts."

2. Rigor and Liberation

It is symptomatic that the innovative character of Classicism sprang from a need for greater rigor. Still in the Baroque period, but already manifesting this tendency, seventeenth-century theater reacted with Classical tragedy to the rules concerning the unities of time, space, and action. This was all in the name of a closer adherence to reality: for how can an action lasting years be compressed into a few hours, how can the pause between two acts condense the years that have supposedly gone by between one event and another? And thus the need for a more rigorous naturalism led to the compression of time and the reduction of place, to an increase in the space accorded to the scenic illusion and to a drastic reduction of the action that ideally had to make stage time and the spectators' time coincide. The Beauty faithful to the reality of the Theater of the Pléiade was replaced by a stylized Beauty, inserted into a violently altered reality, within which man was placed at the center of a drama that had no need for scenic frills. The works of Jean Racine express very well the simultaneous presence of Classicism and anti-Classicism, of an extended, exuberant, and solemn Beauty and of a Beauty that was stylized, condensed, and *tragic* in the Greek sense of the term.

Jean-Honoré Fragonard,
Coresus and Calliroë,
1760. Paris, Musée
du Louvre

3. Palaces and Gardens

That Neoclassicism was a reaction to a false Classicism in the name of a more rigorous Naturalism emerges even more clearly from the new architectural styles, especially in Britain. Eighteenth-century British architecture is above all the expression of sobriety and good taste, and marks a decisive move away from the excesses of the Baroque.

The aristocracy and gentry of Britain were not at all inclined to flaunt their wealth: the idea was therefore to adhere to the rules of Classical architecture, especially to Palladio's version of it. Baroque architecture is

Lord Burlington,
Chiswick House,
Chiswick, 1729.

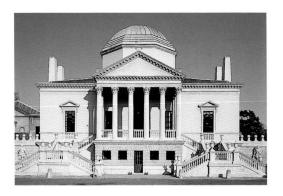

opposite
Villa Chigi
Centinale, Siena,
seventeenth century.

beautiful because it surprises and amazes with its excesses, superfluities, and its elaborate lines. But to the rational gaze of the eighteenth century this Beauty appeared absurd and contrived, nor was the Baroque garden spared this censure: the gardens of Versailles were taken as a negative model, whereas the English garden did not create anew, but reflected the Beauty of nature; its appeal did not lie in excess but in the harmonious composition of the setting.

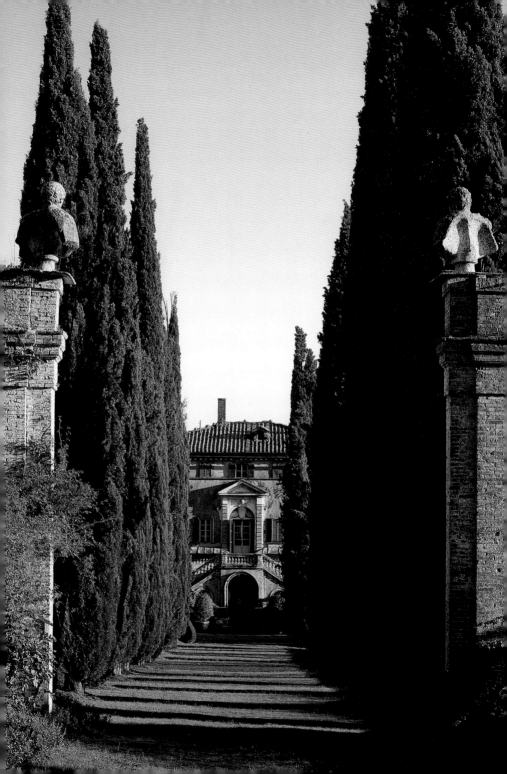

4. Classicism and Neoclassicism

In Neoclassicism two distinct but convergent requirements, characteristic of the bourgeois spirit, come together: individualist rigor and archaeological enthusiasm. Care for the private dimension, for the home as an expression of the individualism typical of modern man, took concrete form in the search for and in the application of extremely strict norms: one example of this is the house personally designed by Thomas Jefferson, one of the founders of the American Revolution and the third president of the United States. The new Classicism became popular as the canon of a "truly" Classical Beauty, the new Athens, in the dual sense of the Classical Greek city *par excellence* and the incarnation of the goddess of Reason that swept away the recent past. This aspect went hand in hand with so-called "archaeological Neoclassicism," an expression of the growing eighteenth-century interest in archaeology.

Archaeological research was certainly in fashion in the second half of the eighteenth century—a fact that speaks of enthusiasm for journeys to distant lands, in search of an exotic beauty beyond European models. But the research, the digs, and the unearthing of the ruins alone are not enough to explain the phenomenon: this is demonstrated by public indifference to the digs at Herculaneum (1738), a mere decade before the excavations at Pompeii (1748), which marked the beginning of an authentic craze for the Antique and the original.

Between the dates of the two digs European tastes underwent a profound transformation. The decisive factor was the discovery that the Renaissance image of the Classical world was in reality a product of the age of Decadence and, as a consequence, people understood that Classical Beauty was really a deformation brought about by the Humanists and, rejecting this, they set out to find "true" Antiquity.

Hence the typically innovative theories of Beauty that arose in the second half of the eighteenth century: the search for the original style involved breaking with traditional styles, both on theoretical grounds—as is shown by the eclecticism of the Encyclopedists—and on the grounds of content, while traditional subjects and poses were rejected in the interests of greater freedom of expression.

But it was not only the artistic community that was calling for greater freedom from the canons: according to Hume, critics can determine the **standards of taste** only if they manage to rid themselves of the external

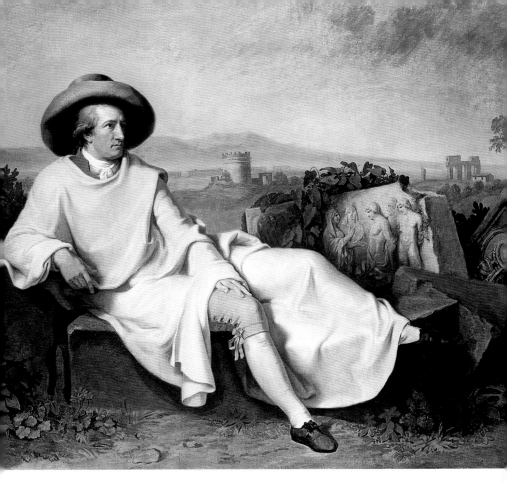

Johann Heinrich
Wilhelm Tischbein,
*Goethe in the Roman
Campagna*, 1787.
Frankfurt, Städelsches
Kunstinstitut

The Standards of Taste
David Hume
Of the Standard of Taste, 1757

So advantageous is practice to the discernment of beauty, that, before we can give judgment of any work of importance, it will even be requisite, that that very individual performance be more than once perused by us, and be surveyed in different lights with attention and deliberation. There is a flutter or hurry of thought which attends the first perusal of any piece, and which confounds the genuine sentiment of beauty. The relation of the parts is not discerned: The true characters of style are little distinguished: The several perfections and defects seem wrapped up in a species of confusion, and present themselves indistinctly to the imagination. Not to mention, that there is a species of beauty, which, as it is florid and superficial, pleases at first; but being found incompatible with a just expression either of reason or passion, soon palls upon the taste, and is then rejected with disdain, at least rated at a much lower value.

It is impossible to continue in the practice of contemplating any order of beauty, without being frequently obliged to form comparisons between the several species and degrees of excellence, and estimating their proportion to each other. A man, who has had no opportunity of comparing the different kinds of beauty, is indeed totally unqualified to pronounce an opinion with regard to any object presented to him. By comparison alone we fix the epithets of praise or blame, and learn how to assign the due degree of each.

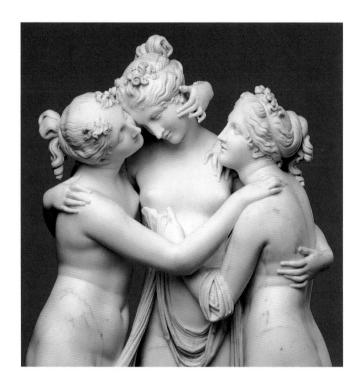

Antonio Canova,
The Three Graces, detail,
1812-1816.
St. Petersburg, State
Hermitage Museum

customs and prejudices that influence their judgment, which should instead
be based on internal qualities like good sense and freedom from bias, as well
as method, refinement, and experience. This critique, as we shall see,
presupposes a public opinion in which the ideas in circulation are the
subject of debate and—why not?—the market. At the same time, the
activity of the critic presupposes the definitive emancipation of taste from
Classical rules: a movement that originated in Mannerism at the very least,
and that in Hume arrives at an aesthetic **subjectivism** bordering on
skepticism (a term that Hume himself did not hesitate to attribute, in a
positive sense, to his own philosophy). In this context the fundamental thesis
is that Beauty is not inherent in things but is formed in the mind of the critic
(that is to say in the beholder free of external influences). The importance of
this discovery is on a par with Galileo's discovery of the subjective character
of the qualities of bodies (hot, cold, etc.) in the seventeenth century. The
subjectivity of "bodily taste"—the fact that a food tastes bitter or sweet
depending on the taste organs of those who sample it, and not on its
nature—corresponds to an analogous subjectivity of "spiritual taste": since
no criterion of judgment is objective and intrinsic to things, the same object
can appear beautiful to one person and ugly to another.

Giovanni Paolo Pannini,
*Gallery of Views of
Ancient Rome,* 1758.
Paris, Musée du Louvre

Subjectivism

David Hume
Of the Standard of Taste, 1757

Beauty is no quality in things themselves: It exists merely in the mind which contemplates them; and each mind perceives a different beauty. One person may even perceive deformity, where another is sensible of beauty; and every individual ought to acquiesce in his own sentiment, without pretending to regulate those of others. To seek in the real beauty, or real deformity, is as fruitless an enquiry, as to pretend to ascertain the real sweet or real bitter. According to the disposition of the organs, the same object may be both sweet and bitter; and the proverb has justly determined it to be fruitless to dispute concerning tastes. It is very natural, and even quite necessary to extend this axiom to mental, as well as bodily taste; and thus common sense, which is so often at variance with philosophy, especially with the skeptical kind, is found, in one instance at least, to agree in pronouncing the same decision.

À MARAT.
DAVID.

L'AN — DEUX

5. Heroes, Bodies, and Ruins

The aesthetics of ruins that developed in the second half of the eighteenth century is an expression of the ambivalence of Neoclassical Beauty. That the ruins of history could be perceived as beautiful was a novelty the reasons for which lay in an impatience with traditional objects and in a consequent search for new themes, over and above canonical styles.

It is not far-fetched to compare the rational and at once melancholy way in which Denis Diderot or Johann Joachim Winckelmann contemplated the ruins of an ancient building with the way in which David saw the murdered body of Marat, who no painter of the preceding generation would have portrayed in the bathtub. In David's painting the need to respect historic truth right down to the details does not signify a gelid reproduction of nature, but a blend of contradictory sentiments: the stoic virtue of the murdered revolutionary makes the Beauty of his limbs the vehicle for a reaffirmation of

opposite
Jacques-Louis David,
The Death of Marat,
1793. Brussels, Musées
Royaux des Beaux-Arts

Jakob Philipp Hackert,
*Goethe in Rome Visiting
the Colosseum,* 1786.
Rome, Casa di Goethe

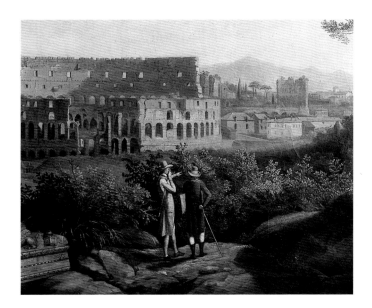

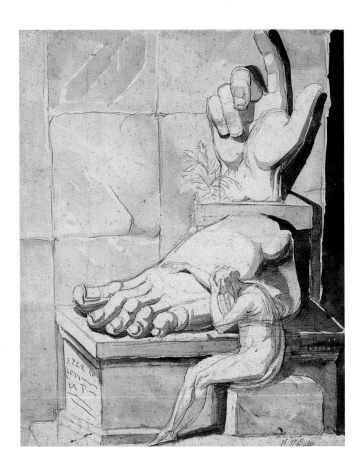

Johann Heinrich Füssli,
*The Artist in Despair over
the Magnitude of
Antique Fragments,*
c. 1778-1780.
Zurich, Kunsthaus

faith in the values of Reason and the Revolution; nonetheless, the lifeless body reveals a sense of deep sorrow for the transience of life and for the irretrievability of those things that time and death swallow up.

We find the same ambivalence in the discourses of Diderot and Winckelmann upon their contemplation of ruins. The **Beauty of ancient monuments** is a warning not to forget the devastation of time and the silence that reigns over nations, but it also reinforces a belief in the possibility of making an absolutely faithful reconstruction of origins that had once been held lost forever, thus leading to a mistaken preference for natural Beauty. There is a profound nostalgia in Winckelmann's aspiration to a clear and simple **linear purity,** the same sentiment that Rousseau felt for the original purity of natural man. But there is also a sentiment of rebellion against the empty abundance of Rococo constructions, artificial at best and simply against nature at worst.

Beauty of Ancient Monuments

Johann Joachim Winckelmann
Thoughts on the Imitation of Greek Art in Painting and Sculpture, 1755

It is known that the great Bernini was one of those who challenged both the greater Beauty of Greek nature, and the ideal Beauty of their figures. He was also of the opinion that nature bestows on all her parts the Beauty that befits them: art, in his view, consists in knowing how to find that Beauty. His boast was that he had freed himself of a preconception that sprang from his fascination with the Beauty of the Medici Venus. But this earlier bias, which had once held sway over him, was dissipated when—after much laborious and dogged study of nature—he eventually discovered its inherent inconsistency.

The Venus, therefore, taught him to find Beauty in nature, which he had first thought could be found only in her and without her he would never have sought it in nature. Does it not follow from this that the Beauty of the Greek statues can be discovered before the Beauty of nature, and thus it moves us more and is not diffuse like the Beauty of nature, but is more concentrated? Hence, for those desirous of attaining a knowledge of perfect Beauty, the study of nature is at least longer and more laborious than the study of Antiquity; and Bernini would not have taught young artists this shortcut by identifying the Beauty of nature with supreme Beauty. The imitation of natural Beauty is either achieved in conformity with a single model or by observations made on various models brought together in a single subject. In the first case we have a copy, a portrait: this is the method that leads to the forms and the figures of the Dutch school. But in the second case we take the path of universal Beauty and of the ideal images of this Beauty; and this was the path taken by the Greeks. But the difference between the Greeks and us lies in this: the Greeks succeeded in creating these images, even though these last were not inspired by beautiful bodies, thanks to the continuous opportunities they had to observe the Beauty of nature, something that is not revealed to us every day and seldom in a way the artist would prefer.

Linear Purity

Johann Joachim Winckelmann
Monumenti antichi inediti, I, 1767

In the images that they named after one divinity or another, the Greek craftsmen wished to portray consummate human Beauty. To this end, they sought to imbue the countenances and the posture of these gods with a calm utterly devoid of any trace of impatience or agitation, which the philosophers thought unsuited to the nature and condition of those same divinities. The figures made with this marked composure expressed a perfect sense of poise, and this alone made it possible to portray in the face of the Genius kept in Villa Borghese that Beauty whose prototype it may fairly be said to represent. But since art is not made in [a spirit of] total indifference, and since art could not avoid sculpting the deities with human feelings and affections, it had to be content with the degree of Beauty that the god portrayed in the work could show. No matter how marked the expression may be, this is not why it is so well balanced. For Beauty predominates much like the harpsichord in an orchestra that leads all the other instruments, although they seem to drown it out. This is evident in the statue of Apollo in the Vatican, which is meant to express at once the god's scorn for the dragon Python slain by his arrows, and his disdain for this victory. The judicious sculptor, who wished to model the handsomest of the gods, hinted at this disdain where the poets say this emotion resides: that is to say, in the nose, which he made with flaring nostrils, while there is scorn in the upthrust lower lip and the raised chin. Now, are these two emotions not capable of marring Beauty? No; because this Apollo's gaze is calm, and his brow is wholly serene.

6. New Ideas, New Subjects

Aesthetic debate in the eighteenth century possessed strongly innovative features in comparison with the Renaissance and the seventeenth century, features that are responsible for its particularity and intrinsic modernity: this is a matter of the relationship between intellectuals and the public, of the success of women's salons and the role of women, and of the appearance of new artistic subjects.

In the eighteenth century, intellectuals and artists were less and less subject to the humiliating dependence on patrons and sponsors, and they began to acquire a certain economic independence thanks to the expansion of the publishing industry. Whereas at an earlier date Defoe had sold the rights to his *Robinson Crusoe* for a mere ten pounds sterling, now Hume could earn more than three thousand pounds with his *History of England*. Less successful authors found work as compilers of books that

opposite
François Boucher,
The Breakfast, 1739.
Paris, Musée du Louvre

Jean-Étienne Liotard,
The Chocolate Girl,
1745. Dresden,
Gemäldegalerie

synthesized and popularized the great philosophical and political themes, books that, in France, were sold in the itinerant markets: books thus spread even to the outlying reaches of the provinces, in a country in which over half of the population was literate. These changes paved the way for the Revolution and it was no accident that Neoclassical Beauty became the emblem of this event (and of the Napoleonic Empire that followed it), while Rococo Beauty was associated with the hateful and corrupt ancien régime.

The figure of the philosopher merged into that of the critic and the opinion-maker, while a public (far broader than the restricted circle of intellectuals of the so-called "Republic of Letters") came into being, within which the instruments for the spread of ideas assumed more and more importance. The best-known critics of the period were Addison and Diderot. The former reassessed the imagination as the power to arrive at an empirical understanding of both artistic and natural Beauty; the latter, with his typical eclecticism, studied Beauty as the interaction between sensible man and nature within a plethora of **surprising and varied relationships,** the perception of which underpinned any judgment of Beauty. In both cases the spread of these ideas was strictly dependent on the spread of the press,

Jacques-Louis David,
*Antoine-Laurent
Lavoisier and His Wife*,
1788. New York,
Metropolitan Museum
of Art

Frontispiece to the *Encyclopédie* of Diderot and d'Alembert, 1751.

The Pleasure of the Imagination
Joseph Addison
The Pleasures of the Imagination, *The Spectator*, 1726
There is a second kind of beauty that we find in the several products of art and nature, which does not work in the imagination with that warmth and violence as the beauty that appears in our proper species, but is apt however to raise in us a secret delight, and kind of fondness for the places or objects in which discover it. This consists either in the gaiety or variety of colours, in the symmetry and proportion of parts, in the arrangement and disposition of bodies, or in a just mixture and concurrence of all together. Among these several kinds of beauty the eye takes most delight in colours. We nowhere meet with a more glorious or pleasing show in nature, than what appears in the heavens at the rising and setting of the sun which is wholly made up of those different stains of light that show themselves in clouds of a different situation.

Surprising and Varied Relationships
Denis Diderot
Treatise on Beauty, 1772
Despite all these causes of divergence in judgments, there is no reason to think that real Beauty, the kind that consists in a perception of relationships, is a chimera; the application of this principle can vary infinitely and its accidental modifications can give rise to literary disagreements and conflicts: but the principle remains constant. It may be that there are no two men in the whole world who perceive exactly the same relationships in the same object and who deem it beautiful in the same way; but if there were so much as one man who was insensible to relationships of any kind, he would be a real brute; and if he were insensible only in a few fields, this phenomenon would reveal in him a want of animal economy; and the general condition of the rest of the species would in any case be sufficient to keep us far from skepticism. Beauty is not always the work of an intelligent cause. Motion often determines, both in a being considered in isolation, and in various beings compared to one another, a prodigious multitude of surprising relationships. Natural history collections offer a great number of examples of this. Relationships are thus the result of fortuitous combinations, at least as far as we are concerned. On hundreds of occasions, nature playfully imitates the productions of art; and—while I'm not saying whether or not the philosopher hurled by a storm onto the shores of an unknown island was right to exclaim, on seeing certain geometrical figures: "Be of good heart, my friends, here are the signs of man"—we might wonder about the number of relationships that would have to be distinguished in a being in order to have the absolute certainty that it is the work of an artist; about which occasions where a single flaw in symmetry would prove more than the sum of its relationships; about the ratio between the time of the fortuitous cause and the resulting relationships; and if, with the exception of the works of the Almighty, there are cases in which the number of relationships can be compensated for by that of probabilities.

exploited by Addison with his *Spectator* and by Diderot with the *Encyclopédie*. Naturally, the publishing market also produced new forms of reaction and frustration. This was the case with Hogarth, excluded from the market by the British aristocracy's preference for foreign artists, and therefore obliged to earn himself a living by illustrating printed books. Hogarth's painting and aesthetic theories expressed a type of Beauty in open contrast with the Classicism favored by the British nobility. With his preference for intricate composition, with sinuous and flowing lines (which suit a fine head of **hair** as well as they do a witty conceit) as opposed to rigid lines, Hogarth rejects the classical link between Beauty and proportion, in a way that is in a certain sense analogous to that of his fellow countryman Burke. Hogarth's paintings express an edifying, narrative Beauty, exemplary in its own way and embedded in a story from which it cannot be extrapolated (a novel or a novelette, one might say). When correlated to the narrative context, Beauty loses all ideal aspects and, being no longer bound to any type of perfection, it can also express itself through new subjects; servants, for example, a theme common to other artists, too, for that matter.

It is no accident that in Mozart's *Don Giovanni*—which marks the end of the Classical age and the dawning of the modern age—the figure of the libertine vainly searching for ideal Beauty in his thousand and one sexual conquests is observed ironically from a distance, while his amours are scrupulously catalogued by the servant Leporello.

Hair
William Hogarth
The Analysis of Beauty, V, 1753
But the hair of the head is another very obvious instance, which, being design'd chiefly as an ornament, proves more or less so, according to the form it naturally takes, or is put into by art. The most amiable in itself is the flowing curl; and the many waving and contrasted turns of naturally intermingling locks ravish the eye with the pleasure of the pursuit especially when they are put in motion by a gentle breeze. The poet knows it, as well as the painter, and has described the wanton ringlets waving in the wind.
And yet to shew how excess ought to be avoided in intricacy, as well as in every other principle, the very same head of hair, wisped and matted together, would make the most disagreeable figure; because the eye would be perplex'd, and at a fault, and unable to trace such a confused number of uncomposed and entangled lines; and yet notwithstanding this, the present fashion the ladies have gone into, of wearing a part of the hair of their heads braided together from behind like intertwisted serpents, arising thickest from the bottom, lessening as it is brought forward, and naturally conforming to the shape of the rest of the hair it is pin'd over, is extemely picturesque. Their thus interlacing the hair in distinct varied quantities is an artful way of preserving as much of intricacy, as is beautiful.

Perfection Is Not the Constituent Cause of Beauty
Edmund Burke
A Philosophical Inquiry into the Origin of Our Ideas of the Sublime and Beautiful, III, 9, 1756
There is another notion current, pretty closely allied to the former; that Perfection is the constituent cause of beauty. This opinion has been made to extend much further than to sensible objects. But in these, so far is perfection, considered as such, from being the cause of beauty, that this quality, where it is highest, in the female sex, almost always carries with it an idea of weakness and imperfection. Women are very sensible of this; for which reason; they learn to lisp, to totter in their walk, to counterfeit weakness, and even sickness. In all they are guided by nature. Beauty in distress is much the most affecting beauty. Blushing has little less power; and modesty in general, which is a tacit allowance of imperfection, is itself considered as an amiable quality, and certainly heightens every other that is so.

As Long as She Wears a Skirt
Lorenzo Da Ponte
Don Giovanni, I, 5, 1787
My Lady, this is the list
Of my master's conquests;
I drew it up myself:
Observe, and read with me.
In Italy six hundred forty,
In Germany two hundred thirty one,
One hundred in France, in Turkey ninety-one
But in Spain we're already at one thousand three.
Among their number peasant lasses,
Maids, and women of the town,
Countesses, baronesses,
Marquises and princesses,
Women of all degrees,
All shapes and sizes, and all ages.
With blondes he usually praises
Their courtesy;
With brunettes, their faithfulness;
With gray-haired women, their sweetness.
In winter he wants them plump,
In summer he wants them skinny
The big ones are majestic,
The little ones are charming.
He runs after old women
Just to add them to the list
But his real passion
Is for the young beginner.
He cares not if a girl is rich
Or ugly, or beautiful;
As long as she wears a skirt
You know where he's at.

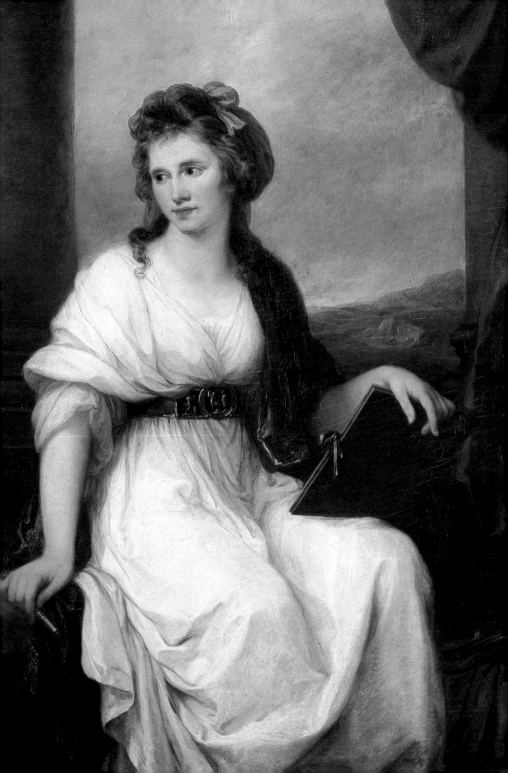

7. Women and Passions

In its portrayal of the seducer's existential checkmate, *Don Giovanni* presents us with a picture of a new woman. The same can be said of *The Death of Marat*, which documents a historical event caused by the hand of a woman. Things could not have been otherwise in the century that marked the arrival of women on the public scene.

This can also be seen in painting, where Baroque woman was replaced by women that were less sensual but more free in their habits, unencumbered by suffocating corsetry and elaborate hair styles. At the end of the eighteenth century it was fashionable not to conceal the breasts, which were at times openly revealed above a band that supported them and emphasized the waistline. Parisian ladies organized salons and took part, in no secondary role, in the debates that were carried on therein, foreshadowing the Revolutionary Clubs but also following a fashion that had already begun in the previous century, with the conversations in the salons on the nature of love. It is indicative that the scene in Watteau's *Pilgrimage to Cythera* springs from the imaginary geography of the amorous passions represented, in seventeenth-century conversations, by a sort of **map of the heart**, the *carte du tendre*. Toward the end of the seventeenth

opposite
Angelica Kauffmann,
Self-Portrait, c. 1787.
Florence, Galleria
degli Uffizi

Jean-Étienne Liotard,
*Marie Adelaide
of France in Turkish
Dress*, 1753.
Florence, Galleria
degli Uffizi

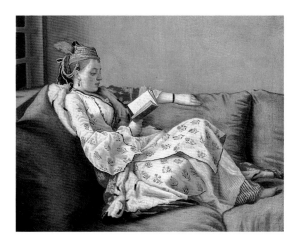

century, in fact, such discussions had led to one of the first novels about love, *The Princess of Clèves* by Madame de La Fayette. This was followed in the eighteenth century by *Moll Flanders* (1722) by Daniel Defoe, *Pamela* (1741) by Samuel Richardson, and *Julie, or the New Heloise* (1761) by Jean-Jacques Rousseau. In eighteenth-century love novels Beauty was seen with the inner eye of the passions, prevalently in the form of the intimate diary: a literary form that already holds within it all of early Romanticism. But, above all, through these discussions the conviction began to gain ground—and this is the contribution of women to modern philosophy—that sentiments are not merely a perturbation of the mind, but express, together with reason and sensibility, a third faculty of humankind.

Sentiments, taste, and the passions therefore lost the negative aura of irrationality and, as they were gradually reconquered by reason, they played a leading role in the struggle against the dictatorship of reason itself. Sentiment was a reservoir into which Rousseau dipped in order to rebel against artificial and decadent modern Beauty, winning back for the eye and the heart the right to immerse themselves in the original, uncontaminated Beauty of nature, with a sense of nostalgia for the "noble savage" and the spontaneous youth that had originally been in man but by Rousseau's day had been lost.

Carte du tendre,
a map of affections
and passions,
seventeenth century.
Paris, Bibliothèque
Nationale de France

following pages
Jacques-Louis David,
*Madame Juliette
Récamier,* 1800.
Paris, Musée du Louvre

A Map of the Heart
Madame de Scudéry
Clélie, histoire romaine, 1654
But as there is no road without obstacles or
without a risk of straying from the right path,
as can be seen, Clélie has determined that
those who are at "New Friendship" and who
move off a little more to the right, or a little
more to the left, will get lost. In fact, on
coming from "Great Intelligence," they will go
to "Negligence" and if they carry on along the
wrong path they will come to "Inequality,"
thence to "Regret," "Carelessness," and
"Oversight," and instead of arriving at "Tender
Esteem" they will find themselves in the "Lake
of Indifference," which is in fact situated here,
on the Map. With its calm waters it illustrates
the aspect whose name it bears.
On the other side, on leaving from "New
Friendship" and then going slightly to the left
toward "Indiscretion" they take the path
leading to "Perfidy" and "Pride," before
moving on to "Slander," which leads to
"Indignity" and instead of finding themselves
at "Tender Gratitude" they end up in the "Sea
of Enmity," in which all ships are wrecked. This
is a restless sea whose waters agitated by the
force of that sentiment are the fate of those
who deviate to the left from "New
Friendship." Here Clélie shows and represents
on the Map that a thousand good qualities
are required to arouse the obligation of a
tender friendship. Those with bad qualities
can have nothing from her but hatred or
indifference at best. Moreover this honest
young lady with her Map also wished to say
that she has never loved or will ever have in
her heart aught but tenderness. The river of
inclination debouches into a sea that she calls
"Perilous," since great perils lie in wait for the
woman who oversteps the bounds of
friendship. To this end beyond that sea she
has situated the "Unknown Land," since we do
not know what exists there, and we believe
that no one has sailed beyond the "Pillars of
Hercules."

Vanity
Daniel Defoe
Moll Flanders, 1722
By this means I had, as I have said above, all
the advantages of education that I could have
had if I had been as much a gentlewoman as
they were with whom I lived; and in some
things I had the advantage of my ladies,
though they were my superiors; but they
were all the gifts of nature, and which all their
fortunes could not furnish. First, I was
apparently handsomer than any of them;
secondly, I was better shaped; and, thirdly, I
sang better, by which I mean I had a better
voice; in all which you will, I hope, allow me to
say, I do not speak my own conceit of myself,
but the opinion of all that knew the family. I
had with all these the common vanity of my
sex, viz. that being really taken for very
handsome, or, if you please, for a great beauty,
I very well knew it, and had as good an
opinion of myself as anybody else could have
of me; and particularly I loved to hear
anybody speak of it, which could not but
happen to me some-times, and was a great
satisfaction to me. […]
But that which I was too vain of was my ruin,
or rather my vanity was the cause of it. The
lady in the house where I was had two sons,
young gentlemen of very promising parts
and of extraordinary behaviour, and it was my
misfortune to be very well with them both,
but they managed themselves with me in a
quite different manner. […]
From this time my head ran upon strange
things, and I may truly say I was not myself; to
have such a gentleman talk to me of being in
love with me, and of my being such a
charming creature, as he told me I was; these
were things I knew not how to bear, my vanity
was elevated to the last degree. It is true I had
my head full of pride, but, knowing nothing of
the wickedness of the times, I had not one
thought of my own safety or of my virtue
about me; and had my young master offered
it at first sight, he might have taken any
liberty he thought fit with me; but he did not
see his advantage, which was my happiness
for that time.

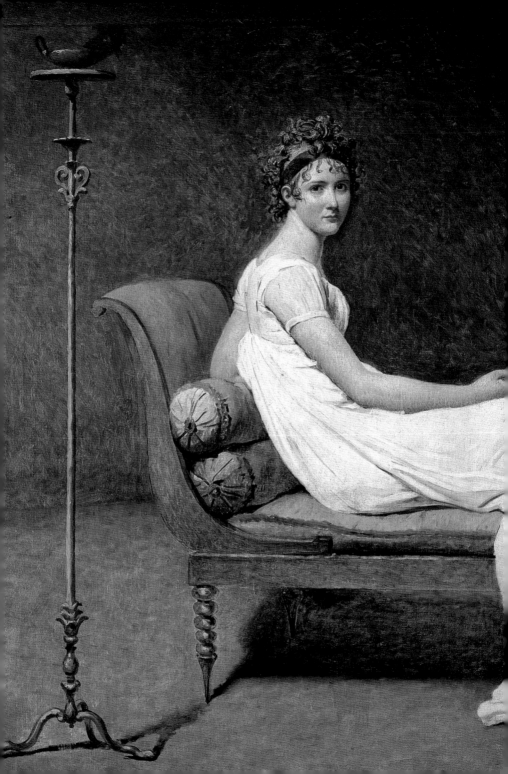

8. The Free Play of Beauty

The aesthetics of the eighteenth century attached great importance to subjective and indeterminable aspects of taste. At the apex of this trend, Immanuel Kant, in his *Critique of Judgment*, asserts that the basis of the aesthetic experience is **the dispassionate pleasure** produced from the contemplation of Beauty. Beauty is that which pleases in an objective manner without its springing from or being ascribable to any concept: taste is therefore the faculty of making a dispassionate judgment of an object (or a representation) through pleasure or displeasure; the object of this pleasure is what we define as beautiful.

The fact remains that, in considering an object to be beautiful, we hold that our judgment must have a universal value and that everyone must (or ought to) share our judgment. But, since the universality of judgments of taste does not require the existence of a concept to be conformed with, the universality of Beauty is subjective: it is a legitimate claim on the part of those who express the judgment, but in no way can it assume universal value in cognitive terms. "To feel" with the intellect that the form of a picture by Watteau portraying a love scene is rectangular, or "to feel" with one's reason that every gentleman has the duty to help a lady in difficulty is not the same as "feeling" that the picture in question is beautiful: in this case, in fact, both the intellect and reason give up the supremacy they respectively exercise in the cognitive and moral fields, and come into free play with the imaginative faculty, in accordance with the rules laid down by this last.

In Kant, as in Rousseau and in the discussions on the passions, we witness a disengagement of reason. Nonetheless, this giving way to those things that

The Dispassionate Pleasure of Beauty
Immanuel Kant
The Critique of Judgment, I, 1, II, 1790
This definition of Beauty can be derived from the preceding definition of it as an object of pleasure apart from any interest. For that which makes us conscious that our feeling of pleasure is independent of any interest can only be evaluated this way. It must contain grounds for pleasure for everyone. For, since [pleasure] is not based on some inclination of the subject (or any other premeditated interest) and since he who judges feels entirely free with regard to his appreciation of the object, he cannot explain his pleasure on the basis of any personal conditions.

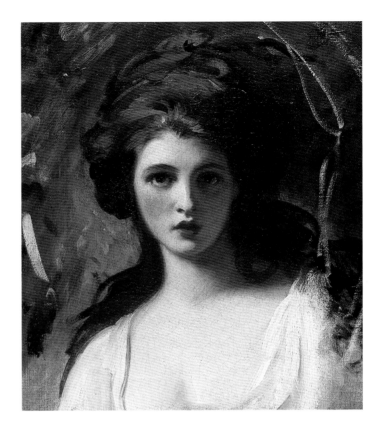

George Romney,
Lady Hamilton as Circe,
c. 1782.
London, Tate Britain

the reason cannot control still occurred in accordance with the rules of reason itself and no one better than Kant was able to handle the tensions set up by this discordance within the Enlightenment. However even Kant acknowledges the presence of nonrational phenomena within the system. One of these is the legitimization, together with "adherent Beauty," of "free Beauty," the indefinable nature of the arabesque and the abstract. The Romantics went on to accord boundless space to free Beauty, making it coincide with Beauty *tout court*. But, above all, Kant had to recognize in the Sublime (cf. Chapter XI) the power of formless and unlimited Nature: the steep, majestic cliffs, storm clouds, volcanoes, hurricanes, the ocean, and every other phenomenon that manifests the idea of the infinity of Nature. In Kant there is still at work an unsubstantiated faith in the positivity of Nature, in its ends and in its harmonies. This "aesthetic theodicy," typical of the century, is also present in Hutcheson and Shaftesbury, for whom the existence in nature of evil and ugliness does not contradict the positive and

John Russel,
Moon, c. 1795.
Birmingham, City Council

Étienne-Louis Boullée,
*Cenotaph of Isaac
Newton*, detail, 1784.
Paris, Bibliothèque
Nationale de France

substantially good order of creation. Nonetheless, if Nature is no longer an English garden but something indescribably more powerful that causes a kind of suffocation of life, it becomes difficult to reconcile this tumult with regular universal harmonies. In fact, for Kant, the *rational* upshot of the experience of the Sublime was the recognition of the independence of human reason from Nature, thanks to the discovery of the existence of a faculty of the spirit capable of going beyond all sensible measure.

Free Beauty
Giacomo Leopardi
Memories—Canti, 1824
Sweet stars of the Great Bear, I never thought I would return, as in the past, to watch you sparkling with light above my father's garden and hold discussions with you from the windows of this great mansion where I spent my childhood and saw my happiness come to an end. How many fantasies and wild ideas your gleam and twinkling of your sister stars used then to conjure up. It was a time when I would while away long evening hours alone and silent, seated on the grass, watching the sky and hearing far away beyond the fields the croaking of the frogs. And fireflies would flit around the hedges above the flowers, the fragrant-scented paths, and the cypresses down there within the grove
would whisper with the breeze; and from the house would come the intermittent sounds of voices as servants worked in peace. And what vast thoughts, what lovely dreams that distant sea evoked, those azure mountains I can see from here and which I fancied I would cross one day, imagining mysterious worlds beyond
in which mysterious joys awaited me, unconscious of what lay in store and how I would have often gladly changed this barren
and lamentable life of mine for death.

The Desire for Beauty
Francis Hutcheson
An Inquiry into the Original of Our Ideas of Beauty and Virtue, I, 15, 1725
[…] It appears evident that some objects immediately bring about this pleasure in Beauty, that we possess senses suited to perceiving it, and that it is different from the joy that arises from the prospect of advantage. For do we not often see

convenience and utility neglected in order to obtain Beauty, without any other prospect of advantage in the beautiful form apart from the suggestion of the pleasant ideas of Beauty? Now this shows us that no matter how we look for beautiful objects out of selfishness, with a view to obtaining the pleasures of Beauty, as in architecture, horticulture, and in many other things, nonetheless there must be a sense of Beauty prior to the prospect even of this advantage, without which sense these objects would not be so advantageous, nor would they create in us the pleasure that makes them advantageous.

Our sense of the Beauty in objects, through which we designate them as good, is quite distinct from our desire for such objects when they are thus constituted. Our desire for Beauty can be counterbalanced by rewards or threats, but this can never be true of our sense of Beauty, just as our fear of death or love of life can make us choose or desire a bitter potion, or neglect those foods that our sense of taste would suggest are pleasurable, and yet no prospect of advantage, or fear of harm, can make that potion pleasing to the senses, or the foods disagreeable, were they not thus prior to that prospect. It is exactly the same with regard to the sense of Beauty and harmony: that the search for such objects is frequently neglected, out of a prospect of advantage, aversion to effort, or out of any other selfish reason does not prove that we have a sense of Beauty, but only that our desire for it can be counterbalanced by a stronger desire. Thus the fact that gold is more important than silver is never taken as proof that the latter is devoid of importance.

267

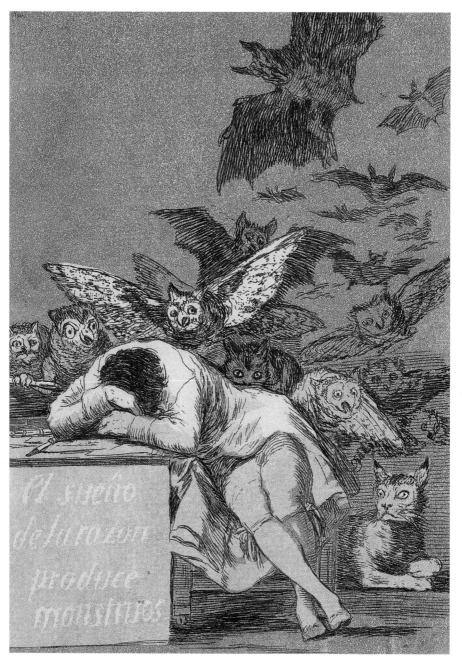

9. Cruel and Gloomy Beauty

Francisco de Goya y
Lucientes, *The Sleep of
Reason Produces
Monsters,*1799.

following pages
Pietro Longhi,
The Foyer, 1750.
Venice, Ca' Rezzonico,
Museo del Settecento
Veneziano

The dark side of reason is inscribed in Kant's very conclusions: reason's independence of nature and the need for an unjustified faith in a good Nature. Human reason has the power to disembody any cognitive object in order to bring it, in the form of a concept, under its own sway, that is to say to make itself independent. Nonetheless, if this is true, what limitation can prevent not only the reduction of things but also of people to the level of objects that may be manipulated, exploited, or modified? Who can prevent the rational planning of evil and the destruction of the hearts of others?

This is what is shown us by the characters in Choderlos de Laclos's *Les liaisons dangereuses,* where refined and cultivated Beauty is a mask behind which lurk the dark side of humankind and especially the thirst for vengeance of a woman, determined to take up the arms of cruelty and evil to revenge herself for the oppression that her sex has endured for centuries.

The cruel and ruthless use of reason leaves us to suspect that in itself Nature is neither good nor beautiful. And so what stops us from seeing it, like de Sade, as a cruel monster hungering for flesh and blood? Does the evidence of human history not offer us abundant proof of this? Cruelty therefore coincides with human nature, suffering is the means for attaining pleasure, the sole end in a world illuminated by the violent light of an unfettered reason that populates that same world with its nightmares. The Beauty of bodies no longer has any spiritual connotation; all it expresses is the cruel pleasure of the torturer or the torments of the victim, stripped of any moral frills. It is the triumph of the kingdom of evil in the world.

Francisco de Goya y
Lucientes,
*Saturn Devouring His
Children*, 1821-1823.
Madrid, Museo del
Prado

The Rational Planning of Evil

Pierre-Ambroise-François Choderlos de Laclos
Les liaisons dangereuses, 1782

Now it's up to you to go about things so that
Mme. de Volanges will not be alarmed by the
little escapades that our young man
permitted himself to relate in his letter. Save
us from the convent, and try above all to
persuade her to drop her request to have the
young lady's letters returned, because
Danceny will not let her have them at any
price, and I can't blame him: this time reason
and love are in complete agreement. I have
read these famous letters, in an attempt to
stave off boredom, and I think they might
prove useful one day. Let me explain. Despite
our precautions, a scandal might erupt
anyway, and this would put paid to the
marriage and with it all our plans for
Gercourt. In this case, since for my own
reasons I will have my revenge upon the
mother too, I would like to reserve myself the
chance to dishonor the daughter. By choosing
well from among this correspondence, and
publishing only excerpts from it, it would be
easy to have people believe that it was the
young lady who made the first move, or
better, that it was she who threw herself at
him. Some letters might even compromise
her mother, or at the very least cause her
name to be sullied by accusations of
unpardonable negligence.

Unfettered Reason

Mary Wollstonecraft Shelley
Frankenstein, 1818

These thoughts supported my spirits, while I
pursued my undertaking with unremitting
ardour. My cheek had grown pale with study,
and my person had become emaciated with
confinement. Sometimes, on the very brink of
certainty, I failed; yet still I clung to the hope
which the next day or the next hour might
realize. One secret which I alone possessed
was the hope to which I had dedicated
myself; and the moon gazed on my midnight
labours, while, with unrelaxed and breathless
eagerness, I pursued nature to her hiding
places. Who shall conceive the horrors of
my secret toil as I dabbled among the
unhallowed damps of the grave or tortured
the living animal to animate the lifeless clay?
My limbs now tremble, and my eyes swim
with the remembrance; but then a resistless,
and almost frantic, impulse, urged me
forward; I seemed to have lost all soul or
sensation but for this one pursuit. It was
indeed but a passing trance, that only made
me feel with renewed acuteness so soon as,
the unnatural stimulus ceasing to operate, I
had returned to my old habits. I collected
bones from charnel-houses and disturbed,
with profane fingers, the tremendous secrets
of the human frame. In a solitary chamber,
or rather cell, at the top of the house, and
separated from all the other apartments by a
gallery and staircase, I kept my workshop of
filthy creation; my eyeballs were starting from
their sockets in attending to the details of my
employment. The dissecting room and the
slaughter-house furnished many of my
materials; and often did my human nature
turn with loathing from my occupation,
whilst, still urged on by an eagerness which
perpetually increased, I brought my work near
to a conclusion.

The Sublime

1. A New Concept of Beauty

Caspar David Friedrich,
Chalk Cliffs at Rügen,
1818.
Winterthur, Oskar
Reinhart Collection

As had been the case in other epochs, the Neoclassicist school saw Beauty as a quality of the object that we perceive as beautiful and for this reason it fell back on Classical definitions such as "unity in variety" or "proportion" and "harmony." In Hogarth's view, for example, there existed a "line of Beauty" and a "line of grace," another way of saying that the conditions for Beauty lie in the form of the object.

In the eighteenth century, however, certain terms began to become popular: "genius," "taste," "imagination," and "sentiment" and it is these words that let us see that a new concept of beauty was coming into being. The idea of "genius" and "imagination" certainly refers to the qualities of those who invent or produce a beautiful thing, while the idea of "taste" denotes more clearly the qualities of those capable of appreciating it. It is clear, however, that all these terms are not concerned with the characteristics of the object but rather the qualities, capacities, or disposition of the subject (both the producer and the judge of Beauty). And while in the preceding centuries there had been no lack of terms referring to the aesthetic capacities of the subject (for example, concepts like "ingenuity," "wit," "agudeza" and "esprit") it was in the eighteenth century that the rights of the subject began to play a full part in the experience of Beauty.

A beautiful thing is defined by the way we apprehend it, by analyzing the reaction of the person who pronounces a judgment of taste. The debate about Beauty shifted from the search for the rules for its production or for its recognition to a consideration of the effects that it produces (even though in his work *Of the Standard of Taste*, Hume tries to reconcile the

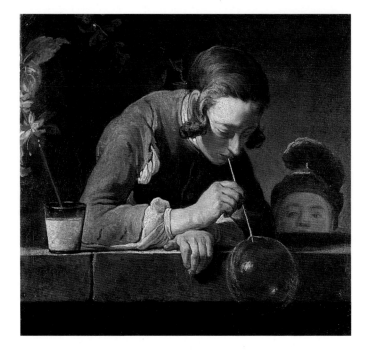

Jean-Baptiste-Siméon Chardin, *Soap Bubbles,* c. 1734. New York, Metropolitan Museum of Art

Subjectivity of Taste Judgment
David Hume
Of the Standard of Taste, 1757
One obvious cause, why many feel not the proper sentiment of beauty, is the want of that *delicacy* of imagination, which is requisite to convey a sensibility of those finer emotions. This delicacy every one pretends to: Every one talks of it; and would reduce every kind of taste or sentiment to its standard.

Objective Features
David Hume
Of the Standard of Taste, 1757.
Though it be certain, that beauty and deformity, more than sweet and bitter, are not qualities in objects, but belong entirely to the sentiment, internal or external; it must be allowed, that there are certain qualities in objects, which are fitted by nature to produce those particular feelings. Now as these qualities may be found in a smaller degree, or may be mixed and confounded with each other, it often happens, that the taste is not affected with such minute qualities, or is not able to distinguish all the particular flavors, amidst the disorder, in which they are presented. Where the organs are so fine, as to allow nothing to escape them; and at the same time so exact as to perceive every ingredient in the composition: This we call delicacy of taste, whether we employ these terms in the literal or metaphorical sense. Here then the general rules of beauty are of use; being drawn from established models, and from the observation of what pleases or displeases, when presented singly and in a high degree: And if the same qualities, in a continued composition and in a small degree, affect not the organs with a sensible delight or uneasiness, we exclude the person from all pretensions to this delicacy.

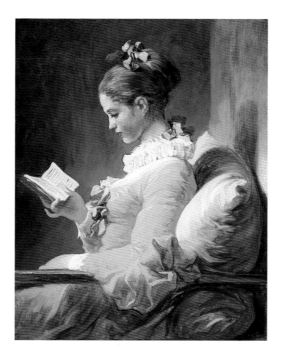

Jean-Honoré Fragonard,
A Young Girl Reading,
c. 1776.
Washington, D.C.,
National Gallery of Art

subjectivity of taste judgment and the experience of an effect with some **objective features** of the thing deemed beautiful). The idea that Beauty is something that appears as such to the perceiver, that it is bound up with the senses, the recognition of a pleasure, was dominant in diverse philosophical circles. At the same time, again in diverse philosophical circles, the idea of the Sublime was also making headway.

2. The Sublime Is the Echo of a Great Soul

Pseudo-Longinus, who probably lived in the first century AD, was the first to talk of the **Sublime,** to which he devoted a famous treatise that was widely read in John Hall's English translation and in Nicolas Boileau's French version from the seventeenth century onward, but it was not until the mid-eighteenth century that this concept was taken up with any particular vigor.

In Pseudo-Longinus's view, the Sublime is an expression of grand and noble passions (like those expressed in Homeric poetry or in the great Classical tragedies) that bring into play the **emotional involvement** of both the creator and the perceiver of the work of art. With regard to the process of artistic creation, Longinus accords the maximum importance to the moment of enthusiasm: in his view the Sublime is something that animates poetic discourse from within, thus leading the listener or the reader into transports of ecstasy. Longinus paid close attention to the rhetorical and stylistic techniques that produce this effect and came to the conclusion that the Sublime is reached through art.

For Longinus, therefore, the **Sublime is an effect of art** (and not a natural phenomenon) whose realization is determined by a convergence of certain rules and whose end is the procurement of pleasure. The first seventeenth-century reflections inspired by Pseudo-Longinus still refer to a "Sublime style" and therefore to a rhetorical procedure appropriate to heroic topics and expressed through elevated language capable of arousing noble passions.

Sublime
Pseudo-Longinus (first century AD)
On the Sublime, I
[…] Sublime does not persuade the audiences but rather transports them out of themselves. Invariably what inspires wonder casts a spell upon us and is always superior to what is merely convincing and pleasing.

Emotional Involvement
Pseudo-Longinus (first century AD)
On the Sublime, VIII
[…] Almost by nature our soul, in the presence of that which is truly Sublime, rises up and, seized by a proud exultation, is filled with a haughty joy, as if it was responsible for

what it has felt. When, on reading or listening to something several times, a cultivated and expert reader feels nothing great inside, no reflection richer than the literal perception of the discourse, but on the contrary notices—on reading and re-reading—that the sense of the work has waned, then he is not in the presence of the true Sublime, but of something that lasts only the space required for reading and listening. For true greatness is something that enriches the thoughts, something that is hard, if not impossible to gainsay, something that leaves an enduring, indelible memory. In short genuinely Sublime beauty is something that always pleases everyone.

Gianlorenzo Bernini,
Apollo and Daphne,
detail, 1622-1624.
Rome, Galleria Borghese

The Sublime Is an Effect of Art
Pseudo-Longinus (first century AD)
On the Sublime, VII

There are, one may say, some five genuine sources of the sublime in literature, the common groundwork, as it were, of all five being a natural faculty of expression, without which, nothing can be done. The first and most powerful is the command of full-blooded ideas—I have defined this in my book on Xenophon—and the second is the inspiration of vehement emotion. These two constituents of the sublime are for the most part congenital. But the other three come partly of art, namely the proper construction of figures—these being probably of two kinds, figures of thought and figures of speech—and, over and above these, nobility of phrase, which again may be resolved into choice of words and the use of metaphor and elaborated diction. The fifth cause of grandeur, which embraces all those already mentioned, is the general effect of dignity and elevation.

279

3. The Sublime in Nature

At this point in the eighteenth century, however, the idea of the Sublime was associated primarily with an experience bound up with art rather than nature, an experience that contained within itself a bias toward formlessness, suffering, and dread. In the course of the centuries, it was recognized that there are beautiful and agreeable things, and terrible, frightening, and painful things or phenomena: art has often been praised for having produced beautiful portrayals or imitations of ugliness, formlessness, and terror, monsters or the devil, death or a tempest. In his *Poetics*, Aristotle explains how tragedy, in representing horrific events, has to call up **fear and pity** in the spirit of the spectator. Nonetheless, the emphasis is placed on the process of purification **(catharsis)** through which spectators liberate themselves from those passions, which procure no pleasure in themselves. In the seventeenth century some painters were appreciated for their portrayals of ugly, foul, maimed, and crippled creatures, or for their cloudy and stormy skies, but no one said that a tempest, a stormy sea, or something threatening and devoid of any definite form could be beautiful in itself.

In this period, the world of aesthetic pleasure split up into two provinces, that of Beauty and that of the Sublime, even though the two provinces were not entirely separated (as happened with the distinction between Beauty

Caspar Wolf,
The Devil's Bridge, 1777.
Aarau, Aargauer
Kunsthaus

Fear and Pity
Aristotle (fourth century BC)
Poetics, XIV
Fear and pity sometimes result from the spectacle and are sometimes aroused by the actual arrangement of the incidents, which is preferable and the mark of a better poet. The plot should be so constructed that even without seeing the play anyone hearing of the incidents happening thrills with fear and pity as a result of what occurs. So would anyone feel who heard the story of Oedipus. To produce this effect by means of an appeal to the eye is inartistic and needs adventitious aid, while those who by such means produce an effect which is not fearful but merely monstrous have nothing in common with tragedy. For one should not seek from

tragedy all kinds of pleasures but that which is peculiar to tragedy, and since the poet must by "representation" produce the pleasure which comes from feeling pity and fear, obviously this quality must be embodied in the incidents.

Catharsis
Aristotle (fourth century BC)
Poetics, VI
Tragedy is, then, a representation of an action that is heroic and complete and of a certain magnitude—by means of language enriched with all kind of ornament, each used separately in the different parts of the play: it represents men in action and does not use narrative, and through pity and fear it effects relief to these and similar emotions.

Caspar David Friedrich,
Arctic Shipwreck, 1823.
Hamburg, Kunsthalle

opposite
Caspar David Friedrich,
*Wanderer Above the Sea
of Fog,* 1818.
Hamburg, Kunsthalle

and Truth, Well and Good, Beauty and Utility, and even between Beauty and Ugliness), because the experience of the Sublime acquired many of the characteristics attributed previously to that of Beauty.

The eighteenth century was an age of travelers anxious to get to know new landscapes and new customs, not out of a desire for conquest, as in previous centuries, but in order to savor new pleasures and new emotions. This led to the development of a taste for things that were exotic, interesting, curious, different, and astounding. This period marked the birth of what we might call the "poetics of mountains": the traveler bold enough to venture to cross the Alps was fascinated by impervious cliffs, endless glaciers, bottomless chasms, and boundless stretches of land.

Even before the end of the seventeenth century, in his *Telluris theoria sacra* Thomas Burnet saw in the experience of the mountains something that uplifted the soul toward God, calling up a hint of infinity and capable of arousing great thoughts and passions. In the eighteenth century, in his *Moral Essays*, the Earl of Shaftesbury said that even the rugged crags, the mossy caves, the caverns, and the waterfalls, adorned with all the graces of the wilderness, struck him as all the more fascinating for they represented nature in a more genuine manner and were enveloped in a magnificence far superior to what he described as the "ridiculous counterfeits" of princely gardens.

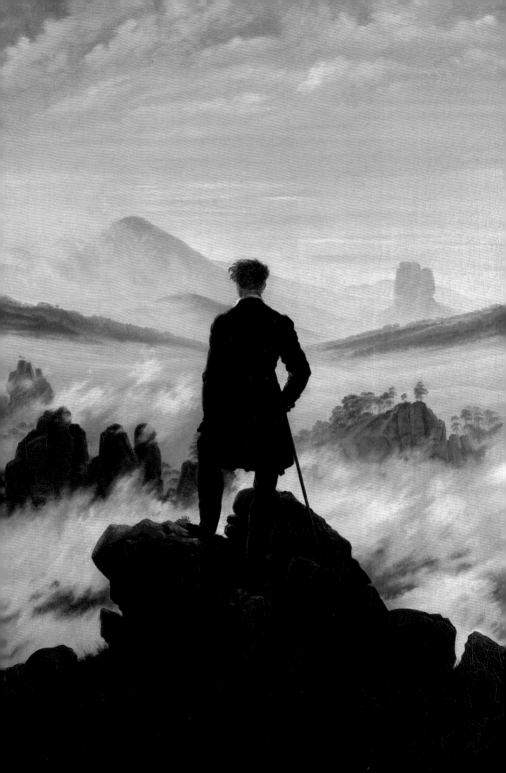

Astounding
Edgar Allan Poe
A Narrative of Arthur Gordon Pym, XXV, 1838
A sullen darkness now hovered above us—
but from out the milky depths of the ocean a
luminous glare arose, and stole up along the
bulwarks of the boat. We were nearly
overwhelmed by the white ashy shower
which settled upon us and upon the canoe,
but melted into the water as it fell. The
summit of the cataract was utterly lost in the
dimness and the distance. Yet we were
evidently approaching it with a hideous
velocity. At intervals there were visible in it
wide, yawning, but momentary rents, and
from out these rents, within which was a
chaos of flitting and indistinct images, there
came rushing and mighty, but soundless
winds, tearing up the enkindled ocean in their
course.

Boundless Stretches of Land
Ugo Foscolo
The Last Letters of Jacopo Ortis, May 13, 1798
If I were a painter! What a wealth of material
for my brush! The artist immersed in the
delightful idea of Beauty lulls or at least
soothes all the other passions. But what if I
were a painter? In the works of painters and
poets I have seen beautiful and sometimes
realistic nature; but I have never seen
sublime, immense, inimitable nature in any
painting. Homer, Dante, Shakespeare, three
masters of superhuman ingenuity, have
taken my imagination by storm and set my
heart afire: I have bathed their verses in
scalding tears; and I have worshipped their
divine shades as if I could see them seated in
the lofty vaults that tower over the universe
and dominate eternity. Even the originals
that I see before me fill all the powers of my
soul and I would not dare, Lorenzo, I would
not dare, even if Michelangelo were instilled
in me, to begin such a work. Almighty God!
When you admire a spring evening are you
perhaps satisfied with your creation? To
console me you have poured out an
inexhaustible source of pleasure, and I have
often looked upon it with indifference. On
the mountaintop gilded by the peaceful rays
of the setting sun, I see myself surrounded
by a chain of hills covered by undulating
wheat, and the olive trees and the elms are
richly festooned with swaying vines: the
distant crags and ridges grow steadily
upward as if one were piled upon the other.
Below me the mountainsides are furrowed
by barren ravines among which the evening

shadows gather as they gradually rise up; the
dark and horrible background looks like the
mouth of an abyss. On the southern slope
the view is dominated by the wood that
overhangs and obscures the valley where
the sheep graze in the open and scattered
goats cling to the steep crags. The birds sing
feebly as if weeping for the dying day, the
heifers low, and the wind seems to enjoy
murmuring among the foliage. But to the
north the hills divide, and a boundless plain
opens out before the eye: in the nearby
fields you can descry the oxen returning
home: the weary farmer accompanies them
leaning on his staff; and while wives and
mothers prepare dinner for the tired family,
the distant villas still gleam whitely, while
smoke rises from them and the cabins
scattered around the countryside. The
shepherds milk the flocks, and the old lady
who was spinning at the gate of the sheep
pen leaves her work to caress and fondle the
bullock and the little lambs that run bleating
around their mothers. Meanwhile the view is
fading away, and after a long series of trees
and fields it ends at the horizon where all
dwindles and merges into one. The setting
sun throws out a few rays, as if they were its
last farewell to nature; the clouds glow pink,
then slowly languish into pallor before they
darken: then the plain is lost and the
shadows spread out over the face of the
earth, and I, as if in the middle of the ocean,
can find only the sky.

The Experience of the Mountains
Thomas Burnet
Telluris theoria sacra, IX, 1681
The greatest objects of nature are, methinks,
the most pleasing to behold; and next to
the great concave of the heavens, and those
boundless regions where the stars inhabit,
there is nothing that I look upon with
more pleasure than the wide sea and the
mountains of the earth. There is something
august and stately in the air of these things
that inspires the mind with great thoughts
and passions; we do naturally upon such
occasions think of God, and His greatness,
and whatsoever hath but the shadow and
appearence of INFINITE as all things have that
are too big for our comprehension, they fill
and overbear the mind with their excess, and
cast it into a pleasing kind of stupor and
admiration.

4. The Poetics of Ruins

The second half of the eighteenth century marked the success of Gothic architecture, which, in comparison with Neoclassical proportions, could not fail to appear out of proportion and irregular, and it was precisely this taste for the irregular and the formless that led to a new appreciation of ruins. The Renaissance was passionately enthusiastic about the ruins of ancient Greece because through them it was possible to descry the complete forms of the original works; the Neoclassicist movement attempted to reinvent these forms (see Canova and Winckelmann). But in the eighteenth century ruins were appreciated precisely for their incompleteness, for the marks that inexorable time had left upon them, for the wild vegetation that covered them, for the cracks and the moss.

Karl Friedrich Schinkel,
Medieval Town by the River, 1815.
Berlin, Nationalgalerie

following pages
Caspar David Friedrich,
Abbey in an Oak Wood,
1809-1810.
Berlin, Nationalgalerie

Ruins
Percy Bysshe Shelley
Adonais, XLIX, 1821
Go thou to Rome,—at once the Paradise,
The grave, the city, and the wilderness;
And where its wrecks like shattered
mountains rise,

And flowering weeds, and fragrant copses dress
The bones of Desolation's nakedness
Pass, till the spirit of the spot shall lead
Thy footsteps to a slope of green access
Where, like an infant's smile, over the dead
A light of laughing flowers along the grass is
spread [...].

285

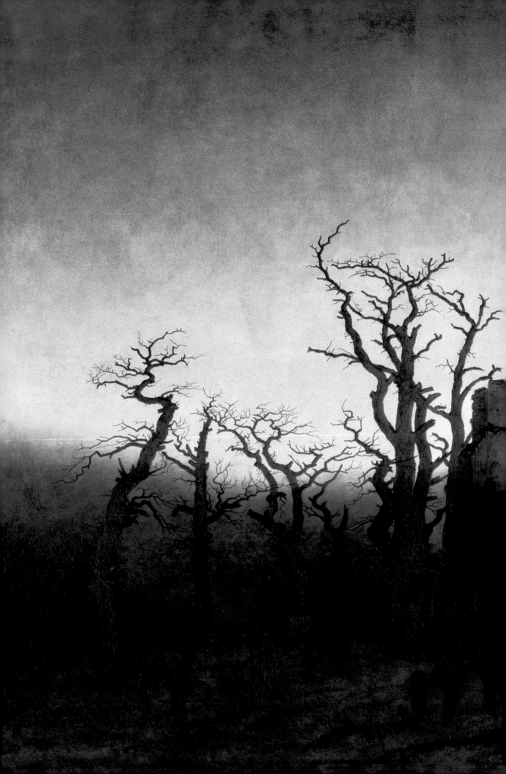

5. The "Gothic" Style in Literature

This taste for ruins and the Gothic was not just a characteristic of the visual universe, it also spread to literature; and in fact the second half of the century witnessed the rise of the "Gothic" novel, populated by dilapidated castles, monasteries, and disquieting cellars, which lent themselves to nocturnal visions, dark crimes, and ghosts.

By way of a parallel with this, the same period also witnessed the flourishing of graveyard poetry and funeral elegies, a sort of mortuary eroticism (which had already made an appearance in seventeenth-century poetry, with Torquato Tasso's Death of Clorinda) that went on to reach the heights of morbidity with the Decadentist school of the late nineteenth century. Thus, while some represented gloomy landscapes, specters, and terrifying situations, others wondered why it was that horror could give pleasure, given that until then the idea of pleasure and delight had been associated with the experience of Beauty.

Graveyard Poetry
Percy Bysshe Shelley
Hymn to Intellectual Beauty, 1815-1816
While yet a boy I sought for ghosts, and sped
Through many a listening chamber, cave, and ruin,
And starlight wood, with fearful steps pursuing
Hopes of high talk with the departed dead.
I called on poisonous names with which our youth is fed;
I was not heard—I saw them not—
When musing deeply on the lot
Of life, at that sweet time when winds are wooing
All vital things that wake to bring
News of birds and blossoming,—
Sudden, thy shadow fell on me;
I shrieked, and clasped my hands in ecstasy!

Mortuary Eroticism
Percy Bysshe Shelley
The Waning Moon, 1820
And like a dying lady, lean, and pale,
Who totters forth, wrapped in a gauzy veil,
Out of her chamber, led by the insane

And feeble wanderings of her fading brain,
The moon arose up in the murky East,
A white and shapeless mass—

The Death of Clorinda
Torquato Tasso
Jerusalem Delivered, XII, 1593
As violets blue mongst lilies pure men throw,
So paleness midst her native white begun;
Her looks to heaven she cast, their eyes I trow
Downward for pity bent both heaven and sun,
Her naked hand she gave the knight, in show
Of love and peace, her speech, alas, was done,
And thus the virgin fell on endless sleep,—
Love, Beauty, Virtue, for your darling weep!
But when he saw her gentle soul was went,
His manly courage to relent began,
Grief, sorrow, anguish, sadness, discontent,
Free empire got and lordship on the man,
His life within his heart they close up pent,
Death through his senses and his visage ran:
Like his dead lady, dead seemed Tancred good,
In paleness, stillness, wounds and streams of blood.

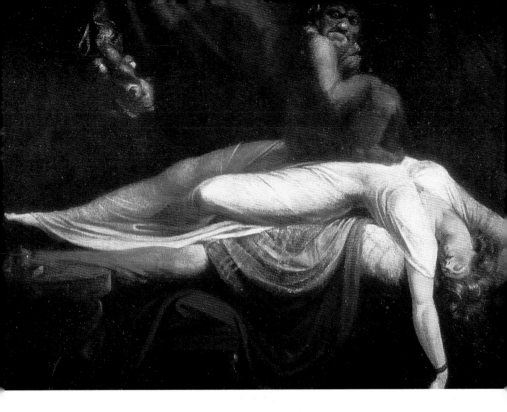

Johann Heinrich Füssli,
The Nightmare, 1781.
Detroit, Detroit Institute
of Arts

Horror

Friedrich von Schiller
On Tragic Art, 1792

It is a general phenomenon of our nature that sad, terrible, and even horrible things have an irresistible attraction for us; and that scenes of suffering and terror repel and attract us with equal power. Full of expectation, all will cluster around someone who is telling a murder story; we eagerly devour the most adventurous ghost story, and the more it makes our hair stand on end, the greater our eagerness.

This impulse of the spirit is all the more manifest when we are faced with reality. Seen from the shore, a storm that causes an entire fleet to sink would delight our imagination with the same power with which it would agitate the sentiments of our heart; it would be difficult to believe, as Lucretius does, that this natural pleasure springs from the comparison of our own safety with the danger perceived. And how numerous is the crowd that accompanies a criminal to the scene of his execution! Neither the pleasures of a love of justice

fulfilled, nor an ignoble taste for the lust for revenge appeased can explain this phenomenon. The hapless wretch may also be forgiven in the heart of the spectators, the most sincere compassion may take an interest in his salvation; yet the spectators are moved, to a greater or lesser degree, by a curious desire to see and listen to the expression of his suffering. If an educated man of refined sentiments is an exception to this, it is not because he does not possess this instinct, but because it is overcome by the sorrowful power of pity or because it is kept at bay by the laws of decorum. The coarse son of nature, untrammeled by any sense of human deiicacy, unashamedly abandons himself to this powerful impulse. Which must therefore have its basis in the natural disposition of the human animal and must be explained by a general psychological law.

6. Edmund Burke

The work that more than any other had contributed to the spread of the theme of the Sublime was *A Philosophical Inquiry into the Origin of Our Ideas of the Sublime and Beautiful* by Edmund Burke, the first version of which appeared in 1756, followed by another in 1759: "Whatever is fitted in any sort to excite the ideas of pain and danger, that is to say, whatever is in any sort terrible, or is conversant about terrible objects, or operates in a manner analogous to terror, is a source of the Sublime; that is, it is productive of the strongest emotion which the mind is capable of feeling."

Burke opposed Beauty to the Sublime. For him, Beauty was primarily an objective quality of bodies "for which they arouse love" that acts on the human mind through the **senses.** Burke was against the idea that Beauty consists in proportion and harmony (and in this sense he was at odds with centuries of aesthetic culture), and maintained that typical aspects of the beautiful were variety, **smallness, smoothness,** the **gradual variation,** delicacy, purity, and **fairness of color,** and also—to a certain extent—**grace** and elegance.

Burke's preferences are interesting because they are in contrast with his idea of the Sublime, which implies vastness of dimensions, ruggedness and negligence, solidity, even massiveness, and darkness. The Sublime comes into being with the unleashing of passions like terror, it flourishes in obscurity, it calls up ideas of power, and of that form of privation exemplified by emptiness, **solitude, and silence.** Predominant aspects of the Sublime are nonfinite things, difficulty, and aspirations to **greater and greater** things.

In this series of characteristics it is hard to find a unifying idea, also because Burke's categories are heavily influenced by his own personal tastes (birds are beautiful but out of proportion because the neck is longer than the rest of the body while the tail is very short, and among his examples of magnificence the starry sky is on a par with a firework display). What appears interesting in his treatise is rather the somewhat incongruous list of characteristics that in one way or another, and not necessarily all together, appeared between the eighteenth and nineteenth centuries whenever attempts were made to define or portray the Sublime: thus once more we find evocations of dark and gloomy buildings, a preference for cloudy skies to sunny ones, for night rather than day and even (in the field of taste) for bitter or foul-smelling things.

Giovanni Battista
Piranesi, *Prisoners on a
Suspended Platform*,
plate from
Imaginary Prisons,
1749-1750.

When Burke deals with the acoustic Sublime and calls up "the noise of vast cataracts, raging storms, thunder, or artillery," or the loud cries of animals, some may find his examples rather rough-hewn, but when he speaks of the sudden emotion caused by a sound of considerable intensity, with regard to which "the attention is roused […] and the faculties driven forward, as it were, on their guard," and says that "a single sound of some strength, though but of short duration, if repeated after intervals, has a grand effect," it is hard not to think of the opening of Beethoven's Fifth Symphony.

Burke avers that he is unable to explain the true causes of the effect of the Sublime and the beautiful, but in fact the question he poses himself is: how can terror be pleasant? His answer is: when it does not press too closely upon us. Let us take a closer look at this statement. It implies a **detachment from the causes of fear** and hence a certain indifference to it. Pain and terror are causes of the Sublime as long as they are not really harmful. This indifference is the same attitude that in previous centuries was closely associated with the idea of Beauty. Beauty is that which produces a pleasure that does not necessarily engender a desire to possess or consume the thing that pleases; likewise, the horror bound up with the Sublime is the horror of something that cannot possess us and cannot harm us. In this lies the deep relationship between Beauty and the Sublime.

Senses

Edmund Burke

A Philosophical Inquiry into the Origin of Our Ideas of the Sublime and Beautiful, I, 10, 1756

The object therefore of this mixed passion, which we call love, is the beauty of the sex. Men are carried to the sex in general, as it is the sex, and by the common law of nature; but they are attached to particulars by personal beauty. I call beauty a social quality; for where women and men, and not only they, but when other animals give us a sense of joy and pleasure in beholding them (and there are many that do so), they inspire us with sentiments of tenderness and affection towards their persons; we like to have them near us, and we enter willingly into a kind of relation with them, unless we should have strong reasons to the contrary.

Smallness

Edmund Burke

A Philosophical Inquiry into the Origin of Our Ideas of the Sublime and Beautiful, III, 13, 1756

In the animal creation, out of our own species, it is the small we are inclined to be fond of; little birds, and some of the smaller kinds of beasts. A great beautiful thing is a manner of expression scarcely ever used; but that of a great ugly thing is very common. There is a wide difference between admiration and love. The sublime, which is the cause of the former, always dwells on great objects, and terrible; the latter on small ones, and pleasing; we submit to what we admire, but we love what submits to us; in one case we are forced, in the other we are flattered, into compliance. In short, the ideas of the sublime and the beautiful stand on foundations so different, that it is hard, I had almost said impossible, to think of reconciling them in the same subject, without considerably lessening the effect of the one or the other upon the passions. So that, attending to their quantity, beautiful objects are comparatively small.

Smoothness

Edmund Burke

A Philosophical Inquiry into the Origin of Our Ideas of the Sublime and Beautiful, III, 14, 1756

The next property constantly observable in such objects is smoothness: a quality so essential to beauty, that I do not now recollect anything beautiful that is not smooth. In trees and flowers, smooth leaves are beautiful; smooth slopes of earth in gardens; smooth streams in the landscape; smooth coats of birds and beasts in animal beauties; in fine women, smooth skins; and in several sorts of ornamental furniture, smooth and polished surfaces. A very considerable part of the effect of beauty is owing to this quality; indeed the most considerable. For, take any beautiful object, and give it a broken and rugged surface; and however well formed it may be in other respects, it pleases no longer. Whereas, let it want ever so many of the other constituents, if it wants not this, it becomes more pleasing than almost all the others without it. This seems to me so evident, that I am a good deal surprised, that none who have handled the subject have made any mention of the quality of smoothness, in the enumeration of those that go to the forming of beauty. For indeed any ruggedness, any sudden projection, any sharp angle, is in the highest degree contrary to that idea.

Gradual Variation

Edmund Burke

A Philosophical Inquiry into the Origin of Our Ideas of the Sublime and Beautiful, III, 15, 1756

In this description I have before me the idea of a dove; it agrees very well with most of the conditions of beauty. It is smooth and downy; its parts are (to use that expression) melted into one another; you are presented with no sudden protuberance through the whole, and yet the whole is continually changing. Observe that part of a beautiful woman where she is perhaps the most beautiful, about the neck and breasts; the smoothness; the softness; the easy and insensible swell; the variety of the surface, which is never for the smallest space the same; the deceitful maze, through which the unsteady eye slides giddily, without knowing where to fix or whither it is carried. Is not this a demonstration of that change of surface, continual, and yet hardly perceptible at any point, which forms one of the great constituents of beauty?

Fairness of Color

Edmund Burke

A Philosophical Inquiry into the Origin of Our Ideas of the Sublime and Beautiful, III, 17, 1756

First, the colors of beautiful bodies must not be dusky or muddy, but clean and fair. Secondly, they must not be of the strongest kind. Those which seem most appropriated to beauty, are the milder of every sort; light greens; soft blues; weak whites; pink reds; and violets. Thirdly, if the colors be strong and

vivid, they are always diversified, and the object is never of one strong color; there are almost always such a number of them (as in variegated flowers), that the strength and glare of each is considerably abated. In a fine complexion, there is not only some variety in the coloring, but the colors: neither the red nor the white are strong and glaring. Besides, they are mixed in such a manner, and with such gradations, that it is impossible to fix the bounds. On the same principle it is, that the dubious color in the necks and tails of peacocks, and about the heads of drakes, is so very agreeable.

Grace
Edmund Burke
A Philosophical Inquiry into the Origin of Our Ideas of the Sublime and Beautiful, III, 22, 1756
Gracefulness is an idea not very different from beauty; it consists of much the same things. Gracefulness is an idea belonging to posture and motion. In both these, to be graceful, it is requisite that there be no appearance of difficulty; there is required a small inflection of the body; and a composure of the parts in such a manner, as not to encumber each other, not to appear divided by sharp and sudden angles. In this ease, this roundness, this delicacy of attitude and motion, it is that all the magic of grace consists, and what is called its *je ne sais quoi*; as will be obvious to any observer, who considers attentively the Venus de Medicis, the Antinous, or any statue generally allowed to be graceful in a high degree.

Solitude and Silence
Ugo Foscolo
To the Evening—Sonnets, I, 1803
Mayhap because you are the image
Of that mortal quietus so dear to me,
Come, O Evening! And when
Summer clouds and calm breezes
Lightsome pay you court,
And when from the snowy air
Upon the world you cast
Shadows unquiet and long
You always fall invoked, to lay a gentle hand
Upon my heart and its secret ways.
You force me to roam in thought on paths
That lead to eternity and the void, while
The felon time flees, and with him the hordes
Of cares that consume us both;
And as I look upon your peace, the soul
Of that warrior spirit within me slumbers.

Greater and Greater
Caspar David Friedrich
Observations on Viewing a Collection of Paintings by Artists Most of Whom Are Alive or Recently Deceased, 1830
This picture is large, yet one would want it to be even larger, for the superiority with which the subject is conceived demands a greater extension in space. Thus, when we would like a picture to be larger than it really is, this is always a form of praise.

Detachment from the Causes of Fear
Edmund Burke
A Philosophical Inquiry into the Origin of Our Ideas of the Sublime and Beautiful, IV, 7, 1756
As common labour, which is a mode of pain, is the exercise of the grosser, a mode of terror is the exercise of the finer parts of the system; and if a certain mode of pain be of such a nature as to act upon the eye or the ear, as they are the most delicate organs, the affection approaches more nearly to that which has a mental cause. In all these cases, if the pain and terror are so modified as not to be actually noxious; if the pain is not carried to violence, and the terror is not conversant about the present destruction of the person, as these emotions clear the parts, whether fine or gross, of a dangerous and troublesome encumbrance, they are capable of producing delight; not pleasure, but a sort of delightful horror, a sort of tranquillity tinged with terror; which, as it belongs to self-preservation, is one of the strongest of all the passions. Its object is the sublime. Its highest degree I call astonishment; the subordinate degrees are awe, reverence, and respect, which, by the very etymology of the words show from what source they are derived, and how they stand distinguished from positive pleasure.

7. Kant's Sublime

The person who was to define with greatest precision the differences and affinities between Beauty and the Sublime was Immanuel Kant in his *Critique of Judgment* (1790). For Kant the characteristics of the beautiful are: disinterested pleasure, universality without concept, and regularity without law. What Kant means by this is that we can enjoy the beautiful thing without necessarily wanting to possess it; we see it as if it were perfectly organized for a particular end, whereas in reality the only end to which that form aspires is its own existence; and therefore we enjoy it as if it were the perfect embodiment of a rule, whereas it is a rule unto itself. In this sense a flower is a typical example of a beautiful thing, and precisely in this sense we also understand why universality without concept is part of Beauty: for aesthetic judgment is not a matter of stating that all flowers are beautiful, but of stating that *this* particular flower is beautiful, while the need that leads us to say "this flower is beautiful" does not depend on reasoning based on principles, but on our sentiments. In this experience, then, we have "free play" of the imagination and the intellect.

The experience of the Sublime is different. Kant distinguishes between two sorts of Sublime, the mathematical and the dynamic variety. A typical example of the mathematical Sublime is the sight of the starry sky. Here we have the impression that what we see goes far beyond our sensibilities and we are thus induced to imagine more than we see. We are led to this because our reason (the faculty that leads us to conceive ideas such as God, the world, or freedom, which our intellect cannot demonstrate) induces us to postulate an infinity that is not only beyond the grasp of our senses but also beyond the reach of our imagination, which cannot manage to harness it to a single intuition. With the collapse of the possibility of "free play" between the imagination and the intellect there arises a disturbing, negative pleasure, which causes us to sense the magnitude of our subjectivity, capable of wanting something that we cannot have.

A typical example of the dynamic Sublime is the sight of a **storm.** Here, what shakes our spirit is not the impression of infinite vastness, but of infinite power: in this case, too, our sensible nature is left humiliated and, again, this is a source of a feeling of unease, compensated for by the sense of our moral greatness, against which the **forces of nature** are powerless.

These ideas, which were to nourish the Romantic sensibility, were later

William Bradford,
The View of the Sermitsialik Glacier,
1873. New Bedford, Massachusetts, Old Dartmouth Historical Society, New Bedford Whaling Museum

Storm
Immanuel Kant
The Critique of Judgment, I, 2, 28, 1790
Bold, overhanging, and, as it were, threatening rocks, thunderclouds piled up the vault of heaven, borne along with flashes and peals, volcanoes in all their violence of destruction, hurricanes leaving in all their track, the boundless ocean rising with rebellious force, the high waterfall of some mighty river, and the like, make our power of resistance a trifling moment in comparison with their might. But, provided our own position is secure, their aspect is all the more attractive for its fearfulness; and we readily call these objects sublime, because they raise the forces of the soul above the height of vulgar commonplace, and discover within us a power of resistance of quite another kind, which gives us courage to be able to measure ourselves against the seeming omnipotence of nature.

Forces of Nature
Samuel Taylor Coleridge
The Rime of the Ancient Mariner, 1798
And now the storm came, and he
Was tyrannous and strong:
He struck with his o'ertaking wings,
And chased south along.
With sloping masts and dipping prow,
As who pursued with yell and blow
Still treads the shadow of his foe
And forward bends his head,
The ship drove fast, loud roared the blast,
And southward aye we fled.
And now there came both mist and snow,
And it grew wondrous cold:
And ice, mast-high, came floating by,
As green as emerald.
And through the drifts the snowy clifts
Did send a dismal sheen:
Nor shapes of men nor beasts we ken—
The ice was all between.

Caspar David Friedrich,
*The Moon Rising over the
Sea*, 1822.
Berlin, Nationalgalerie

taken up and reelaborated in diverse ways by a variety of authors through-
out the eighteenth century. For Schiller, the Sublime is an object or re-
presentation in the presence of which our physical nature becomes aware
of its own limitations, in the same way as our reasonable nature feels itself
to be superior to and independent of all limitations (*On the Sublime*). For
Georg Wilhelm Friedrich Hegel it was an attempt to express the infinite
without finding an object in the realm of phenomena that might prove
itself fit for this representation (*Aesthetics: Lectures on Fine Art*, II, 2, 1835).

As we have said, however, in the eighteenth century the notion of the
Sublime established itself in an entirely original way, because it concerns an
experience we feel about nature, and not art. Although successive authors
applied the notion of the Sublime to the arts, the Romantic sensibility found
itself faced with a problem: how to portray artistically the impression of
sublimity we feel upon witnessing the spectacles of nature? Artists
attempted this feat in various ways, painting or writing about (or even
expressing in music) scenes of tempests, of boundless reaches, of mighty
glaciers, or immoderate passions.

Nonetheless, there are pictures, by Friedrich for example, which show
human beings as they observe the Sublime. The people are portrayed from
behind, in such a way that we must not look at them, but through them,
putting ourselves in their place, seeing what they see and sharing their
feeling of being negligible elements in the great spectacle of nature. In all
these cases, more than portraying nature in a moment of sublimity, the
painter has tried to portray (with our collaboration) what we feel on
experiencing the Sublime.

Beauty and the Sublime

Friedrich von Schiller
On the Sublime, 1801
Nature has given us two geniuses to accompany us through life. The joyful playfulness and sociable appeal of the first of these shortens our tedious journey; it loosens the shackles of necessity and with jovial good cheer it leads us to the perilous places where we must act as pure spirits and shrug off all that is physical—up to knowledge of truth and the practice of duty. There it must leave us, for its realm is the sensible world and beyond this its earthly wings cannot carry us. But then comes the second, silent and solemn, and in its strong arms it bears us across the profound abyss.

In the first of these geniuses we perceive our sense of Beauty, while in the second we recognize our sense of the Sublime. Beauty is indeed an expression of freedom, but not of the freedom that raises us above the power of nature to release us from all physical influences; it is rather the expression of that freedom we enjoy as men within nature. We feel free in the presence of Beauty because our sensible instincts are in harmony with the law of reason, for here the spirit acts as if untrammeled by no laws other than its own. The sense of the Sublime is a mixed emotion. It is composed of a sense of sorrow whose extreme expression is manifested as a shudder, and of a feeling of joy that can mount to rapturous enthusiasm and, while it is not actually pleasure, refined souls prefer it by far to all pleasure. This combination of two contradictory perceptions in a single feeling is irrefutable proof of our moral independence. For, as it is quite impossible for the same object to be related to us in two different ways, it therefore follows that we are related to the object in two different ways; and as a consequence, two opposed natures must be united in us, each of which deals with the perception of the object in a diametrically opposed manner. Through the sense of the Sublime, therefore, we discover that our state of mind is not necessarily determined by the state of our sensible perceptions, that the laws of nature are not necessarily our own, and that we possess an autonomous principle that is independent of all sensible emotions. The Sublime object is a kind of duality. Either we refer it to our intellectual capacities, only to be vanquished in our attempts to form an image and a concept of it; or we refer it to our vital energy and consider it as a power against which our own vanishes away.

Experiencing the Sublime

Ludwig Achim von Arnim and Clemens Brentano
Various Sentiments Before a Seascape by Friedrich, c. 1811
Amid an infinite solitude it is magnificent to stand on the seashore and contemplate a boundless watery waste beneath a gloomy sky, and to that feeling we must add our having gone to that place—from where we must return—our desire to cross that sea, our knowledge that this is not possible, and the fact that we notice the absence of all life and yet we sense its voice in the roaring of the waves, in the wind, in the scudding clouds and in the solitary cry of the birds; all this is the expression of a need that comes from the heart, while nature, so to speak, renders it vain. But, on standing before the image, all this is impossible and all the things I would have liked to find in the picture itself I discovered principally in the relationship between me and the picture, since the need that the picture had set before me was thwarted by the picture itself: and thus I became the Capuchin monk and the picture became the sand dune; the sea, which my eye sought with longing, was entirely absent. Now, in order to experience this marvelous feeling, I listened to the diverse comments expressed by the beholders around me, and I set them down here as appertaining to the picture, which is without a doubt an ornament before which an action necessarily takes place, since it grants us no rest.

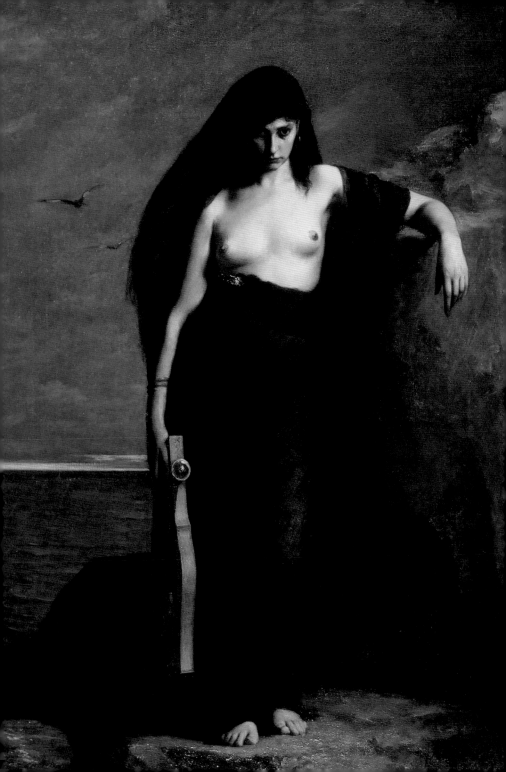

Romantic Beauty

1. Romantic Beauty

Charles-Auguste
Mengin, *Sappho*, 1877.
Manchester, Manchester
Art Gallery

"Romanticism" is a term that does not so much designate a historical period or a precise artistic movement as a set of characteristics, attitudes, and sentiments whose particularity resides in their specific nature and especially in the originality of the relationships between them. And some particular aspects of the Romantic concept of Beauty are indeed original, even though it is not hard to find antecedents and precursors: the Beauty of the Medusa, grotesque, gloomy, melancholy, formless. But what is especially original is the bond linking up the various forms, dictated not by reason, but by the sentiments *and* reason. The aim of this bond is not to exclude contradictions or to resolve antitheses (finite/infinite, whole/fragment, life/death, mind/heart), but to bring them all together and it is in this that the true originality of Romanticism lies.

Foscolo's portrait of himself is a good example of the way men of the Romantic period tended to represent themselves: **Beauty and melancholy,** heart and reason, reflection and impulse are reciprocally commingled. But we should beware considering the historical period in which Foscolo lived— between the Revolution and the Restoration, between Neoclassicism and Realism—as the epoch of the expression of Romantic Beauty.

Indeed this Beauty, which can be found in a gaunt, emaciated face behind which, not overly concealed, peeps Death, was already markedly present in Tasso and its influence was felt right to the end of the nineteenth century with D'Annunzio's interpretation in a macabre vein of Leonardo's *Mona Lisa*. Romantic Beauty expresses a state of mind that, depending on the themes, started with Tasso and Shakespeare and was still present in Baudelaire and D'Annunzio, as forms were elaborated to be adopted in their

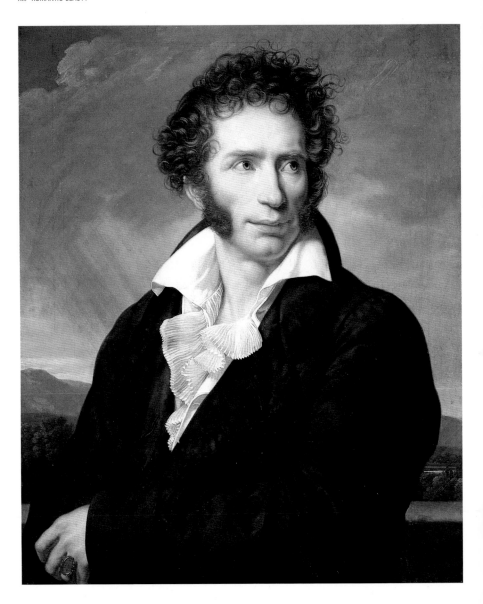

François Xavier Fabre,
Portrait of Ugo Foscolo,
Florence, Galleria
degli Uffizi

Flemish School
(formerly attributed to
Leonardo da Vinci),
Head of Medusa,
sixteenth century.
Florence, Galleria
degli Uffizi

The Brightness of Beauty
William Shakespeare
Romeo and Juliet, II, 2, 1594-1597
But soft! What light through yonder window breaks?
It is the East, and Juliet is the sun!
Arise, fair sun, and kill the envious moon,
Who is already sick and pale with grief
That thou her maid art far more fair than she.
Be not her maid, since she is envious.
Her vestal livery is but sick and green,
And none but fools do wear it. Cast it off.
It is my lady; O, it is my love!
O that she knew she were!
She speaks, yet she says nothing. What of that?
Her eye discourses; I will answer it.
I am too bold; 'tis not to me she speaks.
Two of the fairest stars in all the heaven,
Having some business, do entreat her eyes
To twinkle in their spheres till they return.
What if her eyes were there, they in her head?
The brightness of her cheek would shame those stars
As daylight doth a lamp; her eyes in heaven
Would through the airy region stream so bright
That birds would sing and think it were not night.
See how she leans her cheek upon her hand!
O that I were a glove upon that hand,
That I might touch that cheek!

Beauty and Melancholy
Ugo Foscolo
*Wrinkled Is My Brow, Sunken and Intent My Eyes
—Sonnets*, VII, 1802
Wrinkled is my brow, sunken and intent my eyes,
Tawny hair, gaunt cheeks, a bold air,
Fleshy red lips and white teeth,
Head bowed, a fine neck and a deep chest;
 Good limbs, well formed, plainly dressed;
Nimble of step and thought, word and deed,
Quiet, humane, loyal, generous, and sincere,
Against the world, when events are against me;
Bold of speech, and often of hand;
Alone most days and sad, ever pensive;
Hot-tempered, alert, restless, and tenacious;
Rich in vices and in virtues both, I praise
Reason, yet I follow my heart:
Death alone will grant me fame and peace.

Potion and Spell
Charles Baudelaire
Little Prose Poems, 1869
She is really ugly. Yet she is delightful!
Time and Love have marked her with their
talons, and they have cruelly taught her that
every minute and every kiss carry off a tribute
in youth and freshness.
She is really ugly; an ant, a spider if you will,
even a skeleton; but she is also potion,
mastery, spell! In short she is exquisite!
Time has not sapped the buoyant harmony
of her step or the indestructible elegance of

301

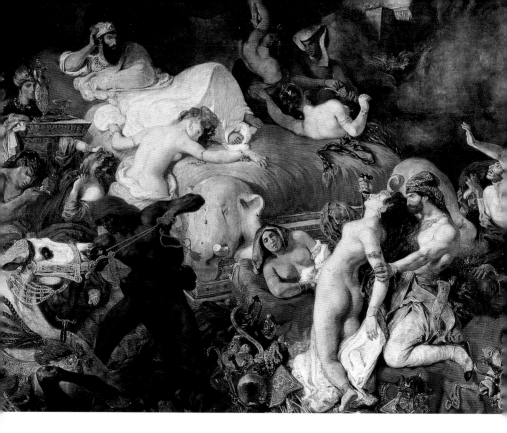

her defenses. Love has not altered the sweetness of her breath, that of a little girl; and Time has quite failed to wrest away her flowing mane, which gives off the wild scents of the mad vitality of the French *Midi*: Nîmes, Aix, Arles, Avignon, Narbonne, Toulouse, cities blessed by the sun, amorous and fascinating!

Time and Love have sunk their teeth into her in vain, albeit with good appetite; for in no way have they reduced the vague but eternal charm of her masculine breast.

The worse for wear, perhaps, but undaunted, and ever heroic, she makes you think of those thoroughbred horses that real connoisseurs recognize, even when harnessed to a hackney cab or a heavy cart.

And then she is so sweet and so fervent! She loves as one loves in autumn; one would say that the coming winter has lit a new fire in her heart, and the servility of her tenderness never betrays a trace of anything wearying.

The Gorgon
Gabriele D'Annunzio
Isaotta Guttadauro and Other Poems, 1886
In her face she had
That gloomy pallor I adore. [...]
On her lips was the splendid
And cruel smile
That the divine Leonardo
Pursued in his canvases.
Sorrowfully, that smile
Battled with the sweetness
Of almond eyes to lend a superhuman
Charm to the beauty
Of the female heads
That the great da Vinci loved.
Her mouth was a sorrowing flower [...]

Death and Beauty
Victor Hugo
Ave, Dea, 1888
Death and Beauty are two profound things
That contain so much blue and so much black
As to seem two sisters terrible and fecund
With the same enigma and the same mystery.

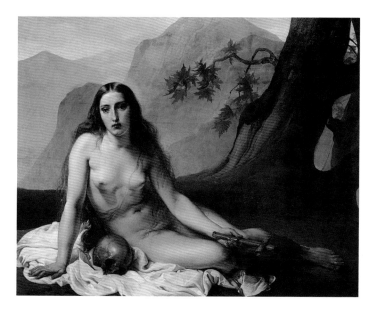

turn by the dreamlike Beauty of the Surrealists and the macabre taste of modern and postmodern kitsch.

It is interesting to trace the progressive formation of Romantic taste through the semantical changes that affected terms such as "Romantic," "Romanesque," and "Romantisch." Midway though the seventeenth century the term "Romantic" was a synonym (in a negative sense) of the Italian term *romanzesco* (like the old romances); a century later its meaning was rather "chimerical" ("Romanesque") or "picturesque"; to this picturesque spectacle Rousseau added an important subjective definition: the expression of a vague and indeterminate *je ne sais quoi*.

Finally, the first German Romantics broadened the scope of the indefinable and of the vague covered by the term "Romantisch," which came to cover all that was distant, magical, and unknown, including the lugubrious, the irrational, and the cemeterial. Above all, what was specifically Romantic was the *aspiration* (*Sehnsucht*) to all this. Since this aspiration cannot be characterized historically, then Romantic is a label that can be attached to any art that expresses such an aspiration, or perhaps all art is Romantic insofar as it expresses nothing other than that aspiration. Beauty ceases to be a form and the beautiful becomes the formless and the chaotic.

2. Romantic Beauty and the Beauty of the Old Romances

'Like the old romances': midway through the seventeenth century the reference was to the chivalric romances set in medieval times, as opposed to the new sentimental novel, whose subject matter was not the fantastic life of heroism and derring-do, but real everyday life.

This new novel, born in the salons of Paris, profoundly influenced the Romantic sense of Beauty, the perception of which was a blend of passion and sentiment: an excellent example of this, also in view of the author's destiny, is the novel written by the young Napoleon Bonaparte, *Clisson et Eugénie*, which already contains the novelty of Romantic love in contrast with the seventeenth-century concept of amorous passion.

Unlike the characters of Madame de La Fayette, the Romantic heroes—from Werther to Jacopo Ortis, just to mention the best known—are unable to resist the force of the passions. Amorous Beauty is a tragic Beauty, in the face

Francesco Hayez,
The Kiss, 1859. Milan,
Pinacoteca
di Brera

The Relativity of Beauty
Pierre-Ambroise-François Choderlos de Laclos
The Education of Women, XI, 1785
On the other hand, if someone would convince us that Beauty acts only because it calls up the idea of pleasure and that, for us, Beauty is represented by the set of features that we are most accustomed to seeing, all we need do is change country. For example, transport a Frenchman to Guinea: at first, the aspect of the negresses will repel him because their features—unusual for him—will call up no sensual recollections, but as soon as he gets used to them, he will no longer feel repulsion and so, while he will continue to choose from their number those who are closest to European canons of Beauty, he will begin to rediscover the taste for freshness, height, and strength that are signs of Beauty everywhere; moreover, as he gets increasingly accustomed to them, he will very soon end up preferring the aesthetic characteristics he sees every day to those of which he has by that time only a vague memory, and thus he will prefer a broad nose, very full lips, etc.; thus are born the many

interpretations of Beauty and the apparent contradictions in the tastes of men.

The Ancients and Beauty
Friedrich Schlegel
Lyceum, fragment 91, 1795
The Ancients are neither the Jews, nor the Christians, nor the English poets. They are not a people of artists elected arbitrarily by God; nor do they alone possess a beatifying faith in Beauty; nor do they hold a monopoly on poetry.

Defenseless
Ugo Foscolo
The Last Letters of Jacopo Ortis, May 12, 1798
I did not dare, no, I did not dare. I could have embraced her and clasped her here, to this heart. I saw her asleep: sleep kept those big black eyes closed, but the roses were strewn brighter than ever over her dewy cheeks. Her fair body lay slumped on a sofa. Her head rested on one arm while the other hung slackly down. I have seen her several times strolling and dancing; deep down in my soul I heard her harp and her voice; I adored her full

of awe as if I had seen her descend from paradise—but I have never seen her as beautiful as she is today, never. Her apparel permitted me a glimpse of her angelic curves; and my soul contemplated her and—what more can I tell you? All the passions and ecstasy of love had set me ablaze and ravished me away. Like a devotee I touched her clothes and her perfumed hair and the posy of violets she had in her bosom—yes, yes, beneath this hand become sacred I felt her heart beating. I drew in the breath from her half-open mouth—I was about to suck all the raptures of those celestial lips—her kiss! And I would have blessed the tears that I have long been drinking for her—but then I heard her sigh in her sleep: I withdrew, almost thrust back by a divine hand.

Lucia Mondella
Alessandro Manzoni
The Betrothed, II, 1827
Just then Lucia came out, all dressed up by her mother. Her girl friends contended for the bride, and they insisted that she show herself; and she kept trying to elude them with that rather belligerent modesty typical of country girls, shielding her face with her elbow and holding it bowed over her bosom and knitting her long black eyebrows, while her mouth opened in a smile. The youthful black hair, separated above her brow by a fine white parting, was gathered up at the nape of her neck into a multitude of braided circlets, pierced by long silver pins arranged all around, almost like the rays of a halo, in the manner still favored by peasant women in the Milan area.
Around her neck she had a necklace of garnets alternated with gold filigree buttons: she was wearing a fine brocaded bodice with a floral pattern, with slit sleeves laced up by pretty ribbons: a short floss-silk skirt with serried ranks of fine pleats, crimson stockings and slippers made of embroidered silk. Apart from this, which was the particular ornament of the wedding day, Lucia also had the everyday adornment of an unassuming Beauty, enhanced by the various emotions that painted themselves on her face. Joy tempered by a slight anxiety and that serene sorrow occasionally to be seen on brides' faces, which does not mar Beauty but lends it a particular character.
Little Bettina plunged into the crowd, went up to Lucia, and shrewdly made her understand that she had something to tell her; and she said a few words in her ear.

Kindling a Strong Passion
Napoleon Bonaparte
Clisson and Eugénie, c. 1800
Skeptical by nature, Clisson became melancholic. In him, dream had taken the place of reflection. He had nothing to do, to fear, or to hope for. This state of quietude, so new to his character, was to lead him without warning to torpor.
Dawn would find him wandering in the countryside, his customary thoughts touched him.
He would often go to the spa at Alles, which stood one league from his home. There he would spend whole mornings observing the men or walking through the forest, or reading some good author.
One day when, unusually, there was a lot of people, he came across two handsome young ladies who seemed to be having great fun on their walk. They were coming back from there alone, with all the carefree gaiety of their sixteen years. Amélie, seventeen, had a beautiful body, beautiful eyes, beautiful hair and complexion. Eugénie, one year younger, was less beautiful.
Amélie's look seemed to say: you love me, but you are not the only one, there are many others; know therefore that if you want me to like you, you must adulate me, I appreciate compliments, and I like a ceremonious tone. Eugénie never looked a man in the eye. She smiled sweetly in order to show off the most beautiful teeth you could imagine. If you offered her your hand, she would take it shyly and withdraw it quickly. You would have said that she was being provocative when she gave a glimpse of the most beautiful hand ever seen, in which the whiteness of the skin was set off by the blue of the veins.
Amélie was like a piece of French music, which you listen to with pleasure because all can follow the sequence of chords, and all appreciate the harmony.
Eugénie was like the song of the nightingale, or like a piece by Paisiello that only sensitive souls appreciate, a melody that transports and moves those souls made to feel it intensely, but which most find mediocre. Amélie enslaved most young men, she expected love.
But Eugénie could please only the ardent man who does not love for fun, out of gallantry, but with the passion of a deep emotion.
The former conquered love with her beauty. Eugénie had to kindle in the heart of one man alone a powerful passion, worthy … of heroes.

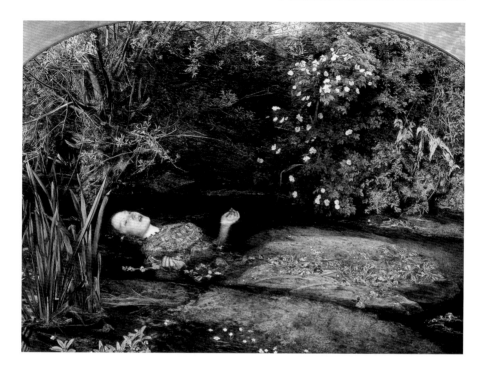

John Everett Millais,
Ophelia, 1851-1852.
London, Tate Britain

of which the protagonist is helpless and **defenseless**. The fact remains—as we shall see later—that for the Romantics even death itself, wrested from the realm of the macabre, had its appeal and could be beautiful: when Napoleon became emperor he had to issue a decree forbidding the very suicide for love that he had ordained for his own character Clisson, proof of the spread of Romantic ideas among the young people of the early nineteenth century.

Romantic Beauty, which inherited the realism of passion from the sentimental novel, is an exploration of the relationship with destiny that characterizes the Romantic hero. This inheritance, however, does not invalidate the fact that the roots of Romantic Beauty lie deeply embedded in history. For the Romantics, in fact, history was a subject worthy of the maximum respect, but not of veneration: the Classical age did not contain absolute canons that the modern age was obliged to imitate.

Deprived of its ideal component, the very concept of Beauty was profoundly modified. In the first place, **the relativity of Beauty** that some eighteenth-century writers had already arrived at could be grounded in history through proper historical research into the sources. The simple, rustic (but not fatuous) Beauty of Manzoni's **Lucia Mondella** certainly reflects an ideal—the immediacy of the values of a premodern Italy idealized in the seventeenth-century Lombard countryside—but it is an

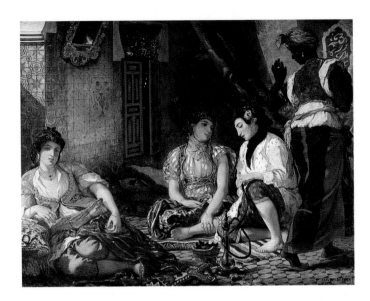

Eugène Delacroix,
Women of Algiers in Their Apartment, 1834.
Paris, Musée du Louvre

opposite
Jean-Auguste-Dominique Ingres,
The Countess Haussonville, 1845.
New York,
Frick Collection

ideal described in historical, i.e., realistic, terms devoid of any abstraction. Similarly, again in Manzoni's *The Betrothed*, the Beauty of the Alpine landscape as described in the episode of the escape expresses a sincere and ingenuous sentiment of a Beauty still uncontaminated by the values of modernity and progress, a modernity and progress that Manzoni the realist and rationalist knew was a consequence of national independence and the liberal age, but that Manzoni the Jansenist could not accept.

In the second place, in the conflict between **Classical canons** and Romantic taste there emerges a vision of history as a reservoir of surprising and unusual images that Classicism had tended to relegate to the background and that the fashion for travel had relaunched with the cult of the exotic and the oriental: nothing expresses this gap better than the comparison between the extraordinary technical mastery of Ingres, which conveys a sense of perfection that contemporaries occasionally found intolerable, and the relative imprecision of Delacroix's style, which expresses a striving for a surprising, exotic, violent Beauty.

Classical Canons
Johann Wolfgang von Goethe
Italian Journey
(Caserta, March 16, 1787), 1816-1817
The Lord Hamilton […] has found the acme of delight both in nature and in art in the person of a beautiful girl. He keeps her in his home. She is a young Englishwoman of about twenty years, truly beautiful and well formed. He has had them make her a Greek costume that suits her marvelously: thus dressed, she lets down her hair, takes two or three shawls, and she knows how to lend such variety to her poses, to her gestures, and to her expressions, that you end up really believing you are dreaming. That which many artists would be glad to express, in her appears complete, brimming with life and a surprising variety. […] The old Lord finds in her all the statues of Antiquity, all the fine profiles of Sicilian coins, and even the Apollo of Belvedere.

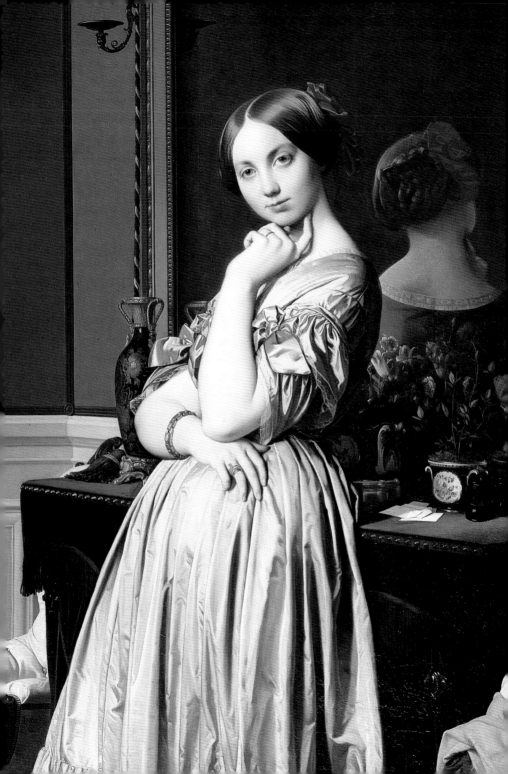

3. The Vague Beauty of *Je Ne Sais Quoi*

The expression *je ne sais quoi* with reference to a Beauty that defies verbal description, and especially with reference to the corresponding sentiment in the mind of the beholder, was not coined by Rousseau. The phrase is not original, as it had already been used by Michel de Montaigne and later by Père Dominique Bouhours, who, in his *Entretiens d'Ariste et d'Eugène* (1671), stigmatized the fashion among Italian poets to render everything mysterious with their *non so che*; nor is the usage original, as it was already present in Agnolo Firenzuola's *On the Beauty of Women*, and above all in Tasso, with whom *non so che* had come to signify Beauty no longer as grace, but as the emotional impulse aroused in the mind of the beholder.

Jean-Baptiste-
Camille Corot,
*Reading Woman
Crowned with Flowers*,
1845. Paris, Musée du
Louvre

opposite
Karl Friedrich Schinkel,
*The Passage
through the Rocks*,
1818. Berlin,
Nationalgalerie

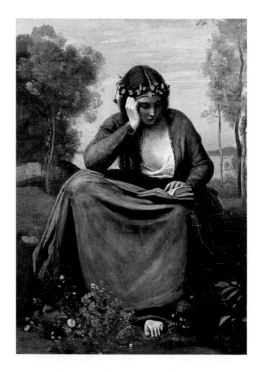

It was in this sense of the expression that Rousseau used *je ne sais quoi*, thereby "romanticizing" Tasso. But above all Rousseau inserted this expressive vagueness into the context of a wider offensive against the preciosity of lofty, mock-Classical Beauty, an offensive that he launched with means that were more radical than those of his Enlightenment and Neoclassical contemporaries. If modern man is not the result of the development but of the degeneration of original purity, then the battle against civilization should be fought with new weapons, no longer taken from the arsenal of reason (which is a product of the same degeneration): the arms of sentiment, nature, and spontaneity.

Before the eyes of the Romantics, on whom Rousseau left a decisive and lasting impression, there opened out a horizon that Kant prudently scaled down with his critique of the Sublime. Nature itself, as opposed to the artifice of history, appeared obscure, formless, and mysterious: it would not let itself be captured by precise, clear-cut forms, but overwhelmed the spectator with grandiose and sublime visions. For this reason the Romantics did not describe the Beauty of nature, but experienced it directly, sensing it by plunging into it. And since nocturnal **melancholy** was the sentiment that best expressed this immersion in all-pervasive nature, the Romantics were also given to nocturnal walks and **restless wandering** in the moonlight.

Melancholy
Immanuel Kant
Observations on the Feeling of the Beautiful and Sublime, II, 1764
The person with melancholic tendencies is not thus defined because, devoid of the joys of life, he pines away in gloomy melancholy, but because his sensations—when they spread out beyond a certain measure, or follow a mistaken course—come to this sadness of the soul more easily than they do to other conditions of the spirit. The dominant feature of the melancholic is the sentiment of the Sublime. Even Beauty, to which he is just as sensible, does not only tend to fascinate him, but, by inspiring his admiration, to move him. In him the enjoyment of pleasure is more composed, but no less intense for that; but all emotions aroused by the Sublime are more attractive to him than all the fascinating attractions of Beauty.

Restless Wandering
Percy Bysshe Shelley
Hymn to Intellectual Beauty, 1815-1816
Spirit of Beauty, that dost consecrate
With thine own hues all thou dost shine upon
Of human thought or form,—where art thou
gone?
Why dost thou pass away and leave our state,
This dim vast vale of tears, vacant and
desolate?
Ask why the sunlight not for ever
Weaves rainbows o'er yon mountain-river,
Why aught should fail and fade that once is
shown,
Why fear and dream and death and birth
Cast on the daylight of this earth
Such gloom,—why man has such a scope
For love and hate, despondency and
hope?

Mysterious Night
Novalis
Hymns to the Night, I, 1797
Do you too take pleasure in us, dark night?
What do you hold beneath the mantle that,
with invisible power, touches my soul?
Precious balm drips from your hands, from a
sheaf of poppies. You uplift the heart's heavy
wings. We are moved in a dark and
inexpressible way. With fear and joy I see an
austere face that, sweet and composed, is
bent over me to reveal among an infinity of
tangled curls the dear youth of the mother.
What a poor and childish thing the light now
seems and how joyous and blessed the
departure of the day.

4. Romanticism and Rebellion

Rousseau unwittingly gave voice to a widespread uneasiness with regard to the contemporary period that pervaded not only artists and intellectuals but also the entire middle class. The common denominator linking people who were often very different from one another and who only later were to cohere into a homogeneous social class sharing similar tastes, attitudes, and ideology was the perception that the aristocratic world, with its Classical rules and elevated concept of Beauty, was a cold and narrow-minded one. This outlook was strengthened by the increasing importance of the individual, in its turn amplified by the fact that writers and artists were obliged to compete with one another on the free market in an attempt to win the favor of public opinion. As in Rousseau, this rebellion was expressed through sentimentalism, the search for ever more stirring emotions, and the exploitation of surprising effects.

It was in Germany that these trends found their most immediate expression. This was the *Sturm und Drang* movement, which opposed the despotic rationale of the Enlightened monarchs because it denied a legitimate space to an intellectual class that had by then emancipated itself from the court aristocracy in terms of both morality and ideas.

Charles Giraud,
Feverish Man in the Roman Countryside, ,
c. 1815.
Clermont-Ferrand,
Musée des Beaux-Arts

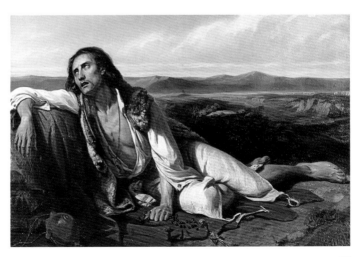

Eugène Delacroix,
*Liberty Leading
the People*, 1830.
Paris, Musée du Louvre

The pre-Romantics opposed the disenchanted Beauty of the day with a concept of the world seen as inexplicable and unpredictable: a "literary sansculottism" (as Goethe was to put it) that drew vigor from outward restraints in order to nourish a wholly inward sentiment of rebellion. But, precisely because of its rejection of the rules of rationality, this was an inwardness that was in itself free and despotic at the same time: the Romantics lived their lives like a novel, carried away by **the power of sentiments** they were unable to resist. It is from this that the melancholy of the Romantic hero springs. It is no accident that Hegel had Romanticism begin with Shakespeare, referring to that prototype of the sad and wan hero, Hamlet, created centuries before by the man the Romantics acknowledged as their master.

The Power of Sentiments
Ugo Foscolo
To Paolo Costa, 1796
Now that for some few moments the shadows that darken all my sad thoughts have been dispelled, and now that my downcast heart has found some rest, and my fancy does not paint all things with its deathly hues, I think of friendship, and, cloaked in an elegant melancholy, I find delight in murmuring the moving verses of Ossian and Geremia, in contemplating the images of Canova, of Raphael, and of Dante; and finally—seized by the sweetest of thrills—I lose myself in the appearance of the most beautiful of women. I bless the hand of Nature, I adore the effigies of the Sublime and the Beautiful, and I delight in the tumultuous aspect of the passions, and in a restless pleasure.

5. Truth, Myth, and Irony

Hegel himself played a conscious role in the normalization of Romantic impulsiveness, by formulating aesthetic categories that for many years were to impose a distorted view of the entire Romantic movement. Hegel associated aspirations to infinity with the idea of "Beautiful Souls," a term used to convey illusory attempts to take refuge in an inward dimension in which any ethical confrontation with the real world is avoided.

Hegel's judgment is profoundly ungenerous because, by mocking the purity of the Beautiful Soul, he did not grasp just how much profound innovation the Romantic sensibility had brought to the concept of Beauty. The Romantics—particularly Novalis and Friedrich Schlegel, the moving spirits of the magazine *Athenäum*, and Friedrich Hölderlin—were not looking for a static and harmonious Beauty, but a dynamic one, in the process of becoming, and therefore discordant because (as Shakespeare and the Mannerists had already taught) Beauty can spring even from Ugliness, form from formlessness, and vice versa.

In short, the question was how to retable the debate about the Classical antitheses of thought, in order to reelaborate them within the framework of a dynamic relationship: to reduce the distance between subject and

Beautiful Souls
Georg Wilhelm Friedrich Hegel
The Phenomenology of Mind, 1807
Consciousness lives in terror of staining the splendor of its inner being by acting or being; and, in order to preserve the purity of its heart, it shuns contact with actuality and stubbornly refuses to renounce its own Self, which is pared down to the ultimate degree of abstraction, and [thus] to give itself substantial existence, i.e., to transform its thought into being and to commit itself to the absolute distinction [between thought and being].
The empty object that consciousness produces is now filled, therefore, with an awareness of emptiness. Its activity consists of longing, which merely loses its way in the process of becoming a unsubstantial object that, in falling back on itself, finds itself simply lost. In the shining purity of its moments, it becomes a sorrowing beautiful soul, as they say. It burns itself all up and dissipates like some insubstantial haze that vanishes into thin air.

Beauty is Truth
John Keats
Ode on a Grecian Urn, 1820
O Attic shape! Fair attitude! with brede
Of marble men and maidens overwrought,
With forest branches and the trodden weed;
Thou, silent form, dost tease us out of thought
As doth eternity: Cold Pastoral!
When old age shall this generation waste,
Thou shalt remain, in midst of other woe
Than ours, a friend to man, to whom thou say'st,
"Beauty is truth, truth beauty,"—that is all
Ye know on earth, and all ye need to know.

object—and the novel was decisive for the formation of this sentiment—in view of a more radical discussion of the gap separating the finite and the infinite, the individual and totality. Beauty was configured as a synonym for Truth, within a deep rethinking of a traditional hendiadys. For Greek thinkers Beauty coincided with truth because, in a certain sense, it was truth that produced Beauty; contrariwise, the Romantics held that it was Beauty that produced truth. Beauty does not participate in truth, but is its artifice. Far from shunning reality in the name of a pure Beauty, the Romantics thought in terms of a Beauty that produced greater truth and reality.

The hope of the German Romantics was that this Beauty might produce a new mythology, that it might replace the "tales" of the Classical world with a discourse containing modern content allied to all the communicative immediacy of the Greek myths. Friedrich Schlegel and the young Hölderlin, Friedrich Schelling, and Hegel all worked separately around this idea. Of these last three there still remains a document, written by the young Hegel but of uncertain attribution (did Hegel give an account of a discussion between Hölderlin and Schelling or did he transcribe a discourse made by Hölderlin to Schelling that the latter had related to him, with or without annotations and corrections?). In any event, the older Hegel was to get nowhere near the radicality of the bond between Beauty, mythology, and liberation expressed in this document. The function of this mythology of reason was of unprecedented scope: to realize, in the immediacy of universal communication, the complete liberation of the human spirit. This Beauty had the power to dissolve its own particular content in order to open the work of art toward the Absolute, and at the same time to go beyond the work of art toward the absolute work of art, a wholly Romanticized expression of art. The Romantics, especially Schlegel, associated the concept of "irony" with this particular Beauty. Romantic irony was not a subjective movement with the power to diminish all objective content until it dissolved into mere arbitrariness. On the contrary, at the roots of the Romantic use of irony lies the Socratic method: by using a light touch even in the presence of weighty

New Mythology
Friedrich Schlegel
Dialogue on Poetry, II, 1800
The only thing I pray you is not to cast doubt upon the possibility of a new mythology; the other doubts, of whatever provenance and bearing, are instead welcome and they will permit me to enhance my analysis with greater detail and freedom. And now listen carefully to my hypotheses, because—given the state of affairs—hypotheses are all I have to offer you. I hope that you will transform them into truth: actually they are, should you wish to make them such, proposals in view of future developments.
If it is true that a new mythology can arise, with its forms alone, from the remotest

profundities of the soul, idealism—the greatest phenomenon of our age—offers us a highly meaningful pointer to and an extraordinary proof of that which we are seeking.
This is precisely how idealism was born, as if from nothing, and now even in the world of the spirit it constitutes a fixed point, whence the energy of man may spread out in all directions and progressively develop, sure that it will lose neither itself nor the way back. This great revolution will spread to all the sciences and all the arts. Its action is already visible in physics, where idealism erupted spontaneously even before philosophy came to tap it with its magic wand.

Francesco Hayez,
*Self-Portrait with Tiger
and Lions*, 1831.
Milan,
Museo Poldi Pezzoli

and demanding contents, the ironic method makes it possible to reveal the copresence of two opposing points of view or opinions, without any preconceived or biased selection. Irony is therefore a philosophical method—if not *the* philosophical method. Furthermore, the ironic stance allows the subject a double movement of approach and withdrawal with respect to the object: irony is a sort of antidote that curbs the enthusiasm correlated to contact with the object and the nullification of the object itself, but it also prevents any lapsing into a skepticism correlated to distancing oneself from the object. Thus, without becoming the slave of the object, the subject can interpenetrate with the object itself, maintaining his or her own subjectivity. This interpenetration of subject and object mirrors the correlative interpenetration of a subjective aspiration to a Romantic life, hurled beyond the narrow limits of given reality, and the life of the hero of the Romantic novel, be he **Jacopo Ortis** or Goethe's **Werther.**

The Aesthetic Act
Georg Wilhelm Friedrich Hegel
Dialogue on Poetry, 1821
I have the certainty that the supreme act of reason, the one in which it encompasses the totality of ideas, is an aesthetic act, and that truth and goodness are intimately merged only in Beauty. […]
I shall now explain an idea that, as far as I know, has yet to strike any man: we must have a new mythology, but it must place itself at the service of ideas, it must become a mythology of reason. Mythology must become philosophical, so that the people may become rational, and philosophy must become mythological, so that philosophers may become sensible. If we do not give ideas a form that is aesthetic, i.e., mythological, they

will hold no interest for people. […] And thus in the end those who are enlightened and those who are not will come together. No more scornful glances, no more shall the people be in awe of their wise men and high priests. No capacity shall be repressed any more: finally there will come the rule of a general freedom and equality of minds! This shall be the ultimate, the noblest work of man.

Jacopo Ortis
Ugo Foscolo
The Last Letters of Jacopo Ortis, March 25, 1798
I loved you therefore I loved you, and I still love you with a love that I alone can conceive of. Death is a small price, O my angel, for one who has heard you say that you love him and who has felt his entire soul thrill to the

Johann Heinrich Füssli,
*Titania, Bottom, and the
Fairies*, 1793-1794.
Zurich, Kunsthaus

rapture of your kiss, and has wept with you—I have one foot in the grave; yet even in this pass you return, as was your wont, before these eyes that in dying will be fixed on you, in you who shine in the sacred light of all your Beauty. And time is running out! All is in readiness; the night is already too far on—adieu—soon we shall be separated by nothingness, or by incomprehensible eternity. Nothingness? Yes. Yes, yes; since I shall be without you I pray to Almighty God, should he not reserve us some place where I may be reunited with you forever, and I pray this from the depths of my soul, in this terrible hour of death, that he will abandon me only in nothingness.

But I die pure, and my own master, and filled with you, and sure of your tears! Forgive me, Teresa, if

ever—oh, console yourself, and live for the happiness of our wretched parents, your death would be a curse upon my ashes. And if some would blame you for my hapless fate, confound them with this my solemn oath that I pronounce as I hurl myself into the night of death. Teresa is innocent. Now gather you up my soul.

Werther
Johann Wolfgang von Goethe
The Sorrows of Young Werther, III, December 20, 1774
A neighbor saw the flash and heard the shot; but since all was calm after, he thought no more of it. At six in the morning the valet went in with a candle. He found his master on the floor, he saw the pistol and the blood. He called him, shook him: no response. He ran for the doctor, to Albert.

Eugène Delacroix,
The Death of Lara,
1820. Los Angeles,
Paul Getty Museum

Lotte heard the ringing of the bell and a shudder ran through her every limb. She wakened her husband, they got up and the servant gave them the news, trembling and weeping. Lotte fell in a swoon at Albert's feet.

When the doctor got to the hapless man, he found him in a desperate condition; there was a pulse, but his limbs were all paralyzed. He had shot himself in the head, in the right eye, his brains were blown out.

By way of precaution they lanced a vein in his arm: the blood flowed: he was still breathing. From the blood on the back of the chair they saw that he had shot himself while seated at his desk; then he had fallen and rolled convulsively around the chair. He was lying supine by the window, unconscious; he was fully dressed, in a blue jacket and a yellow vest. The house, the neighborhood, the city was moved. Albert arrived. Werther had been laid on the bed, with his forehead bandaged; his face was deathly pale and he was quite motionless. The rattle was still terrible,

sometimes feeble, sometimes loud: the end was nigh. He had drunk only one glass of wine. The play *Emilia Gallotti* was open on his desk. Albert's emotion and Lotte's suffering were indescribable. The old burgomaster, on hearing the news, came in haste on horseback and with scalding tears kissed the dying man. The eldest children arrived on foot immediately after him, they bent over the bed with expressions of bitter grief, they kissed his hands and his mouth, and the oldest son, who had always been his favorite, did not remove his lips until the last breath and had to be dragged away by force.

At noon Werther died. The presence of the burgomaster and the orders he gave calmed the agitation of the crowd. That evening, toward eleven, he was buried in the place he had designated. The old man and the sons followed the coffin; Albert did not have the strength; they feared for Lotte's life.

Some workmen bore the coffin and no priest accompanied it.

6. Gloomy, Grotesque, and Melancholic

From an artistic point of view, Rousseau's rebellion against civilization is expressed as a rebellion against Classical rules and conceits and especially against the Classicist *par excellence*, Raphael, a rebellion carried on from Constable to Delacroix (who preferred Rubens and the Venetian school) and from him all the way down to the Pre-Raphaelites. The ambiguous, moralistic and erotic Beauty of the Pre-Raphaelites, with its tendency to the gloomy and the macabre, was one of the effects of the liberation of Beauty from Classical canons. Beauty could now express itself by making opposites converge, so that Ugliness was no longer the negation of Beauty, but its other face.

By opposing the idealized, impersonal Beauty of the Classicists, Friedrich Schlegel claimed that Beauty should be interesting and characteristic and posed the problem of an aesthetics of Ugliness. The power of Shakespeare, compared to that of Sophocles, lies precisely in the fact that the latter expressed a pure Beauty, whereas in the works of the former we witness the presence of both Beauty and Ugliness, often accompanied by the grotesque (Falstaff, for example).

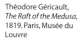

Théodore Géricault,
The Raft of the Medusa,
1819. Paris, Musée du
Louvre

By way of further approximations of reality we come to the repugnant, the extravagant, and the horrible. It was Victor Hugo, the theorist of the grotesque as the antithesis of the Sublime in Romantic art, who gave us an unforgettable gallery of repellent and grotesque characters, from the hunchback Quasimodo to the deformed face of *The Man Who Laughs,* down to women devastated by poverty and the cruelty of life, who seem to hate the tender Beauty of innocent youths. As we have already seen, the drive toward the Absolute and the acceptance of destiny can make the hero's death no longer simply tragic but above all beautiful: the same form, emptied of content such as freedom and rebellion against the world, was to constitute the kitsch packaging of the "beautiful death" acclaimed (mostly in terms of lip service) by the Fascist movements of the twentieth century.

Jean Delville,
Plato's Academy,
1898. Paris, Musée
d'Orsay

Even tombs, nocturnal or otherwise, were seen as beautiful: in Shelley's view there seemed to be no Beauty more worthy of a stay in Rome than the little cemetery where his friend Keats lay buried. The same Shelley, a deliberate purveyor of themes related to Satanism and vampirism, was bewitched by the image of the **Gorgon** erroneously attributed to Leonardo, in which horror and Beauty are all one.

Romanticism gave voice to earlier ideas, creating a tradition: behind "beautiful death" lurk the languid deaths of Olindo and Clorinda in *Jerusalem Delivered*; behind Satanism, which for good or ill implies the **humanization of Satan,** lies the gloomy gaze that Giovanbattista Marino had attributed to the **Prince of Darkness** in the *Slaughter of the Innocents*, and above all Milton's **Satan** (acclaimed by a good part of Romantic literature) who, despite his Fall, does not lose his scintillating Beauty.

The Humanization of Satan

Torquato Tasso
Jerusalem Delivered, IV, vv. 56-64, 1575
The tyrant proud frowned from his lofty cell,
And with his looks made all his monsters tremble,
His eyes, that full of rage and venom swell,
Two beacons seem, that men to arms assemble,
His feltered locks, that on his bosom fell,
On rugged mountains briars and thorns resemble,
His yawning mouth, that foamed clotted blood,
Gaped like a whirlpool wide in Stygian flood.

The Prince of Darkness

Giambattista Marino
The Slaughter of the Innocents, 1632
In his eyes, where evil dwells and death,
A murky crimson light blazes.
His sidelong gaze and twisted pupils
Seem comets, and lanterns his brows.
And from his nostrils and bloodless lips
He vomits soot and fetor;
Irate, Proud, and Desperate,
Thunderclaps are his sighs,
And lightning bolts his breath.

Satan

John Milton
Paradise Lost, I, 1667
… he above the rest
In shape and gesture proudly eminent
Stood like a Tow'r; his form had yet not lost
All her Original brightness, nor appear'd
Less then Arch Angel ruin'd, and th' excess
Of Glory obscur'd: As when the Sun new ris'n
Looks through the Horizontal misty Air
Shorn of his Beams, or from behind the Moon
In dim Eclips disastrous twilight sheds
On half the Nations, and with fear of change
Perplexes Monarchs. Dark'n'd so, yet shon
Above them all th' Arch Angel: but his face
Deep scars of Thunder had intrencht, and care
Sat on his faded cheek, but under Browes
Of dauntless courage, and considerate Pride
Waiting revenge …

The Gorgon

Percy Bysshe Shelley
On the Medusa of Leonardo da Vinci in the Florentine Valley, 1819
It lieth, gazing on the midnight sky,
Upon the cloudy mountain peak supine;
Below, far lands are seen tremblingly;
Its horror and its beauty are divine.
Upon its lips and eyelids seems to lie
Loveliness like a shadow, from which shrine,
Fiery and lurid, struggling underneath,
The agonies of anguish and of death.

Yet it is less the horror than the grace
Which turns the gazer's spirit into stone;
Whereon the lineaments of that dead face
Are graven, till the characters be grown
Into itself, and thought no more can trace;
'Tis the melodious hue of beauty thrown
Athwart the darkness and the glare of pain,
Which humanize and harmonize the strain.

The Poetry of the Primitive

Eugène Delacroix
Variations on the Beautiful, 1857
We judge all the rest of the world from our own restricted horizons: we do not abandon our little habits, and our enthusiasms are often as insensate as our disdain. We judge with equal presumption the works of art and those of nature. The man who lives in London or Paris is perhaps farther from having a correct sense of Beauty than the uncultivated man who lives in parts where civilization has yet to arrive. We see the beautiful only through the imagination of poets and painters; the savage encounters it at every step of his wandering life.
I am prepared to admit that such a man will have little occasion to devote himself to poetic impressions, when we all know that his constant preoccupation is to avoid dying of hunger. He must struggle unceasingly against a hostile nature in order to defend his wretched life. Nonetheless the sight of imposing spectacles and the power of a sort of primitive poetry can cause a feeling of admiration to be born in men's hearts.

7. Lyrical Romanticism

Romantic portrayals of Beauty are not foreign to nineteenth-century opera. In Verdi, Beauty often verges on the territories of darkness, the satanic, and the grotesque: think of the presence, in *Rigoletto*, of Gilda's youthful beauty together with the deformity of Rigoletto and the shadowy Sparafucile, a creature who hails from the darkest night. As Rigoletto passes seamlessly from ferocious irony to squalid debasement, so Gilda expresses three different images of womanly Beauty. In *Il Trovatore*, the vortex of wild passions in which love, jealousy, and vendetta meet is even more pronounced. Beauty here is expressed through disturbing images of fire: while Leonora's love for Manrico is *perigliosa fiamma* (a perilous flame), the count's jealousy is *tremendo foco* (a terrific blaze): a bleak image, since the stake at which witches were burned is at the same time the background and destiny of the beautiful gypsy girl **Azucena.** Verdi's mastery here lies in his capacity to hold the volcanic, centrifugal power of these images within solid musical structures that were still traditional.

The typically Romantic connection between Beauty and death is accentuated in a pessimistic vein by Wagner. In his music (especially in *Tristan and Isolde*) musical polyphony serves to give a unitary structure to a dual movement of bewitching eroticism and tragic destiny. The fate of Beauty is not to find its fulfillment in passion, but in death for love: Beauty withdraws from the light of the world and slips into the embrace of the powers of the night, through the sole form of union possible, that of death.

Azucena
Salvatore Cammarano
Il Trovatore, II, 1, 1858
The flame crackles!
And the indomitable crowd
Rushes to that blaze
With happy faces;
Shouts of joy
Echo all around;
Surrounded by hired thugs
A woman steps forth!
The grim blaze
Casts a sinister glare
On their horrible faces

It reaches up to the heavens!
The flame crackles!
The victim comes,
Clad in black,
Shabby, barefoot!
A ferocious cry
For death is raised.
The echo sends it
Resounding from crag to crag!
The grim blaze
Casts a sinister glare
On their horrible faces
It reaches up to the sky!

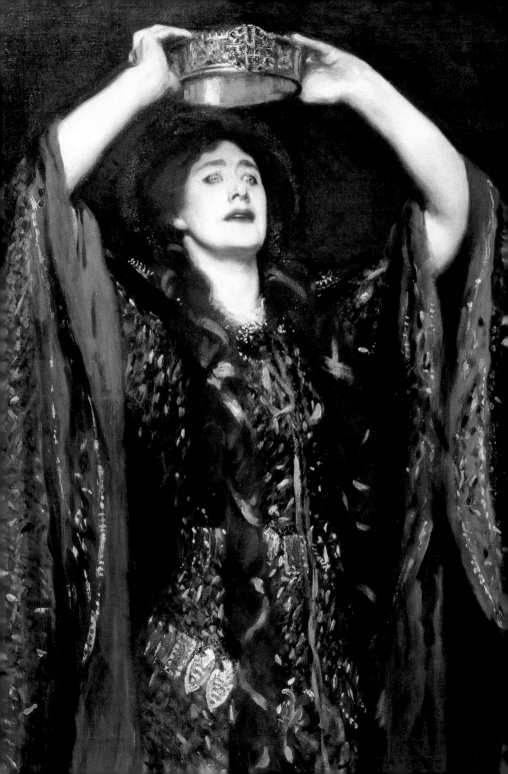

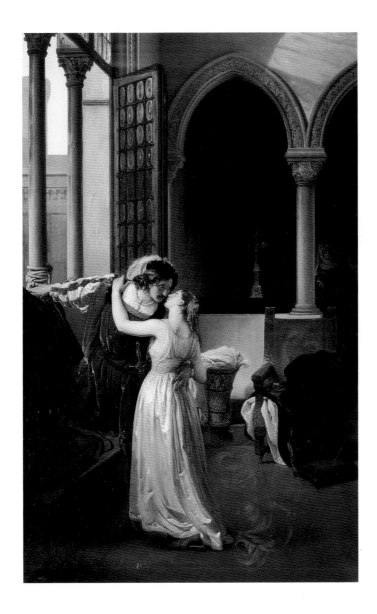

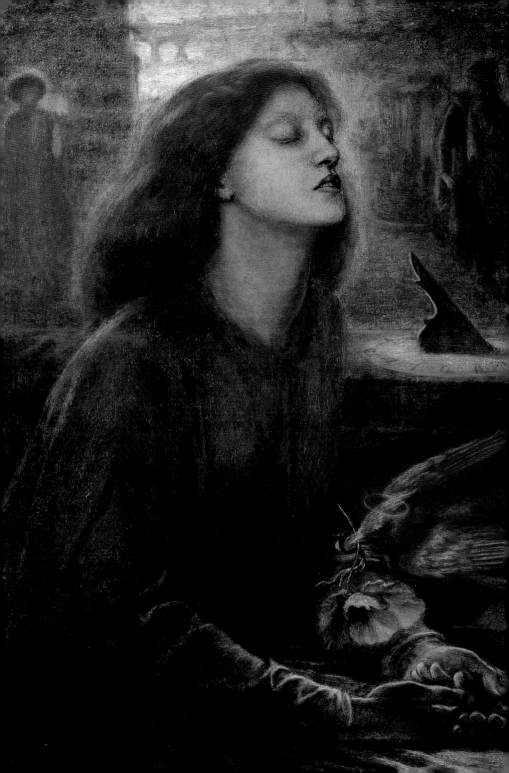

The Religion of Beauty

1. Aesthetic Religion

In *Hard Times* (1854) Charles Dickens describes a typical English **industrial town:** the realm of sadness, uniformity, gloom, and ugliness. The novel was written at the beginning of the second half of the nineteenth century, by which time the enthusiasms and disappointments of the early decades of the century had given way to a period of modest but efficient ideals (it was the Victorian period in Britain, the Second Empire in France) dominated by solid bourgeois virtues and the principles of expanding capitalism. The working-class had become aware of its plight: the *Communist Manifesto* appeared in 1848.

Confronted with the oppressiveness of the industrial world, the expansion of the metropolis swarming with immense anonymous crowds, the appearance of new classes whose urgent needs certainly did not include aesthetics, and offended by the form of the new machines that stressed the pure functionality of new materials, artists felt that their ideals were threatened and saw the democratic ideas that were gradually making

Industrial Town
Charles Dickens
Hard Times, 1854
Coketown was a triumph of fact. It was a town of red brick, or of brick that would have been red if the smoke and ashes had allowed it; but as matters stood, it was a town of unnatural red and black like the painted face of a savage. It was a town of machinery and tall chimneys, out of which interminable serpents of smoke trailed themselves for ever and ever, and never got uncoiled. [...] It contained several large streets all very like one another, and many small streets still more like one another, inhabited by people equally like one another, who all went in and out at the same hours, with the same sound upon the same pavements, to do the same work, and to whom every day was the same as yesterday and to-morrow, and every year the counterpart of the last and the next.

Dante Gabriel Rossetti,
Beata Beatrix,
1864-1870.
London, Tate Britain

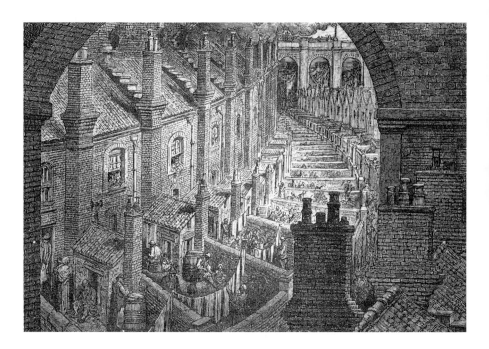

Gustave Doré,
A London Slum,
from Gustave Doré
and William Blanchard
Jerrold, *London:
A Pilgrimage,* 1872.
Venice, Galleria
Internazionale d'Arte
Moderna di Ca' Pesaro

opposite
Thomas Couture,
*The Romans of the
Decadence,* 1847.
Paris, Musée d'Orsay

headway as inimical. Thus they decided to make themselves "different."

This led to the formation of an authentic aesthetic religion, and amid a spirit of Art for Art's Sake the idea became established that Beauty was a primary value to be realized at all costs, to such a point that many thought that life itself ought to be lived as a work of art. And while art detached itself from morality and practical requirements, there arose a growing drive— already present in Romanticism—to conquer for the world of art the most disturbing aspects of life: sickness, transgression, death, darkness, the demoniac, and the horrible. The difference lay in the fact that art no longer claimed to portray in order to document and judge. In portraying such aspects, art wanted to redeem them in the light of Beauty and to make them fascinating even as life models.

This ushered in a generation of high priests of Beauty who took the Romantic sensibility to its extreme consequences, exaggerating its every aspect, and leading it to a point of decay of which its exponents were so conscious that they perceived a parallel between their destiny and that of the great ancient civilizations at the time of their decline: Roman civilization in its death-throes following the barbarian invasions, and the thousand-year-old Byzantine Empire. This yearning for periods of decadence led to the adoption of the term Decadentism for the cultural period usually said to span the second half of the nineteenth and the early decades of the twentieth centuries.

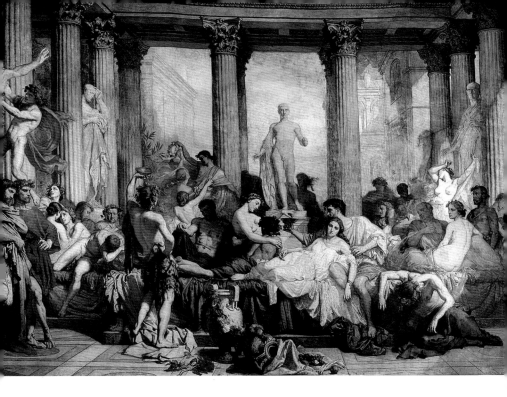

Different
Charles Baudelaire
On the Modern Idea of Progress Applied to the Fine Arts, 1868
Beauty is always bizarre. I don't mean to say that it is deliberately, coldly bizarre, for in that case it would be a monster that has gone off the rails of life. I say that it always contains a hint of the bizarre, which makes it Beauty in particular.

Sickness
Jules-Amédée Barbey d'Aurevilly
Léa, 1832
"Yes, my Lea, you are beautiful, you are the most beautiful of creatures, I would not give you up; you, your defeated eyes, your pallor, your sick body, I would not give them up for the beauty of the angels in the heavens!" […] That dying woman whose clothes he touched burned him like the most ardent of women. There was no *bayadera* on the banks of the Ganges, no odalisque in the baths of Istanbul, nor any naked Bacchante whose embrace could ever have made the marrow of his bones burn with greater ardor, than the contact, the simple contact with that delicate, feverish hand whose slight perspiration he could feel through the glove that covered it.

Death
René Vivien
To His Beloved, 1903
And the longest lilies of sacred pallor
Die in your hands like spent candles.
Your fingers give off flagging scents
In the exhausted breath of supreme suffering.
From your white clothes
The love and the agony
Gradually fade away.

Decay
Paul Verlaine
Languor, 1883
I am the Empire in the last days of its decline,
Watching the tall, fair-haired Barbarians pass by,
As, idly, I compose acrostics, in a style imbued
With gold and the languid dance of sunbeams.
[…]
Oh, to will no more, only to die a little!
All has been drunk. Bathyllus, have done with laughter!
All has been drunk, and all eaten. Nothing more to say!

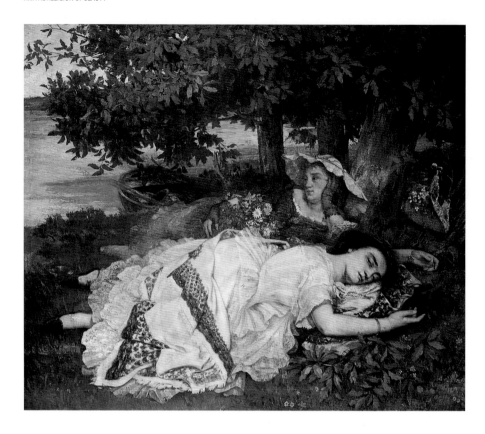

Gustave Courbet,
The Young Ladies on the Banks of the Seine, 1857.
Paris, Musée du Petit Palais

Enamored of Three Forms
Gabriele D'Annunzio
Pleasure, 1889
Enamored of three forms, all elegant in a different way; that is a woman, a cup, and a greyhound, the watercolorist found a composition with the most beautiful lines. The woman, nude, was standing inside the basin.

Bracing herself with one hand resting on the protuberance of the chimera and with the other on that of Bellerophon, she was bending over forward to make fun of the dog who, his body flexed in an arch with front paws lowered and rear paws raised, like a cat about to pounce, was lifting up toward her a muzzle that was long and slim as that of a pike.

2. Dandyism

The first signs of a cult of the exceptional came with the advent of dandyism. The dandy appeared in the Regency period of British history, in the first decades of the nineteenth century, with George "Beau" Brummel. Brummel was not an artist, nor a philosopher who reflected on art and the beautiful. In his case, the love of Beauty and the exceptional manifested itself as the art of dressing—and living—with style. Elegance, which he identified with simplicity (at times so exaggerated as to verge on the bizarre) was allied to a taste for paradoxical quips and provocative behavior. By way of a sublime example of aristocratic ennui and disdain for common sentiments, it is said of Brummel that, on seeing two lakes from a hilltop as he was out riding in the hills with his valet, he asked his man: "Which of the two do I prefer?" As Villiers de l'Isle-Adam was to say later, "Live? Our servants will do that for us." In the Restoration period and during the reign of Louis Philippe, dandyism (riding a wave of widespread Anglomania) penetrated France, winning over men of the world, successful poets and novelists, and finding its theorists in Charles Baudelaire and Jules-Amédée Barbey

Oscar Wilde, 1880.

d'Aurevilly. Toward the end of the century dandyism made a singular comeback in Britain, where—having by that time become an imitation of French fashions—it was practiced by Oscar Wilde and the painter Aubrey Beardsley. In Italy, the behavior of the poet Gabriele D'Annunzio revealed elements of dandyism.

But while some artists of the nineteenth century saw the ideal of Art for Art's Sake as the exclusive, painstaking, craftsmanlike cult of a work worthy of dedicating one's life to in order to realize the Beauty in an object, the dandy (and likewise those artists who saw themselves as dandies) saw this ideal as the cult of his own public life, to be "worked" and modeled like a work of art in order to transform it into a triumphant example of Beauty. Life was not to be dedicated to art, art was to be applied to life. Life as Art.

As it was a social phenomenon, dandyism had its contradictions. It was no revolt against bourgeois society and its values (like the cults of money and technology), because it was never really any more than a marginal aspect and one that was definitely not revolutionary but aristocratic (accepted as eccentric embellishment). Sometimes dandyism manifested itself as opposition to current prejudices and mores, and this is why it is significant that some dandies were homosexual—which was totally unacceptable at the time and regarded as a criminal offense (the cruel trial of Oscar Wilde being a famous example of this).

The Perfect Dandy
Charles Baudelaire
The Painter of Modern Life, 1869
The idea that a man forms of Beauty is impressed on all his clothing, it rumples or irons his suit, rounds or stiffens his gestures and it even finds its subtle way, in the long run, into his features. Man ends up resembling what he would like to be.
The wealthy man, who, blasé though he may be, has no occupation in life but to chase after fortune, the man born to luxury, and accustomed from youth to the obedience of other men, the man who has no profession other than elegance, will always have a distinct look. Dandyism is an ill-defined institution, as strange as dueling. [...] These individuals have no obligation other than to cultivate the concept of beauty in their own persons, satisfying their passions, feeling and thinking.
The dandy does not see love as a special end in itself. [...] The dandy does not aspire to wealth as an essential thing; unlimited bank credit would suffice for him; he willingly leaves this banal passion to vulgar men. Contrary to what many unthinking people believe, dandyism is not about taking excessive pleasure in clothes and material elegance. For the perfect dandy, such things are merely a symbol of the aristocratic superiority of his mind. Thus, in his view, desirous as he is of distinction above all, perfection in dress consists in the utmost simplicity, which is the best way to stand out. [...]
Dandyism is first and foremost a burning desire to create an original look, on the edge of society's conventional limits. It is a sort of cult of oneself, which can do without the pursuit of that happiness one finds in others, in women, for example: a cult that can even do without all that we call illusions. It is the pleasure to be had in causing others to marvel, and the satisfaction to be had in never marveling at anything oneself.

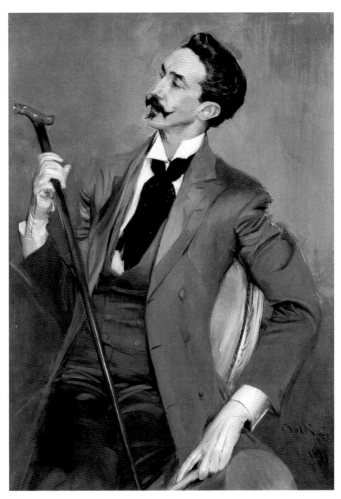

Giovanni Boldini,
*Count Robert de
Montesquiou-Fézensac*, 1897.
Paris, Musée d'Orsay

Beauty as Costume
Oscar Wilde
The Picture of Dorian Gray, 1891
Yes, the lad was premature. He was
gathering his harvest while it was yet
spring. The pulse and passion of youth were
in him, but he was becoming self-conscious.
It was delightful to watch him. With his
beautiful face, and his beautiful soul, he was
a thing to wonder at. It was no matter how
it all ended, or was destined to end. He was
like one of those gracious figures in a
pageant or a play, whose joys seem to be
remote from one, but whose sorrows stir
one's sense of beauty, and whose wounds
are like red roses.

3. Flesh, Death, and the Devil

With D'Annunzio, dandyism took on heroic forms (the Beauty of bold deeds); with other artists, especially the French Decadents, it took the form of traditionalist and reactionary Catholicism, a manifestation of rebellion against the modern world. However, this return to religious sources did not take the form of a restoration of moral values and philosophical principles, but of a yielding to the fascination of sumptuous, ancient liturgies, to the corrupt and exciting savor of late Latin poetry, to the splendors of Byzantine Christianity, and to the marvels of barbarian jewelry of the early Middle Ages. As far as concerns the religious phenomenon, religious Decadentism embraced only the ritual aspects, preferably if they were ambiguous, while its version of the mystical tradition was morbidly sensual.

The aberrant "religiosity" of the Decadents took another path again, that of Satanism. Hence not only the excited interest in supernatural phenomena, the rediscovery of magical and occult traditions, a cabalism that had nothing to do with the true Jewish tradition, the fanatical attention

The Taste for the Horrible
Charles Baudelaire
Consolatory Maxims on Love, 1860-1868
For some more curious and depraved spirits, the pleasures of ugliness spring from an even more mysterious sentiment, which is the thirst for the unknown, and a taste for the horrible. It is the same sentiment, the germ of which each of us carries with him in some way, that has poets rushing to anatomy laboratories or clinics, and women to public executions.

Celebration of All Forms of Excess
Arthur Rimbaud
Letter to P. Demeny, 1871
A poet makes himself a visionary through a long, boundless, and systematized disorganization of all the senses. All forms of love, of suffering, of madness; he searches

himself, he exhausts within himself all poisons, and preserves their quintessences. Unspeakable torment, where he will need the greatest faith, a superhuman strength, where he becomes amongst all men the great invalid, the great criminal, the great accused—and the Supreme Scientist! For he attains the unknown! Because he has cultivated his soul, already rich, more than anyone! He attains the unknown, and if, demented, he finally loses the uderstanding of his visions, he will at least have seen them!

An Aesthetics of Evil
Oscar Wilde
The Picture of Dorian Gray, 1891
There were moments when he looked on evil simply as a mode through which he could realize his conception of the beautiful.

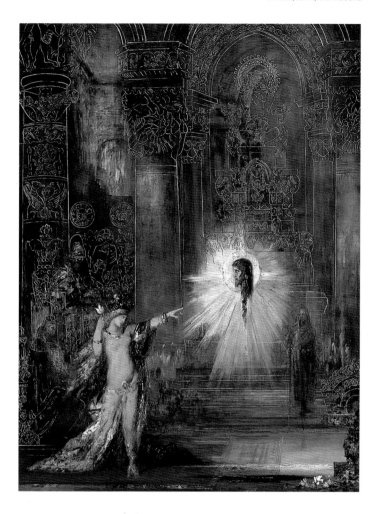

Gustave Moreau,
The Apparition,
1874-1876.
Paris, Musée du Louvre

devoted to the presence of the demoniac in art and in life (Huysmans's *Down There* being exemplary in this sense), but also participation in authentic magical practices and the calling up of devils, the **celebration of all forms of excess,** from sadism to masochism, a taste for the horrible, the appeal to Vice, the magnetic attraction of perverse, disquieting, or cruel people: **an aesthetics of Evil.**

In order to characterize the elements of carnal pleasure, necrophilia, interest in personalities who defied all moral rules, interest in disease, sin, and the refined pleasures of pain, Mario Praz originally entitled one of his most famous books (known in English as *The Romantic Agony*) *La Carne, la Morte e il Diavolo* (Flesh, Death, and the Devil).

4. Art for Art's Sake

It would be difficult to put all the various aspects of late nineteenth-century aesthetics under the umbrella of Decadentism. We cannot forget the combination of the aesthetic ideal and socialism in William Morris nor can we neglect the fact that in this period, in 1897, when aestheticism was at its peak, Leo Tolstoy wrote *What is Art?*, in which he reaffirms the profound links between Art and Morals, Beauty and Truth. At this point, we are poles apart from Wilde, who, in those very years, upon being asked whether a certain book was immoral, replied: "It's worse than immoral. It's badly written."

As the Decadent sensibility was forming, painters like Courbet and Miller were still tending toward a realistic interpretation of human reality and nature, democratizing the Romantic landscape and bringing it back to an everyday reality made up of labor, toil, and the humble presence of country people and common folk. And—as we shall see later—in the work of the

Jean-François Millet,
The Angelus,
1857-1859.
Paris, Musée d'Orsay

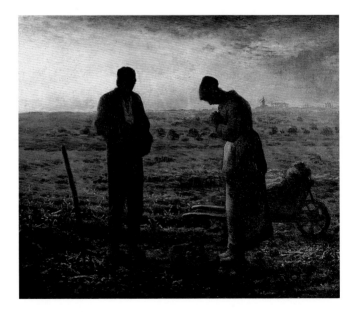

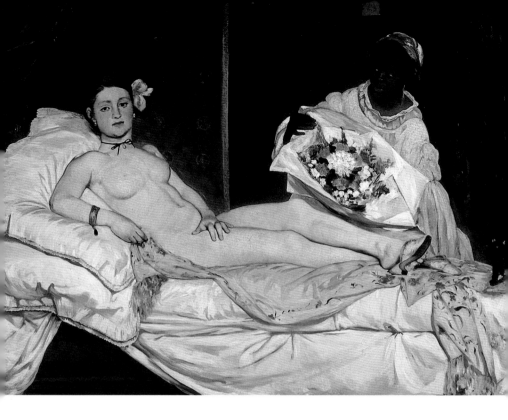

Édouard Manet,
Olympia, 1863.
Paris, Musée d'Orsay

Impressionists there is something more than a vague dream of Beauty, there is the meticulous, quasi-scientific study of light and color aimed at penetrating deeper into the world of vision. In this same period, moreover, dramatists like Ibsen were tackling stage representations of the great social conflicts of the age, the struggle for power, the clash between generations, women's liberation, moral responsibilities, and the rights of love.

Nor should we think that the aesthetic religion is to be identified solely with the ingenuousness of the later dandies or the virulence, often more verbal than moral, of the devotees of the demoniac. Flaubert alone suffices to show us how much craftsman like probity, how much asceticism there was in a religion of Art for Art's Sake. In Flaubert, the predominant feature is the cult of the word, the "right word," which alone can confer harmony, an absolute aesthetic necessity, to the page. Whether he is observing with ruthless and meticulous accuracy the banality of everyday life and the vices of his day (as in *Madame Bovary*), or evoking an exotic, sumptuous world, pregnant with sensuality and barbarism (as in *Salammbô*), or tending toward demoniac visions and glorifications of Evil as Beauty (*The Temptation of Saint Anthony*), his ideal remains that of an impersonal, precise, exact language, capable of making any subject beautiful thanks to the sheer power of his style: "There are no beautiful or sordid subjects, and it might almost be established as

axiomatic that, from the point of view of pure Art, there is no such thing as a subject, style being on its own an absolute way of seeing things."

On the other hand, in 1849, Edgar Allan Poe (who from America, thanks largely to Baudelaire, was to have a profound influence on European Decadentism) wrote in his essay *Poetic Principles* that Poetry ought not to concern itself with mirroring or promoting the Truth: "There neither exists nor can exist any work more thoroughly dignified, more supremely noble than this very poem (in and of itself), this poem which is a poem and nothing more, this poem written solely for the poem's sake." While the Intellect is concerned with Truth and the Moral Sense with Duty, Taste teaches us about Beauty; Taste is an autonomous faculty provided with its own laws that, if it can induce us to hold Vice in contempt it is only because (and to the extent that) this last is deformed, contrary to measure, and to Beauty.

Whereas in past epochs it often appeared difficult to understand the connection, which today strikes us as clear, between Art and Beauty, it was in this period—which marked the appearance of a sort of scornful intolerance of nature—that Beauty and Art amalgamated to form an indissoluble pair. There was no Beauty that was not the work of artifice; only that which was artificial could be beautiful. "Nature is usually wrong," said Whistler, and Wilde declared: "The more we study art, the less we care for nature." Brute nature could not produce Beauty: art had to take a hand to create—where there was merely accidental disorder—a necessary and inalterable organism.

This profound belief in the creative power of art was not only typical of Decadentism, but it was the Decadents, taking their cue from the statement that Beauty could alone be the object of the long and loving labors of the craftsman, who arrived at the realization that the more an experience is artificial the more valuable it is. From the idea that art creates a second nature, we have moved on to the idea that every violation of nature, preferably as bizarre and morbid as possible, is art.

Requiem for Nature
Joris-Karl Huysmans
Against the Grain, 1884
Nature has had her day; the sickening monotony of her landscapes and skyscapes has definitely and finally exhausted the patience of refined temperaments.

Disregard for Nature
Oscar Wilde
The Decay of Lying, 1889
My own experience is that the more we study

Art, the less we care for Nature. What Art really reveals to us is Nature's lack of design, her curious crudities, her extraordinary monotony, her absolutely unfinished condition.

The Verse is All
Gabriele D'Annunzio
Isotteo, c. 1890
Poet, divine is the Word:
in pure Beauty the heavens place
all our joy: and the Verse is all.

5. Against the Grain

Floressas Des Esseintes is the protagonist of *À rebours*, the novel published in 1884 by Joris-Karl Huysmans. *À rebours* means "against the grain, backward, the wrong way, against the mainstream," and both the book and the title strike us as the analogue to the Decadent sensibility. In order to escape nature and life, Des Esseintes has himself virtually walled up in a villa furnished with oriental fabrics, tapestries with a liturgical air, hangings and woodwork that simulate monastic coldness but are made with sumptuous materials. He cultivates only flowers that are real but seem artificial, has abnormal love affairs, inflames his imagination with drugs, prefers imaginary journeys to real ones, enjoys late medieval texts written in effete and sonorous Latin, and composes symphonies of liquors and perfumes, transferring the sensations of hearing to those of taste and smell; in other words, he constructs a life made up of artificial sensations, in an equally artificial environment in which nature, rather than being recreated, as happens in works of art, is at once imitated and negated, re-elaborated, languid, disquieting, sick …

Edgar Degas,
The Absinthe Drinker,
1875-1876.
Paris, Musée d'Orsay

If a turtle is pleasing to the eye, then the turtle reproduced by a great sculptor possesses a symbolic capacity that no real turtle has ever had; and this was known even to Greek sculptors. But for the Decadent the process was a different one. Des Esseintes chooses to place a turtle on a light-colored carpet in order to obtain a contrast between the golden and silvery hues of the weave and the raw sienna tones of the animal's carapace. But the combination does not satisfy him and he has the turtle's back encrusted with precious stones of many different colors, thus composing a dazzling arabesque, which irradiates light "like a Visigothic targe inlaid with shining scales, the handiwork of some Barbaric craftsman." Des Esseintes has created the beautiful by violating nature, because "Nature has had her day; the sickening monotony of her landscapes and skyscapes has definitely and finally exhausted the patience of refined temperaments."

The great themes of Decadent sensibility all revolve around the idea of a Beauty that springs from the alteration of natural powers. The English aesthetes, from Swinburne to Pater, and their French epigones, began a rediscovery of the Renaissance seen as an unexhausted reserve of cruel and sweetly diseased dreams: in the faces painted by Botticelli and Leonardo they sought for the vague physiognomy of the **androgyne,** of the man-woman of **unnatural and indefinable Beauty.** And when they fantasize about woman (when she is not seen as Evil triumphant, the incarnation of Satan, elusive because incapable of love and normality, desirable because she is a sinner, beautified by the traces of corruption), what they love is the altered nature of her femininity: she is the **bejeweled woman** of Baudelaire's dreams, she is the **flower-woman** or the **jewel-woman,** she is D'Annunzio's woman, who can be seen in all her charm only if compared to an artificial model, to her ideal progenitrix in a painting, a book, or a legend.

As far as taste was concerned, the only object in nature that seemed to survive and triumph during this period was the flower, which was even to give rise to a style, the ornamental style known in Italy as *floreale*. Decadentism was **obsessed with flowers:** but it was very soon realized that what was attractive about flowers was the pseudoartificiality of natural jewelry work, the way they lend themselves to stylization, to becoming ornaments, gems, arabesques, the sense of **fragility and corruption** that pervades the vegetable kingdom, within whose bounds there is a rapid transition from life to death.

Dante Gabriel Rossetti, *Lady Lilith*, detail, 1867. New York, Metropolitan Museum of Art

Leonardo's Ambiguity

Algernon Charles Swinburne
Essay on Leonardo, 1864

Of Leonardo the examples are few and select: full of that indefinable grace and that profound mystery that belongs to his finest and most intense work. Fair strange faces of women full of vague doubt and faint scorn; touched by the shadow of an obscure fate; while the eyes and thoughts of his men, so it seems, are at once anxious and tired, pale and fervent with patience and passion, allured and perplexed.

Botticelli's Ambiguity

Jean Lorrain
Rome, 1895-1904

Oh, Botticelli's mouths, those fleshy lips, plump as fruits, ironic and sorrowing, enigmatic in their sinuous folds, without giving any clue as to whether they are suppressing purity or abomination!

Androgyne

Joris-Karl Huysmans
Certains, 1889

The saint's entire aspect induces dream. Those girlish forms, still slim of hip, that young lass's neck whose flesh is white as the pith of the elder bush, that mouth with lips like prey, that willowy build, those curious fingers lost on

[the haft of] a weapon, that bulge in the armor swelling in place of the breasts, protecting and emphasizing the fall of the torso, that linen glimpsed under the armpit left free between the pauldron and the gorget, even that girlish blue riband, right under the chin, all obsess me. All the disturbing influences of Sodom seem to have been accepted by this androgyne whose subtle Beauty, now suffering, shows itself to be purified, as if transfigured by the slow approach of a God.

Unnatural and Indefinable Beauty

Théophile Gautier
Enamels and Cameos, 1852

Is he a youth? Is she a woman?
Is she a goddess or a god?
Love, fearing to be ignoble,
Hesitates and suspends its confession.
To make this beauty *maudit*
Each gender brought its gift.
Blazing chimera, supreme effort
Of art and sensuousness,
Fascinating monster, how I love you
In your many-sided beauty.
Dream of poet and artist,
For many nights you have seized me
And my fancy, which endures,
Will not be deceived…

The Artistic Gender Par Excellence
Joseph Péladan
The Amphitheater of Dead Sciences, 1892-1911
In the *Canon* of Polyclitus, Leonardo found what is known as the androgyne. […] The androgyne is the artistic gender *par excellence*, it blends the two principles, the female and the male, and it sets them in equilibrium. […] In the *Mona Lisa*, the cerebral authority of the man of genius is blended with the sensuousness of the noblewoman; it is moral androgynism. In the *Saint John* the commingling of the forms is such that the gender becomes an enigma.

Bejeweled Woman
Charles Baudelaire
Spleen and Ideal, from *The Flowers of Evil*, 1857
My beloved was nude and, knowing my heart,
Was clad in but tinkling gems
Whose splendor gave her that air of triumph
Worn by Moorish slave girls on their days of joy

This scintillating world of stones and metal
Whose trembling emits a lively ironic sound
Truly enchants me: I am frightfully enamored
Of this, light in league with music.

Flower-Woman
Émile Zola
The Sin of Father Mouret, 1875
Below, ranks of hollyhocks seemed to bar the entrance with a fence of red, yellow, green, and white blooms whose stems were lost among colossal nettles of a bronzed green color, tranquilly oozing the burning sting of their venom. Then, there was a prodigious surge, a sudden series of upward bounds: jasmine bushes, starred with their sweet flowers; wisteria with its delicate, lacy leaves; thick ivy, as if cut out of lacquered tin, sweet woodbine, perforated with tips of pale coral; amorous clematis stretching out its arms adorned with white plumes. And other, more delicate plants fastened themselves to these last, binding them closer, intertwining with them to form a scented weave. […] A huge green head of hair, covered with a shower of blossoms, whose tresses overflowed from every part, roaring in mad disorder, putting one in mind of some gigantic maiden, abandoned on her back, her head thrown back in a spasm of passion, superb hair strewn all around, as if scattered in a scented pool.

Jewel-Woman
Joris-Karl Huysmans
Against the Grain, 1884
Starting from the lozenges of lapis lazuli, arabesques wound their way along the cupolas, where glittering rainbows and prismatic flashes glided along mother-of-pearl marquetry work. […] She is almost naked: in the heat of the dance her veils have come undone, her brocaded robes have fallen away; now she is clad only in jewelry and gleaming gemstones; a gorget encircles her waist like a corselet and, like some superb clasp, a marvelous jewel flashes in the cleft of her bosom; lower down, her hips are girded by a broad belt that conceals the upper thighs, against which swings a gigantic pendant, a cascade of carbuncles and emeralds. Finally, on the bare flesh between gorget and girdle, her belly arches, the dimpled navel flushed with a hint of pink like a milk-white onyx seal. Beneath the burning rays shining out from around the Precursor's head, the gemstones blaze fierily; they come to life, limning the woman's body with an incandescent aura; her neck, legs, and arms are aglitter with sharp points of light, now red as smoldering embers, now violet as gas jets, now blue as burning alcohol, now white as starlight.

Obsessed with Flowers
Oscar Wilde
The Picture of Dorian Gray, 1891
The studio was filled with the rich odor of roses, and when the light summer wind stirred amidst the trees of the garden there came through the open door the heavy scent of the lilac, or the more delicate perfume of the pink-flowering thorn. From the corner of the divan of Persian saddle-bags on which he was lying, smoking, as usual, innumerable cigarettes, Lord Henry Wotton could just catch the gleam of the honey-sweet and honey-colored blossoms of the laburnum, whose tremulous branches seemed hardly able to bear the burden of a beauty so flamelike as theirs.

Fragility and Corruption
Paul Valéry
Narcissus Speaks, 1891
Brothers, sorrowful lilies, I languish in Beauty […]

Aubrey Beardsley,
John and Salomé,
from Oscar Wilde,
Salomé, 1907.
Milan, Biblioteca
Nazionale Braidense

345

6. Symbolism

Decadent Beauty is permeated by a sense of corruption, swooning, weariness, and languor; and *Languor* is the title of a poem by Verlaine that can be taken as the manifesto (or the barometer) of the entire Decadentist period. The poet was aware of his kinship with the world of Roman decadence and that of the Byzantine Empire, oppressed by a history that was too long and too great; everything had already been said, all pleasures experienced and drained to the lees, on the horizon loomed the hordes of barbarians that an ailing civilization could not stop: there was nothing left to do but plunge into the sensuous joys of an overexcited and overexcitable imagination, list the art treasures, and run weary hands through the jewels accumulated by past generations. Byzantium, glittering with its golden cupolas, was the crossroads of Beauty, Death, and Sin.

The most significant literary and artistic movement produced by Decadentism was Symbolism, whose poetics established simultaneously a view of art and a view of the world. At the roots of Symbolism lie the works of Charles Baudelaire. The poet roamed a city that was industrialized and mercantile, mechanized, in which no one belonged to himself and any attempts to draw on spirituality seem to have been discouraged: the press (which Balzac had already held up as an example of corruption, of the falsification of ideas and tastes) took individual experience and flattened it into generic patterns; photography, then triumphant, cruelly immobilized nature, fixed the human face in a bewildered gaze directed at the lens, deprived portrayals of any aura of impalpability, and killed—in the view of many contemporaries—all the possibilities of the imagination. How to recreate more intense possibilities of experience, how to make them deeper and more impalpable?

In his *Poetic Principles* Poe suggests that Beauty is a reality that is always beyond our reach, defying all our attempts to immobilize it. And it is against the background of the Platonism of Beauty that the idea took shape of a secret world, a world of mysterious analogies that natural reality usually conceals, showing it only to the eye of the poet. Nature is like a temple, we read in Baudelaire's celebrated sonnet *Correspondences*, in which living columns sometimes let slip garbled words; nature is a forest of symbols. Colors and sounds, images and things all refer to one another, revealing mysterious affinities and correspondences. The poet becomes the

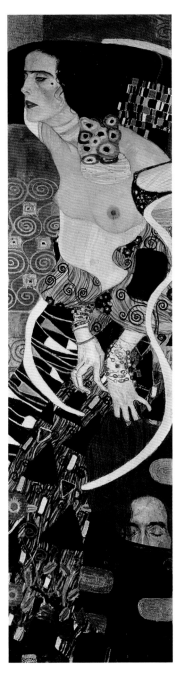

Gustav Klimt,
Salomé, 1909.
Venice, Galleria
Internazionale d'Arte
Moderna di Ca' Pesaro

Jewels
Oscar Wilde
The Picture of Dorian Gray , 1891
He would often spend a whole day settling
and resettling in their cases the various stones
that he had collected, such as the olive-green
chrysoberyl that turns red by lamplight, the
cymophane with its wirelike line of silver, the
pistachio-colored peridot, rose-pink and
wine-yellow topazes, carbuncles of fiery
scarlet with tremulous four-rayed stars, flame-
red cinnamon-stones, orange and violet
spinels, and amethysts with their alternate
layers of ruby and sapphire. He loved the red
gold of the sunstone, and the moonstone's
pearly whiteness, and the broken rainbow of
the milky opal.

Forest of Symbols
Charles Baudelaire
The Flowers of Evil, 1857
In Nature's temple where living columns
Set to murmuring at times;
Man wanders midst a forest of symbols
That observe him with familiar gaze.
As lingering echoes that from afar
Merge into a profound and shadowy unity,
Vast as the night and bright as day,
Scents, colors, and sounds converse.
There are perfumes fresh as infants,
Sweet as oboes and green as meadows;
But others, corrupt, rich, and triumphant,
Spread out like infinite things,
As amber, musk, benzoin, and incense
Sing of the raptures of the soul
And the senses.

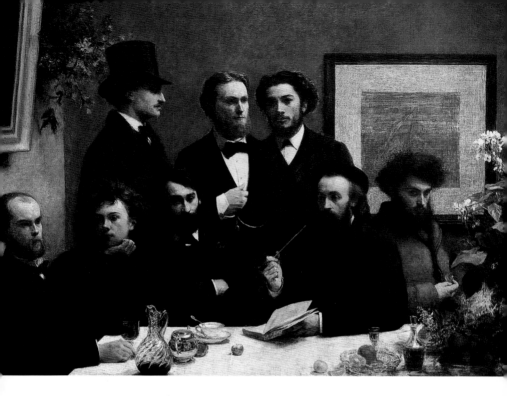

Henri Fantin-Latour,
The Corner of the Table,
from left: Paul Verlaine,
Arthur Rimbaud, Elzéar
Bonnier, Léon Valade,
Émile Blémont, Jean
Aicard, Ernest d'Hervilly,
Camille Pelletan, 1872.
Paris, Musée d'Orsay

Revelation
Charles Baudelaire
My Heart Laid Bare, 1861
In certain almost supernatural states of mind,
the profundity of life is revealed in its entirety
in the spectacle, common as it may be, that we
have before our eyes. It becomes the symbol
of it.

The Art of Poetry
Paul Verlaine
The Art of Poetry, 1882
Music above all other things,
And thus prefer uneven lines,
More soluble in air,
With nothing weighty or fixed.
[…]
For we want pure nuance,
Not color, nothing but nuance!
Oh, nuance alone can wed
The dream to the dream,
And the flute to the horn!
[…]
More and yet more music!
May your song be a stolen thing

Seeming to flee from a soul upraised
Toward other skies and other loves.

May your song be a fair adventure
Turned to face the morning breeze
Where blooms the mint and the thyme…
And all the rest is literature.

To Suggest
Stéphane Mallarmé
Enquête sur l'évolution littéraire, 1897
The Parnassians take the thing in its entirety
and show it: but that way they lack mystery,
they steal from the spirit the delightful joy
that springs from believing that it can
create. To name an object means to
suppress three quarters of the enjoyment of
poetry, which consists in guessing little by
little. To suggest, that is the dream. It is the
perfect use of this mystery that constitutes
the symbol: to evoke an object in order to
show a state of mind, or to choose an object
and make it emanate a state of mind,
through a progressive process of
decipherment.

decipherer of this secret language of the universe and Beauty is the hidden Truth that he will bring to light. Thus we understand how, if everything possesses this power of revelation, experience must be intensified where it has always appeared as a taboo, in the abysses of evil and dissipation, from which the most violent and fecund combinations may spring and in which hallucinations will be more revealing than elsewhere. In *Correspondences*, Baudelaire speaks of a "shadowy and profound unison" and alludes to a sort of magical identity between humankind and the world, to a universe beyond the universe of reality, revealing to us a kind of secret soul within things; in other words, the action of the poet is such that it confers upon things, by virtue of poetry, a value that they did not possess before.

If Beauty is to spring from the fabric of everyday events, whether they conceal it or whether they allude to a Beauty that lies beyond them, the problem is how to turn language into a perfect allusive mechanism. Let us consider Paul Verlaine's *The Art of Poetry,* the most comprehensible of the programs produced by the Symbolist movement:

Édouard Manet,
Portrait of Stéphane Mallarmé, 1876.
Paris, Musée d'Orsay

through a musicalization of language, and a certain amount of chiaroscuro and allusion, the correspondences are triggered and the connections become clear.

But, more than Verlaine, it was Stéphane Mallarmé who worked out an authentic metaphysics of poetic creation. In a universe dominated by Chance, only the poetic Word can realize the absolute, through the immutable meter of the verse (the fruit of long patience and of heroic, essential effort). Mallarmé thought of his *Grand Oeuvre* (the Great Work), a life's work left unfinished at his death, as an "Orphic explanation of the Earth, the sole duty of the poet and the literary game *par excellence.*" It was not a question of showing things in the round, with the clarity and rigor of Classical poetry; as Mallarmé says in his *Divagations,* "to name an object is to destroy three quarters of the enjoyment of a poem, which is given to be

guessed little by little: **to suggest** it, that is the dream. It is the perfect use of this mystery that constitutes the symbol, to evoke an object little by little… To establish a relationship between precise images, in such a way that a third aspect is detached from them, a fusible and clear aspect, presented for divination… I say: a flower! And out of the obscurity whence my voice has banished some shape, in so far as it is different from known calyxes, musically there arises, the idea itself, mellifluous, the flower absent from all bouquets." A technique of obscurity, evocation through the blank spaces, not saying, the poetics of absence: only in this way could the Great Work finally reveal "the immutable lacework of Beauty." Here too there is a Platonic reaching out toward a beyond, but at the same time an awareness of poetry as magical action, as a divinatory technique.

In Arthur Rimbaud the divinatory technique overlapped into the author's life itself: the intemperance of the senses becomes the preferred path to clairvoyance. With Rimbaud, the aesthetic religion of Decadentism does not lead to the eccentricity (all things considered urbane and agreeable) of the dandy. The cost of dissipation is suffering; the aesthetic ideal has a price. Rimbaud consumed his youth in the search for the absolute poetic Word. When he realized that he could go no farther, he did not ask of life any compensation for an impossible literary dream. Not yet twenty years of age, he withdrew from the cultural scene and went to Africa, where he died at thirty-seven.

Beauty on My Knee
Arthur Rimbaud
A Season in Hell, 1873
One evening, I lured Beauty onto my knee. And I found her bitter, and I abused her. I armed myself against justice. I took to flight. O witches, O misery, O hate, I entrust treasure to you! I came to banish all human hope from my soul. Like a wild beast, I leapt on every joy and sought to strangle it.
I have called for executioners as I wish to die chewing on their rifle butts. I have called for scourges, to smother in sand and blood. Misfortune has been my god. I have wallowed in the mud. I have dried myself in the air of crime. I have flirted wildly with madness. And spring brought me the alarming laugh of an idiot.

Believing in All Magic
Arthur Rimbaud
A Season in Hell, 1873
For a long time my boast was that I was lord of all possible landscapes, and I thought that all the leading lights of modern painting and poetry were a joke. I loved outlandish pictures, paintings over doorways, stage sets, the scenery used by street artists, store signs, garish prints; passé literature, church Latin, badly-spelled erotic books, the romances of our grandparents, fairy tales, books for little children, the old melodramas, stupid jingles and naïve rhythms.
I dreamed of crusades, voyages of discovery of which no account exists, republics without a history, wars of religion suppressed, conventions revolutionized, the migration of races and continents: I believed in all kinds of magic.

7. Aesthetic Mysticism

While Baudelaire was writing *Correspondences* (published in 1857 in the collection *The Flowers of Evil*) English cultural society was dominated by John Ruskin. Ruskin reacted—the theme is a constant one—to the sordidly unpoetic nature of the industrial world and urged a return to the loving and patient world of craftsmanship of the medieval centuries and of fifteenth-century society; but the aspect of Ruskin that interests us here is the ardent mysticism and the diffuse religiosity with which his speculations on Beauty are permeated. The love of Beauty is a reverent love for the miracle of nature and for the all-pervasive marks of divinity to be found in it; nature reveals to us in common things "the parable of deep things, the analogies of divinity." "All is adoration," or "the highest perfection cannot exist without the admixture of some darkness." The "Platonic" reaching out for a transcendent Beauty, the evocation of medieval art and of art before Raphael: these were the points of Ruskin's teachings calculated to inspire the English poets and painters of the period, and especially those who came together to form the Pre-Raphaelite Brotherhood, founded by Dante Gabriel Rossetti in 1848. In Ruskin's works, in those of Edward Burne-Jones, of William Holman Hunt, and of John Everett Millais, the themes and techniques of pre-Renaissance painting—which had already fascinated the German "Nazarenes" working in Rome at the beginning of the century—were employed to express atmospheres of delicate mysticism, laden with sensuality.

Rossetti advised: "Paint only what you desire and paint it simply: God is in all things, God is Love"; but his women, his Beatrixes and his Venuses, have full lips and eyes blazing with desire. More than the *donna angelicata* of the Middle Ages they are reminiscent of the perverse women found in the verses of Swinburne, England's master of poetic Decadence.

John Everett Millais,
The Blind Girl, detail,
1856. Birmingham,
City Council

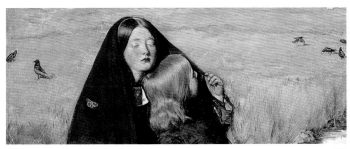

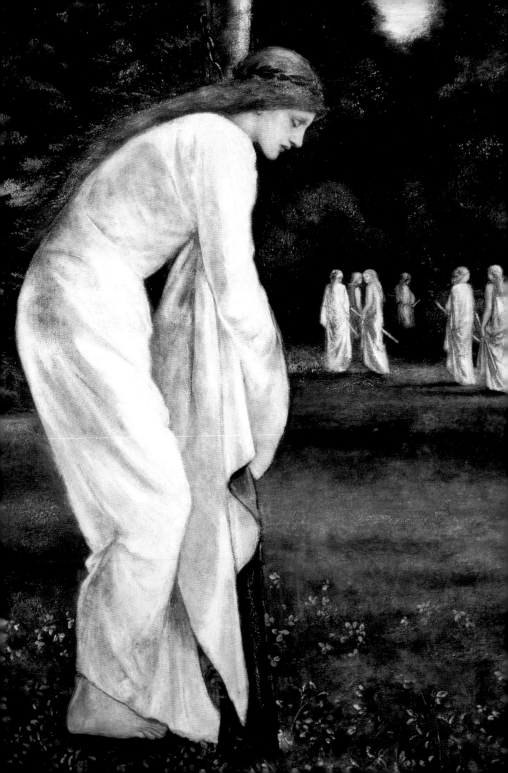

8. The Ecstasy Within Things

An intense current that has permeated all of European literature, Symbolism is still producing its followers to this day. But from its mainstream there emerged a new way of seeing reality: things are a source of revelation. This was a poetic technique that was defined on a theoretical level, in the first two decades of the twentieth century, by the young James Joyce (In *Stephen Hero* and *A Portrait of the Artist as a Young Man*), but which can be found in different forms in many other great novelists of the period. The roots of this stance lie in the thinking of Walter Pater.

In Pater's critical works we find all the themes of Decadent sensibility: the sense of living in a transitional period (his character, Marius the Epicurean, is an aesthete, a dandy of the late Roman Empire); the languid sweetness of the autumn of a culture (all refined colors, exquisite shades, and delicate, subtle sensations); admiration for the world of the Renaissance (his essays on Leonardo are famous); and the subordination of all other values to Beauty (it would appear that when someone once posed him the question "Why should we be good?," he replied: "Because it's so very beautiful").

But in some pages of *Marius the Epicurean* and especially in the Conclusion to his essay *The Renaissance* (1873), Pater developed a precise aesthetics of the epiphanic vision. He did not actually use the word "epiphany" (later used by Joyce in the sense of "manifestation"), but the concept is implied: there are moments in which, in a particular emotive situation (an hour of the day, an unexpected event that suddenly fixes our attention on an object), things appear to us in a new light. They do not refer us to a Beauty outside themselves, they do not call up any "correspondence": they appear, simply, with an intensity that was previously

Edward Burne-Jones,
*The Princess Chained
to the Tree*, 1866.
New York, formerly
Forbes Collection

Epiphanic Vision
Walter Pater
On the Renaissance, 1873
Every moment some form grows perfect in hand and face; some tone on the hills or the sea is choicer than the rest; some mood or passion or insight or intellectual excitement is irresistibly real and attractive to us—for that moment only. Not the fruit of experience, but experience itself, is the end. [...]
To burn always with this hard, gemlike flame, to maintain this ecstasy, is success in life. In a

sense it might even be said that our failure is to form habits: for, after all, habit is relative to a stereotyped world, and meantime it is only the roughness of the eye that makes any two persons, things, situations, seem alike. While all melts under our feet, we may well grasp at any exquisite passion, or any contribution to knowledge that seems by a lifted horizon to set the spirit free for a moment, or any stirring of the senses, strange dyes, strange colours, and curious odours, or work of the artist's hands, or the face of one's friend.

Berenice Abbott,
James Joyce,
1928.

unknown to us, and they come to us full of meaning, causing us to understand that only in that moment have we had the complete experience—and that life is worth living only in order to accumulate such experiences. The epiphany is an ecstasy, but an ecstasy without God: it is not transcendence, but the soul of the things of this world, it is—as has been said—a materialist ecstasy.

Stephen Dedalus, the protagonist of Joyce's early novels, is struck from time to time by apparently insignificant happenings, the voice of a woman singing, the smell of rotten cabbage, a street clock whose luminous face suddenly emerges from the night, leaving Stephen: "glancing from one casual word to another on his right or left in stolid wonder that they had been so silently emptied of instantaneous sense until every mean shop legend bound his mind like the words of a spell until his soul shrivelled up sighing with age."

The Seabird Girl
James Joyce
A Portrait of the Artist as a Young Man, 1916
A girl stood before him in midstream, alone and still, gazing out to sea. She seemed like one whom magic had changed into the likeness of a strange and beautiful seabird. Her long slender bare legs were delicate as a crane's and pure save where an emerald trail of seaweed had fashioned itself as a sign upon the flesh. Her thighs, fuller and soft-hued as ivory, were bared almost to the hips, where the white fringes of her drawers were like feathering of soft white down. Her slate-blue skirts were kilted boldly about her waist and dovetailed behind her. Her bosom was as a bird's, soft and slight, slight and soft as the breast of some dark-plumaged dove. But her long fair hair was girlish: and girlish, and touched with the wonder of mortal beauty, her face.

She was alone and still, gazing out to sea; and when she felt his presence and the worship of his eyes her eyes turned to him in quiet sufferance of his gaze, without shame or wantonness. [...]

—Heavenly God! cried Stephen's soul, in an outburst of profane joy. [...]

A wild angel had appeared to him, the angel of mortal youth and beauty, an envoy from the fair courts of life, to throw open before him in an instant of ecstasy the gates of all the ways of error and glory. On and on and on and on!

Jacques-Émile Blanche,
Marcel Proust, c. 1892.
Paris, Musée d'Orsay

Elsewhere the Joycean epiphany is still bound to the climate of aesthetic mysticism, and a young girl walking along the seashore can strike the poet as a legendary bird, the very "visible spirit of Beauty" enveloping it "like a cloak." In other writers, Proust for example, revelation occurs through the play of memory: over a given image or tactile sensation the memory of another image, of another sensation felt in another moment, is superimposed and, by virtue of a short circuit in the "involuntary memory," it triggers the revelation of a kinship among the events of our life, which the cement of memory holds together by conferring unity upon them. But, here too, the thing that gives sense to life as the pursuit of Beauty is the privileged experience of these moments, and these moments can be obtained only if we learn to enter ecstatically into the heart of the things that surround us.

Naturally, these authors associate this idea of epiphany as vision with the idea of epiphany as creation: if we can have a fleeting experience of epiphanic enchantment, it is art and art alone that allows us to communicate it to others. Indeed, in most cases art causes it to gush out from nothingness, thus giving a meaning to our experiences.

As Joyce put it, for Stephen "the artist who could disentangle the subtle soul of the image from its mesh of defining circumstances most exactly and reembody it in artistic circumstances chosen as the most exact for it in its new office, was the supreme artist." Yet again we have a reference to Baudelaire, who really was the origin of all these currents: "The whole of the visible universe is only a storehouse of images and signs to which the imagination assigns a place and a relative value; it is a kind of nourishment that the imagination must digest and transform."

9. The Impression

With epiphanies, writers worked out a visual technique and in certain cases it seems as if they wished to replace painters; however, the technique of the epiphany is an eminently literary one and it has no precise equivalent in the theories of the visual arts. It is no accident that Proust, in *Within a Budding Grove*, dwelt at length on the description of the pictures of a nonexistent painter, Elstir, in whose art we can recognize analogies with the works of the Impressionists. Elstir portrays things as they appear to us in the first moment, the only true moment, in which our intelligence has not yet intervened to explain to us what the things are, and in which we have yet to superimpose the notions we possess about them over the impression they have made on us. Elstir reduces things to immediate impressions and subjects them to a "metamorphosis."

Manet, who stated "real things do not exist, paint what you see straight off," and "one does not paint a landscape, a harbor, or a figure: one paints *an impression* of an hour of the day of a landscape, a harbor, or a figure"; van Gogh, who wanted to express something eternal with his figures, but through "the vibrations of colors"; Monet, who gave the title *Impression* to one of his paintings (thus unwittingly giving a name to the entire movement); and Cézanne, who said that he wanted to reveal in an apple that which represents the soul of the object, its "appleness": all of these

Claude Monet,
Three versions of *Rouen*,
1892-1894.
Paris, Musée d'Orsay

opposite
Auguste Renoir,
The Blonde Bather,
1882.
Turin, Pinacoteca
Giovanni e Marella
Agnelli

artists showed an intellectual kinship with the late Symbolist current that might be called "epiphanic."

The Impressionists did not tend toward the creation of transcendent Beauty: they wanted to solve problems of pictorial technique, to invent a new space, new perceptive possibilities, just as Proust wished to reveal new dimensions of time and awareness, and just as Joyce determined to make an in-depth exploration of the mechanisms of psychological association.

By that time Symbolism was giving rise to new ways of getting in touch with reality, the quest for Beauty abandoned the heavens and led artists to immerse themselves in the living stuff of matter. As this process gradually proceeded, artists even forgot the ideal of Beauty that guided them, and saw art no longer as a record and cause of an aesthetic ecstasy but as an instrument of knowledge.

aesthetic ideals may coexist even in the same period, and even in the same country. Thus, as the aesthetic ideal of Decadentism was coming into being and developing, an ideal of Beauty that we shall call "Victorian" was also flourishing. The period spanning the insurgent movements of 1848 to the economic crisis of the end of the century is generally defined by historians as "the age of the bourgeoisie." This period marked the culmination of the capacities of the middle classes to represent their own values in the field of trade and of colonial conquest, but also in everyday life: moral outlook, aesthetic and architectural canons, good sense, and the rules governing dress, public behavior, and furnishings were all bourgeois—or, more specifically, given the hegemony of the British bourgeoisie, "Victorian." Together with its own military power (imperialism) and economic strength

Hector Guimard,
Metro Station, 1912.
Paris

Augustus Welby Pugin,
Gothic Sofa,
c. 1845.

(capitalism), the bourgeoisie boasted its own concept of Beauty, which was a commingling of those characteristics of practicality, solidity, and durability that differentiated the bourgeois outlook from that of the aristocracy.

The Victorian world (and especially that of the bourgeoisie) was a world underpinned by a simplification of life and of experience in a bluntly practical sense: things were right or wrong, beautiful or ugly, with no useless self-indulgence in mixed characteristics or ambiguity. The bourgeois was not torn by the dilemma between altruism and egoism: he was an egoist in the outside world (in the stock exchange, on the free market, in the colonies) and a good father, educator, and philanthropist within the four walls of the home. The bourgeois did not have moral dilemmas: a moralist and a puritan at home, he was a hypocrite and a libertine with young working-class women outside the home.

This practical simplification was not perceived as an ambiguity: on the contrary, it is reflected in the domestic self-portrait of the **bourgeois home** in the form of objects, furnishings, and things that necessarily had to express a Beauty that was at once luxurious and solid. Victorian Beauty was not perturbed by the alternative between luxury and function, between

Bourgeois Home
Eric Hobsbawm
The Age of Capital, 1848-1875, 1975
The home was the quintessence of the bourgeois world because in the home and only in it, could people forget, or suppress artificially, the problems and contradictions of society. Here and only here the bourgeois family, and even more the petit bourgeois family, could maintain the illusion of a harmonious and hierarchical happiness, surrounded by the artefacts which demonstrate it and made it possible, the dreamlife which found its culminating expression in the domestic ritual systematically developed for this purpose, the celebration of Christmas. The Christmas dinner (celebrated by Dickens), the Christmas tree (invented in Germany but rapidly acclimatised through royal patronage in England), the Christmas song—best known through the Germanic *Stille Nacht*—symbolised at one and the same time the cold of the outside world, the warmth of the family circle within and the contrast between the two.

The most immediate impression of the bourgeois interior of the mid century is overcrowding and concealment: a mass of objects more often than not disguised by drapes, cushions, cloths, wallpapers and always, whatever their nature, elaborated. No picture without a gilded, a fretted, a chased, even a velvet covered frame, no seat without upholstery or cover, no piece of textile without tassel, no piece of wood without some touch of the lathe, no surface without some cloth or object on it. This was no doubt a sign of wealth and status: [...] Objects express their cost and, at a time when most domestic ones were still produced largely by manual crafts, elaboration was largely an index of cost together with expensive materials. Cost also bought comfort which was therefore visible as well as experienced. Yet objects were more than merely utilitarian or symbols of status and achievement. They had value in themselves as expressions of personality, as both the programme and reality of bourgeois life, even as *transformers* of men.

appearances and being, spirit, and matter. From the solidity of carved picture frames to the piano for the education of daughters, nothing was left to chance: there was no object, surface, or decoration that did not express at one and the same time its cost and its ambition to endure over the years, immutable as the expectations of the "British way of life" that British gunboats and banks were exporting to the four corners of the earth.

Victorian aesthetics were therefore the expression of a basic duality, arising from the introduction of practical function to the realm of Beauty. In a world in which, over and above its usual function, every object became goods, in a world in which exchange value (the equivalence of the object with a certain amount of money) was superimposed over all values of utility (the purpose, practical or aesthetic, of the object), even the aesthetic enjoyment of the beautiful object was transformed into a display of its commercial value. Beauty ended up by coinciding no longer with the superfluous, but with value: the space once occupied by the vague, by the indeterminate, was now filled by the practical function of the object. The entire subsequent development of objects, in which the distinction between form and function was to become steadily fuzzier, was to be marked by this original duality.

Children's Tea Party, c. 1880. London, National Historical Photoarchive

2. Iron and Glass: The New Beauty

A further element of duality lies in the sharp distinction between the interior (the home, morals, the family) and the exterior (the market, the colonies, war). "A place for everything and everything in its place" was the motto of Samuel Smiles, a writer who was very well known at the time for his ability to express the bourgeois moral of "self-help" in clear and edifying prose.

But this distinction was thrown out of kilter by the long economic crisis of the end of the century (1873-1896), which undermined public certainty in the progressive and unlimited growth of a world market governed by the "invisible hand" and even in the rationality and regulability of economic processes. In another sense, the new materials used to express the architectonic Beauty of buildings simultaneously contributed to the crisis of Victorian forms and to the success of the new forms of the late nineteenth and early twentieth century. But this authentic revolution in architectural taste, which hinged on the combined use of glass, iron, and cast iron, had more distant origins: the utopian positivism of the followers of Saint-Simon who, mid-way though the nineteenth century, were convinced that humanity was on its way toward the apex of its history—the organic stage. The first signs of novelty were, precisely in mid-century, the public buildings designed by Henri Labrouste: the Bibliothèque de Sainte-Geneviève (whose completion marked the beginning of the so-called "Neo-Greek movement") and the Bibliothèque Nationale.

Labrouste, who in 1828 had caused a sensation with a meticulous paper in which he demonstrated that one of the temples in Paestum was in reality a public building, was convinced that buildings must not express ideal

opposite and above
Henri Labrouste,
Bibliothèque Nationale de France, Paris,
1854-1875.

The Neo-Greek Style
A. E. Richardson
Architectural Review, 1911
[…] The true Neo-Greek style synthesizes the lengthy planning process, it reflects the indefatigable mind of the designer, who, having collected many ideas about his subject, melts them down in the crucible of his imagination, refining them until the mint-new metal gleams with splendor. Any material will serve for this purpose. With these means, and with these alone, is original design possible.

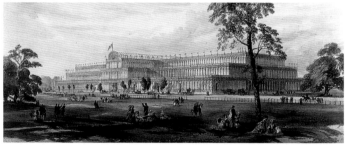

Paris, detail, Eiffel Tower, 1889.

Joseph Paxton, *Design for the Crystal Palace*, 1851. London, National Museum of Science and Industry

Beauty—which he deliberately rejected—but the social aspirations of the people that were to use the building. The daring lighting systems and cast-iron pillars that give form to the spaces and volumes of his great Parisian libraries mark the realization of a model of Beauty intrinsically permeated by a social, practical, and progressive spirit. Artistic Beauty was thus expressed by the single elements of the construction: down to the smallest bolt or nail, there was no material that did not become a newly-created *objet d'art*.

In Britain too there was a growing conviction that the new Beauty of the twentieth century should be expressed through the powers of science, trade, and industry, destined to supplant the moral and religious values whose past dominance had run its course: this was the standpoint of Owen Jones, the designer of the Crystal Palace (later executed by Joseph Paxton). In Britain, the Beauty expressed by buildings in glass and iron aroused the hearty dislike of those who thought in terms of a return to the Middle Ages (Pugin, Carlyle) and to the Neo-Gothic (Ruskin, Morris), all of which culminated in the establishment of the Central School of Arts and Crafts. It is nonetheless symptomatic that this aversion, which hinged on the regressive utopia of a

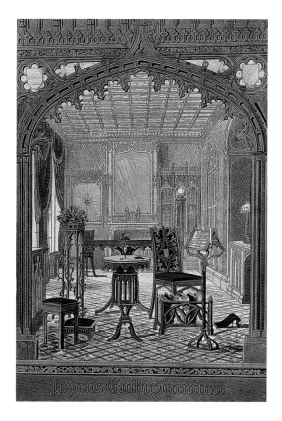

Augustus Welby Pugin,
Neo-Gothic Interior

return to the Beauty of nature and on a refusal to see a new Beauty in the civilization of machines, did not challenge (as Wilde was to do) the conviction that Beauty ought to express a social function: the issue at stake here was *what* function the façades of buildings ought to reflect.

The purpose of architecture was, according to Ruskin, the realization of a natural Beauty obtained by harmonizing the building within the landscape: this rustic Beauty, which rejected the new materials in the name of the naturalness of stone and wood, was the only one capable of expressing the vital spirit of a people. This was a palpable, tactile Beauty, which was expressed by physical contact with the façade and the materials used in the building and which revealed the history, the passions, and the nature of its producers. But a beautiful house could be produced only if behind "good architecture" stood happy men, not alienated by industrial civilization. Morris's utopian socialism came to the point of dreaming of a return to the social forms of the Middle Ages—country villages and craft guilds—in antithesis to the alienation of the metropolis, the cold and artificial Beauty of iron, and the uniformity of mass production.

3. From Art Nouveau to Art Deco

The Central School of Arts and Crafts, with its glorification of the Beauty of the craftsman and its advocacy of a return to manual work, was opposed to all contamination between industry and nature. In the field of the arts, one of the movement's most direct results was Art Nouveau, which became rapidly widespread in the period straddling the two centuries, especially in the decorative field, design, and the production of fancy goods.

It is interesting to note that, unlike other artistic movements that were defined *a posteriori* (like the Baroque, Mannerism, etc.), Art Nouveau was a movement that arose and took shape "from the grass roots," spontaneously, taking a different name in each of the countries it came from: *Jugendstil* in Germany, *Secession* in Austria, and *Liberty* (from the name of the owner of a famous London department store) in Italy. Art Nouveau took its first steps with the ornamentation of books: flourishes, frames, and initials transformed books into objects in which the precious Beauty of the decoration was allied to the customary function of the object. This proliferation of decorative work on such a common and widespread object-goods item was the symptom of an irresistible impulse to embellish structural forms with new,

Philippe Wolfers,
Electric Lamp, from
"La Fée Paon,"
c. 1901.

sinuous lines: it was not long before this Beauty took possession of iron window frames, the entries to the subway in Paris, buildings, and furnishings. We might even talk of a narcissistic Beauty: just as Narcissus, on looking at his reflection in the water, projected his own image outside himself, so did the inner Beauty of Art Nouveau project itself onto the external object and appropriate it, enveloping it with its lines.

Jugendstil Beauty is a Beauty of line, which does not disdain the physical, sensual dimension: as these artists soon discovered, even the human body—and the female body in particular—lends itself to envelopment in soft lines and asymmetrical curves that allow it to sink into a kind of voluptuous vortex. The stylization of figures is not just a decorative element. Jugendstil clothing, with its fluttering scarves, is not merely a matter of outer style, it is above all an inner one: the swaying walk of Isadora Duncan, the queen of dance, was a real icon of the epoch. Jugendstil woman was an erotically emancipated, sensual woman who rejected corsets and loved cosmetics: from the Beauty of book decorations and posters, Art Nouveau moved on to the Beauty of the body.

Jugendstil
Dolf Sternberger
Panorama of the 19th Century, 1977
Jugendstil is not therefore a concept representative of an epoch, but it certainly defines an epoch-making phenomenon. On a geographical level it spread more or less throughout the Western world: England, Belgium, Holland, France, Germany, Austria, Switzerland, Scandinavia, the United States, and with limited reference to a few motifs and characters, to Spain, Italy, and even Russia. At the same time, in all those countries there were movements of a quite different kind, often far more important: but Jugendstil was the hallmark of novelty, and innovation and renewal were the hallmarks of Jugendstil (since then novelty has become a characteristic sign, indeed an essential requisite, of any artistic enterprise with a claim to esteem, fame, the market, and a place in history). This peculiarity is expressed with clear immediacy in the other name that spread throughout the West outside Germany: *Art Nouveau*. Naturally, apart from schools, groups, and individuals, a distinction must also be made between the different centers: London, Glasgow, Brussels, Paris, Nancy, Munich, Darmstadt, or Vienna, where another password came into use: Secession. […]
Nor do I wish to draw a clear line of demarcation between "symbolism" and Jugendstil: this would be a forced interpretation. I prefer to search for the differences between the works and the personalities. We are dealing with a single

formal universe that is continuous and interwoven and contains within itself both positive and negative aspects. Motifs such as youth, spring, light, and health are contrasted by dream, longing, fairy-tale obscurity, and perversion; the very principle of organic ornamentation signifies at once the humanization of nature and the denaturing of man. In separating the contradictions and attributing them to different trends or phases of development, we lose sight of the profound and fertile ambiguity that both attracts and disturbs us in Jugendstil. An ambiguity that it cannot do without. How many contradictions exist in architecture between the "rationality" of a van de Velde and the whimsy of an Antonio Gaudì in Barcelona, between the modesty of a Mackintosh in Glasgow and the opulence of a Hector Guimard in Paris! What a poetic contrast there is between the elegant roguery of Oscar Wilde and the idealizing pathos of the couple in the poem by the German Richard Dehmel, between the visionary presentience of Maurice Maeterlinck and the mordant delights of Frank Wedekind! In painting, what worlds separate the lascivious luxury of Gustav Klimt from the intense desperation of the works of Edvard Munch (without wishing to discuss the various differences in level, stature, and energy)! Yet there is something that unites them; the works of these painters, poets, architects, and designers share some common features: and it is this impression that we define with the term Jugendstil.

Art Nouveau contains none of the nostalgic melancholy and the hint of death of Pre-Raphaelite and Decadent Beauty, nor of the rebellion against commercialization led by the Dadaists: what these artists were looking for was a style that could protect them from their self-confessed lack of independence. Nonetheless, Jugendstil Beauty has marked functionalist features, which can be seen in the attention paid to materials, in the refined utility of objects, in the simplicity of forms devoid of profuseness and redundancy, and in the care taken with the decor of home interiors. In all this a contributory role was certainly played by elements deriving from the Arts and Crafts movement, but even this influence was tempered by a clear compromise with industrial society. Having said this, however, the original Jugendstil was not immune to a certain antibourgeois tendency, dictated more by the desire to scandalize the middle classes—*épater les bourgeois*—rather than to overturn the established order. But the impact of this trend, present in Aubrey Beardsley's prints, in Frank Wedekind's theater, and in Henri de Toulouse-Lautrec's posters, soon dwindled away with the disappearance of the threadbare Victorian clichés. The formal elements of Art Nouveau were developed, starting from 1910, by the Deco style, which inherited its characteristics of abstraction, distortion, and formal simplification while moving toward a more marked functionalism. Art Deco (but the term was not coined until the 1960s) retained the iconographic motifs of Jugendstil—stylized bunches of flowers, young and willowy female figures, geometrical patterns, serpentines and zigzags—enhancing them with elements drawn from Cubism, Futurism, and Constructivism, always with a view to subordinating form to function. The colorful exuberance of Art Nouveau was replaced by a Beauty that was no longer

opposite
Louise Brooks

Henry van de Velde,
*Habana Department
Store*, Brussels

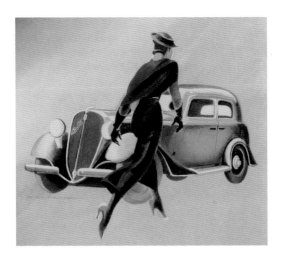

Marcello Dudovich,
*Sketch for a Poster for the
Balilla Automobile*, 1934.
Turin, Archivio Fiat

opposite
Janine Aghion,
*The Essence of the Mode
of the Day*, 1920.
Susan J. Pack Collection

aesthetic but functional, a refined synthesis of quality and mass production. The characteristic feature of this Beauty is the reconciliation of art and industry: this explains, at least in part, the extraordinary popularity of Deco objects in the 1920s and 1930s even in Italy, where the official canons of **Fascist female Beauty** were decidedly against the slender and willowy women of Deco production. Its lack of emphasis on the decorative element made Art Deco a participant in a widespread sentiment that pervaded early twentieth-century European design. The common features of this functionalist Beauty were the decided acceptance of metallic and glass materials as well as exaggerated geometrical linearity and rational elements (drawn from the late nineteenth-century Austrian Secession movement). From the everyday objects (sewing machines and tea pots) designed by Peter Behrens to the products of the Munich *Werkbund* (founded in 1907), from the German Bauhaus (later closed down by the Nazis) to the glass houses foreshadowed by Paul Scheerbart, right down to Adolf Loos's buildings, there emerged a Beauty that was a reaction against the decorative stylization of technical elements as found in Jugendstil (which did not see technology as a threat, and could therefore come to a compromise with it). The struggle against this decorative element—the "dragon ornament," as Walter Benjamin defined it—was the most pronouncedly political trait of this Beauty.

Fascist Female Beauty
Press Office of the Prime Minister
*Drawings and Photographs of Women's
Fashions*, 1931
The Fascist woman must be physically healthy, to be able to become the mother of healthy children, according to the "rules of

life" pointed out by the Duce in his memorable speech to the medical profession. Drawings of female figures who have been artificiously slimmed down and rendered masculine, representative of the barren woman of decadent Western civilization, must therefore be eliminated absolutely.

4. Organic Beauty

As we have seen, Liberty art contributed (together with events in other cultural fields of the day, such as the philosophies of Friedrich Nietzsche and Henri Bergson, the works of James Joyce and Virginia Woolf, and Freud's discovery of the subconscious) to the demolition of a canon of the Victorian period: the clear and reassuring distinction between interior and exterior. This trend found its fullest expression in twentieth-century architecture, most notably in that of Frank Lloyd Wright. The ideal of a "new democracy" based on individualism and on the recovery of the relationship with nature, but free of regressive utopias, finds its expression in the "organic" architecture of Wright's Prairie Houses, where the internal space spreads out and overlaps into the external space: in the same way the Eiffel Tower painted by Robert Delaunay is welded on to the surrounding environment. In Wright's reassuring glass and iron "cabins" Americans participated in a

Antoni Gaudí Cornet,
Casa Milà, detail of a
staircase, 1906-1910.
Barcelona

opposite
Frank Lloyd Wright,
Fallingwater, 1936.
Bear Run

Beauty that was at once architectonic and natural, which retrieved the concept of a natural place by integrating it with a human artifact.

This reassuring Beauty is in contrast with the disturbing and surprising Beauty of the constructions designed by Antoni Gaudí, who substituted linear structures with extraordinary labyrinthine spaces and the severity of iron and glass with magmatic, fluctuating plastic materials devoid of any apparent linguistic or expressive synthesis. His façades, resembling grotesque collages, turned the relationship between function and decoration on its head, thus bringing about a radical annulment of the association between the architectonic object and reality: in their apparent uselessness and resistance to classification, Gaudí's buildings express the extreme rebellion of inner Beauty against the colonization of life by the cold Beauty of machines.

5. Articles of Everyday Use: Criticism, Commercialization, Mass Production

One of the characteristic features of twentieth-century art is the constant attention paid to articles of everyday use in the age of the commercialization of life and things. The reduction of all objects to the level of goods, and the progressive disappearance of the value of use in a world regulated solely by exchange value radically modified the nature of everyday objects: the object had to be useful, practical, relatively cheap, of standard taste, and mass-produced. This meant that, within the circuit of goods, qualitative aspects of Beauty spilled over with growing frequency into quantitative aspects: it was practicality that determined the popularity of an object, and practicality and popularity grew in direct proportion to the quantity of objects produced from the basic model. In other words, objects lost the "aura" conferred upon them by certain singular features that

Xanti Schawinsky,
*Photomontage
for an Olivetti Calendar
for Studio Boggeri*, 1934

determined their Beauty and importance. The new Beauty could be reproduced, but it was also transitory and perishable: it had to persuade the consumer of the need for rapid replacement, either out of wear and tear or disaffection, so that there might be no cessation of the exponential growth of the circuit involving the production, distribution, and consumption of goods. It is symptomatic that in some great museums—like the Museum of Modern Art in New York and the Musée des Arts Décoratifs in Paris—space has been allotted to everyday items like furniture and accessories.

Marcel Duchamp,
Bicycle Wheel (replica),
1913. Philadelphia,
Philadelphia Museum
of Art

Marcel Duchamp,
Bottle Dryer (replica),
1914. Stockholm,
Moderna Museet

The response to this trend was the ferociously ironic critique of everyday objects as expressed by the Dadaist movement, and above all by its most rational exponent, Marcel Duchamp, with his *Readymades*. By showing a bicycle wheel or a urinal (entitled *Fountain*) he offered a paradoxical criticism of the subservience of the object to function: if the Beauty of objects was a result of the process of commercialization, then any common object could be defunctionalized as an object of everyday use and refunctionalized as a work of art.

While Duchamp's work still possessed a taste for criticizing the existing state of affairs and for rebellion against the world of business, the approach to everyday objects adopted by the Pop art movement was devoid of utopias and of hopes. With a clear, cold eye sometimes allied to a confessed cynicism, Pop artists acknowledged the artist's loss of the monopoly of images, of aesthetic creation and of Beauty.

The world of business attained an undeniable capacity to take its own images and to saturate people's perceptions with them, irrespective of their social status: thus the distinction between artists and ordinary people grew less marked. There was no longer any room for criticism, the task of art was to

Giorgio Morandi,
Still Life, 1948.
Turin, Galleria Civica
d'Arte Moderna e
Contemporanea

establish that any object, without making any distinction between people and things—from the face of Marilyn Monroe to a can of soup, from comic strip images to the inexpressive presence of a crowd standing at a bus stop—acquires or loses its own Beauty not on the basis of its being, but on the social coordinates that determine the way it is presented: a simple yellow banana, devoid of any apparent connection with the object it "represents," was nonetheless chosen to illustrate the cover of an album (produced by Andy Warhol) by the Velvet Underground, one of the most avant-garde bands of its day. From Roy Lichtenstein's comic strips to George Segal's sculptures, down to Andy Warhol's artistic production, what was on show was mass-produced Beauty: the objects were extrapolated from a product run or were already suitable for inclusion in one.

Is this aspect of mass production therefore the destiny of Beauty in the age of the technical reproducibility of art? Not everybody seems to think so. Giorgio Morandi simply painted groups of ordinary bottles. However—with a pathos unknown to the cynicism of Pop art—he continually went beyond the limits of mass production. Morandi searched ceaselessly for the point in which the Beauty of the everyday object is located in space, determining it, while, in the same movement, the space determines the position of the object. It does not matter whether the objects are bottles, cans, or old boxes. Or perhaps this is the very secret of the Beauty that Morandi sought until his dying day: its gushing forth, unexpectedly, from the gray patina that covers the everyday object.

Claes Oldenburg and
Coosje van Bruggen,
Spoonbridge and Cherry,
1988. Minneapolis,
Walker Art Center

Andy Warhol,
Turquoise Marilyn, 1962.
Stefan T. Ellis Collection

Andy Warhol,
Mao, 1973.
Private collection

The Beauty of Machines

1. The *Beautiful* Machine?

Today we are accustomed to talking about beautiful machines, be they automobiles or computers. But the idea of a beautiful machine is a fairly recent one and it might be said that we became vaguely aware of this around the seventeenth century, while a genuine aesthetics of machines developed no more than a century and a half ago. But despite this, right from the appearance of the first mechanical looms, many poets have expressed their horror of machines.

In general a machine is any prosthesis, or any artificial construction, which prolongs and amplifies the possibilities of our body, from the first sharpened flints through to the lever, the walking stick, the hammer, the sword, the wheel, the torch, eyeglasses, and telescopes, all the way to corkscrews or lemon-squeezers. In this sense the term prosthesis also covers chairs, or beds, or even

opposite
Mould for continuous casting of thin slabs,
2000

Phoenician ceremonial axe, gold and silver, eighteenth century BC

clothes, which are artificial substitutes for the natural protection that in animals is provided by fur or plumage. Humankind became practically identified with these "simple machines" because they were and are in direct contact with our body, of which they are all but natural extensions and, like our body, we take care of them and decorate them. And so we created weapons or walking sticks with ornate and costly handles, sumptuous beds, decorated chariots, and refined clothing. One machine alone had no direct relationship with the body and did not imitate the form of the arm, fist, or leg, and that was the wheel. But it was a reproduction of the form of the sun and moon, it possessed the absolute perfection of the circle, and it is for this reason that the wheel has always had religious connotations.

Right from the start, however, man also invented "complex machines," mechanisms with which our body has no direct contact, such as the windmill, for example, or bucket conveyors, or the Archimedean screw. In such machines the mechanism is concealed and internal; in any case, once they are set in motion, they continue to work by themselves. The terror inspired by these machines arose because, by multiplying the strength of human organs,

Lion Hunt,
relief from the Palace of
Ashurbanipal, Nineveh,
c. 650 BC.
London, British Museum

The Wheel
William Blake
The Four Zoas, 1795-1804
And all the arts of life they changd into the arts of death
The hourglass contemnd because its simple workmanship
Was as the workmanship of the plowman & the water wheel
That raises water into Cisterns broken &

burnd in fire
Because its workmanship was like the workmanship of the Shepherd
And in their stead intricate wheels invented Wheel without wheel
To perplex youth in their outgoings & to bind to labours
Of day & night the myriads of Eternity that they might file
And polish brass & iron hour after hour

they emphasized their power, since the concealed gears that make such machines work are dangerous for the body (anyone who puts his hand in the gears of a complex machine gets hurt), and especially because—given that they acted almost as if they were alive—it was impossible not to see the great arms of the windmill, the teeth of the cogwheels of clocks, or the two red eyes of the locomotive in the night and not think of them as living things.

Thus machines appeared as quasi-human or quasi-animal, and it was in that "quasi" that their monstrosity lay. These machines were useful, but disquieting: people made use of what they produced, but saw them as vaguely diabolical creations, and thus devoid of the gift of Beauty.

Greek civilization knew all the simple machines and many complex ones, such as water mills, for example; that the Greeks knew about apparatus of a certain sophistication is revealed to us by the theatrical device known as the *deus ex machina*. But the ancient Greeks make no mention of these machines. In those days no more interest was taken in them than was taken in slaves. Their work was physical and servile and, as such, unworthy of intellectual reflection.

Lewis Hine,
Powerhouse Mechanic,
1920

*Machine for Boring and
Lathing Cannon,*
in Denis Diderot and
Jean d'Alalmbert,
Encyclopédie,
plate XC, 1751

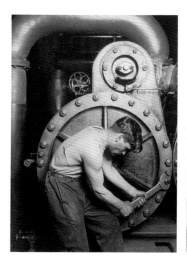

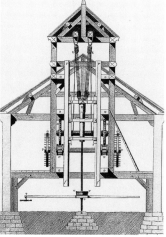

laborious workmanship
Kept ignorant of the use that they might
spend the days of wisdom
In sorrowful drudgery to obtain a scanty
pittance of bread
In ignorance to view a small portion & think
that All.

Are the Zombies Right?
Eugenio Montale

Occasions, 1939
Farewells, whistles in the dark, waves, coughs
And windows down. It's time. Maybe
The zombies are right. Looming and
Leaning in the corridors, mured up!
[…]
And you?, when the faint litany of
Your fast train begins, do you too
Play along with the awful constant rhythm of
the carioca?

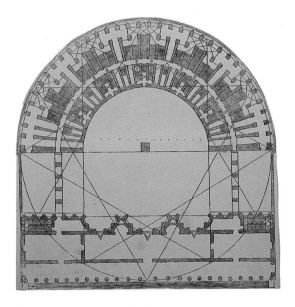

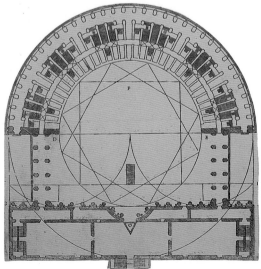

*Diagrams of Curion's
revolving theaters,
from Daniele Barbaro,
I dieci libri dell'architettura
di Vitruvio*, 1556

2. From Antiquity to the Middle Ages

The Greeks of the Hellenistic period told of prodigious automatons: the first treatise dealing with them, the *Spiritalia* of Heron of Alexandria (first century AD)—even though Heron was probably reporting some inventions made by Ctesibius of Alexandria a few centuries earlier—describes some mechanisms that foreshadow inventions of almost two thousand years later (such as a sphere filled with water and heated, which then rolled along, propelled by jets of steam emitted by two nozzles). Nevertheless Heron saw these inventions as curious toys or as artifices for creating the illusion of a prodigy in the temples, and certainly not as works of art.

This attitude remained virtually unchanged (save perhaps for the greater attention paid by the Romans to constructional problems, see Vitruvius) until the Middle Ages, when Hugh of Saint Victor wrote in his *Didascalicon* that *mechanicus* derived from *moechari* (to commit adultery)

Diagram reconstructing an automaton of Heron of Alexandria, published in an Italian translation by Giovanni Battista Aleotti, "Gli artificiosi et curiosi moti spiritali dit Herrone," Bologna, 1589

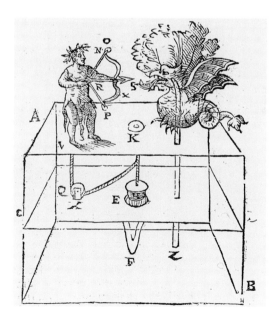

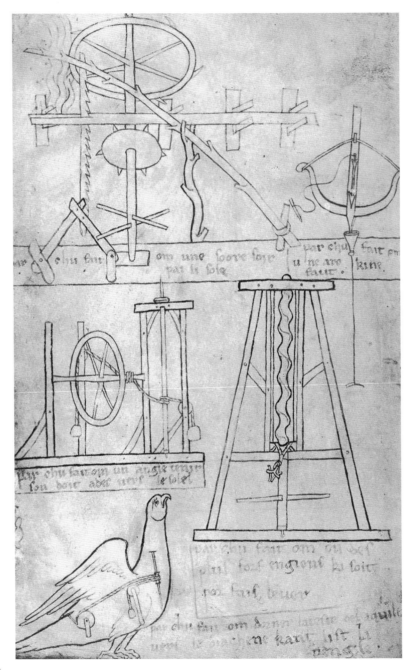

or from *moechus*, an adulterer. And while Greek art has left us no representations of machines, Medieval art contains images of construction machinery, but always to commemorate the creation of something, such as a cathedral for example, which was considered beautiful irrespective of the means by which it was constructed.

Yet, between the year one thousand and the thirteenth century, work in Europe was revolutionized by the adoption of the horse collar and the windmill, by the introduction of the stirrup and the invention of the hinged rear rudder, and by the invention of eyeglasses. These things were recorded in the visual arts, but only because they were elements of the landscape and not because they were objects worthy of explicit consideration.

Of course, an enlightened mind like Roger Bacon dreamed of machines that might have transformed human life (*Epistola de secretis operibus artis et naturae*), but Bacon did not think that such machines could be beautiful. In the stonemasons' guilds they used machines and representations of machines, and Villard de Honnecourt's *Portfolio* is famous to this day. In this work Honnecourt drew mechanical devices for perpetual motion and there is even a design for a flying eagle, but these were the drawings of a craftsman who wanted to show how to make machines and not of an artist who wanted to reproduce their Beauty.

Medieval writers often spoke of mechanical lions or birds, of the automatons sent by Harun al Rashid to Charlemagne or of those seen by Liutprand of Cremona at the court of Byzantium. They spoke of them as amazing things, but what was deemed marvelous was the external aspect of the automaton, the impression of realism that it aroused, and not the concealed mechanism that animated it.

opposite
Villard de Honnecourt, *Diagrams of an automatic sawmill, mechanical crossbow, a hoist, a movable eagle lectern, and other machines, from Portfolio,* B.N. Ms. fr. 19093, thirteenth century. Paris, Bibliothèque Nationale de France

The Magic Throne
Liutprand of Cremona (tenth century)
Report on the Embassy to Constantinople
Before the throne there stood a tree of gilded bronze, whose boughs teemed with bronze birds of different species, whose song differed accordingly. The Emperor's throne was fashioned in such a way that at first it seemed low, then a little higher, and then suddenly very high indeed. It was also extremely large: I don't know whether it was of wood or bronze. Two gilded lions seemed to guard it: they struck the floor with their tails, roaring with maws agape and moving their tongues. Two eunuchs bore me on their shoulders into the palace, and into the Emperor's presence. Upon my arrival the lions roared and the birds sang each in its own way, but I was not at all afraid or amazed, because I had been informed of all beforehand by one who knew of these things. I made my obeisances three times, bowing; then I raised my head and suddenly I saw, seated just beneath the ceiling of the room, and now differently attired, the man I had previously seen on the throne, had just been raised up from the floor. How this was done I could not understand: perhaps they pulled it up with a winch, like the ones they use in wine presses.

3. From the Fifteenth Century to the Baroque

An early idea of the symbolic value of mechanical **prodigies** arguably appeared in the fifteenth century with the works of Marsilio Ficino, and it has to be acknowledged that when Leonardo da Vinci designed his mechanisms he represented them with the same love that he devoted to the portrayal of the human body. The articulations of Leonardo's machines are proudly revealed, just as if the subject were an animal.

But Leonardo was not the first to show the internal structure of machines. He was preceded, almost a century before, by Giovanni Fontana. Fontana designed clocks driven by water, wind, fire, and earth, which thanks to its own natural weight flowed through the hourglass; a mobile mask of the devil, magic lantern projections, fountains, kites, musical instruments, keys, picklocks, war engines, ships, trapdoors, drawbridges, pumps, mills, and moving stairways. Fontana was certainly an example of that oscillation between technology and art that was to become the hallmark of the **"mechanicals"** of the Renaissance and the Baroque. At this point we can glimpse signs of a gradual comeback on the part of the *maker* and of a new respect for the technician, whose activities were described in sumptuously illustrated books. Machines were definitively associated with the production of aesthetic effects and were used to produce "theaters," or stunningly beautiful and amazing architectures, such as gardens enlivened by miraculous fountains. Hydraulic mechanisms that replicated Heron's discoveries were now to be found hidden in grottoes, amid vegetation,

Salomon de Caus,
*Drawing of a Nymph
Playing an Organ, to
Whom an Echo Replies,*
from *Les raisons des
forces mouvantes,* 1615

Leonardo da Vinci, *Study for a Spring-Operated Clock*, Ms. I, BMN, c. 4r. Madrid, Biblioteca Nacional

Prodigies
Marsilio Ficino
Theologia platonica de immortalitate animorum, II, 13, 1482
Certain figures of animals, connected by a system of levers to a central sphere, moved in different ways in relation to the sphere: some ran to the left, others to the right, upward or downward; some rose up and down, others surrounded the enemy, others again smote them, and you could hear the sounding of trumpets and horns, the singing of birds and other similar phenomena that were produced in great numbers, merely by the movement of that sphere […]. Thus it is with God, from whom, owing to His being the infinitely simple center […] all things proceed like a play of lines as with the slightest movement He causes to vibrate all that depends on Him.

The Mechanicals
Giovan Leone Sempronio
(seventeenth century)
Clocks, Hourglasses, and Sundials
He who betrays and steals other's lives,
Like one condemned to the wheel
On a hundred wheels turns,
And he, whose wont it is to reduce
Men to dust, is now bound and measured
By man with a handful of dust.
And if with shadows he obscures our days,
He himself now becomes shadow
In the light of the sun;
Learn, therefore, O mortal,
How time and nature
Dissolve all things here below.

or in towers, and the only outwardly visible things were symphonies of spouting water and the appearance of animated figures. The designers of such marvels were often unsure as to whether they ought to reveal the mechanical secrets that produced them or to restrict themselves to displaying their natural effects, and they frequently opted for a compromise between the two. At the same time people began to appreciate machines for themselves, for the ingenuity of the mechanisms, which were for the first time exposed as objects of wonder. Such machines were described as "artificial" or "ingenious," and let us not forget that, with the Baroque

Athanasius Kircher,
Magic Lantern,
from *Ars magna lucis et umbrae*, 1645

opposite
Agostino Ramelli, *Machines*, from *Le diverse et artificiose machine*, 1588

sensibility, amazing artifice and ingenious invention became criteria of Beauty. The machine seemed to live *gratia sui*, that is to say solely for the purpose of showing off its marvelous internal structure. It was something that was admired for its form, irrespective of its utility; it already had many aspects in common with the creations (of nature or of art) that had traditionally been deemed beautiful. The machines of the Renaissance and of the Baroque period were the triumph of the cogwheel, of the rack, of the con-rod and the bolt. This triumph of the mechanism produced a kind of giddiness, whereby the importance attached to what the machine actually produced was less than that attached to the extravagance of mechanical resources required to produce it, and frequently many of these machines displayed a wholly disproportionate relationship between the simplicity of the effect they produced and the highly sophisticated means required to obtain it.

With the fantasies of the Jesuit priest Athanasius Kircher, at the height of the Baroque age, we come to a fusion of the amazing Beauty of the effect and the ingenious Beauty of the artifice that produced it. One example of this is the catoptric theater (based on the wizardry of mirrors) as described in the *Ars magna lucis et umbrae*—which to some extent foreshadowed some of the techniques of cinematographic projection.

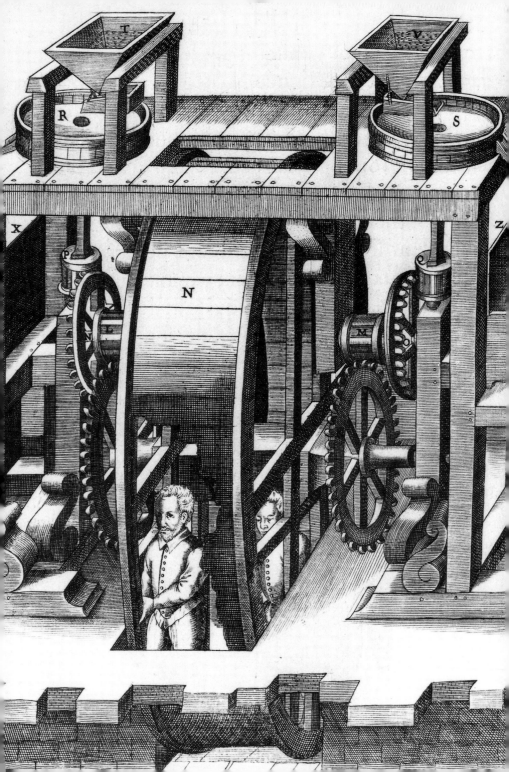

4. The Eighteenth and Nineteenth Centuries

This triumph of the machine as aesthetic object was not always progressive and linear. When James Watt constructed his first machine at the beginning of the third industrial revolution, he tried to have its functionality forgiven by concealing it beneath an exterior resembling a Classical temple. And in the following century, when people were already taking a certain pleasure in the new metallic structures and "industrial" Beauty was coming into being, the technological prodigy that is the Eiffel Tower had to be made visually acceptable with classically inspired arches that were put there as pure ornament, because they have no weight-bearing function.

Diagram of James Watt's engine, eighteenth century

Artificial Hand, from Ambroise Paré, *Instrumental chyrugiae et icones anathomicae,* 1564

Surgical Tools, from Denis Diderot and Jean d'Alembert, *Encyclopédie,* 1751

Machines were celebrated for their rational efficiency, which was also a Neoclassical criterion of Beauty, in the illustrations of the *Encyclopédie,* where descriptions of them are complete and there is no trace of any picturesque, dramatic, or anthropomorphic aspects. If we compare the surgical instruments shown in the *Encyclopédie* with those portrayed in the sixteenth-century works of the physician Ambroise Paré, we can see that the Renaissance instruments were still intended to resemble jaws, teeth, and the beaks of birds of prey, and that they still had a kind of morphological involvement, as it were, with the suffering and violence (albeit of the redeeming sort) with which they were connected. But eighteenth-century instruments are shown in the same way as we would today represent a lamp, a paper-knife, or any other product of industrial design (cf. Chapter XIV).

The invention of the steam engine marked the definitive advent of aesthetic enthusiasm for the machine, even on the part of poets: it suffices to mention Giosuè Carducci's *Hymn to Satan,* in which the locomotive, that "beautiful" and terrible monster, becomes a symbol of the triumph of reason over the obscurantism of the past.

Satanic Train
Giosuè Carducci
Hymn to Satan, 1863
A monster of awful beauty
Has been unchained,
It scours the land
And scours the seas:
Sparkling and fuming
Like a volcano,

It vanquishes the mountains
And devours the plains.

It leaps over chasms;
Then burrows deep
Into hidden caverns
Along paths unfathomed;
Only to re-emerge, invincible,
From shore to shore

Like a tornado
It howls out its cry,

Like a tornado
It belches forth its breath:
It is Satan, O peoples,
Great Satan is passing by.

5. The Twentieth Century

At the beginning of the twentieth century the time was ripe for the Futurist exaltation of speed and, after having called for the murder of moonlight because it was useless poetic garbage, Marinetti went so far as to state that a racing car was more beautiful than the Nike of Samothrace. This was the start of the definitive heyday of industrial aesthetics: the machine no longer had to conceal its functionality beneath the frills of Classical quotation, as happened with Watt, because the notion was established that *form follows function*, and the more a machine demonstrated its efficiency, the more beautiful it was.

Even in this new aesthetic climate, however, the ideal of essential design alternated with that of styling, in which the machine was given forms that did not derive from its function, but were intended to make it aesthetically more pleasing, and therefore better able to appeal to its possible users. With regard to this struggle between design and styling, Roland Barthes left us a magisterial analysis—still celebrated to this day—of the first model of the Citroen DS (where the initials, which look so technical, when pronounced correctly make *déesse*, i.e., the French word for "goddess").

Yet again our story is not linear. Having become beautiful and fascinating in itself, the machine has never ceased, over the last few centuries, to arouse new anxieties that spring not from its mystique but from the appeal of the mechanism laid bare. It suffices to think of the reflections on time and death that **clock** mechanisms aroused in certain Baroque poets, who wrote about bitter and keen cogwheels gashing the days and rending the hours, while the flow of the sand through the hourglass was perceived as a constant bleeding, in which our life dribbled away grain by grain.

A leap of almost three centuries and we come to the machine described in Franz Kafka's *In the Penal Colony*, where mechanism and **instrument of torture** are seen as one and the same thing and the whole business becomes so fascinating that even the executioner opts to immolate himself for the greater glory of his own creation.

Machines just as absurd as Kafka's invention stopped being lethal instruments to become what have been called "celibate machines," that is to say machines that are beautiful because they have no function at all, or have absurd functions; machines and architectures consecrated to waste. In other words, useless machines. The term "celibate machine" comes from a work by

The Beauty of Speed

Filippo Tommaso Marinetti
The Multiplication of Man and the Sovereignty of the Machine, c. 1909

It has been possible to verify, during the great French rail workers' strike, that the organizers did not manage to persuade a single train driver to sabotage his locomotive.

This strikes me as absolutely natural. How could one of those men injure or kill his great devoted, faithful friend, with its ardent and ready heart: his beautiful steel machine that he had lovingly burnished with his lubricating caress? This is not a figure of speech, but almost a reality, which we will easily be able to confirm within a few years' time.

You will certainly have heard those remarks commonly made by car owners and garage managers: "Engines are truly mysterious things…" they say, "they have whims, unexpected vagaries; it seems as if they have a personality, a soul, a will. You have to coddle them, treat them with respect, never ill treat them, or overtax them.

"If you treat it well, this machine of cast iron and steel, this engine built to precise specifications, will not only give you all its performance, but twice that, three times, far more and far better than foreseen by the calculations of the manufacturer: its father!"

Well, I attach a great and revealing importance to such expressions, which are the harbingers of the forthcoming discovery of the laws of the true sensibilities of machines!

We must therefore prepare for the imminent and inevitable identification of man and machine, facilitating and perfecting an incessant exchange of intuitions, rhythm, instincts, and metallic discipline, absolutely unknown to the majority and only foreseen by the most lucid spirits.

The Sanctity of the Tracks

Filippo Tommaso Marinetti
The New Religion—Morality of Speed, 1916

If prayer means communicating with the divinity, traveling at high speed is a prayer. The sanctity of wheels and tracks. We must kneel on the tracks to pray to divine speed. We must kneel before the rotating speed of a gyrocompass: 20,000 rpm, the maximum mechanical speed attained by man. We must steal from the stars the secret of their amazing, incomprehensible speed. So let's take part in the great celestial battles; let's tackle the star-shells fired by invisible cannons; let's compete against the star known as 1830 Groombridge, which flies at 241 kilometers per second, and against Arcturus, which flies at 430 kilometers per second. Invisible mathematical artillerymen. Wars in which the stars, being at once projectiles and gunners, battle with speed to flee a larger star or to strike a smaller one. Our saints are the innumerable corpuscles that penetrate our atmosphere at an average speed of 42,000 meters per second. Our saints are light and electromagnetic waves traveling at 3 x 10 meters per second. The exhilaration of high speed in a motor car is none other than the joy of feeling as one with the sole divinity. Sportsmen are the first catechumens of this religion. [Then will come] imminent destruction of houses and cities, to create great meeting-places for motor cars and airplanes. […]

The Arms of Electricity

Luciano Folgore
Electricity, 1912

Instruments of power, tools,
maneuvered by this will,
heavy trailers,
greedily devouring
space, time, and speed;
O arms of Electricity
outstretched everywhere,
to seize life, to transform it,
to mold it
with rapid elements,
or powerful gears;
superb sons of Electricity
that crush dream and matter,
I hear your sibilant note
converging on the factories,
and the construction sites,
through streets robust with sound,
with the hymn of the great wagons,
and sing the praises
divine
of the will
that all wonders makes
unshackled Electricity.

The Clock

Giovan Leone Sempronio
(seventeenth century)
The Clock Face

Time is a serpent coiled up on itself,
That poisons names and consumes beauty;
Yet you, solely because it ticks away your hours,
Will keep it in your bosom, in a golden casket.
Oh wretched man, how blind and foolish you are!
Time's treacherous hands betray those who look on them,

And with them he marks the deathly hours,
Silvering your hair and furrowing your face.

You idolize your form in life
And see not how the deceitful predator
Will work to make it pale and dismal aday.
Like an ireful greyhound or clever thief,
He barks not but bites only;
Fangs of bronze he has and tongue of iron
And he steals in silence.

The Precious Machine

Raymond Roussel
Impressions of Africa, 1910

Bedu, the hero of the day, pressed a spring on the housing and started up the precious machine he had created with such industriousness and perseverance.
Moved by invisible driving belts, of which the upper parts were lost inside the housing, the panel and its shuttles slipped horizontally along the runner. Despite the movement and the countless yarns attached to the corner of the beam, a counteracting tension system devised for each of the shuttles made sure it stayed perfectly rigid. Left to itself, the spindle of each shuttle, on which the spinning bobbin rested, gradually unwound. This was checked by a spring that provided very slight resistance to the uncoiling of the silk. The mechanism ensured that some yarns were shortened while others became longer, so the mesh maintained its original shape without either slackening or becoming entangled. The panel was held up by a sturdy vertical shaft that at a certain point bent sharply at right angles to penetrate the housing. Here a long groove, which we could not see from the bank, enabled the silent sliding movement that had just begun.
Shortly after, the panel stopped and then started moving upwards. Now the vertical part of the shaft very gently started extending, revealing a series of sliding sections rather like those of a telescope. Governed by a set of internal pulleys and cables, only the thrust of a powerful coil spring could have produced the gradual upward movement, which stopped a moment later. [...] In a flash, a spring in the panel suddenly hurled a shuttle right through the shed of silk yarns, going from one side to the other and ending up in a recess located in a position carefully calculated to receive it. Reeled out from the fragile device, a transversal weft thread was now stretched across the middle of the beam to form the first row of the fabric.
Moved from below by a mobile rod in a groove on the housing, the reed struck the filling thread with its countless dents before shooting back upright.
The heddle threads started moving again and completely changed the arrangement of the silk yarns, which were now moved far apart above and below.
Thrust by a spring in the compartment on the left, the shuttle suddenly darted back over the beam and returned to its recess. The second thread of the weft, unreeled from the spindle in the shuttle, was smartly struck by the reed. As the heddles started their curious toing and froing, the panel used both its means of displacement to travel obliquely: heading towards a specially designated place, the second recess took advantage of a short lull in operations and expelled a shuttle that shot into the corner where all the silk yarns had been conveyed to lodge itself right at the end of the opposite recess, which had stayed put ever since the beginning.
The reed again hit the new weft thread, and this was followed by a long play of the heddles as they prepared the return path for the shuttle, which had been brusquely forced back into its recess.

Instrument of Torture

Franz Kafka
In the Penal Colony, 1919

"Yes, the harrow," said the Officer. "The name fits. The needles are arranged as in a harrow, and the whole thing is driven like a harrow, although it stays in one place and is, in principle, much more artistic. You'll understand in a moment. The condemned man is laid out here on the bed [...]. That way you'll be able to follow it better. Also a sprocket in the inscriber is excessively worn. It really squeaks. When it's in motion one can hardly make oneself understood.
Unfortunately replacement parts are difficult to come by in this place. So, here is the bed, as I said. The whole thing is completely covered with a layer of cotton wool, the purpose of which you'll find out in a moment. The condemned man is laid out on his stomach on the cotton wool—naked, of course. There are straps for the hands here, for the feet here, and for the throat here, to tie him in securely. At the head of the bed here, where the man, as I have mentioned, first lies face down, is this small protruding lump of felt, which can easily be adjusted so that it presses right into the man's mouth. Its purpose is to prevent him screaming and biting his tongue to pieces. Of course, the man has to let the felt in his mouth—otherwise the straps around his

397

throat would break his neck." […]
It was a massive construction. The bed and
the inscriber were the same size and looked
like two dark chests. The inscriber was set
about two meters above the bed, and the two
were joined together at the corners by four
brass rods, which almost reflected the sun.
The harrow hung between the chests on a
band of steel. […] "So now the man is lying
down," said the Traveler. He leaned back in his
chair and crossed his legs. "Yes," said the
Officer, pushing his cap back a little and
running his hand over his hot face. "Now,
listen. Both the bed and the inscriber have
their own electric batteries. The bed needs
them for itself, and the inscriber for the
harrow. As soon as the man is strapped in
securely, the bed is set in motion. It quivers
with tiny, very rapid oscillations from side to
side and up and down simultaneously. You
will have seen similar devices in mental
hospitals. Only with our bed all movements
are precisely calibrated, for they must be
meticulously coordinated with the
movements of the harrow. But it's the harrow
which has the job of actually carrying out the
sentence." […] When the man is lying on the
bed and it starts quivering, the harrow sinks
onto the body. It positions itself automatically
in such a way that it touches the body only
lightly with the needle tips. Once the machine
is set in this position, this steel cable tightens
up into a rod. And now the performance
begins. Someone who is not an initiate sees
no external difference among the
punishments. The harrow seems to do its
work uniformly. As it quivers, it sticks the tips
of its needles into the body, which is also
vibrating from the movement of the bed.
Now, to enable someone to check on how the
sentence is being carried out, the harrow is
made of glass. That gave rise to certain
technical difficulties with fastening the
needles securely, but after several attempts
we were successful. We didn't spare any
efforts. And now, as the inscription is made on
the body, everyone can see through the glass.
Don't you want to come closer and see the
needles for yourself." The Traveler stood
slowly, moved up, and bent over the harrow.
"You see," the Officer said, "two sorts of
needles in a multiple arrangement. Each long
needle has a short one next to it. The long
one inscribes, and the short one squirts water
out to wash away the blood and keep the
inscription always clear. The bloody water is
then channeled here in small grooves and
finally flows into these main gutters, and the
outlet pipe takes it to the pit."

"Déesse"
Roland Barthes
Mythologies, 1957
I believe that today the automobile is a
fairly exact equivalent of the great Gothic
cathedrals: by this I mean to say a great
creation of the epoch, conceived with
passionate enthusiasm by unknown artists,
whose image—if not its use—is consumed
by an entire people who, through it, take
possession of a perfectly magical object.
The new Citroën has plainly fallen from the
heavens in the sense that, right from the start,
it appears as a superlative *object*. It must not
be forgotten that the object is the best
vehicle of the supernatural: the object can
easily hold within itself a perfection and an
absence of origin, a closure and a brilliance, a
transformation of life into matter (matter is far
more magical than life), and finally a *silence*
that belongs to the order of the marvelous.
The *Déesse* has all the characteristics (or at
least the public is starting to attribute them
to it with one voice) of one of those objects
fallen from another universe that fed the
mania for novelty in the eighteenth century
and a similar mania expressed by modern
science fiction: the *Déesse* is first and foremost
the new *Nautilus*.

Charlie Chaplin, *Modern Times*, film still, 1936

Marcel Duchamp, *The Large Glass*, also known as *La mariée mise à nu par ses celibataires même (The Bride Stripped Bare by Her Bachelors, Even)*, a cursory examination of which suffices to reveal that it is a work inspired directly by the machines of the Renaissance "mechanicals."

The machines invented by Raymond Roussel in *Impressions of Africa* were celibate machines. But while the machines described by Roussel still produced recognizable effects, such as marvelous weaves, those actually constructed as sculptures by artists like Jean Tinguely produce no more than their own insensate movement, and their only function is to clank along to no purpose. In this sense they are celibate by definition, devoid of functional fertility—they move us to laughter or put us in a playful mood, because by so doing we can control the horror that they would inspire in us if we glimpsed some hidden purpose, which could only be malefic. Tinguely's machines therefore have the same function as many works of art capable of using Beauty to exorcize pain, fear, death, the disquieting, and the unknown.

Jean Tinguely, *Horror Chariot, Viva Ferrari*, 1985. Basel, Museum Tinguely

From Abstract Forms to the Depths of Material

1. "Seek His Statues among the Stones"

Contemporary art has discovered the value and fecundity of material. This is not to say that the artists of the olden days were unaware of the fact that they were working with a given material, or that they did not understand that the use of this material involved limitations and creative cues, shackles, and freedom.

It was Michelangelo who maintained, as is known, that sculptures came to him as though they were already virtually present in the original marble block, so that all the artist had to do was to carve away the superfluous rock in order to bring to light the form that the material already contained within itself. And so, as his biographers say, he used to "send his man to seek his statues among the stones." But while artists have always known that they must hold a dialogue with the material and that they have to find a source of inspiration in it, nevertheless it was felt that the material in itself was formless and that Beauty arose only after an idea or a form had been impressed upon it.

Indeed, according to the aesthetics of Benedetto Croce, real artistic invention develops in that moment of intuition-expression that is wholly consummated within the creative spirit, while the technical expression, the translation of the poetic phantasm into sounds, colors, words, or stone is merely incidental and adds nothing to the fullness and definiteness of the work.

Michelangelo
Buonarroti,
The Awakening Slave,
1516. Florence, Galleria
dell'Accademia

Form and Material
Michelangelo Buonarroti
Poem 151, c. 1538-1541
The excellent artist has no concept
That does not lie within the abundant compass
Of a marble block, and all that artist has
Is the hand that obeys the intellect.

2. The Contemporary Re-Assessment of Material

It is in reaction to this persuasion that contemporary aesthetics has re-assessed material. An invention that takes place in the presumed profundities of the Spirit, and that has nothing to do with the challenge of concrete physical reality, is a pale ghost indeed: Beauty, truth, invention, and creation do not lie solely on the side of some angelic spirituality, they also have to do with the universe of things that can be touched and smelled, that make a sound when they fall, that are drawn downward by the inescapable law of gravity, that are subject to wear and tear, transformation, decay, and development.

While aesthetic systems engaged in a profound re-assessment of the importance of work "on," "with," and "in" material, twentieth-century artists often gave it their exclusive attention, which grew in intensity the more the abandonment of figurative models pushed them into a new exploration of the realm of possible forms. Thus, for the greater part of contemporary artists material is no longer the body of the work and the body of the work alone, but also its end, the object of the creative discourse. The style of painting known as "informal" marked the triumph of splashes, cracks, lumps, seams, drips, and so on.

Jackson Pollock,
Full Fathom Five, detail,
1947. New York,
Museum of Modern Art

Material
Luigi Pareyson
Aesthetics, 1954
The artist lovingly studies his material, he examines in depth, he observes its behavior and reactions; he questions it in order to be in command of it, he interprets it with a view to taming it, he obeys it in order to bend it to his will; he studies it in depth to discover latent possibilities that might suit his ends; he delves into it so that it might itself suggest new and original possibilities; he follows it so that its natural developments may coincide with the exigencies of the work to be created; he investigates the ways in which a long tradition has taught [artists] to handle it in order to engender new ways of working with it, or to extend the old manner of working it; and if the tradition with which that material is laden seems to jeopardize its ductility,

making it heavy and dated and dull, he tries to recover its pristine freshness so that, the more it is unexplored, the more fecund it will be; and if the material is new he will not be frightened by the daring of certain cues that seem to emerge from it spontaneously, nor will he lack the boldness to make certain experiments or shirk the difficult task of penetrating it the better to identify its possibilities. [...]
This is not a matter of saying that the humanity and the spirituality of the artist is manifested in a material, becoming complex, formed, be it of sounds, colors, or words, for art is not the representation and formation of a person's life. Art is merely the representation and formation of a material, but the material is formed according to an unrepeatable way of forming that is the very spirituality of the artist wholly transformed into style.

opposite
Alberto Burri,
Sacco P5, detail,
1953. Città di Castello,
Palazzo Albizzini

Lucio Fontana,
Spatial Concept—Wait,
1964. Private collection

Sometimes the artist leaves things to the materials themselves, to the colors freely splashed onto the canvas, to the burlap or the metal, so that they may speak with the immediacy of a random or unexpected laceration. Thus, it often seems as if the work of art has foresworn all pretensions to form in order to allow the canvas or the sculpture to become what is almost a natural thing, a gift of chance, like those shapes the seawater draws on the sand, or the patterns made by raindrops in the mud.

Some informal painters have given their works titles that evoke the presence of raw material, prior to any artistic intention: *tarmac, asphalt, paving, rubble, molds, tracks, dirt, textures, floods, slag, rust, trimmings, shavings,* and so on. But we cannot ignore the fact that artists are not simply inviting us (through a written message, let us say) to go and observe on our own account paving stones and rust, tarmac or burlap bags lying abandoned in an attic. They are using such materials to make an artwork and, in so doing, they are selecting, highlighting, and thereby conferring form upon the formless and setting the seal of their style upon it. It is only after seeing a work of informal art that we feel encouraged to explore with a more sensitive eye genuinely random splashes, the natural form of rubble, or the wrinkles in certain threadbare or moth-eaten fabrics. In this way, therefore, the exploration of materials, or the elaboration of them, leads us to discover their hidden Beauty.

3. The Readymade

It is in this same spirit that we ought to see the poetics of the *objet trouvé* (or readymade), which had already been invented in the early twentieth century by artists like Marcel Duchamp. The object exists on its own account, but the artist acts like someone who, on strolling along a beach, finds a seashell or a pebble that has been polished by the sea and takes it home, to put it on a table, as if it were a work of art that possesses its own surprising Beauty. In this way artists "selected" as sculptures bottle racks, bicycle wheels, a bismuth crystal, a geometrical solid originally used for teaching purposes, glasses deformed by heat, dummies, and even a urinal.

Of course, underlying such selections there is an intention to provoke, but also the persuasion that every object (even the lowest variety) has formal aspects that we rarely pay any attention to. As soon as they are singled out, "focused," and offered to our attention, these objects take on an aesthetic significance, as if they had been manipulated by the hand of an author.

Marcel Duchamp,
Fountain (replica), 1917.
Paris, Musée National
d'Art Moderne, Centre
Georges Pompidou

4. From Reproduced to Industrial Material to the Depths of Material

On other occasions the artist did not find, but *reproduced* by his own hand the stretch of road or the graffiti scribbled on walls, like Dubuffet's road surfaces and Cy Twombly's canvases with their infantile scribblings. Here, the artistic operation is more evident. The artist knowingly uses refined techniques to remake things that ought to appear as the product of random chance, **material in the raw state.** Other times the material is not natural, but is already industrial waste or a commercial object that has outlived its usefulness and has been retrieved from the trash can.

Cy Twombly,
Untitled, 1970. Houston,
Menil Collection

Material in the Raw State
André Pieyre de Mandiargues
Dubuffet, or The Extreme Point, 1956
To make things simpler we might note that what he likes especially about earth is that it is more common and widespread than any other thing in the world, and owing to this commonness it has often discouraged those who merely give it a passing glance. For this has nothing to do with the ideal concept of earth or its sentimental spirit, which often inspires wise men and fools alike, nor with its relationship to humanity. […] It has to do with that ordinary material right beneath our feet, that stuff that sometimes sticks to our shoes, that kind of horizontal wall, that level plane upon which we stand, a plane so banal that it eludes the sight, except in cases of prolonged effort. That material of which we might say that there is nothing more concrete, because we would have never ceased to tread upon it without the artifices of architecture.

opposite
César, *Compression,*
1962. Paris, Musée
National d'Art Moderne,
Centre Georges
Pompidou

Andy Wharol
Campbell's Soup Can I,
1960. Aachen, Neue
Galerie, Ludwig
Collection

Roy Lichtenstein,
Crak!, 1963-1964.
Estate of
Roy Lichtenstein

This brings us to César, who compressed, deformed, and exhibited the contorted metal of an old car radiator, Arman who filled a transparent showcase with mounds of old pairs of eyeglasses, Rauschenberg who glued chair backs or clock faces onto the canvas, Lichtenstein who made gigantic and highly faithful copies of scenes from old comic strips, and Warhol, who offered us a can of Coca-Cola or canned soup, and so on.

In such cases the artist engages in a sort of mocking polemic against the industrialized world all around us, showing the archaeological finds of a contemporary world that is consumed day by day, petrifying in his ironic museum the things we see every day without our realizing that in our eyes their function is like that of a fetish. But, by so doing, no matter how ferocious or mocking his polemic may be, the artist also teaches us to love these objects, reminding us that even the world of industry has certain "forms" that can convey an aesthetic emotion.

Having come to the end of their cycle as consumer goods, now supremely useless, these objects are in some ironical way redeemed of their uselessness, of their "poverty," even of their wretchedness, to reveal an unsuspected Beauty. Finally, today, sophisticated electronic techniques also allow us to find unexpected formal aspects in the depths of material, just as once we used to admire the Beauty of snowflake crystals under a microscope.

following pages
Mandelbrot Set,
from Heinz-Otto
Peitgen and Peter H.
Richter, *The Beauty of*
Fractals, New York, 1986

This marks the birth of a new form of ready made, which is neither a craft nor an industrial object, but a profound feature of nature, a structure invisible to the human eye. We might call this a new "aesthetics of fractals."

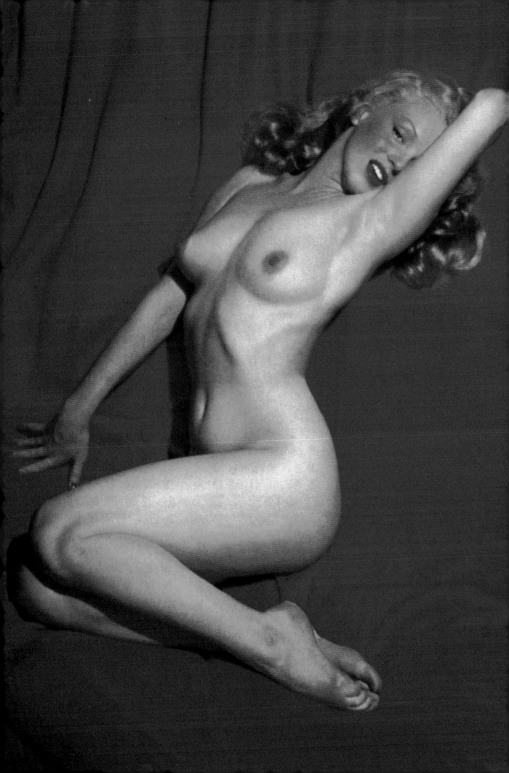

The Beauty of the Media

1. The Beauty of Provocation or the Beauty of Consumption?

Let us imagine an art historian of the future or an explorer arriving from outer space who both ask themselves the same question: what is the idea of Beauty that dominated the twentieth century? At bottom we have done nothing else, in this cavalcade through the history of Beauty, but pose ourselves similar questions about ancient Greece, the Renaissance, and the early or late nineteenth century. True, we have done our best to identify the contrasts that caused a stir in individual periods, moments in which, for example, Neoclassical tastes coincided simultaneously with the presence of the aesthetics of the Sublime, but basically we always had the feeling— on looking at things "from a distance"—that each century possessed consistent characteristics, or at least a single fundamental inconsistency.

Marilyn Monroe,
from the *Calendar
of Marilyn*, 1952

Adolphe de Meyer,
*Vaslav Nijnsky
and the Nymphs*,
from *L'après-midi
d'un faune*, 1912

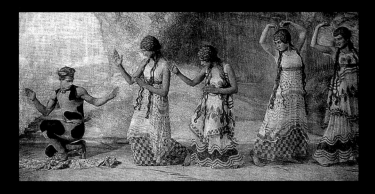

It may be that, on looking at things "from a distance" in their turn, the interpreters of the future will identify something as truly characteristic of the twentieth century and thus give Marinetti the rights of the matter, by saying that the twentieth-century equivalent of the *Victory of Samothrace* was indeed a beautiful racing car, perhaps ignoring Picasso or Mondrian. We cannot look at things from such a distance; all we can do is content ourselves with noting that the first half of the twentieth century, up to and including the 1960s at most (after which it would be more difficult), witnessed a dramatic struggle between the Beauty of provocation and the Beauty of consumption.

Man Ray,
Venus Restored, 1936.
Milan, Arturo Schwarz
Collection

2. The Avant-Garde, or the Beauty of Provocation

The Beauty of provocation is the idea of Beauty that emerged from the various avant-garde movements and artistic experimentalism: from Futurism to Cubism, from Expressionism to Surrealism, and from Picasso to the great masters of informal art and beyond.

Avant-garde art does not pose itself the problem of Beauty. And while it is implicitly accepted that the new images are artistically "beautiful," and must give us the same pleasure that Giotto's frescoes or Raphael's paintings gave to their own contemporaries, it is important to realize that this is so precisely because the avant-garde has provocatively flouted all aesthetic canons respected until now. Art is no longer interested in providing an image of natural Beauty, nor does it aim to procure the pleasure ensuing from the contemplation of harmonious forms. On the contrary, its aim is to teach us to interpret the world through different eyes, to enjoy a return to

Gino Severini,
La danseuse obsédante,
1911. Turin, Pinacoteca
Giovanni e Marella
Agnelli

Pablo Picasso,
Les demoiselles d'Avignon,
1907. New York, Museum
of Modern Art

415

Kazimir Malevich,
*Black Square and
Red Square,*
1915. New York,
Museum of
Modern Art

archaic or esoteric models, the universe of dreams or the fantasies of the mentally ill, the visions provoked by drugs, the rediscovery of material, the startling re-presentation of everyday objects in improbable contexts (see readymades, Dada, etc.), and subconscious drives.

Only one school of contemporary art has retrieved an idea of geometrical harmony, reminiscent of the aesthetics of proportion, and that is abstract art. By rebelling against both subjection to nature and to everyday life, abstract art has offered us pure forms, from the geometries of Piet Mondrian to the large monochromatic canvases of Yves Klein, Mark Rothko, or Piero Manzoni. But who has not had the experience, on visiting an exhibition or a museum over the past decades, of listening to visitors who—faced with an abstract work—say "but what is it meant to be?", or come out with the inevitable "they call this *art*?"? And so even this "Neo-Pythagorean" return to the aesthetics of proportion and number works against current sensibilities, against the ideas that ordinary people have about Beauty.

Finally there are many schools of contemporary art (happenings, events in which the artist cuts or mutilates his own body, involvement of the public in light shows or acoustic phenomena) in which—in the name of art—people apparently stage ceremonies smacking of ritual, not unlike the ancient mystery rites, whose end is not the contemplation of something beautiful, but a quasi-religious experience, albeit of a carnal and primitive sort, from which the gods are absent. Other occasions of a similar nature include "raves" and other events involving huge crowds in discos or rock concerts, where strobe lights and music played at extremely high volume constitute a way of "being together" (often accompanied by the use of chemical stimulants) that may even seem "beautiful" (in the traditional sense of circensian games) to someone contemplating the scene from the outside, but is not experienced in the same way by those who are actively involved. Participants may talk about a "beautiful experience," as we might talk about a beautiful swim, a beautiful motorcycle ride, or a satisfactory sexual encounter.

3. The Beauty of Consumption

But our visitor from the future could not avoid making another curious discovery. Visitors to an exhibition of avant-garde art who purchase an "incomprehensible" sculpture, or those who take part in a "happening," are dressed and made up in accordance with the canons of fashion. They wear jeans or designer clothes and wear their hair or make-up according to the model of Beauty offered by glossy magazines, the cinema, or television—in other words by the mass media. These people follow the ideals of Beauty as suggested by the world of commercial consumption, the very world that avant-garde artists have been battling against for over fifty years.

How to interpret this contradiction? Without attempting to explain it, we can say that it is the contradiction typical of the twentieth century. At this point the visitor from the future would have to ask himself what the mass media's model of Beauty really was, and he would discover that the century was traversed by a double caesura.

Twiggy

opposite
Greta Garbo

following pages
page 420
Rita Hayworth

page 421, clockwise
Grace Kelly
Brigitte Bardot
Marlene Dietrich
Audrey Hepburn

pages 422-423
Anita Ekberg

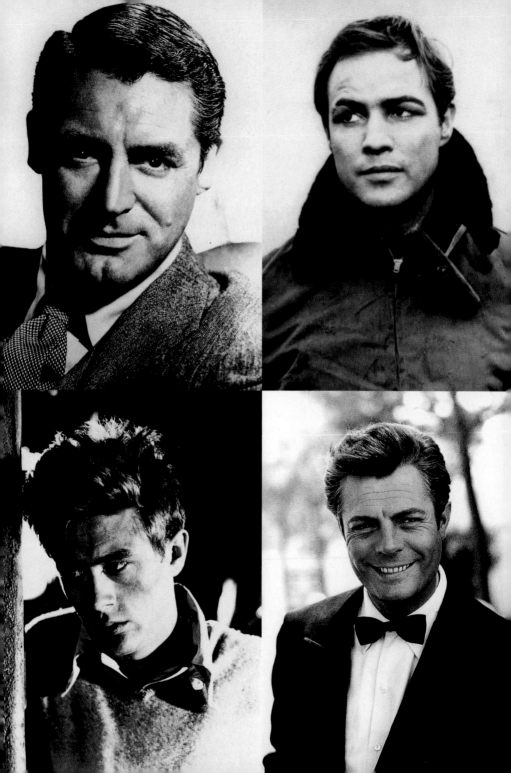

opposite, clockwise
Cary Grant
Marlon Brando
Marcello Mastroianni
James Dean

John Wayne, 1967

Fred Astaire
and Ginger Rogers, 1936

The first of these takes the form of a contrast between models in the course of the same decade. Just to provide a few examples, in the same years the cinema offered the model of the "femme fatale" as represented by Greta Garbo and Rita Hayworth, and that of the "girl next door," as played by Claudette Colbert or Doris Day. It also gave us the western hero in the form of the hulking and ultra virile John Wayne along with the meek and vaguely effeminate Dustin Hoffman. Gary Cooper and Fred Astaire were contemporaries, and the slightly built Fred danced with the stockily built Gene Kelly. Fashion offered sumptuous womenswear like the outfits seen in *Roberta*, and at the same time it gave us the androgynous designs of Coco Chanel. The mass media are totally democratic, offering a model of Beauty for those already naturally endowed with aristocratic grace, as well as for the voluptuous working-class girl. The svelte Audrey Hepburn constituted a model for those women who could not compete with the full-bosomed Anita Ekberg; while for those men who do not possess the refined masculine Beauty of Richard Gere, there is the sensitive appeal of Al Pacino and the blue-collar charm of Robert De Niro. And finally, for those who cannot afford the Beauty of a Maserati, there is the convenient Beauty of the Mini.

The second caesura split the century in two. All things considered, the ideals of Beauty presented by the mass media over the first sixty years of the twentieth century refer to models originating in the "major arts." The languorous women who appeared in the ads of the 1920s and 1930s are reminiscent of the slender Beauty of the Art Nouveau and Art Deco movements. Advertising material for a variety of products reveals Futurist, Cubist, and Surrealist influences. The "Little Nemo" strips were inspired by

Alex Raymond,
Flash Gordon, The Five-Headed Monster,
detail from the comic
strip, 1974

opposite
Heinz Edelmann,
illustration of
The Beatles in *Yellow
Submarine*, 1968.
© Subafilms Ltd.

Art Nouveau, the urban scenarios of other worlds that appear in Flash Gordon comics remind us of the utopias of Modernist architects like Sant'Elia and even anticipate the shape of modern missiles. Dick Tracy strips express a growing familiarity with avant-garde painting. And, finally, it suffices to follow Mickey and Minnie Mouse from the 1930s to the 1950s in order to see how the drawings conformed to the development of dominant aesthetic sensibilities.

But when Pop art took over and began to turn out provocative experimental works based on images from the worlds of commerce, industry, and the mass media, and when the Beatles skillfully reworked certain traditional musical forms, the gap between the art of provocation and the art of consumption grew narrower. What is more, while it seems that there is still a gap between "cultivated" and "popular" art, in the climate of the so-called post-Modern period cultivated art offers new experimental work that goes beyond visual art and revisits of visual art at one and the same time, as the tradition is continually reassessed.

For their part, the mass media no longer present any unified model, any single ideal of Beauty. They can retrieve, even for an advertising campaign destined to last only a week, all the experimental work of the avant-garde, and at the same time offer models from the 1920s, 1930s, 1940s, and 1950s, even in the outmoded forms of automobiles from the mid-century. The mass media continue to serve up warmed-over versions of nineteenth-century iconography, the Junoesque opulence of Mae West and the

Daryl Hannah
and Rutger Hauer in
Blade Runner,1982

opposite, clockwise
Ling by Richard Avedon
(Pirelli Calendar, 1997)
Naomi Campbell by
Terence Donovan
(Pirelli Calendar, 1987)
Kate Moss by Herb Ritts
(Pirelli Calendar, 1994)
Dennis Rodman

anorexic charms of the latest fashion models; the sultry Beauty of Naomi Campbell and the Nordic Beauty of Claudia Schiffer; the grace of traditional tap dancing in *A Chorus Line* and the chilling futuristic architectures of *Blade Runner*; the femme fatale of dozens of television shows or advertising campaigns and the squeaky clean girls-next-door like Julia Roberts or Cameron Diaz; Rambo and RuPaul; George Clooney with his short hair, and neo-cyborgs who paint their faces in metallic shades and transform their hair into forests of colored spikes, or who shave their heads entirely.

Our explorer from the future will no longer be able to identify the aesthetic ideal diffused by the mass media of the twentieth century and beyond. He will have to surrender before the orgy of tolerance, the total syncretism and the absolute and unstoppable polytheism of Beauty.

Bibliographical References
of Anthology Translations

Translator's Note
Unless otherwise indicated, all the
excerpts in the quotations section
were translated by me from Italian
versions of the texts in question. This
does not apply, obviously, to those
texts originally written in English, with
the exception of two small passages
that proved impossible to trace. While
every effort was made to provide an
accurate and pleasing rendition of the
many poetic works included here, my
brief was to give the reader an idea of
the content rather than to recreate the
poems as poems. Again, it must be
borne in mind that many of the poems
are translations from Italian
translations and so, in some cases,
readers able to read these works in the
original languages will find significant
differences between my translation
and the original works. I should like to
thank Umberto Eco for his unstinting
generosity and patience, as well as
many friends and colleagues whose
contributions enabled me to tackle the
interpretation of some of the most
arduous passages: Luciana Bettucchi,
Vincenzo Mantovani, Leonardo
Mazzoni, Winifred McEwen, Anna
Mioni, Sergio Musitelli, Valentina
Pisanty, Mirella Soffio, and Simon
Turner. The responsibility for any
inaccuracies is of course mine.

Alighieri, Dante
Purgatorio, VII, vv. 70-78 *109*
Paradiso, XIV, vv. 67-75 *114*
Purgatorio, I, vv. 13-24 *114*
Paradiso, XXX, vv. 97-120 *129*
La vita nuova , Indiana University Press,
Bloomington 1962 *171, 174*
Paradiso, XXIII, vv. 1-34 *174*
translated by Henry Wadsworth
Longfellow (e-text courtesy ILT's
Digital Dante Project)

Alberti, Leon Battista
On Painting; and *On Sculpture*, edited
with translations, introduction, and
notes by Cecil Grayson, Phaidon Press,
London 1972 *180*

Boccaccio, Giovanni
The Decameron, Third day, First
Novella, *160*, translated by J. M. Rigg,

London, 1921

Burnet, Thomas
The Sacred Theory of the Earth , London,
Fontwell, Centaur Press, 1965 *284*

Castiglione, Baldassare
The Book of the Courtier, Penguin
books, Harmondsworth 1967 *212, 217*

Cervantes, Miguel de
Don Quixote, Book I, Chapter XIII, 1605-
1615 *212*, from *The Classical Authors
Library* translated by John Ormsby

St. Hildegard of Bingen
Scivias / Hildegard of Bingen, translated
by Columba Hart and Jane Bishop;
Paulist Press, New York 1990 *114*

Kafka, Franz
In the Penal Colony, 1919 *397*,
translation by Ian Johnston, Malaspina
University-College, Nanaimo, British
Columbia, Canada.

Leonardo da Vinci
*Leonardo on Painting: an Anthology of
Writings by Leonardo da Vinci with a
Selection of Documents Relating to His
Career as an Artist*, edited by Martin
Kemp, selected and translated by
Martin Kemp and Margaret Walker,
Yale University Press, New Heaven-
London 1989 *178*

Marco Polo
The Travels of Marco Polo, Introduction
by John Mansfield, London-New York
1939 *108, 142*

Nietzsche, Friedrich Wilhelm
The Birth of Tragedy, I, 1872, *55*
The Birth of Tragedy , I, 1872 *56*
The Birth of Tragedy , III, 1872 *55, 56, 58*
in G. Allen and H. Clark, *Literary
Criticism: Pope to Croce*, Wayne State
University Press, Detroit 1962;
The Birth of Tragedy , XVI, 1872 *58*
translated by Francis Golffing and
Walter Kaufmann for *The Nietzsche
Channel*

Novalis
Hymns to the Night, Phoenix Press,
London 1948 *312*

Plato
The Republic, X *38*
Symposium 41
Phaedrus, XXX
Timaeus, V
Timaeus , 55e-56c *51*
Timaeus , XX *67*
translated by Benjamin Jowett
The Gutemberg Project

Plotinus
Enneads, in *Plotinus*, translated by
A.H.Armstrong, Harvard University
Press, Cambridge, Mass., 1988-89
103, 180

Plutarch
The Obsolescence of Oracles, in *Selected
Essays and Dialogues* , Oxford
University Press, Oxford-New York
1993 *82*

Pseudo-Longinus
Longinus on the Sublime, edited, with
introduction and commentary by D. A.
Russell, Clarendon Press, Oxford 1982
278, 279

Rimbaud, Arthur
Complete Works, Selected Letters,
translation, introduction and notes by
Wallace Fowlie. University of Chicago
Press, Chicago-London 1966 *336, 350*

Tasso, Torquato
Jerusalem Delivered, XII, 1593 *288*
Jerusalem Delivered, IV vv. 56-64, 1575
324, translated by Edward Fairfax
(1560-1635); translation first published
in London, 1600. The text of this
edition is based on that edited by
Henry Morley, LL.D. (New York, 1901).
Public domain

Index of Anthology Authors